THE CAMBRIDGE COMPANION TO
Masaccio

The Cambridge Companion to Masaccio explores the visual, intellectual, and religious culture of Renaissance Florence in the age of Masaccio, 1401–28. Written by a team of internationally renowned scholars and conservators, the essays in this volume investigate the artistic, civic, and sacred contexts of Masaccio's works and the sites in which they were seen. They also reassess the artist's connection to the past, especially to medieval workshop practices and ancient and Gothic art, as well as his novel experiments with technique, perspective, and narrative. Collectively, they reevaluate his association with Brunelleschi, Ghiberti, Donatello, and his collaborator Masolino. Inspired by the 600th anniversary of Masaccio's birth, *The Cambridge Companion to Masaccio* celebrates the achievements, influence, and legacy of early Renaissance art and one of its greatest masters.

Diane Cole Ahl is the Arthur J. '55 and Barbara S. Rothkopf Professor of Art History at Lafayette College. Former president of the Italian Art Society, she is the author of *Benozzo Gozzoli*, which shared the Otto Gründler Prize for Best Book in Medieval Studies; editor of *Leonardo da Vinci's Sforza Monument Horse: The Art and the Engineering*; and co-editor with Barbara Wisch of *Confraternities and the Visual Arts in Renaissance Italy: Ritual, Spectacle, Image*.

THE CAMBRIDGE COMPANION TO

Masaccio

Edited by

Diane Cole Ahl

Lafayette College

CAMBRIDGE
UNIVERSITY PRESS

PUBLISHED BY THE PRESS SYNDICATE OF THE UNIVERSITY OF CAMBRIDGE
The Pitt Building, Trumpington Street, Cambridge, United Kingdom

CAMBRIDGE UNIVERSITY PRESS
The Edinburgh Building, Cambridge CB2 2RU, UK
40 West 20th Street, New York, NY 10011-4211, USA
477 Williamstown Road, Port Melbourne, VIC 3207, Australia
Ruiz de Alarcón 13, 28014 Madrid, Spain
Dock House, The Waterfront, Cape Town 8001, South Africa

http://www.cambridge.org

First published 2002

Printed in the United Kingdom at the University Press, Cambridge

Typeface Fairfield Medium 10.5/13 pt. *System* QuarkXPress® [GH]

A catalogue record for this book is available from the British Library.

Library of Congress Cataloging-in-Publication Data

The Cambridge companion to Masaccio / [edited by] Diane Cole Ahl.
 p. cm. – (Cambridge companion to the history of art)
 Includes bibliographical references and index.
 ISBN 0-521-66045-9 – ISBN 0-521-66941-3 (pc.)
 1. Masaccio, 1401-1428? – Criticism and interpretation. 2. Art, Italian –
Italy – Florence – 15th century. 3. Art, Renaissance – Italy – Florence. I. Ahl,
Diane Cole, 1949– . II. Cambridge companions to the history of art.

ND623.M43 C36 2002
759.5 – dc21 2001037496

ISBN 0 521 66045 9 hardback
ISBN 0 521 66941 3 paperback

To Paul Barolsky, treasured mentor and friend

Contents

Contents

List of Illustrations

FIGURES

Contributors

Anthony Molho teaches the history of the Mediterranean in the late medieval and early modern age at the European University Institute in Florence. Before assuming this position, he taught at Brown University for many years. His two most recent books are *Marriage Alliance in Late Medieval Florence* (1994) and *Imagined Histories. American Historians Interpret the Past* (1998), co-edited with Gordon Wood. Among his many publications is a fundamental article on the Brancacci Chapel.

Gary M. Radke is Professor of Fine Arts at Syracuse University, where he has served as department chair and director of the University Honors Program. His publications include *Viterbo: Profile of a Thirteenth-Century Papal Palace* (1996) and, with John T. Paoletti, *Art in Renaissance Italy* (1992). A fellow of the American Academy in Rome, Radke also has published on the sculpture of Benedetto da Maiano and the patronage of nuns in fifteenth-century Venice.

Ellen Callmann is Professor Emerita of Art History at Muhlenberg College. She also has taught graduate courses at Bard Graduate Center for Studies in the Decorative Arts. Her publications include *Apollonio di Giovanni* (1974) and *Beyond Nobility: Art for the Private Citizen in the Early Renaissance* (1980). She has published extensively on Renaissance secular painting, the iconography and attribution of painted *cassoni*, and the collecting and display of Renaissance *cassoni* in the nineteenth century.

Perri Lee Roberts is Associate Professor of Art History and Vice Provost for Undergraduate Affairs at the University of Miami. She is the author of *Masolino da Panicale* (1993) and numerous articles on fourteenth- and fifteenth-century Italian painting. Dr. Roberts is guest curator for an exhibition of early Italian paintings from southern collections, hosted by the Georgia Museum of Art. Her *Corpus of Early Italian Paintings in North American Public Collections: The South* is forthcoming.

Roberto Bellucci has been a restorer at the Opificio delle Pietre Dure e Laboratori di Restauro in Florence since 1969, and chief restorer since 1975. He

has restored several major paintings, including Raphael's *Portrait of Agnolo Doni*, Sandro Botticelli's *Coronation of the Virgin*, Caravaggio's *Self-Portrait as Bacchus*, Guglielmo's *Sarzana Cross*, and Masaccio's *Stories of Saint Julian*. He is the author of more than twenty scientific papers on conservation and technical subjects.

Cecilia Frosinini has been with the Opificio delle Pietre Dure in Florence since 1990, serving as art historian, Deputy Director of the Painting Conservation Department, and Director of the Paper and Parchment Conservation Department. She has published more than thirty papers on art-historical subjects, including the workshop of the Bicci and the partnership of Donatello and Michelozzo. Her main interests concern archival research on fifteenth-century Florentine society and artists' technical procedures based on old treatises.

Dillian Gordon is Curator of Early Italian Paintings at the National Gallery, London. She has contributed a number of articles to the *Burlington Magazine* and *Apollo,* and is co-author of several National Gallery publications, including *Art in the Making: Italian Painting before 1400* (1989), *Giotto to Dürer: Early Renaissance Painting in the National Gallery* (1991), and *Art in the Making: The Wilton Diptych* (1993). She currently is revising the National Gallery catalogue of Italian Renaissance painting 1400–1600.

Diane Cole Ahl is Arthur J. '55 and Barbara S. Rothkopf Professor of Art History at Lafayette College and former president of the Italian Art Society. Her books include *Benozzo Gozzoli* (1996), co-awarded the Otto Gründler Prize in Medieval Studies; *Leonardo da Vinci's Sforza Monument Horse: The Art and the Engineering* (1995), which she edited; and *Confraternities and the Visual Arts in Renaissance Italy. Ritual, Spectacle, Image* (1999), co-edited with Barbara Wisch.

Timothy Verdon is a canon of Florence Cathedral; Director, Office for Catechesis through Art, Archdiocese of Florence; consultant to the Vatican Commission for the Cultural Heritage of the Church; and Visiting Professor of Art History, Stanford University in Florence. He is the author of numerous books, essays, and articles on religion and art, including studies on Masaccio and Donatello. He has edited and co-edited several books, including the three-volume *Atti del VII Centenario di Santa Maria del Fiore* (2001).

J. V. Field is an Honorary Visiting Research Fellow in the School of History of Art, Film, and Visual Media, Birkbeck College, University of London. Dr. Field is the author (with Frank A. L. James) of *Science in Art: Works in the National Gallery That Illustrate the History of Science and Technology* (1997) and *The Invention of Infinity: Mathematics and Art in the Renaissance* (1997, rpt. 1999), and has just completed *Piero della Francesca: A Mathematician's Art.*

Francis Ames-Lewis is Professor of the History of Renaissance Art at Birkbeck College, University of London. His publications include *Drawing in Early Renaissance Italy* (1981, 2nd ed. 2000), *The Library and Manuscripts of Piero di Cosimo de' Medici* (1984), *The Draftsman Raphael* (1986), *Tuscan Marble Carving 1250–1350* (1997), and *The Intellectual Life of the Early Renaissance Artist* (2000), as well as several edited volumes and many scholarly articles on Italian Renaissance themes.

THE CAMBRIDGE COMPANION TO
Masaccio

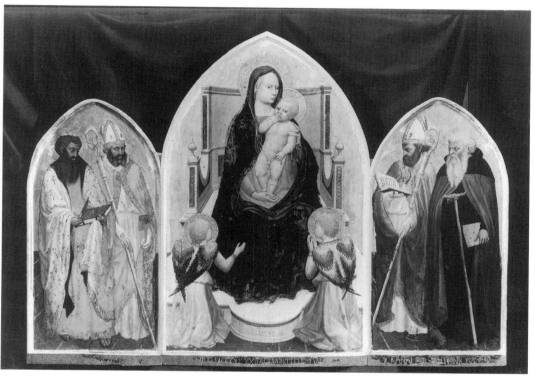

Plate 1. Masaccio, *Cascia di Reggello Altarpiece,* 1422, Cascia di Reggello, ex-San Giovenale (now Pieve di San Pietro). (Photo: Antonio Quattrone)

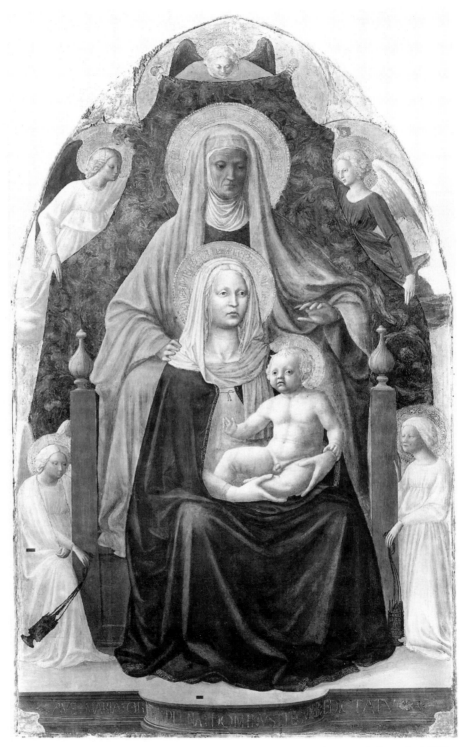

Plate 2. Masaccio and Masolino, *Sant'Anna Metterza,* c. 1423–5, Florence, Galleria degli Uffizi. (Photo: Ministero dei Beni e le Attività Culturali, Firenze, Pistoia, e Prato)

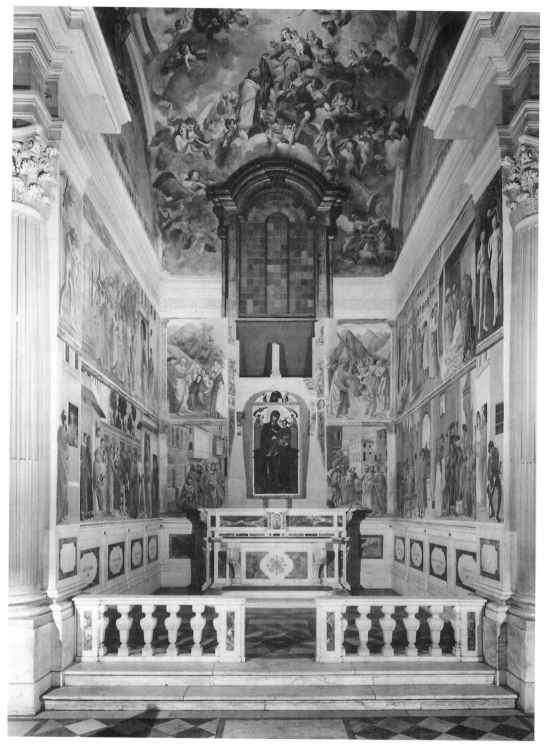

Plate 3. Masaccio, Masolino, and Filippino Lippi, Brancacci Chapel, 1424–6; 1480–1, Florence, Santa Maria del Carmine. (Photo: Antonio Quattrone)

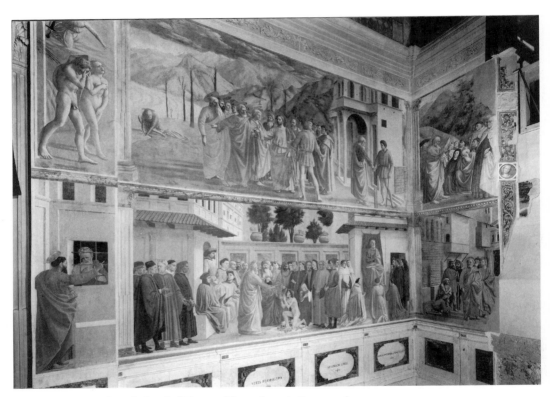

Plate 4. Left Wall, detail of Plate 3. (Photo: Antonio Quattrone)

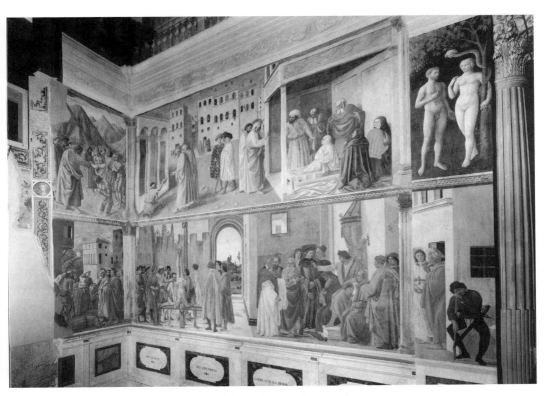

Plate 5. Right Wall, detail of Plate 3. (Photo: Antonio Quattrone)

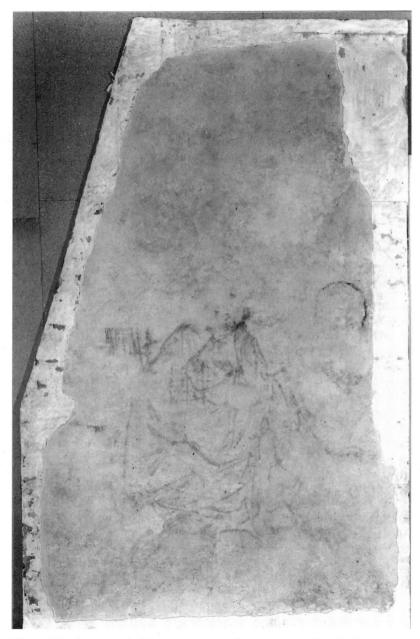

Plate 6. Masolino, *Denial of Saint Peter,* sinopia from Brancacci Chapel. (Photo: Antonio Quattrone)

Plate 7. Masolino, *Feed My Sheep*, sinopia from Brancacci Chapel. (Photo: Antonio Quattrone)

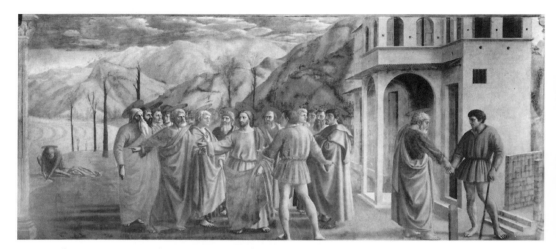

Plate 8. Masaccio, *Tribute Money,* detail of Plate 3. (Photo: Antonio Quattrone)

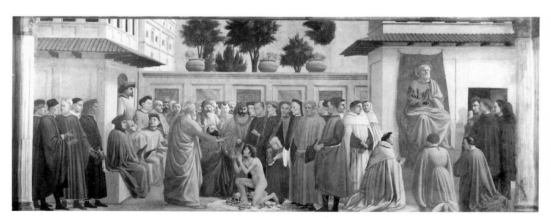

Plate 9. Masaccio and Filippino Lippi, *Raising of the Son of Theophilus,* detail of Plate 3. (Photo: Antonio Quattrone)

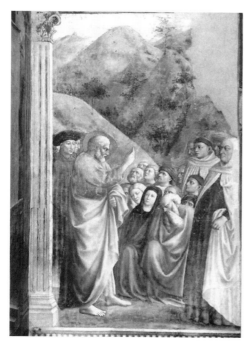

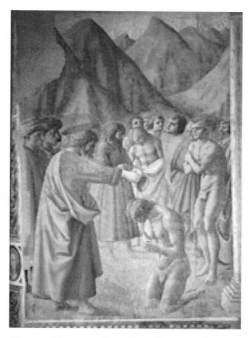

Plate 10. Masolino, *Saint Peter Preaching,* detail of Plate 3. (Photo: Antonio Quattrone)

Plate 11. Masaccio, *Saint Peter Baptizing the Neophytes,* detail of Plate 3. (Photo: Erich Lessing/Art Resource, New York)

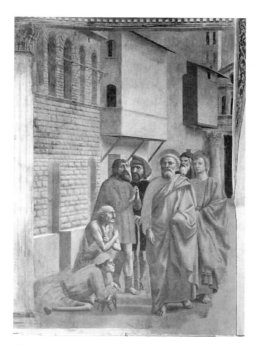

Plate 12. Masaccio, *Saint Peter Healing with His Shadow,* detail of Plate 3. (Photo: Antonio Quattrone)

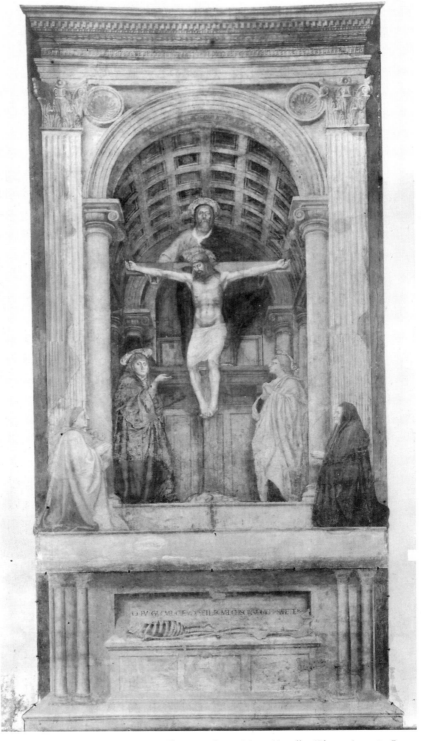

Plate 13. Masaccio, *Trinity*, c. 1424, Florence, Santa Maria Novella. (Photo: Antonio Quattrone)

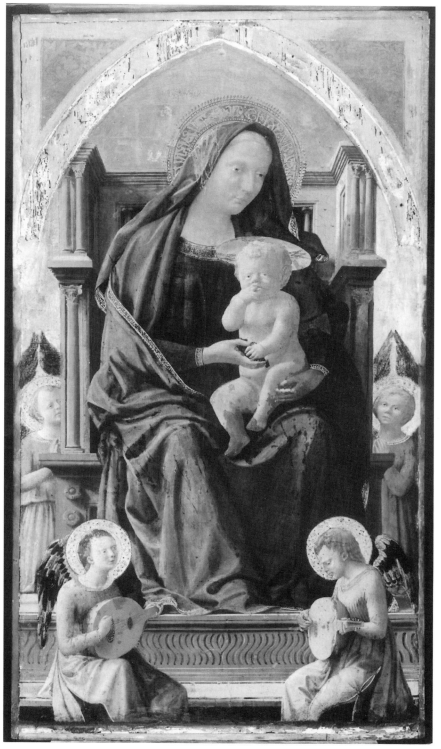

Plate 14. Masaccio, *Madonna and Child with Angels,* from the *Pisa Altarpiece,* 1426, London, National Gallery. (Photo: © National Gallery, London)

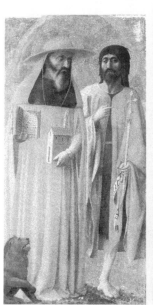
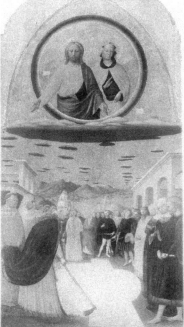
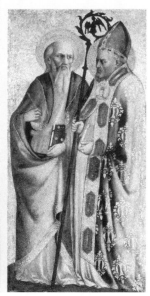

Plate 15. Masaccio and Masolino, Computer imaging (front) by Rachel Billinge of *Santa Maria Maggiore Altarpiece*, 1427–8.

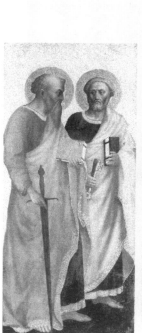
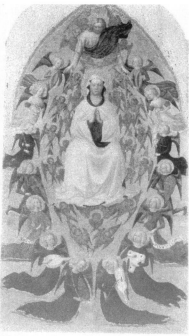
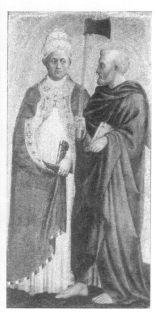

Plate 16. Masaccio and Masolino, Computer imaging (back) by Rachel Billinge of *Santa Maria Maggiore Altarpiece*, 1427–8.

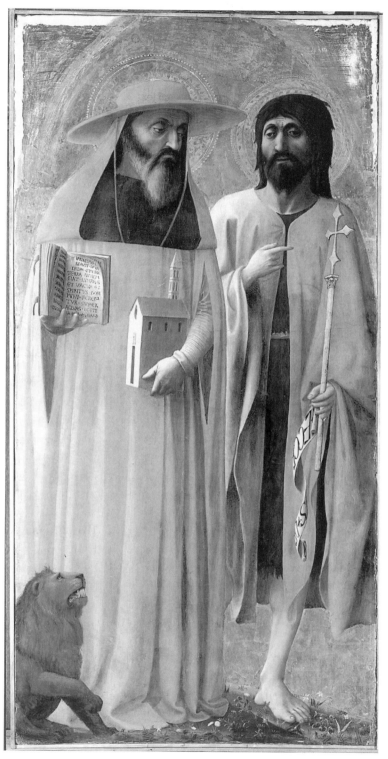

Plate 17. Attributed to Masaccio and Masolino, *Saints Jerome and John the Baptist*, 1427–8, London, National Gallery. (Photo: © National Gallery, London)

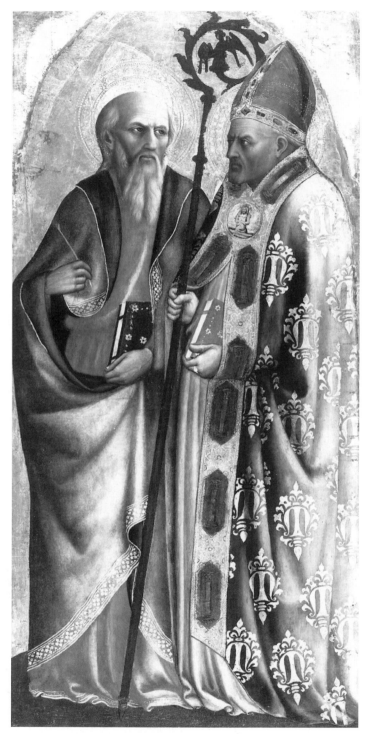

Plate 18. Masolino and Masaccio, *Saints John the Evangelist and Martin of Tours,* 1427–8, Philadelphia, Philadelphia Museum of Art, The John G. Johnson Collection. (Photo: The John G. Johnson Collection, Philadelphia Museum of Art)

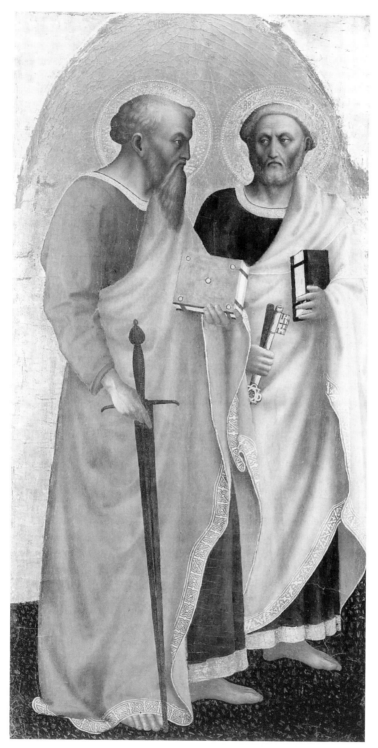

Plate 19. Masolino and Masaccio, *Saints Paul and Peter*, 1427–8, Philadel-
phia, Philadelphia Museum of Art, The John G. Johnson Collection.
(Photo: The John G. Johnson Collection, Philadelphia Museum of Art)

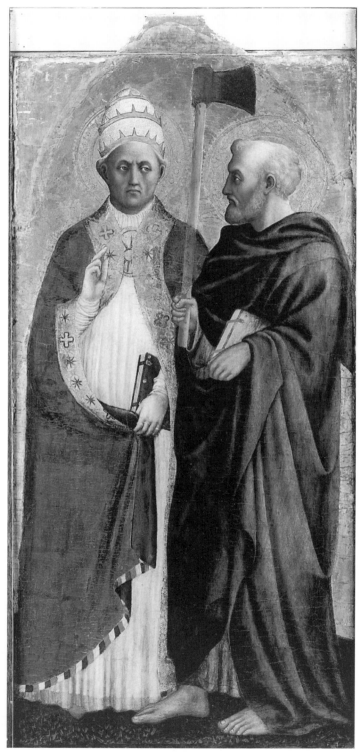

Plate 20. Masolino, *Saints Gregory and Matthias*, 1427–8, London, National
Gallery. (Photo: © National Gallery, London)

Introduction

Diane Cole Ahl

Identified in Leon Battista Alberti's treatise *On Painting* (1435/6) among the creators of a new style of art, Masaccio (1401–28) ever since has been recognized as the founder of fifteenth-century Florentine painting.[1] In a career lasting less than a decade before his death at age twenty-seven, Masaccio transformed the course of Renaissance art. His works are universally renowned: the Santa Maria Novella *Trinity* (see Plate 13), the earliest extant painting composed in accord with Brunelleschian perspective; the London *Madonna and Child with Angels* (see Plate 14) from the dismembered *Pisa Altarpiece* (1426); and the magisterial frescoes in the Brancacci Chapel (see Plate 3), Santa Maria del Carmine, executed in collaboration with Masolino. His contributions to Renaissance art include the solemn portrayal of narrative, the mathematical construction of space, the consistent illumination of form, and the depiction of figures possessing extraordinary physical and psychological realism. Such innovations were as crucial to later generations as they seemed to his own contemporaries. Leonardo da Vinci celebrated Masaccio in his treatise on painting (c. 1498) for halting the "decline" of painting that had prevailed since Giotto's death.[2] Giorgio Vasari, whose *Lives of the Most Illustrious Painters, Sculptors, and Architects – Le vite de' più eccellenti pittori scultori ed architettori* (1550, 1568) – has influenced criticism to this day, praised Masaccio for inspiring the "new rebirth" of painting.[3]

Vasari and the *Lives* of Masaccio and Masolino

Vasari introduced his *vita* of Masaccio by proclaiming the opening years of the fifteenth century in Florence as a golden age, when the city "produced at one and the same time Filippo [Brunelleschi], Donatello, Lorenzo

[Ghiberti], Paolo Uccello, and Masaccio, each superb in his own field."[4] While recognizing the greatness of "these founders," Vasari elevated Masaccio above them all because of his superiority in the art of painting, from his natural rendering of figures and movement to his mastery of foreshortening, which even "exceeded" that of Uccello, famous for his exploration of perspective.[5] So intense was Masaccio's devotion to his art, Vasari related, that the artist cared little about clothing or money, even failing to collect debts, despite his poverty. For this reason, Vasari explained, he affectionately was called Masaccio ("careless Tom").

In Vasari's heroic portrayal, only a few words were spared for Masaccio's collaborator, Masolino (1383/4–c. 1436), who is identified only in passing (and incorrectly) as Masaccio's teacher.[6] Although many scholars have defined Masolino exclusively – and unfavorably – in relation to Masaccio, he was in fact an accomplished master in his own right.[7] His refined works, much influenced by those of Ghiberti and Gentile da Fabriano, were commissioned throughout Tuscany, Umbria, Lombardy, Rome, and Hungary. His association with Masaccio in the mid-1420s was brief yet extremely intense. So closely did Masolino approximate Masaccio's style that Vasari, an astute connoisseur, did not recognize his hand in the collaborative *Santa Maria Maggiore Altarpiece* (see Plates 15 and 16) and the *Sant'Anna Metterza* (see Plate 2).[8] Vasari ascribed both of these to Masaccio, as did generations of critics who followed him. Also included in Masaccio's *vita* were three works that Masolino seems to have painted alone: the Castiglione Branda Chapel in San Clemente, Rome; the *Carnesecchi Altarpiece;* and the *Annunciation* for San Niccolò sopr'Arno, which Vasari praised for its perspective and illusionistic landscape.

In contrast to Vasari's impassioned account of Masaccio's life, the *vita* of Masolino is perfunctory. While noting the artist's training with Ghiberti and Starnina,[9] it mentions nothing of his association with Masaccio. Vasari listed only a few of his works, and of these, the Brancacci Chapel alone elicited true admiration. Describing Masolino's scenes one by one, he praised their monumentality, subtle colors, and grace.[10] But as Vasari recounted, painting these frescoes exacted a high toll. The effort so ruined Masolino's health, Vasari proclaimed, that the artist died, which, as he noted in the *vita* of Masaccio, forced Masaccio to complete them alone. This cautionary fable about the demands of great art was a fabrication, for Masolino outlived Masaccio by almost a decade. It may have served to rationalize what for Vasari was at once obvious yet inexplicable: the absence of Masolino's hand from the last scenes in the cycle, the very episodes that came to define Masaccio's genius.

Vasari expressed unbounded admiration for Masaccio. He praised the *Pisa Altarpiece* from pinnacle to predella, pausing to describe the angel at the Madonna's feet who "is playing a lute, listening attentively to the harmony of its sound."[11] He marveled at the perspective of the *Trinity,* explain-

ing the skillful illusion of its receding vault, which made it seem "that the very wall was pierced."[12] Two of Masaccio's frescoes (since destroyed) in Santa Maria del Carmine inspired Vasari to great eloquence on account of their realism. The first, serving as a counterpart to Masolino's lost fresco of Saint Peter, was an image of Saint Paul, portrayed with the countenance of a prominent Florentine citizen and convincingly foreshortened. The second was the monochrome fresco in the cloister that recorded the Carmine's formal consecration in 1422. The *Sagra* (Consecration) commemorated an illustrious moment in Florentine history, recognizably representing the most prominent artists, including Brunelleschi and Donatello, in the company of the city's noble statesmen.[13] This gathering comprised the most extensive and natural gallery of portraits of the day.

Vasari concluded his account of Masaccio's life with a moving encomium of the Brancacci Chapel, especially of the *Tribute Money* (see Plate 8) and *Saint Peter Baptizing the Neophytes* (see Plate 11).[14] Declaring that Masaccio finished what Masolino began, he eloquently described the *Tribute Money* and the man shivering with cold in *Saint Peter Baptizing the Neophytes*. His appraisal of the chapel's influence seems just. According to the *vita*, the Brancacci Chapel became a "school of art for the most celebrated sculptors and painters," among them, Fra Angelico, Fra Filippo Lippi (then a friar in the Carmine), Filippino Lippi (who, as Vasari recognized, completed the unfinished frescoes), Sandro Botticelli, Leonardo da Vinci, "and the most divine Michelangelo." Vasari recounted that Masaccio died "in the flower of his youth" and was interred in the Carmine in an unmarked grave. Although his report is factually inaccurate – Masaccio almost certainly died in Rome[15] – it seems appropriate that Vasari imagined him entombed in the company of his renowned frescoes.[16]

The Life of Masaccio

In actuality, we know little about Masaccio's life. Although surviving documents provide some biographical data and details of the artist's financial affairs, they are unrevealing about the course of his career.[17] There is little consensus on the chronology of his paintings, and the dates of most of his works are entirely unknown. Although the *Cascia di Reggello Altarpiece* (dated 1422: see Plate 1) is accepted as his earliest painting by most critics,[18] the sequence of all the others, save for the *Pisa Altarpiece* (documented 1426), is disputed. Though his collaboration with Masolino is attested by stylistic evidence, no extant documents confirm or date their professional association. Until new evidence is discovered, any reconstruction of Masaccio's career must balance the few known facts about his life with conjecture.

The artist known as Masaccio was born Tommaso di ser Giovanni di

Mone Cassai in the rural Tuscan town of San Giovanni Valdarno. He was
the oldest son of a notary. His birth took place in 1401 on December 21 –
the feast of Saint Thomas – in whose honor he was named. In 1406, his
father died, and his brother, the painter known as lo Scheggia (1406–86)
was born.[19] Around 1412, his mother married an apothecary. By the time of
his mother's remarriage, Masaccio was likely to have completed six years
of "abacus school," where he would have learned the rudiments of read-
ing, writing, and mathematics required for a professional career.[20] In all
probability, he also began training as an artist around this time. Whether
this training initially occurred in San Giovanni Valdarno or Florence can-
not be determined.

In fact, we can only speculate about Masaccio's early exposure to art
and his apprenticeship. Perhaps he was introduced to painting by his
grandfather or stepfather. As an artisan who made boxes and chests, which
generally were decorated, his grandfather is likely to have had contact with
local artists.[21] His stepfather, an apothecary, belonged to the same guild as
painters and could have provided them with pigments. Yet the few surviv-
ing works of art in San Giovanni Valdarno from this period and earlier
were executed by Florentine and Sienese masters.[22] It seems that there was
no local painter from whom Masaccio could have learned the complexities
of his craft. By 1418, when he was sixteen, Masaccio had established him-
self in Florence, where he was documented as a painter.[23]

The identity of Masaccio's teacher has been much debated. Although
his brother was employed in the large workshop of the artist Bicci di
Lorenzo in 1421,[24] there is no evidence of Masaccio's association with the
master. On January 7, 1422, Masaccio enrolled in the Arte de' Medici e
Speziali, the guild of artists, physicians, and apothecaries.[25] This would
have marked his establishment as an independent master. The *Cascia di
Reggello Altarpiece,* dated April 23, 1422 on the frame but not signed, may
have been the first work he painted following his registration in the guild.[26]
He joined the Compagnia di San Luca, the confraternity of painters, in
1424, the same year as did Masolino.[27]

Notwithstanding the collaboration of Masaccio and Masolino on at
least three major commissions, no legal records of their affiliation are
known to survive. Ironically, their associations with other masters are well
documented. Masolino worked with the artist Francesco d'Antonio
between 1422 and 1424, evidently forming a partnership that finally was
dissolved after binding arbitration in March 1424.[28] Masaccio is also
known to have worked with another artist, the painter Niccolò di ser Lapo,
with whom he was paid for gilding processional candlesticks (lost) for the
Cathedral of Fiesole in August 1425.[29]

Of all of Masaccio's surviving works, only one – the *Pisa Altarpiece* (see
Plates 56 and 57), painted for the degli Scarsi Chapel in Santa Maria del
Carmine in Pisa in 1426 – is completely documented, providing the only

secure date and attribution in his career.[30] Accounts kept by the patron, the notary ser Giuliano degli Scarsi, exactingly record the beginning of the commission on February 19, 1426, and numerous payments throughout the course of its completion on December 26 of the same year. Two of these payments were accepted by Donatello, then in Pisa, on behalf of Masaccio, confirming that the two masters were acquainted.[31] Another was made to Andrea di Giusto, who evidently assisted Masaccio in executing the altarpiece.[32] Along with his frescoes for the Carmine in Florence, the *Pisa Altarpiece* confirms Masaccio's engagement with Carmelite patrons in Tuscany. The sequence of the works' execution, however, remains a matter of conjecture. It is unknown if the *Pisa Altarpiece* initiated Masaccio's association with the Carmelites, or whether it followed his successes in the Order's sister church in Florence: the lost fresco of the church's consecration, with its many portraits; the stunningly foreshortened *Saint Paul;* the Brancacci Chapel.

Documents clearly indicate that the artist so esteemed today was unsuccessful financially throughout his career. When Masaccio enrolled in the Painters Guild in January 1422, he could afford only one florin of the six required for initiation.[33] In 1425 and again in 1426, he was sued by merchants for not settling his debts to them; one of them, a furrier, accepted a small tabernacle of the Madonna (lost) in partial payment of his account in 1426.[34] Masaccio's tax return of July 1427 confirms that he was experiencing serious economic difficulties.[35] He listed no income, but owed considerable sums to other artists, including one equivalent to three years' rent on his workshop.[36] He also was responsible for his then-widowed mother and his brother. The modest cost of their rent suggests that they lived in the most humble lodgings. Although Vasari characterized Masaccio as little concerned with financial affairs, it is clear that the artist lived in near poverty.

At some point after filing his tax declaration in 1427, Masaccio left for Rome. Whether this was to work on the monumental *Santa Maria Maggiore Altarpiece,* mostly painted by Masolino;[37] the Castiglione Branda Chapel in San Clemente, also executed by his erstwhile collaborator;[38] or another commission is unknown. His death in Rome is recorded by a terse statement scrawled in the margin of his tax declaration.[39] The notation does not include the day or even the year he died. Nearly contemporary sources report his passing at age twenty-six or twenty-seven.[40]

Masaccio and Posterity

Less than a decade after his untimely death, Masaccio had been immortalized in Alberti's treatise *On Painting,* in which he was included with Brunelleschi, Donatello, Ghiberti, and Luca della Robbia among the most

excellent masters of the day in whom "a genius for all praiseworthy endeavors" had flourished.[41] Alberti's encomium was followed by that of other humanist writers, most notably, Cristoforo Landino, who assessed his importance as "universal" in the *Commentary to the Divine Comedy* (1481).[42] Other Renaissance authors, from Bartolommeo Fazio through Leonardo da Vinci, remarked on his greatness.[43] Vasari's account, although the most comprehensive of any from this period, thus did not stand alone. It culminated more than a century of eulogistic writing on the master.

Notwithstanding Masaccio's reputation, the vicissitudes of time, taste, and liturgical reform conspired against the preservation of his works. In 1570, the *Trinity* was concealed – ironically, by an immense altarpiece designed by Vasari – during the renovation of Santa Maria Novella.[44] Although the upper part of the fresco was "rediscovered" around 1860, the lower portion, with its skeleton and memento mori, remained hidden behind the altar table until the mid-twentieth century.[45] Around 1690, the Brancacci Chapel was threatened with destruction when a patron sought to replace "those ugly characters dressed in long robes and cloaks in the manner of the antique."[46] Only the intervention of the Grand Duchess of Tuscany thwarted these plans, although Masolino's vaults and lunettes were replaced in later renovations. In 1771, a devastating fire swept the church, miraculously sparing the remaining frescoes but darkening them with soot.[47] By this time, the famous *Saint Paul* and the *Sagra* had been destroyed. As for the altarpieces, both the *Pisa Altarpiece* and the *Santa Maria Maggiore Altarpiece* had long been sawed apart and broken up. Their frames were destroyed and the individual components were sold individually, some never recovered.[48] In spite of this, the cult of Masaccio's fame endured.

Indeed, so exalted was the artist's stature through the nineteenth century that Gaetano Milanesi, the brilliant editor and commentator of Vasari's *Lives,* could champion Masaccio as a great genius within the grand scheme of Renaissance painting. Considering how few works Milanesi actually knew by the master – Vasari's altarpiece still partly covered the *Trinity,* the Carmine *Saint Paul* and *Sagra* were destroyed, the *Pisa Altarpiece* and *Santa Maria Maggiore Altarpiece* had been dismembered and were presumed lost[49] – his high esteem for the artist was remarkable. It was based almost entirely on the Brancacci Chapel, besmudged as it was with soot. In 1860, Milanesi wrote that "perhaps the most important" question in the history of art was the attribution of the Brancacci Chapel.[50] In an extraordinarily sensitive analysis, he separated the contributions of Masaccio, Masolino, and Filippino Lippi, delineating the style of each with acuity.[51] Milanesi's promotion of Masaccio's cult was highly persuasive. From the pioneering Crowe and Cavalcaselle – who, in evident response to Milanesi, ascribed the entire chapel to Masaccio[52] – to Lindberg and Salmi,[53] many art historians through the 1930s dedicated them-

selves to resolving the "Masaccio question." They took on not only the Brancacci Chapel but several other works associated with the master and his collaborator. It became, in fact, the primary issue with which criticism on Masaccio and Masolino was concerned.

In his groundbreaking essay, "Fatti di Masolino e di Masaccio" ("Facts concerning Masolino and Masaccio") of 1940,[54] Roberto Longhi questioned the long-held belief, originating in Vasari, that Masaccio was a student of Masolino. Instead, he saw them as collaborators with distinct personalities who worked concurrently on the Brancacci Chapel, rather than sequentially, as had been maintained by earlier critics. Longhi posited that they sometimes even worked on the same scene. Challenging Vasari, he identified the participation of both artists in the *Sant'Anna Metterza* as well as the *Santa Maria Maggiore Altarpiece*. Longhi concluded this brilliant essay by tracing Masaccio's influence on painters of the 1420s, most notably, Fra Angelico.

More discoveries were made from the 1950s through the 1970s. In the early 1950s, Ugo Procacci discovered the lower half of the *Trinity*, hidden behind an altar, and then directed the reintegration and restoration of the original fresco.[55] In response, scholars reconsidered the mathematical, devotional, and theological matrix from which the *Trinity* emerged, and explored Masaccio's association with Brunelleschi.[56] In 1961, a parish priest brought Luciano Berti to see the *Cascia di Reggello Altarpiece*, suspecting it was by Masaccio; Berti concurred, and proposed it as the master's earliest work.[57] Dated 1422 by the inscription on its frame, the unsigned altarpiece revealed, in Berti's opinion, the artist's youthful style – somber, austere, and sculptural, with vigorously modeled figures – as totally distinct from that of Masolino. The discovery drew renewed attention to the unresolved question, posed most eloquently by Longhi, of the painter's origins and training. As a result, scholars returned to the archives to research Masaccio's family, his early years in Florence, and his diverse clientele.[58]

Masaccio and the Restored Brancacci Chapel

The most crucial contribution to our understanding of Masaccio and Masolino was the restoration of the Brancacci Chapel, conducted from 1983 to 1988.[59] For the first time in centuries, brilliant colors, previously hidden details, and variations of style became visible, inspiring new appreciation of each artist's mastery and their creativity as collaborators. Conservators analyzed the sequence and length of execution for each scene, confirming the speed with which the murals were executed. Previously hidden fresco fragments were discovered around and below the chapel's window, initiating debate on their attribution and iconography.[60] Some

sinopie (preparatory underdrawings) were recovered, providing valuable evidence for the appearance and subjects of lost scenes (see Plates 6 and 7).[61] Examining the murals from the scaffolding, art historians could understand, as never before, the artists' individual styles, their technique, and the dialogue that evidently characterized their collaboration.

Inspired by the chapel's restoration, new monographs on the artists have been published within the past fifteen years, and exhibitions centered on Masaccio have been organized.[62] With great intelligence and ambition, these studies have addressed the "Masaccio question" first posed by Milanesi. They have synthesized the vast literature[63] and advanced novel interpretations of iconography.[64] The artists who influenced Masaccio as well as those influenced by him have been studied attentively. Scholars have investigated his clientele, focusing on the character of Carmelite patronage and iconography.[65] These significant contributions notwithstanding, issues of attribution and dating still dominate much of the literature. There is no study that integrates Masaccio fully within the ambience in which he lived and produced his paintings, or that incorporates multiple disciplinary perspectives on his achievements.

The Cambridge Companion to Masaccio

The Cambridge Companion to Masaccio seeks to situate Masaccio's career and contributions within the experiential and artistic worlds of early Renaissance Florence. Rather than isolating the master because of his genius, it endeavors to integrate his achievements into the milieu from which he emerged. The volume reflects the disciplinary expertise, engagement, and imagination of scholars from diverse fields. The contributors include a historian, a theologian, a scholar of medieval and Renaissance mathematics, several art historians, and conservators who specialize in fifteenth-century Florentine painting. Each takes up a variety of issues crucial to our conception of the painter while challenging and enriching our knowledge of Renaissance Florence. Although the contributors bring different approaches to understanding Masaccio, they uniformly emphasize continuity rather than change within the civic, spiritual, and visual culture of Florence. In so doing, they explore the depth, richness, and complexity of a city that produced some of the greatest masterpieces of the Renaissance.

Anthony Molho explores the political and economic realities of early Renaissance Florence, the complex arena for Masaccio's major works. He challenges Hans Baron's optimistic portrayal of the "republican" city that has proven so influential in shaping our conception of the age of Masaccio.[66] As Molho observes, this view is based on humanist writings and rhetoric and finds no basis in the political and economic realities of the day, which consistently privileged private interest over public welfare,

favoring the rich. Molho specifies the many troubles that threatened the city: a population that, due to the Black Death of the late 1340s, had dwindled to a third of the pre-plague years; a declining economy and high unemployment; inequitably distributed wealth; widespread poverty; the omnipresent threat or actuality of war. The government attempted to gain control over these failures by imposing ever stricter taxes, regulations, and magistracies, which were effective only temporarily. Such poorly conceived expedients further weakened the economy and devastated the morale of the people. Molho's discussion offers an important and consequential corrective to the prevalent view of early fifteenth-century Florence as a golden age imbued with optimism and republican fervor. It has implications not only for how we understand Masaccio but for our conception of the city's history.

The achievements of Florence in urban planning, architecture, and sculpture are analyzed by Gary M. Radke. He begins by evoking the teeming environment of Florence in the 1420s. Radke reminds us that the medieval city known by Masaccio – and depicted in the background of fifteenth-century paintings, including the Brancacci Chapel frescoes – was largely destroyed by urban renewal in the late nineteenth century, after Italy was united. Indeed, none of Brunelleschi's buildings – the dome of the Cathedral, the church of San Lorenzo, the Innocenti – was even completed during Masaccio's lifetime. Questioning the typical characterization of these structures as "Renaissance," Radke observes how greatly they were influenced by Romanesque, rather than Roman, prototypes. The built environment of Masaccio's Florence was resolutely medieval. Radke's reassessment of the age's sculpture similarly challenges facile assumptions about its style and linear development. Although Masaccio may have been attracted to Donatello's dramatic works, Ghiberti was far more successful and influential. Radke devotes special consideration to Orsanmichele, often simplistically portrayed as a polarized "battleground" for the contest between the "outdated, effete, Gothic manner" of Ghiberti, and the "new, classically inspired" sculpture of Donatello and Nanni di Banco, praised as warriors for "civic humanism." Radke presents a more subtle and complex situation, asking us to put aside labels and to consider instead the diversity of styles as well as exigencies of patronage, medium, setting, and decorum in assessing early Renaissance sculpture. In evaluating Florentine architecture and sculpture in the age of Masaccio, Radke concludes that the city was not, as is often maintained, a "hotbed of nothing but radical innovation," but was braced "at a crossroads," at the confluence of old and new.

Painting in Masaccio's Florence is analyzed by Ellen Callmann, who portrays a similarly ambiguous situation. She reconstructs the artistic world of Masaccio in his birthplace of San Giovanni Valdarno, observing that his opportunities to see works of art there, while limited, did exist. She believes that Masaccio's earliest contacts with artists may have been

negotiated by his grandfather, a maker of boxes, which would have been painted. In her opinion, Masaccio apprenticed with the prolific Bicci di Lorenzo, whose paintings she reassesses in a positive light and whose affiliation with the Carmine, she proposes, introduced Masaccio to its friars. While many scholars have focused on the novelty of Masaccio's style, Callmann emphasizes the importance of tradition to his formation. Significant influences on Masaccio included such late fourteenth-century masters as Agnolo Gaddi, Spinello Aretino, and Gherardo Starnina, whose style she defines with special attention. She believes that their works in the Carmine created a "house style" to which Masaccio responded. Callmann then turns to an assessment of painting in the 1420s, focusing on such well-known artists as Lorenzo Monaco, Gentile da Fabriano, the young Fra Angelico, and Fra Filippo Lippi, then a friar in the Carmine. As does Radke, she observes the range of possibilities open to artists in the 1420s, suggesting the complex interaction of tradition and innovation in shaping early Renaissance visual culture.

New light is shed on the collaboration of Masaccio and Masolino by Perri Lee Roberts, who places it within the context of late medieval and Renaissance workshop practices. She describes the organization and hierarchy of the typical *bottega* (shop), observing how the division of labor between multiple workers allowed artists to maximize productivity and profit while responding to fluctuating demands in the marketplace. As evidence, Roberts considers several collaborative commissions from the fourteenth century, identifying documents, stylistic evidence, and inscriptions on frames that prove the involvement of several artists and shops in a single work. Most professional associations in fourteenth-century Tuscany were long-term. However, by the early fifteenth century, temporary partnerships had become increasingly common as market competition and the cost of operating a shop increased. It is within this new economic milieu that Roberts places the temporary partnership of Masaccio and Masolino, both of whom had been previously affiliated with other artists. Roberts analyzes the role of each artist in their jointly executed commissions, presenting new assessments of their style and chronology. She concludes that their shared experience of the workshop system allowed them to work together successfully. Roberts's discussion implicitly asks us to reconsider our framing of the "Masaccio question" and our insistence – virtually anachronistic to fifteenth-century conceptions of craft and quality – on separating their hands. It makes an important contribution to our understanding of workshop practices, an area that only recently has received due attention from scholars.[67]

Masaccio's technique is analyzed by Roberto Bellucci and Cecilia Frosinini, who contribute significant and new information on the painter's origins, innovations, and association with Masolino. Their discussion is based on their knowledge as conservators and historians of guild practice.

They propose that Masaccio probably was apprenticed in his hometown, where his family had working relationships with artists, artisans, and apothecaries, rather than in Florence. Technical features of his earliest works – for example, the use of a red contour line, typically associated with manuscript illumination, in the *Cascia di Reggello Altarpiece* – suggest that he was not trained conventionally. Bellucci and Frosinini are the first to hypothesize that he may have studied with a manuscript illuminator, a proposal that would explain this and other idiosyncracies of his technique. They then turn to the collaboration of Masaccio and Masolino, which, they observe, must have taken place after the formal dissolution of Masolino's association with the painter Francesco d'Antonio in March 1424. Bellucci and Frosinini reattribute parts of the collaborative works. They identify specific technical innovations, including the use of oil-based binders, and exchanges between Masaccio and Masolino. Although focusing on Masaccio and Masolino, this groundbreaking study reveals the centrality of conservation studies to clarifying issues of attribution, dating, and technique.

Dillian Gordon considers the altarpieces of Masaccio, bringing together little-known information on their patronage, technique, and ambience as well as their attribution and dating. Her discussion begins with the *Cascia di Reggello Altarpiece,* which, she proposes, reveals the artist's training by Bicci di Lorenzo, an opinion shared by Callmann. Gordon presents a hypothesis regarding the work's patronage by the prominent Castellani family, who lived in Cascia di Reggello but also maintained a chapel in Santa Croce, where the altarpiece may have been displayed. Technical and stylistic evidence suggests that an assistant aided Masaccio in painting the work, indicating that Masaccio is likely to have established a shop by 1422. Gordon next turns to the *Pisa Altarpiece,* a commission that may have arisen through his association with the Florentine Carmelites. She thoroughly discusses the decorative program for the chapel in which the altarpiece was placed. She then considers whether it originally was a polyptych or a unified altarpiece. After identifying the *Sant'Anna Metterza* as the first work in which the collaboration of Masaccio and Masolino is evident, Gordon reevaluates its attribution, offering new insight on its design, authorship, and technique. The chapter concludes with the *Santa Maria Maggiore Altarpiece,* commissioned by the Colonna family. It is identified by Gordon – as well as by Roberts, Bellucci, and Frosinini – as the artists' last collaborative work, left unfinished due to Masaccio's death in Rome. This comprehensive discussion includes a new reconstruction of the dismembered altarpiece, identifies significant changes made to the painting during its execution, and considers technical evidence for reattributing parts of the panels. Additionally, the altarpiece is placed within the devotional, patronal, and artistic sphere of Roman art, the basilica of Santa Maria Maggiore, and Colonna patronage. Gordon's study is methodologically important for its considera-

tion of style, technique, iconography, and patronage in assessing Masaccio's contributions.

The Brancacci Chapel is discussed by Diane Cole Ahl, who rejects the usual focus of the literature on attribution and chronology for a more inclusive consideration of its significance. Ahl situates the chapel within the devotional, artistic, and patronal ambience of Santa Maria del Carmine, discussing the church's history and describing its extensive decoration (now mostly destroyed) before Masaccio. Founded in 1367 by Piero [Peter] di Piuvichese Brancacci, the funerary chapel, strategically located near the high altar, remained unadorned into the early fifteenth century, an affront to the family's honor and reputation that had to be redressed. Ahl traces the family's history, focusing on Felice Brancacci, who evidently commissioned the frescoes executed by Masolino and Masaccio. She challenges the prevalent view that the life of Saint Peter was chosen as their subject in response to contemporary politics: The theme, she contends, was mandated by Felice's obligation to commemorate the patron saint of Piero di Piuvichese Brancacci, the chapel's founder. Ahl identifies the artistic, liturgical, and textual legacy from which the chapel's iconography emerged, focusing on *The Golden Legend*. She then explores the artists' collaboration, discussing the attribution and dating of their collective and individual contributions. She concludes with an assessment of Filippino Lippi's role in completing the cycle. By reintegrating the chapel within "the dialogue of sacred ceremonies and images" in the Carmine and the history of Petrine iconography, Ahl endeavors to evoke the resonance it had for the fifteenth-century worshiper.

The myriad associations – theological, social, and civic – evoked by the *Trinity* in the church of Santa Maria Novella are illuminated by Timothy Verdon. After tracing the iconography and interpretive history of the theme, Verdon explicates the meanings of the Trinity in Catholic thought. An exegetical tradition beginning with Saint Augustine – and developed eloquently by Dominican theologians, whose writings were well known to the friars of Santa Maria Novella, a Dominican congregation – employed the metaphor of the family to explain the Trinity, the ideal, transcendent "community" of God's love into which believers entered after their death. Verdon then explores other associations specific to the site that the *Trinity*, as the adornment of a funerary chapel, would have evoked. He relates its iconography to the program of Dominican images in Santa Maria Novella, which exalt the Order's mission and the spiritual family of God's love. An important observation is that the original entrance to Santa Maria Novella was on its eastern flank, an area surrounded by tombs: Worshipers in Masaccio's day would have made a "lugubrious" pilgrimage through this cemetery, immediately facing the *Trinity* as they entered, mindful of the inevitability of death and the need for salvation through the family of the Trinity. Finally, in what Verdon has identified as "a body of Dominican

social teaching," particularly resonant at Santa Maria Novella, the Trinity represented God's supreme love, which transcends all relationships on this earth. Verdon's exploration of these themes is exemplary for its breadth and theological subtlety, and unprecedented for its exploration of the Dominican contexts of Masaccio's image.

The belief that Masaccio was the first to use single-point perspective accurately has gained widespread acceptance among many art historians. In an informative survey of perspective in Italy in the fifteenth century, J. V. Field sets the record straight. Field begins by exploring the etymology of the word we translate as "perspective," observing that it originally referred to the science of optics. Field concurs with the historian Manetti in ascribing the "invention" of perspective to Brunelleschi. The mathematical and practical elements of perspective construction are analyzed in the text and demonstrated in drawings. A thorough analysis of Masaccio's understanding of perspective demonstrates conclusively that the painter used perspective "as merely one element" in composing his works, deviating from mathematical correctness to enhance illusionism. Field then surveys the use of perspective by other artists – Donatello, Uccello, Piero della Francesca, and Mantegna – observing that "deviations" may have been intended to compensate for viewing distance or for other reasons. The treatises by Alberti and Piero also are analyzed with respect to their accuracy, applicability, and relationship to other writings on perspective. Field's discussion is important not only for its assessment of Masaccio, but because it intelligibly recounts how artists configured and manipulated spatial constructions to intensify the illusion of reality.

The concluding chapter surveys Masaccio's legacy in both literary and visual forms from the decade after the master's death to the publication of Vasari's *Lives* in 1568. Francis Ames-Lewis begins by examining the artist's stature in Florentine painting during his lifetime, observing that Gentile da Fabriano was far better known and acclaimed during the 1420s. Indeed, while Gentile was praised by Bartolommeo Fazio in his influential *On Famous Men* (1456), Masaccio was not mentioned, apart from the citation in Alberti's treatise *On Painting* (1435/6), until the last decades of the fifteenth century. With the development of interest in Florentine painting and the refinement of a critical vocabulary, humanist writers began to appreciate his imitation of nature. Ames-Lewis then observes how Vasari's *vita* of the artist articulated Masaccio's "prime role" in initiating "the second period" of art. Ames-Lewis then turns to Masaccio's visual legacy, primarily his representation of the human figure draped and nude. He cautiously takes up an earlier attribution to Masaccio of a drawing for the Brancacci *Saint Peter Baptizing the Neophytes* (see Plate 74), identifying it as the only extant sketch by the master. Masaccio's influence is observed in drawings by Maso Finiguerra, Domenico Ghirlandaio, Filippino Lippi, Raphael, and Michelangelo. While Ames-Lewis notes the waning of the

master's authority during the High Renaissance, he observes that by then, Masaccio's reputation had been established for posterity. In reading Ames-Lewis's insightful discussion, it seems ironic that Masaccio's celebrity today is far greater than it ever was in his own brief life.

Conclusion

In reflecting upon the book as a whole, we may identify several recurrent preoccupations and themes. One is the fundamental question of Masaccio's training and formation, on which there is still no consensus. Although Callmann, Roberts, and Gordon place the artist in Bicci di Lorenzo's workshop, Frosinini and Bellucci instead suggest his training as a manuscript illuminator, basing their claim on technical evidence. To be sure, the proposal of Masaccio's training with Bicci seems supported by certain stylistic elements. The presence of Masaccio's brother in Bicci's shop as well as Masaccio's association in 1426 with Andrea di Giusto, once an assistant there, also are highly suggestive. At the same time, the novel proposal of Frosinini and Bellucci merits serious consideration. In light of the technical evidence they adduce, it is not inconceivable that Masaccio initially was trained as a manuscript illuminator. Although generally marginalized in studies of Italian Renaissance art, manuscript illumination in fact constituted a major industry in Florence, one in which Lorenzo Monaco and Fra Angelico, among many important painters of monumental art in the early fifteenth century, were engaged.[68] As their activity demonstrates, these traditions were not inimical but complementary. An investigation of this possibility might prompt scholars to observe more carefully Masaccio's attentiveness to detail in the predella and pinnacles of the *Pisa Altarpiece,* and to reconsider the controversial attribution of some small-scale works that have been associated with the master.[69]

Another pivotal concern is, of course, artistic collaboration and the affiliation of Masolino and Masaccio. Bellucci and Frosinini as well as Gordon identify collaboration in the *Cascia di Reggello Altarpiece,* suggesting that Masaccio may have directed his own shop, though not with Masolino, as early as 1422. In contrast to discussions that dismiss Masolino as a secondary master, Bellucci and Frosinini as well as Roberts highlight his technical ingenuity, an element that has been overlooked by many critics. They stress the importance of his influence on the younger master and recognize that stylistic and technical exchanges between Masolino and Masaccio were reciprocal. They judge the collaborative works as highly uniform in appearance and quality, notwithstanding, according to Bellucci and Frosinini, the presence of a third hand in the *Sant'Anna Metterza.* Indeed, so successful were the masters at melding their individual personalities that the contributors to this book, despite

their consensus on many fundamental issues, still disagree on particulars of attribution in the jointly executed paintings.

Perhaps the most crucial contribution of the book is its reassessment of early fifteenth-century Florentine culture within which Masaccio's achievements must be contextualized. The authors take up key issues in Renaissance visual, spiritual, and intellectual history that have implications beyond the specific focus on Masaccio. In their opinion, Masaccio's Florence was predominantly medieval, a city gripped by economic woes and war, as Molho describes, rather than the idealized republic evoked in humanist writings. Radke and Callmann discuss the monuments and art of a society immersed in an omnipresent medieval past, not one that sought to reclaim its Roman origins. These works derived their resonance and authenticity from their relationship to venerable texts and earlier images, as Gordon, Ahl, and Verdon have proposed. Similarly, as several contributors contend, the tradition of workshop practices that had persisted since the Middle Ages provides a context for understanding the collaboration of Masolino and Masaccio, as indeed for many of their contemporaries. Drawing far-reaching conclusions, the authors illuminate the continuum of the age's culture to find Masaccio's place within it, rather than isolating him because of his genius.

In 2001, as this book is going to press, the 600th anniversary of Masaccio's birth is being celebrated. As preparation for this year, the University of Florence organized a symposium on the *Cascia di Reggello Altarpiece* in December 2000 in order to study the painter's origins. After years of research and conservation, the Soprintendenza of Florence has unveiled the newly restored *Trinity* in Santa Maria Novella. In autumn 2001, the National Gallery of London is hosting an exhibition on the *Pisa Altarpiece*. An exhibition in San Giovanni Valdarno in spring 2002 and a three-day conference on the technique of Masolino and Masaccio, to be held in Florence and San Giovanni Valdarno in May 2002, unquestionably will contribute new information on the painters. No doubt, other activities will follow. All of these events provide an opportunity to examine not only the artist but the world from which he emerged. Although these events take Masaccio as their point of departure, they may inspire further inquiries into Florentine culture at this crucial moment of its history.

1 Masaccio's Florence in Perspective

Crisis and Discipline in a Medieval Society

Anthony Molho

Images

Alternating images of light and darkness define our picture of early fif-
teenth-century Florence. The decades that separate the revolt of the city's
wool-workers (*Ciompi*) in 1378 from the return of Cosimo de' Medici
(1389–1464), posthumously dubbed Florence's *pater patriae,* from his year-
long Venetian exile in late summer of 1434 are often represented as the
opening, striking expression of Florence's renaissance: luminous, innova-
tive if not necessarily progressive, optimistic. Most historians cannot help
but fasten their attention on these qualities: the thought of a remarkable
succession of thinkers, from Coluccio Salutati and Leonardo Bruni to
Poggio Bracciolini, Leon Battista Alberti, and Matteo Palmieri; the awe-
some accomplishments of the painter Masaccio, the sculptor Donatello,
and perhaps most striking, Filippo Brunelleschi – sculptor, goldsmith,
architect, engineer, but also writer of remarkable acuity and wit; the pub-
lic ethos forged by a ruling class immersed, it would seem, in lofty
Ciceronian ideals of *utilitas pubblica* (public welfare), and of the subordi-
nation of private interest to the collective well-being, an ethos that fre-
quently spilled over into a celebration of civic life and of politics as
ennobling, even Christian, acts; and perhaps as significant, the transfor-
mation of Florence from a relatively small communal state into one of the
Italian peninsula's major territorial states, a change brought about, so it

The title of this chapter as well as my general interpretation were suggested by the work of Mar-
vin Becker, with whom, many years ago, I had the good fortune to study, and whose inspired
teaching I am once again pleased to acknowledge. Our specific approaches, of course, differ, as
does the period of time each of us studied. Yet students of Florentine history will have little dif-
ficulty noting the similarity of the concept "discipline," which I use, to his key concept "stern
paideia," which he applied to the mid–fourteenth century.

has been generally thought, thanks to its government's perspicacity and clear-minded pursuit of its goals.

Yet below (or behind) these images of light, optimism, and extraordinary accomplishment, historians in recent years have increasingly caught sight of less edifying and pleasing spectacles. Most striking, one witnesses a political conduct that privileged private interests over public utility, bespeaking anything but the hortatory and heroic Ciceronian rhetoric of the city's political discourse. Patronage networks, whose operations have been minutely described by recent historians and whose decisive influence on the conduct of public affairs was often decried by contemporaries, further accentuated the fragility of political life. A bundle of often ugly fears, evident in the conduct of contemporaries, sprang from a wide array of situations: epidemiological, economic, military, fiscal, social, and administrative. None of these problems could be easily resolved. All of them, jointly, conspired to give rise to anxieties, suspicions, and anger on the part of many members of the city's ruling class. They challenge the conception of Florence as an enlightened center of "republican" government that Hans Baron formulated in *The Crisis of the Early Italian Renaissance,* and provide the context in which Masaccio's world and works must be seen.

Before going further, let us fasten our attention upon some of the contrasts between the edifying manifestations of Florence's early renaissance and the darker side of that city's culture. We start with what, thanks to the pioneering if by now somewhat dated work of Baron, has become one of the classic expressions of early fifteenth-century Florentine political thought. In his Funeral Oration on Nanni degli Strozzi of 1428, Leonardo Bruni expressed himself on the nature of Florentine society, and on the psychological undergrowth that enabled its political culture to flourish:

Equal liberty exists for all . . . the hope of winning public honors and ascending is the same for all, provided they possess industry and natural gifts and lead a serious-minded and respected way of life; for our commonwealth requires *virtus* [excellence] and *probitas* [honesty] in its citizens. Whoever has these qualifications is thought to be of sufficiently noble birth to participate in the government of the republic. . . . This, then, is true liberty, this equality in a commonwealth: not to have to fear violence or wrongdoing from anybody, and to enjoy equality among citizens before the law and in the participation in public office. . . . But now it is marvelous to see how powerful this access to public office, once it is offered to a free people, proves to be in awakening the talents of the citizens. For where men are given the hope of attaining honor in the state, they take courage and raise themselves to a higher plane; where they are deprived of that hope, they grow idle and lose their strength. Therefore, since such hope and opportunity are held in our commonwealth, we need not be surprised that talent and industry distinguish themselves in the highest degree.[1]

Such robust, optimistic rhetoric was far from rare in early fifteenth-century Florence. Just as his mentor Coluccio Salutati had done a few

decades before, Bruni was given to associate Florence's governance with the city's political ethos, and that ethos with the virtue of individual citizens. Not a few other contemporary scholars and politicians echoed similar ideas. A much respected contemporary of Bruni's, the statesman Gino Capponi, did not hesitate to advise his children to place the well-being of their *patria* (fatherland) above their own Christian salvation. His epigrammatic advice was that if, perchance, his sons were ever to find themselves members of their city's war magistracy, they should "love their country more than their soul."[2] And Matteo Palmieri, the much studied humanist-statesman-spice merchant, wove an ideal image of his native city in his ethical-political tract *Della vita civile*, when he imagined Florence as being a set of lineages that by virtue of inhabiting the same physical space and sharing a moral idiom, "give and receive in legitimate marriages, [and] through their marriage alliances and their love [toward each other] encompass a good part of the city, whence, being related by marriage (*parentela*) they charitably assist each other, conferring upon each other advice, favors and assistance, which, in the course of life, result in actions, advantage, and bear abundant fruit."[3] Expressions of this sort are legion in the voluminous documentation that Florentines of that era produced, much of which has survived to our day.

These images – of a compact, selfless, and self-consciously creative and reflective ruling class – found perhaps their supreme expression in Donatello's first sculptural representation of David (known as the master's "marble" *David*). In the summer of 1416, Florence's entanglement in a massive war against Naples had only recently been concluded. So dangerous had this military encounter been, some contemporaries imagined it had threatened the city's very survival. In this atmosphere, in which pride and relief commingled almost in equal doses, the *Signori Priori* (Priors) ordered the recently completed statue moved to the large piazza in front of their official residence. On its pedestal was carved an inscription whose Ciceronian texture was unmistakable: *Pro Patria Fortiter dimicantibus etiam adversus terribilissimos hostes dii prestant auxilium* (To those who fight bravely for the fatherland the gods lend aid even against the most terrible foes).[4] The image of the Old Testament hero – boyish, proud, confident in his virtue and in the justness of his cause, triumphant over his seemingly invincible enemy – was now the very symbol of the city's civic and moral virtues.

These images, striking in themselves, become even more striking when they are set against another set of images, also drawn from contemporary sources. Take the case of Giovanni di Paolo Morelli, a contemporary of the writers and artists mentioned earlier. Like Gino Capponi and a host of other Florentines of Capponi's social class, Morelli was not reticent in offering advice to his sons about how they should comport themselves in the public arena. This, then, was the solicitous father's advice:

Always complain about your taxes. Insist that you did not deserve half your assessment, that you are in debt, that your expenses are great . . . that you suffered losses in your commercial ventures, that your household expenses are great. . . . And be careful not to lie except in these circumstances. This is permitted here because you do not try to take things from others, but you do it so that your own things are not taken from you.[5]

Giovanni di Paolo Morelli, an otherwise mild, indeed timorous man, was not especially subtle in his counsel to his children: Never lie; never cheat, never be dishonest. But when it comes to the government, you should lie, cheat, and be dishonest. Otherwise, you, an aspiring merchant, will not succeed. This notion of a sharp division between what is private (and mine) and what is public (not mine) is also echoed through much of the private literature that circulated among Florentines of Morelli's standing.

Leonardo Bruni himself, however inspired a formulator of the civic ideology associated with his name, could not conceal from readers of his celebratory version of Florence's history his disdain – one is tempted to say his hatred – of his city's working class; these men, it seemed obvious enough to him, possessed neither the *virtus* and *probitas* nor the "industry and natural gifts" to enable them to "lead a serious-minded and respected way of life." Having briefly referred to the events of the 1378 Ciompi revolt in which wool-workers rebelled against their masters, he ended with a pointed rumination. His readers should

never let political initiative and arms into the hands of the multitude . . . for once they have had a taste, they cannot be restrained, and they think they can do as they please because there are so many of them. . . . There was no end [in 1378], no limit to the unleashed appetites of the poor and the criminals who, once armed, lusted after the possessions of the rich and honorable men and thought of nothing except robbing, killing, and banishing citizens.[6]

In the passage of Palmieri's *Della vita civile* that we just quoted, the key words were "alliance," "love," "charitably," "advice," "favor," "assistance." Contrast these with the key words in Bruni's angry, almost apocalyptic vision of the Ciompi: "multitude," "restrained," "unleashed appetites," "criminals," "lusted," "rob," "kill," "banish." Palmieri and Bruni were contemporaries; they almost certainly knew and respected each other; they observed their Florence from very much the same vantage point. In all likelihood, if Palmieri had set out to write about the Ciompi revolt, he would have colored his description in the same Brunian hues; conversely, as we saw, Bruni would have relied – indeed, he did rely – on the same Palmierian tones to refer to his city's rulers and their political culture.

Contrasts of this sort could be easily multiplied. Wherever one looks to early fifteenth-century Florence, one glimpses such tensions, often lurking not even terribly deeply below the surface of the city's culture. How can

we account for these contrasts? Are we confronted here, as some histori-
ans have suggested, with a striking, if not unusual case of a culture's – bet-
ter yet, of a ruling class's – hypocrisy, intent, in the heroically celebratory
and wishfully hortatory rhetoric fashioned by its public intellectuals, upon
concealing the inequities and the profound injustices characteristic of its
society? Are we face-to-face with the sort of tensions, not to say contra-
dictions, engendered in societies closer to our own, and more easily rec-
ognizable by us? Think, for example, of the institution of slavery alongside
the principles of the American Declaration of Independence, or of the
Soviet Union's call to workers to throw off the chains of their bondage
while that self-defined workers' paradise was forcefully imposing ever
stricter limits and oppressive controls on them. Or are we in the presence
of a kind of cultural schizophrenia, whereby seemingly contradictory val-
ues and ideals are juggled in an ever precarious equilibrium in the hope
that the entire ideological edifice will not be undermined by the web of its
corrosive contradictions?

In what follows, it will be suggested that these contrasts can be seen as
standing not in opposition to, but rather in counterpoint with each other,
the luminous side of early fifteenth-century Florentine culture accompa-
nying and complementing its dark side. When set against the backdrop of
a series of often dramatic crises that punctuated the city's history in those
years, the often exuberant rhetoric, as well as the government's impressive
accomplishments, appear for what they largely were: attempts made by the
city's ruling class to master a situation that ever threatened to spin out of
control. The crises of the early fifteenth century – demographic, eco-
nomic, social, political – provided a constant challenge to the city's ruling
elite. Their response was to cobble together an array of measures – rang-
ing from the bold and imaginative to the merely repressive – that collec-
tively aimed at imposing a greater discipline on the city's social and polit-
ical life. The order of the day in early fifteenth-century Florence was
control, the government's attempt to control an ever greater array of polit-
ical and social activities: from refining the criteria for eligibility to public
office and setting new directions for the development of the economy; to
insisting on new, objective, and systematic methods for distributing the fis-
cal burden; to, perhaps more remarkably, regulating public morality and
interfering in the marriage plans of its citizens.

In all of these areas and more, the city's rulers, throughout the first
third of the fifteenth century, but most especially in the 1420s, sought to
discipline so as to control, to render more predictable – perhaps we should
say to render somewhat less unpredictable – a world that seemed at once
threatening and chaotic. The ideological vision that accompanied this
process, with the abstractly geometrical social balances implied in Bruni's
and Donatello's idealized renditions of Florentine society, bespoke the
same penchant for discipline and control. It was not so much an attempt

to paper over the contradictions and the tensions inherent in Florentine society as it was an effort to project an image of a society under control, its parts in perfect harmony with each other. One could perhaps draw a parallel between Masaccio's magnificent depiction of the *Tribute Money* (see Plate 8) in the Brancacci Chapel and Bruni's vision of Florentine society. In both representations, every person and social group had its rightful place; conversely, in them no person or social group was out of place. Both presupposed the strict control of the social, even of the natural world that they inhabited. To be sure, in both instances, we are confronted with idealized renditions of Florentine society, but in this case the ideals seem rooted – perhaps even deeply rooted – in the aspirations and yearnings of the city's ruling class: to discipline and master their world, so as to overcome the precariousness and fragility of life.

Challenges

Let us then start with a glance, however brief, at the challenges and dangers faced by Florence and its rulers in the early fifteenth century. An observer around the year 1430 who looked back to the preceding century might well wonder if, at some time in the subsequent few generations, Florence would simply cease to exist, its people carried away by yet another wave of plague. Modern historians and demographers have measured with enviable accuracy the decline of the city's population; contemporaries might not have measured the epidemic's toll with equal precision, yet they could not help but be frightened at the spectacle of the human losses suffered by the city over the preceding one hundred or so years. A decade before the onslaught of the great epidemic in the middle of the fourteenth century (the Black Death of 1348), Florence counted a population of perhaps as many as 120,000. Then, a series of plagues repeatedly decimated its inhabitants. By the third quarter of the fourteenth century, its population had dropped to perhaps 60–65,000. But the epidemic's virulence did not abate with the passage of time; on the contrary. Two massive epidemics in 1400 and 1417 caused the death of many more thousands of people; a slow recovery toward the end of the century's second decade was reversed in the summer of 1423, when the plague once again made its appearance.

In 1427, when a new fiscal census (known as the *catasto*) was ordered, Florence's population had reached its nadir, standing then at perhaps under 40,000, approximately a third of what it had been a century earlier – this notwithstanding the constant flow of country folk into the city in search of jobs and economic opportunities. Since the beginning of the fourteenth century, the Florentine population had shrunk at the rate of 1 to 1.25 percent per year, an extraordinary (and extraordinarily sustained)

loss, yet one that assumes its full significance when one remembers that during the most acute manifestations of the plague, mortality rates could be as high as 3 to 10 percent per year.[7] By any historical standard, these are catastrophic statistics, and they explain why the population had not been so low since the early thirteenth century. As the experience of 1423 showed, the plague afforded no respite. Time and again, it would return, as in 1433, resulting in new human losses and provoking fears and uncertainties about the future.

Some scholars have recently drawn parallels between the epidemic mortality of the fourteenth and fifteenth centuries and our own society's epidemic mortality caused by AIDS. Such parallels are at once illuminating and misleading. They are misleading because, thankfully, AIDS has not triggered mortality rates anywhere near as severe as those of the late medieval centuries. We can hardly imagine today the catastrophic consequences of the massive death toll experienced by late medieval societies. In Florence, the epidemic of 1400 caused the death of about 12,000 of the city's 60,000 or so inhabitants; an equivalent mortality today would be if one in five New Yorkers were to die of AIDS in the span of a few months! Yet the psychological responses to both diseases do strike comparable chords: Uncertainty and fear overtake victims and observers; suspicion veils people's responses to newcomers who, rumor has it, might be infected; pessimism, if not despair, colors the views of patients and their families. In Florence, in the first decades of the fifteenth century, optimism was difficult to maintain. It was just as difficult to look to the future with the assurance that it held much of a promise. If survival itself was at stake, if young and old were as prone to fall victim to the plague, how could one plan ahead with optimism and cheerfulness?

The condition of Florence's economy in the early fifteenth century was only slightly less worrisome than the state of its population. The demographic decline of the preceding generations had of course provoked its own economic imbalances. Production and consumption had been drastically reduced by the dramatic shrinkage of the market, while Florence's textile industry, for generations the backbone of the city's industrial production, had to face stiff competition by north European (especially English and Dutch) products. In 1381, the wool manufacturing shops were reduced to 283 from a much higher number half a century earlier. By 1427, at the time of the *catasto,* their number had shrunk to 131, and the decline would continue to the middle of the fifteenth century, when there would be only 111. This decline may be measured in other terms as well: In the 1330s, the city produced about 90,000 bolts of wool cloth; by the 1380s, production had declined to 20,000; early in the next century it would shrink to about 10,000.[8] To be sure, silk production had picked up some of the slack, but it would not be until the second third of the century – until the 1440s and thereafter – that silk would make a noticeable difference in the

city's economy. Thus, industrial production – which overwhelmingly refers, for any medieval society, to the manufacturing of textiles – experienced a period of profound crisis early in the fifteenth century. Underproduction by the standards of the past resulted in substantial unemployment and underemployment, even in a society much reduced in numbers.

To be sure, sectors of the economy continued to flourish. This was especially true of banking, which, since the end of the thirteenth century, had provided Florentines with some of their most spectacular economic successes. Banking – which in contemporary practice was connected with international commerce – continued to prosper in the late fourteenth and early fifteenth centuries. The Medici bank, founded by Giovanni di Bicci de' Medici in 1389, reached the apex of its success in the first third of the fifteenth century, guided by its founder and, following his death, by his famous son, Cosimo. Significantly, however, the great opportunities for Florentine bankers were not at home but abroad. It was the vital link with the affairs of the papacy that helped the Medici to amass their fabulous wealth and transform their firm into Europe's largest bank.[9] But money made abroad did not necessarily find its way back into the local economy or, if it did, was not always invested in productive activities. In any case, even bankers could experience periods of acute crisis, as was the case in the summer of 1425, when at least five well-capitalized firms had to declare bankruptcy.[10]

Lately, it has become fashionable to argue that a considerable stimulus to the Florentine economy was offered by the building boom created by the ambitious campaign of the city's principal families to rebuild and restructure their palaces.[11] For our purposes, it may be sufficient to observe that even if this hypothesis were correct, this building activity did not begin until the 1440s, with its peak reached in the century's second half, when a series of prominent families – the Strozzi and Pitti foremost – sponsored the construction of enormous (and enormously expensive) new family palaces. In short, it would take until well after the 1420s for the Florentine economy to show signs of improvement. In the years that concern us, the city's economy had declined substantially from its peaks of a century earlier, and perhaps just as significant, it did not show many signs of improving.

The decline of industrial production and the general fragility of the Florentine economy had far-reaching social consequences. Although this is a complex and often discussed subject, for the purposes of this analysis, one set of observations must suffice. In their pioneering, and to this day, unsurpassed analysis of Florentine society, which they based on the records of the massive tax census of 1427, David Herlihy and Christiane Klapisch reached one arresting conclusion. Their findings about the social distribution of wealth in early fifteenth-century Florence provide us with a picture of a highly, strikingly polarized society, in which a minuscule por-

tion of the population controlled a massive amount of the city's wealth while perhaps as many as half of all residents of the city were entirely indigent (and this figure does not take into account the countryside, where poverty was much more extensive). In 1427, 1,000 fiscal households (10 percent of the city's 10,000) controlled about 68 percent of all liquid wealth and 53 percent of all landed wealth. The richest 1 percent of Florence's urban households owned 20 percent of all capital in the entirety of the Florentine state![12] This imbalance was even more pronounced in the distribution of government credits (i.e., government bonds), of which there were substantial quantities then in circulation. In 1427, 1 percent of all households owned fully 43 percent of these credits.[13] These figures take on additional meaning when one remembers that exemptions in the calculation of the fiscal burden greatly favored the rich. The value of private homes and all of their contents was exempted from taxation, which removed from the fiscal rolls the vast and expensive palaces owned by the wealthy. Furthermore, the possibility of taking a standard deduction for every household member meant that the rich, whose families were always larger than those of the poor, would be able to shield from taxation a much greater amount of wealth than could the poor. In short, it is hard to imagine that a society so deeply engaged in entrepreneurial activities – where banking, commerce, and artisanal/industrial production had such long-standing traditions, and where, presumably, there was a constant circulation of riches – could produce a more skewed distribution of wealth than one finds in early fifteenth-century Florence.

This inequitable distribution of wealth does raise a question, which is not altogether easy to answer on the basis of our current knowledge. It would stand to reason that given the labor shortage produced by the epidemic mortality, wages would increase, and workers would find themselves in a better position than previously. In some respects, this is what happened: Wages did increase slightly at the turn of the fifteenth century while the price of foodstuffs, grain, oil, wine, and other commodities experienced a slight decline.[14] Yet the picture seems to be complicated by several factors. First, as we have observed, industrial production, the primary source of employment, declined far more drastically than did the city's population. If, in the 1420s, Florence's population stood at approximately 35 percent of its pre-1348 level, the manufacturing of wool cloth stood at a mere 10 percent of its peak. As we shall see later, workers were also constrained by the strict controls imposed upon them by their employers. It was difficult to demand higher wages when possibilities of collectively pressuring bosses were limited and attempts were often severely punished.

The result of all this was massive poverty, as many workers often found themselves in a cycle of indebtedness and dependency, a result of their need to supplement their meager wages with loans from their employers or affluent neighbors. It was for exactly this reason that one of the long-

standing Florentine taboos – not to allow Jews to settle in the city – was finally broken in June 1430, when it was decided to invite Jewish money-lenders to Florence. The law's explanation for this measure, considered drastic by contemporary moralists who often gave vent to strikingly anti-Semitic attitudes, was that Jews would set up pawnshops and make credit available to the poor of Florence ("pauperes florentine urbis"), who, in turn, "would be able to provide for their needs." Significantly, according to the terms of this law, Jewish pawnshops could charge a maximum of 20 percent per annum, a ceiling which suggests that in the 1420s, interest rates on (what we would today describe as consumer) loans were much higher.[15]

None of these conditions contributed to social concord. Rather, they explain the fears, suspicions, and disdain that colored the attitudes and dis-cussions of the city's leading citizens concerning their workers. One of the constant refrains in early fifteenth-century Florentine political discourse was the fear that the *popolo minuto* (the "little folk," i.e., the poor) would once again rise in revolt, just as they had done in the summer of 1378.

A strikingly similar situation is evident in the relations between the city of Florence and its countryside and the subject territories (what in con-temporary documents were referred to as the *contado* and *distretto*). Here also, a defining characteristic of that relationship was the geographical dis-tribution of the Florentine state's wealth. According to the fiscal census of 1427, 14.1 percent of the Florentine state's population resided in the city of Florence. Yet this small minority controlled no less than 67.4 percent of the state's entire wealth. The countryside (excluding from calculations the twenty-one more or less large cities and towns controlled by Florence) contained 66.5 percent of the state's population, who collectively owned only 15.9 percent of its total wealth. In short, the Florentine state's social fabric was marked by very much the same imbalances that characterized the society of the city itself.

Such a massive concentration of wealth in the state's capital meant that its market would become the very fulcrum of the state's economy, with products, surplus wealth, and ambitious and talented people con-stantly being drained from the periphery toward the state's center. It also meant that since political privilege was never extended to inhabitants either of the countryside or of subject towns, the fiscal burden would fall disproportionately on residents outside the city of Florence. More often than one might imagine, localities in the territorial state would fall hope-lessly in arrears in the payment of their taxes, and they would be con-strained to borrow from well-to-do Florentine bankers in order to avoid fines and other penalties imposed by the government. In short, the unevenness in the distribution of wealth was translated into an imbalance in the distribution of fiscal burdens, which, in turn, led to the further drainage of wealth from the periphery to the center. The disgruntlement

of *contadini* and *distrettuali* (residents of the countryside and of the subject towns and territories) at what they considered an unfair and intolerable tax burden was a constant factor in the last decades of the fourteenth and the opening ones of the fifteenth century. On occasion, as was to happen in Volterra in 1429 and in Arezzo in 1431, this discontent would threaten to erupt into an open revolt, constraining the city's leaders to marshal military force in order to preserve the imbalance in the distribution of the state's wealth and power.[16]

Life is unpredictable, according to a popular mid-twentieth-century American saying; death and taxes are not. To this duo of inevitabilities, in late fourteenth- and early fifteenth-century Florence one could reasonably have added a third: war. Military entanglements were almost a commonplace in the city's history; in the late fourteenth and the first third of the fifteenth century, war had consequences for political development and also, perhaps more radically, for Florentine political culture. The most profound consequence, which itself weighed heavily on the city's political life, was for the city's fiscal policy. The interminable discussions on taxes were seldom dispassionate, and occasionally they exploded into angry and deeply divisive exchanges. The issue was always the same: Who should be saddled with the burden of taxes; who, in other words, should bear the brunt of funding the costs of Florence's seemingly endless wars? Historians have been no less meticulous in their quantification of the fiscal burden carried by Florentines than they have been in their measurement of the incidence and effect of epidemic mortality. We know more about Florentine fiscal policy than we do about nearly any other topic of that city's rich history. (We shall return to this subject shortly.)

War, of course, was not a novelty in late fourteenth-century Florence. The city had fought many wars in the past, frequently with its once powerful neighbors, occasionally with important foreign (which for our purposes means non-Tuscan) powers: Milan, the papacy, the Empire. But not until the late fourteenth century did Florentines begin to feel the profoundly corrosive influence of war. Not until the mid-1380s did war become a transforming influence on their political institutions and on their lives. Needless to say, these transformations were not painless. They unsettled long-standing political equilibria and social balances. In the end, one would not be far off the mark to suggest that having profoundly marked the years 1423–33, war and fiscal policy were directly responsible for Cosimo de' Medici's exile from Florence in 1433, and for his triumphant return to the city the following year – events that forever reshaped the course of Florentine history.

War with Milan broke out in earnest in 1385. For all its interruptions, which in some instances lasted several years, the Florentine-Milanese confrontation persisted until the 1440s. First, Florence had to face the ambitious policies of Giangaleazzo Visconti, count and then duke of

Milan, who seems to have aspired to the establishment of Milanese domination over much of northern and central Italy. Florence could not let such Milanese policy go unchallenged, all the more so because the Florentines themselves were pursuing an aggressively expansionist policy in Tuscany. Their aim was to bring under their direct control this entire province and, by so doing, at once enlarge their territory and eliminate the economic and political competition of such important rivals as Pisa, Lucca, and Siena. The policy had been launched in the mid-fourteenth century, and by the time of the Ciompi revolt in 1378, San Gimignano, Pistoia, and Prato were under control. It was continued with single-minded attention in the late fourteenth and early fifteenth centuries, when Arezzo (1384), Montepulciano (1385), Pisa (1406), Cortona (1409), and finally Livorno (1421) were forced to find their niche in the ever expanding Florentine territorial state.

Milan, therefore, had to be resisted because it challenged Florence's predominance in its own backyard, and also because, conceivably, it might represent a threat to Florence's own independence. On principle, therefore, Florentines had a strong incentive for fighting. And so they did, throughout the period that interests us. Yet on the whole, their efforts were, at best, lackluster. At the turn of the fifteenth century, disaster seemed imminent, and Florence was saved at the last minute by Giangaleazzo Visconti's unexpected death. Once war resumed in earnest in 1423, this time against Giangaleazzo's successor Filippo Maria Visconti, the stakes seemed even greater than before. This war required an enormous treasury to sustain; successes on the field were rare; resentment in the city and countryside of the government's policy could hardly be contained; and suspicions that foreign agents were secretly combing through the city inciting the poor folk to resist their government (if not outrightly to rebel) put the governing group's nerves on edge. And during the interruptions in the war with Milan, there was no shortage of other military engagements to keep the city's government in a nearly constant state of military preparedness. Thus, in 1411, a war – bitter, dangerous, and prolonged – broke out against Naples, which lasted until 1414 and placed the city's security in jeopardy. Then, as if to tempt their fate, the Florentines, in the late 1420s, while their war against Filippo Maria was at a lull, decided to launch a massive campaign to take over Lucca, their erstwhile ally. It was a disastrous decision. Not only did the campaign fail, but its costs produced a massive reaction that led to the regime's fall.

In short, as we soon shall see, war may have resulted in important institutional transformations and in a strengthening of the government's executive authority. But the constant refrains that accompanied the war effort were fear of loss, resentment against the government for subjecting the city to what many of its residents considered to be excessive and unnecessary risk, suspicion that traitors were operating inside the city, and ten-

sions within the political class itself and between the governors and the
governed. It may be useful to remember that Leonardo Bruni's triumphal-
ist Funeral Oration on Nanni degli Strozzi with which we opened this
chapter was delivered at a moment of such tension, when the war effort
against Milan was uncertain at best and the level of civic unhappiness
especially acute.[17]

Not the least reason for such unhappiness was the government's fiscal
policy, called upon to raise the funds necessary for carrying on the
extremely costly military effort of those decades. Two interrelated facts
help us understand the fiscal predicament faced by successive Florentine
governments: (1) Already by the middle of the fourteenth century, ordinary
revenues were insufficient for covering the vast military expenses of the
age. These revenues consisted mostly of sales taxes and other surcharges
(gabelle) on contracts assessed on all inhabitants of the state, and direct
taxes (estimo) on residents of the contado and distretto but, significantly,
not on Florentine citizens themselves; and (2) Shortfalls in revenues were
made up by a complex system of deficit financing, which was based on the
assessment of forced loans on citizens. These citizens were made creditors
of the city's funded public debt (Monte comune) and were issued quarterly
interest payments, ranging from 3 to 8 percent per annum, depending on
the size of a particular loan floated by the government, the terms of its
issuance, and the government's ability to repay its debts.[18]

Large numbers of citizens, more often than not against their will, thus
became the state's creditors, with sizable portions of their patrimonies now
converted into government credits (crediti del Monte). For its part, in the
face of the church's opposition on theological grounds to this sort of
deficit financing, the government devised various – and variously inge-
nious – schemes to make these investments more attractive, on occasion
resorting to solutions that, in effect, doubled or even tripled the amount
of interest promised to creditors. The credits issued by the government
were ordinarily negotiable by their owners in the marketplace, where they
were traded at discount prices that depended on general economic condi-
tions and on the creditors' expectations of the government's ability to erase
particular loans it had floated previously.

The expression "forced loans" (prestiti forzosi) must be taken literally.
Citizens were forced to pay their assessments, even if the government
accepted these payments as loans. This system of deficit financing could
work to everyone's satisfaction if the state's demands were not great and if
the citizens saw this as an opportunity to place some of their surplus
wealth in a secure investment. But this is not at all how things turned out.
The state made huge demands on its citizens, who, increasingly from the
late fourteenth century onward, viewed forced loans as a huge burden.
Indeed, the state's inability to repay its debts caused the Monte to balloon
to a size beyond anyone's expectations. In the 1340s, the total Monte

indebtedness stood at approximately 500,000 florins. By 1380, its size had more or less doubled to about one million florins. Twenty years later, it had doubled again, standing at two million florins. Another million florins was added to it by the middle of the 1420s. In short, the state was borrowing at a much faster rate than it could repay its creditors. It follows that the increase in the debt's size was accompanied by a corresponding increase in the size of the debt's carrying charges (that is, of the amount of interest needed by the government to pay its creditors). One figure may be sufficient to indicate the size of the problem. By the 1420s, the carrying charges of the funded public debt absorbed nearly all the state's ordinary incomes. At times, the government, to satisfy some of its creditors, had to resort to new borrowing. The state's inability to pay its debts depressed the market price of the Monte credits, which often were traded at a fraction of their nominal value, sometimes at 10–15 percent of par.

The imbalances and tensions triggered by this state of affairs are illustrated by some fairly easily ascertainable facts. By the middle of the 1420s, a little more than one quarter of all taxable wealth in the city of Florence was in the form of Monte credits. What is more, this wealth was far from evenly distributed across social classes and geographic regions: 99.7 percent of the government's funded debt was concentrated in the city of Florence; residents of the countryside and the subject cities and towns were almost entirely excluded from whatever benefits the state's creditors might accrue from this system of deficit financing. Even within the city itself, there was a huge concentration of credits in relatively few hands. More than three out of four households in the city of Florence (78 percent) owned no Monte credits at all. By contrast, 2 percent of these urban households owned nearly 60 percent of all outstanding Monte credits.[19]

One could make two observations about this set of figures. First, a fair fraction of taxes paid by Florence's urban and rural inhabitants was being used to pay the carrying charges of the funded public debt. This meant that a vast number of taxpayers was constrained to pay out of their own pockets the interest on Monte credits owned by a relatively small number of their compatriots. Thus, the govenment's system of deficit financing provoked a constant upward circulation of wealth, from the bottom to the top of the social order. Wars and the accompanying deficit financing were contributing to making the rich richer and the poor poorer. One of the most astute contemporary observers, Giovanni Cavalcanti, noted precisely this phenomenon. Ruminating on the social and economic consequences of the prevalent system of public finance, he pointedly wrote, "Just as the wind moves the sand from one place to another, in like manner, because of taxes, and the result of wars, the wealth of Florence shifts from the weak to the powerful citizens."[20] Second, in all of Florence's long republican history (from the late thirteenth century to the early 1530s), the decade 1423–33 – that is, from the resumption of hostilities against Milan to the conclusion

of the disastrous war against Lucca – witnessed the heaviest burden of forced loans imposed by the city on its citizens. During the 1390s, years of often intense warfare, the government had been compelled to collect an average of slightly more than 270,000 florins per year in forced loans. The burden was somewhat reduced in the first decade of the new century, as an average of about 242,000 florins per year was collected. But in the years 1424–32, the sum collected reached unimaginable, nearly astronomical proportions: An average of 549,637 florins was collected each year.[21]

A situation such as this accentuated, often dramatically, inequalities and inequities in Florence's political and fiscal systems. An undercurrent of discontent about the fiscal burden accompanied all of Florentine history. But never was this undercurrent more acute, never did it surface with potentially more violent and disruptive consequences, than in the 1420s. Indicative and entirely representative of the charged rhetoric of the contemporary political debates was the statement uttered in the course of an intense discussion on this issue by Giotto Peruzzi, scion of an old and distinguished family: "The inequalities [in the distribution of the fiscal burden] were greater than at any time since the city's foundation by Charlemagne."[22] The intensity and breadth of opposition and the defensiveness of the city's leaders conspired to produce a major overhaul of the city's fiscal structures, which we shall briefly examine in the following section.

In the midst of all this, it is perhaps not surprising that ties of dependence between a few powerful men and their dependents (or followers) would become more intense and more persistently cultivated. These ties, which have generally been subsumed to the label of patronage, entailed a relationship between a patron – a man who possessed power and was in a position to dispense goods and favors – and his clients, who were in need of assistance of one sort or another. In the past twenty or so years, historians have much insisted on the vitality of the Florentine patronage system: Some have gone so far as to suggest that because of the extent and profundity of the crises early in the fifteenth century, patronage became more widespread than ever before. Certainly, contemporary documents are filled with the sort of ritual expressions – just as customary in Florence as they have been in many other societies, both earlier and later – reciprocally binding patrons and clients. "I have always considered you as my father, since I have never recognized any other father in the world except Forese Sacchetti," wrote a petitioner to Forese Sacchetti, his powerful contemporary.[23] This sort of servile rhetoric of dependence was repeated ad nauseam in the correspondence exchanged between petitioners and those in a position to assist them throughout the late fourteenth and fifteenth centuries. It was, in fact, widely recognized that such ties of dependence were vital to political success, even survival. A man such as Giovanni Morelli, whose advice to his sons we noted earlier, did not hesitate to suggest to his offspring that they "should connect [themselves] by mar-

riage to those who are in power . . . and if you cannot do this, then make
[the man of influence] your friend by speaking well of him, by serving him
in whatever way you can."[24] Even Gino Capponi, the politician who boldly
urged his sons to "love their country more than their soul," added this
caveat to his advice: "Maintain the closest ties with your neighbors and
relatives, and serve your friends at home and abroad."[25]

Florentines themselves generally recognized that such ties of depen-
dence sat ill with the city's political and republican traditions. Ties of
dependence were intended to protect and advance private interest; loving
one's country more than one's soul suggested that private interest should
be subordinated to the communal well-being. This tension was ever pre-
sent in early fifteenth-century Florence.[26] A man such as Rinaldo Gian-
figliazzi, one of the era's most prominent and eloquent politicians, could,
in the course of a political debate, intone that "our city is more important
than our children, and for its welfare everything possible should be done
to preserve for posterity what we have received from our ancestors."[27] Such
a noble ideal implied that political discussion in Florence would be open,
that citizens would be drawn to the public arena, where their engagement
would assure their assent to the great decisions faced by their city. Yet
everyone also knew that if Gianfigliazzi could utter such exalted senti-
ments, his friend Niccolò da Uzzano, one of the city's consummate politi-
cians in the first decades of the century, could sleep through a political
meeting, then upon awakening offer his recommendation, which would be
adopted by the assembly. This specific incident was reported by an eye-
witness, Giovanni Cavalcanti, whose disgusted comment was that things
of this sort happened in Florence because the city's powerful men were
governing the city privately "in dining halls and in studies."[28] In short, the
contradiction between an abstract, theoretical, and impersonal conception
of governance, and the realization that a few powerful men were able to
set the course of public affairs without honoring the spirit of the city's
political traditions, fueled the sense of crisis and uncertainty that perme-
ated the city in the late fourteenth and early fifteenth centuries.

The picture drawn in the preceding pages has highlighted the numer-
ous and thorny problems that characterized the history of Florence in the
last decades of the fourteenth and the first decades of the fifteenth cen-
turies. Some readers, accustomed to the celebratory and rosy accounts of
the Florentine Renaissance may indeed take exception at the tone and
contents of this description. One could argue with some justification that
important elements of early fifteenth-century culture are missing from the
present account: Where are the almost obligatory references to the age's
much vaunted individualism? Where to the history of capitalism, which as
we all know, had one of its early homes in Florence? Where to the artistic
genius and the social infrastructures that nourished and made Florence
blossom in such astounding outbursts of creativity and originality? Where,

finally, to the introspective insights evident in the works of such merchant-writers as Giovanni Morelli, Luca da Panzano, Bonaccorso Pitti, and others? All this and more could reasonably be expected to find its way into an account such as the one given in this chapter. Yet, in response to such an objection, one could say that only by keeping in mind Florence's grave problems in the age generally labeled as the "early Renaissance" will these great accomplishments be cast against the backdrop of contemporary developments and be seen for what, more often than we might be inclined to think, they were: answers – often rhetorical, as often as not practical, realistic, and effective as they were wishful, imaginary, and ineffectual – to the problems of the day.

Responses

We can perhaps start with a brief excursus into the history of Florence's public finances, an area that might strike us as being arcane, but that never ceased to impress Florentines for its centrality to their lives.

On January 1, 1384, Lionardo di Niccolò Beccanugi, *provveditore* (supervisor) of the *Camera del Comune* (the Exchequer), started a new series of account books.[29] Beccanugi wrote that in this new book, "will be written all incomes and expenses of the Camera del Comune of the city of Florence, each account on its own, followed by all incomes and expenses of all gabelles . . . and every other item that I shall deem necessary to understand the . . . commune's incomes and expenses."

This was the first time ever in Florence's history that one agency would account for all the government's incomes and expenses. Before the 1380s, there existed no central recording of government finances, no way for an official (or modern historian) to have a synthetic picture of the state's resources and its liabilities. Now, a central accounting agency would gather all the information necessary for keeping track of the flow of money in and out of government coffers. In recent years, historians have pored over the series begun by Beccanugi and discovered that his claim was not overstated: Every item in the government's incomes and expenses is carefully itemized, from ordinary *gabelle* to forced loans to, significantly, extraordinary taxes, each accounted for separately. For every one of these, we can trace not only the sum it produced each year and the provenance of its income, but also its assignment to government agencies authorized to spend specific sums of money. These books were continued until the early 1430s, with a succession of prominent politicians following Beccanugi in this office. By 1388, there were two *provveditori* (supervisors), and the description of their charge was even more precise. That year's officials, Iacopo di Francesco Arrighi and Nigi di Nerone di Nigi, described their book as "the mirror," *lo specchio,* in which "we shall write in order all the Commune's incomes and expenses . . . so that

this book will show all the affairs of the Commune and of the Camera." In 1420, Rinieri Baronci, the scribe of the *provveditori*, expressed even more dryly his intent in the preamble of that year's book. In it, he would write "lo stato del Magnificho chomune di Firenze" (the condition of the Magnificent commune of Florence).

There is no trace of a formal decision requiring anyone to undertake such systematic and methodical record keeping; it might even be that the first book was begun by Beccanugi on his own initiative and that it was continued by his successors in office. Even so, the systematic continuation of these books for nearly half a century – with the same format and attention to detail – bespeaks the existence of a political vision that assigned to the government responsibilities and powers that, previously, it had lacked. The "facts" revealed in this public "mirror" were bound to generate a new sense of order and discipline: Their accumulation, year after year, enabled those in charge of policy to have a clearer understanding of the magnitude of the resources on which they could reasonably depend. These books gave rise to new possibilities of power and of its outward application from the government's fiscal core. Thus, in coincidence with the onset of a profound and prolonged period of fiscal crisis, the city's governors devised new instruments of governance that attempted to impose control and discipline on the ever chaotic universe of Florentine public finance.

More than once in the preceding pages, reference was made to the great fiscal census – the *catasto* – prepared in Florence in 1427. For generations, Florentine governments had been plagued with the issue of how to assign rates for the payment of forced loans on their citizens. The urgency of the matter was obvious in the first few decades of the fifteenth century. The government's seemingly insatiable demand for money provoked waves of protest at what many justifiably perceived as an arbitrary system of distributing the fiscal burden, with powerful politicians and their friends getting away with lighter assessments than they should. Fiscal pressure and widespread protest gave rise to the realization that greater fiscal equity was essential. Out of this realization, in 1427 – when, most probably, Masaccio was either executing or had just completed his work in the Brancacci Chapel – was born a grandiose scheme, the preparation of a complete fiscal census of all people and all property in the Florentine domain. Every head of a fiscal household was required to submit a declaration in which were listed all of the household's assets and its liabilities.[30]

These declarations, collectively known as the *catasto* (i.e., a cadastral survey), survive in the State Archives of Florence, and they are a majestic testament to that systematizing penchant born out of a moment of profound crisis. Each declaration includes every farm, every piece of real estate, all debts and all credits, and every person who belonged to the household (with the age of each person and his or her relationship to the household's head). The detail included in these documents is staggering.

Every piece of property is described by reference to other properties that abutted it. The produce of every farm as well as its animals are listed, with elaborate tables prepared by tax officials to compute the worth of every type of product. The owner of the farm listed the name of the peasant to whom the land was let, and the type and duration of the peasant's lease. The peasant, for his part, submitted his own declaration, so that tax officials could double-check entries for their accuracy. The same principle applied to urban properties – these, also, are listed individually, with the name of the tenant who rented each and with the annual income each property produced – as well as to businesses. For these latter, balance sheets were submitted, so that at least for that one year (1427), we have a detailed profile of Florentine business activities throughout the then-known world. And then, of course, in addition to the inventory of this material wealth, each declaration contains an inventory of the state's human wealth, with the name, gender, and age of every person who lived in it, and with his or her relationship to the household head.

Two observations are in order here. First, we note the enormity of this undertaking and the extraordinary imagination it required to foresee the possibility of reducing that vast mass of information into a synoptic picture of Florentine resources. Indeed, government officials and curious private citizens in the fifteenth century (and equally curious historians in the twentieth) proceeded to compute, for their own purposes, the total number of individuals who lived in the city and in the country, the number of men as against the number of women, the age distribution of the two genders, the amount of liquid and landed wealth available in various parts of the state, and a whole host of other statistics. Here, in short – and this is the second observation – is a prime example of how an intellectual and administrative breakthrough was provoked by the profound crisis that was challenging the city's regime to its very foundation.

There is an additional noteworthy example of such an imaginative and inventive, if also desperate, response to the fiscal crisis of the 1420s. As we already have noticed, a key problem in the administration of the public debt was paying its carrying charges. By the mid-1420s, funding the debt swallowed up huge sums of money, sometimes the state's entire regular revenues. It was important, therefore, to figure a way of reducing these charges without, however, arousing the ire of the thousands of Florentine citizens who, over the years, had been required to pay their forced loans, becoming, often against their will, the state's creditors. Such a solution was invented in the summer of 1425 (and further refined in the subsequent years), when it was decreed that a new fund would be instituted, the *Mons puellarum* (the young girls' Monte), also known as the Monte delle Doti (Dowry Fund).[31] Monte creditors would now be entitled to deposit Monte credits in this new fund, opening accounts for each of their unmarried daughters to pay their dowry (the payment of cash and goods given to hus-

bands from the Middle Ages on). After a predetermined number of years (which varied from a minimum of five to a maximum of fifteen), if the girl in whose name the account was opened were still alive, had married, and had consummated her marriage, her husband would be entitled to collect, as her dowry, a sum from three to five times the original deposit. In the meantime, the government would not need to pay the quarterly interest payments on credits left on deposit for dowry accounts.

The idea behind this scheme was both ingenious and naive. The ingenuity lay in understanding that this new scheme would attract the attention of many Florentines who in any case had the obligation to endow their daughters at the time of their marriage. Instead of using their own resources, now they could convert some of their Monte credits and let the government pick up a good portion of the expense of the dowry. Thus, to give an example, if a father planned on giving his daughter a dowry of 1,000 florins, he could open a fifteen-year account when she was very young by turning over 200 florins' worth of Monte credits, which he either owned or acquired in the open market, and wait for his daughter to be married so that the deposit would come to maturity. His risk was that to maximize his investment, he had to open this account when his daughter was but a small child and hope that she would not die in one of the periodic outbreaks of the plague. After the law's revision in 1433, if she died before the deposit's maturity, he would be entitled to get back his deposit, without any accumulated interest. The risk was worth taking, and after 1433, thousands of Florentines took advantage of the scheme and opened up dowry accounts for their daughters.

The naiveté of those who instituted the scheme was that they made no provision whatsoever for paying off the dowries when they came due. They simply hoped that over the years, sufficient savings would be made on the public debt's carrying charges and that a substantial number of depositors would not live to their accounts' maturity. As it turned out, both calculations were wrong. Money saved on the Monte's carrying charges was swallowed up by the government's military policies, while only a small fraction of potential beneficiaries predeceased their deposits' maturity. So, about twenty years after its creation, the Monte delle Doti began running into serious problems of liquidity. In the long run, therefore, the invention of this scheme turned out to be unwise. Nonetheless, if seen in the context of the times when it was created, it bespoke the same penchant for addressing a crisis that was challenging the credibility and good name of the state's ruling class.

In the meantime, just as was the case with the books of the *Provveditori della Camera* and of the *Catasto* (Supervisors of the Exchequer and of the Catasto), the government was setting the stage for intervening more actively – to the point that a generation or two earlier would have been unthinkable – in the affairs of its citizens. As with these two magistracies,

the Monte delle Doti generated an immense archive, an instrument of control in the hands of the Florentine government, and of wonderful possibilities of research in the hands of modern scholars. In fact, the legislation establishing the Dowry Fund stipulated that scribes registering deposits were to note information necessary for identifying every girl for whom an account was opened. This included the girl's first and second Christian names; the names of her father and paternal grandfather, of her mother and maternal grandfather; her date of birth; and very often, when such information could help to identify people more accurately, the occupations of her male kin. In addition, the scribe registered information regarding the deposit: the date; term (i.e., length); date of maturity; cash value; mode of payment (i.e., whether in cash or in Monte credits; and, if the latter, in what type of credits; at what discount rate the conversion was made; and in whose name these credits were registered prior to the deposit); and the value of the Monte dowry at maturity.

All this information was contained in one long paragraph, following an equally long space (which the scribe left blank) into which he later inserted information regarding the deposit's outcome. In case of the girl's marriage, one finds her husband's name, his father's and grandfather's names and, sometimes, his occupation; for husbands legally residing outside of Florence, the locality of their residence was also given. In addition, the scribe registered the date when a husband received payment of his wife's dowry, carefully noting if the payment was received in one or more installments, and if the latter, the date of each and the manner in which each of these payments was made (whether in cash or in Monte credits; if the latter, in what type of Monte credits and their discount rate at the time of payment), and finally, if a tax was withheld from the payment received. If, on the other hand, the girl became a nun, the scribe took note of the date of the vows, the date when notification was made to the Monte, the name of the nunnery, the date of repayment of the capital, and the name of the nunnery's procurator who received payment. Finally, in case the girl died, the scribe noted the date of death, that of the death's notification to the Monte officials, the place of the girl's burial, the date of the capital's repayment, and the identity of the person receiving that payment.

The archive generated by the activities of the Provveditori della Camera concerned the city's public life; that of the Catasto contained massive information on aspects of private life, such as the wealth of individuals and the composition of their households, that had a bearing on the state's ability to raise money efficiently and equitably. For its part, the archive of the Monte intruded, in none too subtle a manner, into the private lives of its citizens. Now, the most private (even some intimate) details of a family's life could be subject to government regulations. If the government could not pay the matured dowries, men would hesitate to marry because a marriage without a dowry was inconceivable in late medieval Europe.

Conversely, the government refused to pay a dowry to a husband who was unable to certify that he had sexually consummated his marriage. Marriage itself – not only in its patrimonial, but even in its biological dimensions – was now subject to the government's regulation and discipline.

Far from being confined to fiscal policy, the government's propensity to order, systematize, and control is evident in many other aspects of early fifteenth-century Florentine life. In the realm of the economy, for example, the first few decades of the fifteenth century witnessed a flurry of government activity.[32] Already in 1415, a new set of communal statutes included, for the first time in the city's history, a lengthy section on the economy. Comprising 281 separate clauses, this *Tractatus et materia Consulum artium et mercatorum* (Treatise and materials regarding the Counsels of the guilds and of the merchants) consolidated and streamlined much existing legislation on economic activity. Most significant, it removed the traditional autonomy of the guilds, which for centuries had regulated the economic activities of their members. Now, guild policy was subordinated to government policy, and guilds were effectively transformed into government agencies intended to ensure that the government's policy in their area of the economy was enforced. Furthermore, in a series of measures from the late 1410s to the late 1420s, the government regulated the manufacturing of silk, discouraging the importation of silk cloth, and offered tax incentives to ensure the development of this industry.

In its intent to render more self-sufficient the state's economy, in 1421, Florence purchased from Genoa the port of Livorno, where it set out to concentrate its maritime ambitions. Within a few years, the government had launched an ambitious program to construct a commercial fleet so as to challenge Venetian and Genoese primacy in Mediterranean trade. Felice Brancacci – who, by the happy association of his name with Masaccio, has ever since been remembered by successive generations of historians and art connoisseurs – made one of his first public appearances as Florentine ambassador to Egypt in 1421, charged with negotiating terms for establishing a base in that crucial commercial emporium.[33] Most astoundingly, as a follow-up to the decision to become a maritime power, in 1422, the Florentine government charged the officials of the fleet to undertake a systematic census of all trades and occupations (*artes, exercitia, et manifacturas et ministeria*) not being exercised in the Florentine state and to encourage their development.[34] To this end, fiscal incentives and strict regulation of the importation of goods were enacted. There is perhaps no more ambitious and no more suggestive indication of this drive to control and discipline all aspects of Florentine life than this measure, whose scope bespeaks at once an awareness of the gravity of the problems besieging Florence's economy and a disarmingly and overarchingly ambitious search for solutions.

One could continue this enumeration of the areas of social, economic,

and political life in which the same tendency toward control and discipline was expressed in those years. The newly formed territorial state was reorganized, with new magistracies created to oversee its functioning: Measures were taken to ensure that citizens had reached the required age before serving in political offices, and to this effect, a new register was created in which their birth dates were written; attempts were made to streamline the judicial branch of government and to enhance the prestige of the government's executive authority as well as to assert the territorial state's sovereignty.[35] Perhaps one final example must do as revealing an expression of this drive to extend the government's control to every aspect of the city's life, to allow not even the most latent manifestations of potential disorder from escaping its attention and regulation. From the new century's earliest years, in an outburst of activist regulations of the city's social life, the government began to create new courts whose jurisdiction would extend to what was considered deviant or disruptive social behavior: Prostitution would be regulated and municipal brothels created (1403), and measures taken to ensure the sexual purity of convents (1421) and to regulate and control homosexuality (1432). In the meantime (1419), the government had decided that infants abandoned by their parents, of whom there were several hundred each year, should be properly housed and cared for in the newly founded Ospedale degli Innocenti, whose facade, a few years later, would be designed by Filippo Brunelleschi.[36]

Afterthoughts

Some time between 1424 and 1428 (scholars are not in agreement as to the exact chronology of its composition), Masaccio painted his magnificent fresco of the *Trinity* (see Plate 13) in Florence's Dominican church of Santa Maria Novella. In its own time, admirers were awed by the painter's inspired representation of one of the great mysteries of Christianity and by his mastery of the newly invented art of perspective. It is generally acknowledged that several elements of what is referred to as the early Renaissance style are present in this work: the rediscovery of antiquity in the magnificent architectural frame within which the mystery of the Trinity is represented; the all-too-human depiction of the protagonists – Christ on the Cross, God, who paternally hovers over his son, and the mystery's two pairs of witnesses, the Virgin Mary and Saint John the Evangelist, and the two patrons in the painting's foreground; and the social context of artistic production in Florence as demonstrated through the depiction of the patrons (according to some scholars, including Timothy Verdon, members of the Lenzi family) prayerfully kneeling before the Cross. Here was one of the quintessential examples of the new spirit of the Renaissance – supportive if not optimistic in its humanness, "this-worldly" in its appro-

priation of classical antiquity, and in control of space and emotions through Masaccio's mastery of perspective.

But for centuries, at least since 1570, an altarpiece that Giorgio Vasari had placed before the fresco had entirely hidden it from view. Around 1860, the upper part was "discovered," detached, and displayed on the entrance wall. Then, shortly after the end of World War II, an amazing discovery was made. The fresco that everyone had so come to admire and that had itself been transformed into an icon of the Renaissance was incomplete! Its lower portion had gone undetected and was not transferred with the rest.[37] What is more, this rediscovered part did not add a trivial, decorative element to the representation. Rather, it restored its original devotional resonance. For below the imaginary triangle consisting of Christ's head at its apex and of the two patrons at its base, Masaccio had painted a human skeleton with a grim inscription above it: IO FUI GIÀ QUEL CHE VOI SIETE E QUEL CH'IO SON VOI ANCO SARETE: "I once was what you are now, and what I am, you too will be." This forceful, one is tempted to say violent, evocation of human mortality shocks one into realizing that the image of death and the inherent consciousness of mortality's inescapable presence in human life were there in the fresco all along. The mystery of the Trinity is linked to human mortality; God's majesty and Christ's suffering are but reverse reflections of the fragility and brevity of human life. Masaccio's mastery of perspective allowed him to convey the illusion of control, balance, and order. But this illusion was based (literally, as well as figuratively) on the reality of death and decomposition.

Masaccio's representation of the Trinity can be taken as a metaphor for Florentine society in the early Renaissance. The age's accomplishments to which reference was made in the preceding pages – the yearning for control and the not-infrequent illusion that it had been achieved – sprang from an often intense awareness that in that place and time, life was precarious, at best; that epidemics, economic reverses, and social tensions were ever present dangers generating instability and anxiety; that survival depended on a constant confrontation with these unpleasant realities and on the struggle to invent ever novel ways to curtail their influence. The humanists' exalted rhetoric – and the politicians' patriotic exhortations in the course of political debates as well as the striking and continuous efforts made by successive governments to enhance control and to impose discipline – were rooted in the however inchoate knowledge that a more passive, resigned, or self-satisfied course could well lead to disaster. The luminous side of Florentine history seems to have been as intimately connected to its dark side as the hope of salvation was to the presence of death in Masaccio's glorious representation of the Trinity.

2 Masaccio's City

Urbanism, Architecture, and Sculpture in Early Fifteenth-Century Florence

Gary M. Radke

Masaccio was an architect's and sculptor's painter. Not only did he count among his close acquaintances Filippo Brunelleschi and Donatello – Florence's preeminent architect and the city's most daring sculptor – but his works gave pictorial form to his companions' most innovative ideas. All three artists were fascinated with the challenge of portraying their world accurately and convincingly. Brunelleschi (1377–1446) revived local interest in ancient architecture and invented scientific perspective, giving artists a new and reliable tool for representing three-dimensional reality on a two-dimensional surface. Donatello (1386–1466) revived ancient strategies for making statues seem to stand like actual human beings and brought new psychological depth to his depictions. Masaccio put all of their ideas – and more – into paint.

Masaccio was a keen-eyed student of the city around him, responding equally to the geometric order of its streets and to the messy plight of its urban poor. In his works, we seem to walk directly back into early fifteenth-century Florence, experiencing that particular time and place with unprecedented immediacy and poignancy. And yet, Masaccio did much more than simply document the world around him: He literally envisioned it. Well before Brunelleschi completed a single major building, before Donatello had secured his position as the city's most famous fifteenth-century sculptor, and before painters and patrons had lost any of their enthusiasm for the colorful, elegant, and idealizing International Gothic Style – in other words, before medieval Florence had become Renaissance Florence – Masaccio was dead. But his art looked to and visualized the future.

This chapter seeks to bring us closer to Masaccio's Florence. Examining urbanism, architecture, and sculpture during the artist's lifetime will reveal how much of the city that we see today dates from after his death. It will also show how much of the urban fabric that he knew has been

destroyed and altered. At the same time, we will see that he responded positively to many medieval aspects of the city and recognized the conscious, urbanistic choices made by city officials in the thirteenth and fourteenth centuries. He was aware of a wide range of sculpture in his city, not just the work of his obvious soulmate, Donatello. Thus, the picture of Masaccio's Florence will become more complicated than we might have expected. If anything, Masaccio's accomplishments will seem all the more remarkable for having been forged in a medieval city, not a Renaissance one.

The Urban Context

Masaccio's Florence had been founded as a Roman encampment, laid out according to the compass in a strict geometric grid that is still evident in the modern city. However, much of the regularity we see today was reimposed late in the city's history. Massive urban renewal took place in Florence and across Italy in the 1880s and 1890s following the reunification of the country into a single, modern state, which Florence temporarily served as capital.[1] City planners sliced off the facades of existing buildings to make streets wider and more regular; new four- and five-story buildings in Renaissance revival style created anachronistically coherent and homogeneous streetscapes. The results are clearly evident along the old Via Larga running north from the Cathedral to the Palazzo Medici (a building erected a decade and a half after Masaccio's death as city development was pushing northward).[2] On the western side of the street, original medieval and Renaissance buildings still vary in height, width, facade articulation, and fenestration as they did in Masaccio's day. In sharp contrast, massive and somewhat anonymous pseudo-Renaissance building blocks from the nineteenth century impose dull uniformity on the eastern side of the disproportionately wide modern street.

Masaccio's city was denser and richer.[3] As seen in *Saint Peter Healing with His Shadow* (see Plate 12), enclosed balconies jutted out over most streets – this in spite of the fact that the city government levied heavy fines to discourage such intrusions. Urban development also pushed into and over the river (Plate 21). Palace facades rose above great struts along the river, and towers – not just of churches but of dozens of rival family enclaves – erupted into the skyline where today we see shed-roofed stumps. Lining the fourteenth-century Ponte Vecchio were butchers' stalls, not the elegant jewelry shops that Duke Cosimo I installed in the mid-sixteenth century and that still occupy the bridge today. The bridge was so finely constructed and dense with shops that a contemporary wrote that it only seemed a bridge at its center, where open loggias allowed viewers to admire the river.[4] Urban space was certainly at a premium. Upstream, a group of recluse nuns perched in small houses on the piers of the Ponte alle Grazie.

Plate 21. View of the Ponte Vecchio, rebuilt 1345, Florence. (Photo: Sabine Eiche, Florence)

Commercial and domestic activity filled the river: Women risked its silty banks to do the family laundry; wool-workers did the same, washing and dyeing their fleece, yarn, and fabrics; fishermen netted pan fish, oblivious to the water's pollution. Millers relied on spring and fall rain surges to turn some of their mills, and shippers floated cargo upstream from Pisa and such famous quarrying sites as Carrara.

City Squares

Only a few but highly significant open squares relieved the density of center city. At its heart stood the market, an open square that occupied the site of the city's ancient Roman forum. As in the rest of Florence, shopkeepers, their families, and their assistants and apprentices lived directly above the shops where they offered their handiwork to the public. Purveyors set up stands and carts in the square to sell products fresh from the countryside. The tiny church of San Tommaso in the far corner of the square served the local community, ensuring that God and his representatives were nearby – even in this center of worldly commerce.[5]

In Masaccio's city, all aspects of life existed cheek by jowl. Modern notions of separating residential and commercial districts, keeping religion distinct from politics, and insulating "polite" society from the lower classes did not exist. By the late nineteenth century, however, Florentines were

embarrassed by their medieval and Renaissance market. They razed all the buildings surrounding it to produce the grandiose but sterile Piazza della Repubblica. An enormous hollow at the center of the modern city, it remains lifeless in spite of the installation of enormous open-air cafes – unknown to Masaccio's world, which had never tasted coffee, let alone tomatoes and other foodstuffs that entered Europe with the "discovery" of the New World. What most troubled nineteenth-century urban planners about the market area and chiefly led to its demise was the disrepute of the narrow allies surrounding it. Nearby in Masaccio's day was the city's largest public brothel, established by the city fathers in 1403, ostensibly to wean late-marrying men from homosexuality, as well as some of the taverns and inns most favored for same-sex trysts, all within view of the bishop's palace and the Cathedral.[6]

Indeed, in old photographs, the Cathedral's dome and bell tower rise beyond the market. In Masaccio's day, however, only the great bell tower would have been completely visible from the market. Cranes and hoists dominated the cavity of the unfinished dome, which was not structurally complete until 1436.[7] The lantern at its summit, though designed by Brunelleschi, was not in place until the 1440s. In other words, Masaccio's Florence lacked the very structure that came to symbolize the Renaissance city, much as the nineteenth-century Eiffel Tower very belatedly became an emblem for Paris. The dome, which Leon Battista Alberti, just one generation after Masaccio's death, could say sheltered all the Tuscan people in its shadow, was barely rising from its drum.

Instead, a shadow of doubt and apprehension surrounded the entire project. Could the Florentines really vault a space of such ambitious magnitude? Would Brunelleschi's novel double-shell scheme sufficiently reduce its weight? Was his spiral of herringbone bricks going to be self-supporting as he claimed? The project had been under way for more than half a century and was still nowhere near completion. Brunelleschi took on the challenge in 1420, but when Masaccio joined the Florentine painters' guild at the beginning of 1422, the architect only had his hoist in place. He had yet to design and build the great crane that facilitated the actual construction. Down in the nave, a wall sealed the entire east end and the gaping, polygonal drum for the dome from the rest of the church. Only by examining a masonry model that had been built alongside the Cathedral in 1367 (when the wall had been built), or the even older satin pink rendition that Andrea da Firenze had painted in his fresco of the *Triumph of the Church* in the Chapter House at Santa Maria Novella, could one have begun to imagine what the structure might look like. In fact, Brunelleschi's wooden model of the church, cupola, and lantern was still under construction in June 1434.

For Florentines of Masaccio's generation, then, it was the pyramidal roof of Florence's Romanesque Baptistery (Plate 22), not the pointed Gothic ribs of Brunelleschi's dome, that marked the ecclesiastical center

Plate 22. Baptistery, 1150, Florence. (Photo: Ralph Lieberman)

of the city.[8] The Baptistery stood in a much smaller piazza than it does today, hemmed in at the back by the now destroyed medieval archbishop's palace. Narrow streets emanated from its corners. Still, the building and its surrounding space was – and still is – particularly impressive as seen from the central door of the Cathedral.[9] In 1296, Arnolfo di Cambio, the Cathedral's first architect, positioned his new facade so that the entire height of the Baptistery and a good portion of its roof would be visible from the Cathedral portal. (Neither the roof nor the lantern had been visible from the smaller piazza that stood in front of the old cathedral Arnolfo was replacing.) City officials cleared tombs and a hospital from around the Baptistery and regularized the sides of the piazza, producing a nearly perfect square (130 × 131 Florentine *braccia;* one *braccio* equals approximately 58.36 cm). Thus when Brunelleschi decided to create a painting demonstrating his new invention of scientific perspective, he had a ready-made subject in the Baptistery as seen from just inside the Cathedral's portal. In fact, the building and its square were so well-proportioned that they may actually have inspired him. Not only was the building itself satisfyingly regular and polygonal in shape – a boon to anyone attempting to create a three-dimensional effect on a two-dimensional surface – but its bold horizontal cornices created clear diagonal lines on either side of the building. They seemed to converge, as perspective demands, exactly at the north

and south limits of the piazza. This, then, was where Masaccio would have learned about perspective and been able to confirm Brunelleschi's scheme.

The city's third major downtown square was the subject of another perspectival demonstration piece by Brunelleschi.[10] The Piazza della Signoria fronts Florence's battlemented and towered city hall, begun in 1299 (Plate 23). In this case, the space seems much less regular than the piazza surrounding the Baptistery, but once again, medieval city planners had tailored the space so as to enhance the appearance of its main building. The government took most of the fourteenth century to expropriate and demolish a dozen dense city blocks around the city hall, not to mention widening the ends of two streets near the piazza. Civic processions moved from the Baptistery and Cathedral down the Via dei Calzaiuoli to the Piazza della Signoria and entered the public square at 160 *braccia* from the near edge of the impressive tower, exactly its height. A sweep of 90 degrees perfectly framed the view. Thus Brunelleschi – and Masaccio following his example – experienced geometric order and calculated perspectival effects in the very fabric of their city. They did not need to invent perspective out of their imaginations or turn to ancient works of art for inspiration. Florence, with its grid of relatively straight streets and geometrically ordered piazzas, was a demonstration piece of rational spatial planning particularly well suited to being represented on two-dimensional surfaces.

As in the market, however, geometry in the Piazza della Signoria was relieved by a great variety of building types. This was no homogeneous, neoclassical world. To the right of the city hall, an enormous late fourteenth-century loggia accommodated state receptions and public events. Its three large arches evoked the grandeur of such Roman ruins as the Basilica of Constantine and Maxentius in Rome, but its main support came from complex medieval piers and cross-ribbed vaults, just as Brunelleschi adapted Gothic ribs to vault his dome. Directly opposite the palace (indicated in dark ink at the far right in Plate 23) was a tall retaining wall anchored with a long bench covered with a simple shed roof (the so-called Tetto dei Pisani, unfortunately replaced at the end of the nineteenth century with an overpowering, pseudo-Renaissance palazzo). On the left side of the piazza stood the church of San Romolo, squeezed between variously tall and short, wide and narrow, public, private, and religious buildings (the corner two again destroyed). Underlying geometric order was present, but variety always relieved it.

Outside the City Center

As one moved away from the religious and governmental center of the city, urban texture changed dramatically. Four times as much sparsely developed land stretched beyond the constricted limits of center city as was

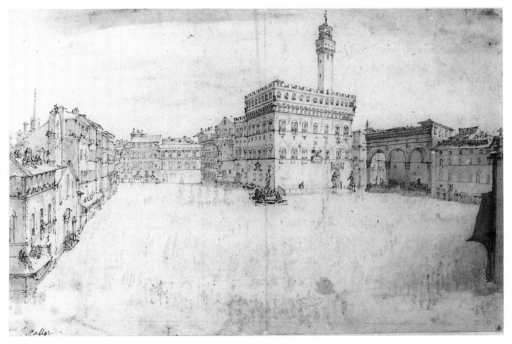

Plate 23. Jacques Callot (1592–1635), *Piazza della Signoria from Corner of the Via dei Calzaiuoli,* HZ 1718, Darmstadt, Hessisches Landesmuseum. (Photo: Hessisches Landesmuseum, Darmstadt)

located within it. Annexed to the city and enclosed with impressive walls from 1288 to 1333, outlying areas included large gardens and open spaces. They were not fully developed until the late nineteenth century, when the medieval walls were torn down to create broad boulevards. In Masaccio's day, many streets ended abruptly at the city walls.[11] For security reasons, only a select few led to heavily fortified city gates that were opened at dawn and closed at dusk. Where the countryside ended and the city began was immensely clear, and yet upon entering the city gates, one did not immediately encounter urban congestion. Suburban and semirural in character, the areas just inside the walls allowed for the production of some foodstuffs within the city itself and gave the Florentines centuries of room for urban expansion.

The reforming Dominican and Franciscan friars (known as mendicants) built their enormous preaching halls in these outlying districts where land was cheap and plentiful.[12] Here in front of the churches of Santa Maria Novella and Santa Croce, popular preachers invited people to break down some of the barriers between religious and secular life. They set up pulpits outside and used dramatic gestures and spectacular storytelling skills in their sermons to keep crowds engaged and entertained for hours on end. Popular tournaments, often featuring teams from different

neighborhoods, took place here, too. They gave healthy outlets for factionalism, and they reinforced solidarity and pride among neighborhood teams and residents.

Inside the churches, none of which had anything but rough brick and stone facades in Masaccio's day, a patchwork of frescoes and tomb monuments covered the walls and piers; stained-glass windows pulsated with constantly changing patterns of richly colored light. Marble tomb slabs covered the floor. Above, flags and banners flew from the rafters; ex-votos hung from the arches. Everywhere one looked, the simple, clean lines of the architecture were embroidered with color and decoration.

As at the Cathedral, the naves of mendicant churches were divided from their east ends. This was due not to construction (as at the Cathedral) but to general liturgical practice, which demanded the separation of clergy and laity even in such populist churches as Santa Croce. A multi-storied choir screen stretched across its nave and pierced the air with spiky, Gothic gables.[13] Beyond were choir stalls and the high altar, barely visible to the laity. Only the stained-glass windows in the apse and frescoes high on the walls above the transept chapels were visible to all. Thus, while a visit to these churches today helps one step back in time, it does so only partially and misleadingly. The wholesale destruction of choir screens in the mid–sixteenth century and the removal of many ephemeral objects over the centuries rob us of the dense, multilayered experience Masaccio would have taken for granted in his city's churches.

Religious services in all churches in Florence maintained much of the mystery they had enjoyed throughout the Middle Ages. The spaces in which they were performed were complex and cluttered – hardly the simple settings of Masaccio's paintings or the drastically monochromatic architectural compositions of Brunelleschi, both of which were not only novel but extremely rare in Florence in the 1420s. The interior of the marble-clad Baptistery, for example, was encrusted with glittering mosaics and crowded with tombs, wax ex-votos, and paintings on the columns and piers that were not removed until 1484.[14]

The general effect still survives in the interior of the city's grain market and miracle-working shrine downtown, Orsanmichele.[15] Crammed into a relatively sober, round-arched building of the 1330s stands a massive, spiraled and crocketed shrine dedicated to the Virgin (built by Andrea Orcagna between 1355 and 1359). Frescoes cover every pier, vault, and rib. Lush, interlacing tracery, being filled in Masaccio's day with stained-glass compositions designed by Lorenzo Monaco and Lorenzo Ghiberti, adorns each window. Add to this the choir screen that once separated the public from the tabernacle, offerings and gifts left at the altar, and sacks that city officials filled with grain from chutes in the hollow piers, and one begins to gain a sense of how radically spare Brunelleschi's work must have seemed to Masaccio's contemporaries.

Unfinished Business: Brunelleschi's Architecture at the Time of Masaccio

If anything, Masaccio's Florence was a Gothic city. All the biggest and most important structures were built in the then "modern" Gothic style, and very little of Brunelleschi's architecture had actually been completed. Many of the buildings that have come to epitomize the early Renaissance in Florence were barely begun in Masaccio's lifetime. They also owed much more to medieval precedents and examples than is usually claimed in surveys of the Renaissance. An excellent example is Brunelleschi's Ospedale degli Innocenti.[16] Built outside the densely populated city center, the complex enjoyed an ample and relatively undeveloped site. The simple arches and pedimented windows of the facade of this home for abandoned children would seem to hearken directly back to ancient Roman prototypes. And yet, medieval hospitals throughout Tuscany were regularly fronted by arcades, and the Ospedale's spare window motifs share more with the Florentine Baptistery than they do with actual Roman models. Often what seems ancient in Renaissance Florence was Romanesque, the work of local architects who distilled Roman elements into essential, easily replicable forms.[17]

The only thing distinctly Roman about the Ospedale's form in Masaccio's day would have been its seemingly ruinous state. The builders completed the famous portico in the summer of 1426, but instead of capping the ground story with the broad frieze and second-story windows we now see, they constructed a rough roof directly over the portico vaults and moved inside to work on the central courtyard. Brunelleschi himself left the employ of the Silk Guild, which sponsored the project, on January 29, 1427. Fully ten years later – nine after Masaccio's death – the "temporary" roof was removed and the second story built. No children entered the institution until eighteen years after that, and then their caretakers had to wait until 1457 for there to be steps between the piazza and the portico. In other words, the building Masaccio saw was little more than a quickly roofed arcade raised incongruously above a rough stone foundation – hardly the elegant, urbanistically sensitive composition we see today.

Equally stranded above and beyond its surroundings was the Old Sacristy at San Lorenzo (Plate 24), which Brunelleschi built for the Medici family beginning in 1418.[18] The work had begun as part of a larger project to rebuild the Romanesque church of San Lorenzo, itself a replacement for one of the first and therefore most venerable Christian buildings in the city. At Masaccio's death in 1428, only the sacristy and an adjoining transept chapel were structurally complete. Construction on the church itself was so slow in coming that there was nothing to connect them until the second half of the 1430s. This obviously means that Masaccio never had the opportunity to stand inside San Lorenzo, which has become Brunelleschi's best-known church. The Old Sacristy and transept chapel,

Plate 24. Filippo Brunelleschi, Old Sacristy, begun 1418, Florence, San Lorenzo. (Photo: Antonio Quattrone)

probably boarded up to protect them from the elements, must have seemed incongruous atop their rough foundations, standing several feet higher than the still functioning Romanesque church and bell tower of San Lorenzo in front of them.

To study these structures, then, Masaccio would have needed special access to the building site, which he could have obtained from Brunelleschi, known to have been his friend. Once inside, Masaccio would have been impressed by the pure and simple geometry of the work. There was little else to see: Donatello had not yet added the stucco and terra-cotta reliefs, bronze doors, and pedimented Ionic doorframes that Brunelleschi is reported to have considered an insult to his composition. Here and only here would Masaccio actually have experienced Brunelleschi's architecture on a relatively large scale.

The only complete work by Brunelleschi that Masaccio could have studied, albeit on a smaller scale, was the Barbadori Chapel in the church of Santa Felicita (c. 1418–25: Plate 25).[19] Located in the front right corner of this nuns' church, it consisted of a simple quadrangular plan opened by arches and crowned with a dome. Transformed in the sixteenth century

Plate 25. Filippo Brunelleschi, Barbadori-Capponi Chapel, 1418–25, Florence,
Santa Felicita. (Photo: Antonio Quattrone)

into the famous Capponi Chapel that was decorated by Jacopo Pontormo,
the Barbadori Chapel has lost much of its original detailing and so is much
less well known than it should be.

One thing is clear. It took very daring patrons and self-confident artists
to create such a work. In the case of the Barbadori Chapel, the patron was
a woman, Sandra Barbadori, widow of Rinaldo di Vieri de' Altoviti and
daughter of the deceased wool merchant Bartolomeo di Gheruccio Bar-
badori.[20] Her brothers oversaw the actual construction. Unfortunately, we
know nothing about the circumstances that led them to choose
Brunelleschi or why they were specifically attracted to – or at least toler-
ant of – his classicizing style. With Sandra's money and her brothers'
actions, the site became an important burial spot for women in the family,
including their mother.[21] Florence was built by much more than just the
Medici, the city government, and church authorities.

Intriguingly, when another set of lay patrons (presumably the Lenzi family) commissioned Masaccio to paint his *Trinity* (see Plate 13), he based the architecture on the Barbadori Chapel. In each composition, the entrance arches were framed by fluted Corinthian piers and smaller, smooth-shafted Ionic columns. Roundels filled the spandrels and a meandering pattern marked the intrados of each large arch. The contrast with the Gothic shrine at Orsanmichele could hardly have been greater. At the same time, Masaccio needed to use a good deal of imagination to "construct" his space. Nowhere in contemporary Florence would he have found a coffered barrel vault or a chapel with the precise form seen in his fresco. His painting, then, did more than replicate Brunelleschi's architecture: It gave vision to what no Renaissance architect had yet built. Life-size and monumental, Masaccio's *Trinity* was as important a piece of architecture as it was a painting.

All the while, elaborate, distinctly unclassical shrines and churches continued to attract the devotion and contributions of the pious. In Masaccio's day, Gothic was one of the chief civic styles, from the Cathedral to Orsanmichele to the preaching halls of the Dominicans and the Franciscans. The other was the more classical Romanesque, which was frequently confused with the Roman (Florentines claimed, for example, that the Baptistery was a reused Roman temple rather than the work of the late eleventh and first half of the twelfth centuries that it actually is). Only in the sixteenth century did writers like Vasari come to call Gothic churches barbarous and German.[22] In the fifteenth century, Gothic churches were still relatively new and in many cases not yet completed.[23] They were rarely replaced. Instead, simple Romanesque structures, small and groaning from age, were torn down to make way for structures in Brunelleschi's new style. Fortuitously, his columnar supports and arcades often resembled the supports of the structures he was replacing, so the balance of Gothic and Roman-inspired church structures in Florence remained relatively constant throughout the fifteenth century. For a long time, the two styles coexisted; they did not compete.

Sculpture

When it came to contemporary sculpture, Masaccio had much more to study. He was particularly impressed by Donatello, whose extraordinarily expressive faces, bodies, and drapery he emulated and whose relief sculpture he must have pondered deeply. During Masaccio's day, however, the city's elite did not consider Donatello to be Florence's leading sculptor. The honor belonged instead to Lorenzo Ghiberti (c. 1378–1455), as evidenced by the scope of his commissions, the expensive materials he lavishly employed, and the high social status of the patrons for whom he

worked. Ghiberti was probably eight years Donatello's senior, and Donatello spent several years as an assistant in Ghiberti's shop.[24]

While Donatello was a great innovator, he did not always please.[25] One of his compositions, a tabernacle door for the Siena Baptismal Font, for example, was rejected. Vasari also tells a story of how Donatello's patrons were displeased with his statue of *Saint Mark* for Orsanmichele and asked him to revise it. Donatello reportedly put the statue in its niche and made some chiseling noises but never actually touched the work. (The change in setting, which he had taken into account, made all the difference.[26]) Perhaps because Donatello often knew better than his patrons, he did not find it easy dealing with them.

Ghiberti also had problems with his clients. Still, who but the smooth-talking, politically savvy Lorenzo Ghiberti could have been chastised by his patrons for slow progress on his first set of bronze doors and have turned the dispute to his advantage, negotiating for himself a higher salary? Who but Ghiberti could have taken twenty-one years to complete a set of bronze doors and then have been rewarded with another set that occupied him even longer (twenty-seven years)? Who but Ghiberti could have lost the competition for the design of the Cathedral dome to Brunelleschi, only to be appointed jointly to supervise the task with the great architect? In Masaccio's day, Ghiberti was the darling of the commissioning classes. Even Cosimo de' Medici, who later became Donatello's protector and patron, worked directly with Ghiberti as the Bankers Guild's principal representative for the commission of a statue of *Saint Matthew* at Orsanmichele. Clearly, in order to understand sculpture in the early fifteenth century – and Masaccio's actual relationship to it – we need to examine much more than just the work of his friend Donatello. Whether or not one liked Ghiberti, he and his sculptural commissions could hardly be ignored. Neither could the accomplishments of earlier sculptors, especially Arnolfo di Cambio (c. 1245–1302), carver of the first sculpture on the Cathedral as well as its architect.

Intriguingly, when Masaccio arrived in Florence in the 1420s, Donatello and Ghiberti were beginning to find common ground. In the teens, their work had claimed very different ground: Donatello, the revival of such important classical formulae as contrapposto to show the human body naturally at rest; Ghiberti, the exploitation of the highly stylized poses and postures of the International Gothic Style to make his figures supremely beautiful and elegant. Now, without abandoning their own individual styles, the work of the sculptors began to intersect. To be sure, many of Donatello's works were as tension-filled, emotional, and naturalistic as ever, but in others, his manner became more elegant and serene, especially as he worked in the alluring and prestigious medium of bronze. For his part, Ghiberti never abandoned a commitment to polish and grace, but he occasionally allowed stronger emotion to erupt in his

more serene compositions, and he took account of classical architectural forms and ancient writings on human proportions to give gravity and weight to his narratives and figures. It was precisely at this moment that the brusque, "Donatellesque" Masaccio was collaborating in the Brancacci Chapel with the tender Masolino, who seems to have studied with Ghiberti. Neither artists nor patrons must have found the two manners as distinct or as incompatible as art historians have sometimes made them out to be.

Sculptural Contexts

There were two major locations where Masaccio could have admired and studied sculpture in Florence besides churches, which contained the usual crucifixes and other devotional works: the Cathedral complex (which included the church itself, the adjacent bell tower, and the Baptistery) and the shrine of Orsanmichele. Both were civic sites as much as religious ones. The prestigious Wool Producers and Wool Finishers Guilds (Arte della Lana and Arte della Calimala) subsidized and oversaw work at the Cathedral and Baptistery, respectively. All of the major and intermediate guilds, as well as two minor ones, owned niches on the exterior piers at Orsanmichele, which they were required by law to fill with statues of their patron saints.

The sculptural program of the Cathedral facade was begun in 1296 by the building's architect, Arnolfo di Cambio, who was also a renowned sculptor. Only sections around and over the portals were completed in his lifetime, and his original program was never fully realized. Still, as with medieval architecture, Arnolfo's work had much to teach and interest Masaccio and his contemporaries. Over one portal reclined an impressive Madonna of the Nativity. The crisp, pleated folds of her garments clearly recalled ancient Roman drapery. Leaning believably on her crossed arms, she bent her head to the right and looked down tenderly at the viewer below, bridging the gap between human and divine. She reappeared in an even more impressive stance over the central portal, enthroned and yet tenderly presenting the Christ Child to the crowds below (Plate 26). The insistent plasticity of her figure – note in particular the richly shadowed space under her outstretched right arm – the noble carriage of her head, and the light touch of her fingers on the Christ Child's shoulder anticipate the imposing but approachable mood of many of Masaccio's Madonnas (see Plate 14).

Four deep niches surrounded the central portal below the Madonna. They remained empty until 1415, when new figures of the four evangelists were finally set in place. (The rest of the facade stood unfinished until it was completely replaced in the late nineteenth century.) The most impres-

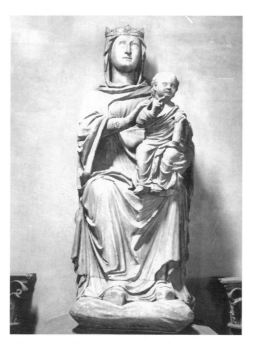

Plate 26. Arnolfo di Cambio, *Madonna and Child,* by 1302, Florence, Museo dell'Opera del Duomo. (Photo: Alinari/Art Resource, New York)

sive and innovative of the early fifteenth-century figures was Donatello's *Saint John the Evangelist.*[27] Although seated, Donatello's figure is hardly at rest. Instead, the saint turns his furrowed brow upward to seek divine inspiration. Psychic energy seems to shoot in rapid currents down his beard and into the broad, bouncing waves of his ample drapery. His exaggeratedly large hands pulsate with the promise of imminent action, fully capable of recording visions in the book he only temporarily balances on his thigh. Seen from below and slightly above eye level on the facade, the entire figure composes into a tight, massive pyramid that would likely have impressed Masaccio as he painted his Madonnas and, most especially, the enthroned Saint Peter seen from below in the *Raising of the Son of Theophilus* in the Brancacci Chapel (see Plate 9). Intriguingly, Donatello achieved the effect by greatly elongating the torso of his figure – a technique he may well have learned from studying Arnolfo di Cambio's equally attenuated statue of Pope Boniface VIII, also on the facade. By anticipating the viewer's point of view, both sculptors were able to make optical corrections that enhanced their figures' impact, effects often lost on modern viewers who confront these gawky figures head-on in the Cathedral museum.

Moving away for a moment from the Cathedral and staring up at another of Donatello's works, a wooden crucifix for the church of Santa Croce,[28] Masaccio may have been inspired to paint one of the most disturbingly accurate renditions of a figure seen from below: the crucified Christ for the pinnacle of his *Pisa Altarpiece.* Masaccio's Christ appears neckless, the artist having recorded with shocking accuracy what occurs when a work like Donatello's is seen at a sharp angle (as if one were kneeling or genuflecting) and close at hand – the exact position occupied by the flailing Magdalen at the foot of the cross in his painting. Masaccio also recalls the taut legs, sagging abdomen, and heaving chest of Donatello's Christ. The painter must have been impressed as well by the sculpture's bold musculature, especially the tendons above the shoulder sockets, which in Donatello's work were hinged so that that figure could be removed from the cross on Good Friday and symbolically "buried" until Easter morning. Life-size and naturalistically polychromed, Donatello's

crucified Christ would have seemed very much alive and present to wor-
shipers in Masaccio's day.[29]

Ghiberti's First Set of Bronze Doors

Masaccio's contemporaries were also extremely impressed with the natu-
ralistic detail they could admire in the bronze reliefs that Ghiberti com-
pleted and installed on the eastern portal of the Florentine Baptistery in
1424, but that were visible in the sculptor's workshop before then (they
were moved to the north portal when Ghiberti completed his second doors
in 1452).[30] Here was a splendid compendium of illusionism and succinct
but vivid forms that would appeal as well to a painter, as suggested by the
Adoration of the Magi, placed directly at eye level. Ghiberti invites the
viewer to follow the ascending forms of the kneeling Magus up to the pre-
cious foot of the baby Jesus, which the Magus holds tenderly in his hands.
Our eyes, following his, look up further to the wriggling child, held in
check by Mary's firm hand and Joseph's watchful gaze. The gilt surface
softly catches the light, suggesting malleable space. Joseph, partly sub-
merged in the presumed shadows of a miniature pavilion, pushes his head
forward while his arm emerges around a pier. At the left, two other Magi
are poised to swing round and present their gifts. They barely contain the
swell of excited onlookers who twist and turn behind them: two intent on
catching a glimpse of the prostrate Magus, three others with their eyes set
on the Holy Family, and another two (one of them a finely rendered
African) occupied with a pet monkey. Ghiberti observed the world closely
and caught his actors at a precise moment in time. While the silky, sway-
ing drapery might have struck Masaccio as a bit precious, the figures'
interactions and the finely modulated space they occupied might well have
impressed him.

Donatello's Relief Sculpture at Orsanmichele

Meanwhile, Donatello had invented yet another, even more illusionistic
type of relief in his *Saint George and the Dragon* (c. 1417) for the frame of
the Armorers Guild's niche at Orsanmichele.[31] Whereas almost all the spa-
tial effects in Ghiberti's reliefs (save some bodiless heads and the figure of
Joseph emerging from the background in the *Adoration of the Magi*) had
depended on the artist composing with actual three-dimensional figurines
on the surface of the relief, Donatello modeled his forms *into* the relief.
The workshop term for this new kind of modeling was *rilievo schiacciato*
(squashed relief).[32] It was well named, because as the artist sought to sug-
gest forms in the distance, he progressively flattened them. He experi-

mented very hesitantly with scientific perspective on the far right, foreshortening the arches on a little pavilion and indicating floor tiles by means of squared diagonal lines, but the primary illusion of depth and atmosphere derives from the bumpy, sketchy surface of the rest of the relief. As though modeling in wax instead of hard marble, Donatello pushed the surface back and forth, creating pockets of light and shade. In the background, beyond the arcaded pavilion, he seems to draw rather than carve the effects of a harsh wind blowing through gnarled trees. Similarly, the neck and head of Saint George's steed barely rise from the surface of the relief and thus seem further back in space than the highly modeled forms of the horse's hindquarters and belly. Masaccio made his own painted version of the composition in his famous *Tribute Money* (see Plate 8), once again placing a small structure on the right and leading the eye back to misty hills fronted by trees. He did not choose to replicate the high-pitched drama of Donatello's scene, but he must have thought differently about space and how to render it by examining Donatello's work.

Figural Sculpture at Orsanmichele

Orsanmichele was also the site of some of the most epoch-making developments in early Renaissance figural sculpture. Once again, Donatello and Ghiberti were the prime actors, joined in this case by a tragically short-lived sculptor of equally rare genius, Nanni di Banco (c. 1384–1421).[33]

As the story is usually told, Orsanmichele was the battleground where a new, classically inspired, naturalistic sculptural style won the day over an outdated, effete, Gothic manner that had outlived its usefulness. Ghiberti's works were impressive, it is usually claimed, but only Donatello's and Nanni's truly belong to the Renaissance.[34] What is more, the new, heroic style that Donatello and Nanni created is alleged to have been a direct expression of Florentine "civic humanism," a philosophy of committed, active citizenship that was inspired by ancient Rome.[35] Indeed, Nanni's *Four Crowned Saints* (c. 1411–13?) for his own Stonemasons and Woodcarvers Guild depicts four early Christian martyrs dressed in togas whose heads are directly inspired by Roman portraiture.[36] Each responds differently to his fate, but together, joined by their glances, gestures, and the cloth of honor that wraps around the walls of the niche behind them, they confront their oppressors and eventually triumph over them. The new classical style of works like these would seem to embody Florentine corporate freedom in the face of serious threats from abroad.[37] Thus, Florentine public sculpture would have changed style in direct response to immediate and well-defined shifts in civic values and concerns.[38]

However, things are not quite as simple as they seem. First of all, historians have now shown that during Masaccio's lifetime, Florence was hardly the

broad-based, guild republic it once had been. Instead, a very narrow elite of men associated with five of the major guilds effectively ran the government and set its policies.[39] While their rule was dependent on popular consensus, they made it quite clear that there were guilds of varying power: That is, the major guilds had the political and financial clout to make things happen; intermediate and minor guilds were usually restricted to keeping things *from* happening. This matters particularly to students of art because the stylistic innovators Donatello and Nanni di Banco did not work for the major guilds; Ghiberti did. Save for one notable exception, Donatello's and Nanni's clients were the intermediate and minor guilds. The new style, then, first appeared in situations where one would not expect to find the official voicing of public policy and values. To be sure, these guilds and their artists may well have "bought into" the civic ideals being promoted by their more elite leaders, but at the very least, these new expressions must have struck many people as quite a surprise.

This situation is made clear by comparing two famous commissions at Orsanmichele, one being *Saint Mark* by Donatello for the intermediate guild of the Linen Weavers (c. 1411–13: Plate 27) and the other *Saint John the Baptist* by Ghiberti for the Wool Finishers Guild (c. 1412/13–17: Plate 28).[40] In common art-historical practice, Ghiberti's work is often presented before Donatello's because of its overt Gothic stylizations.[41] Indeed, though this is a representation of a hoary prophet who lived in the wilderness subsisting on locusts and honey, John the Baptist's hair is stylishly coiffed, his hairshirt (a purposefully scratchy and therefore uncomfortable, penitential garment) is tied in a sumptuous bow, and his outer garments extravagantly curve and curl over his body, eddying down to his toes. How different is *Saint Mark*, whom Donatello dressed in a Roman toga and cloak that lie believably and revealingly across his body. His head is more proportionately sized, and its slight turn, along with his deep-set eyes, suggests that he is

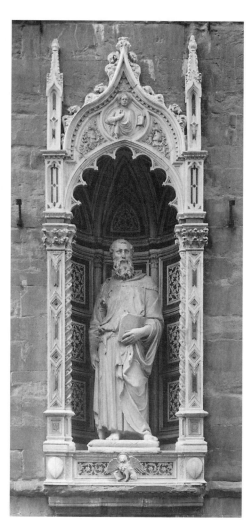

Plate 27. Donatello, *Saint Mark*, c. 1411–13, Florence, Museo di Orsanmichele. (Photo: Antonio Quattrone)

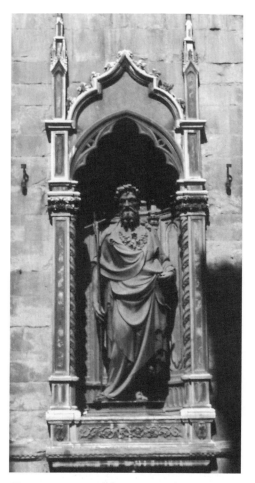

Plate 28. Lorenzo Ghiberti, *Saint John the Baptist,* c. 1412/13–17, Florence, Museo di Orsanmichele. (Photo: Diane Cole Ahl)

a cogitating individual. Indeed, he is set to walk straight out of the niche and into our space, a possibility made apparent by the way Donatello has placed his right leg to sustain most of his weight while bending his left to be free for movement. Here, for the first time since classical antiquity, we encounter true contrapposto, not the indeterminate sway of Ghiberti's *Saint John the Baptist.* Mark, not John the Baptist, would seem to be the more "progressive" work.

And yet we may misread the situation if we do not take into account the fact that Ghiberti's figure was created *after* Donatello's, not before; that it was cast in bronze (a very expensive and prestigious medium), not carved in the much cheaper marble of Donatello's statue; that it stands on the facade that faces the major thoroughfare between the Cathedral and the city square, not its less prestigious and dimly illuminated flank; and that it was commissioned by the wealthiest of the major guilds, not the Linen Weavers, who included among their members the city's ragpickers. If the ruling elite had anything to say artistically about their city's struggles for independence against Milan and Naples, it was to be seen in the almost haughty, cosmopolitan stylization of their patron saint, John the Baptist, not Donatello's figure or Nanni di Banco's *Four Crowned Saints.* Ghiberti and his patrons saw Donatello's *Saint Mark* in its niche as work began on their project, and at least for the moment, they decided to ignore it.

The story did not end there, however. In Ghiberti's next commission, his bronze *Saint Matthew* for the Bankers, another major guild (Plate 29), the artist and his patrons did take notice of the stylistic innovations of Donatello, Nanni, and Brunelleschi.[42] The figure is now more classically proportioned and rationally posed and stands in a Roman-inspired niche.[43] He points to himself and his writings with great confidence and classical self-awareness. Yet he is ever so much more elegant than Donatello's figure, his drapery once again sweeping around his figure and his arms set out to his sides. For the architectural setting, Ghiberti was no slave to antiquity. He crisply pointed

the shell motif and arch behind the saint and added leafy, Gothic crockets to the pediment. Compromise and adaptation, an elegant blend of past and present, are the hallmarks of this major work.

Donatello, too, turned away from rigorous classicism in a later commission for Orsanmichele. Significantly, the work was to be in bronze and was commissioned by the venerable Guelf Party, the only political party represented at Orsanmichele. In 1423, Donatello began creating a gilt bronze statue of their patron saint, Louis of Toulouse (Plate 30).[44] Once again a comparison may be useful, this time to another work by Donatello himself. In 1423, Donatello also was carving a statue in marble, his prophet known as the *Zuccone* ("Pumpkin head"), for the bell tower of Florence Cathedral.[45] Were the two works not well documented as by Donatello, art historians might be tempted to assign them to two masters rather than one, so different are they psychologically, physically, and materially. Still, their impressive drapery and the probing insights Donatello gives us into their sitters' characters are both reflected in Masaccio's figural work (see Plate 8: *Tribute Money*).

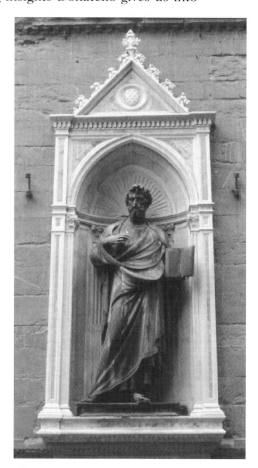

Tense, gawky, and gaunt, the *Zuccone* seems burdened by the weight of his voluminous drapery. Still, we sense his body beneath the fabric, strong and wiry in spite of the emaciation etched into his face. His pockmarked cheeks sag into a broad mouth that parts slightly, ready to issue a prophet's harangue. Summoning up superhuman resources, he seems to channel the divine pronouncements that flash before his deep-set eyes.

Saint Louis, on the other hand, is a model of youthful serenity and classical calm. Raising his elegantly gloved right arm in an incipient gesture of benediction and balancing his crozier between the index and middle fingers of his left hand, he seems every bit the courtly figure that the *Zuccone* is not. And well he should, for Louis was the son of the king of France and direct heir to the throne before he became a Franciscan and was later named Bishop of Toulouse.

One way of explaining the differences between these two figures would be to appeal to their obvious difference in subject manner: one a fiery prophet, the other

Plate 29. Lorenzo Ghiberti, *Saint Matthew,* c. 1419–21, Florence, Orsanmichele. (Photo: Sabine Eiche, Florence)

a royal, saintly youth. But medium and the intended setting for each work also played a role. Louis's expansive, hovering drapes are literally hollow, created separately from numerous plates that Donatello cast, gilt, and then soldered together. This is particularly clear in his disembodied, raised right hand, which is today missing the sleeve that would have joined his glove to his body. On the other hand, the body and drapery of the *Zuccone* are of necessity carved from a single, compact block of marble. Donatello seems to emphasize the very solidity of the material from which he is carving.

The two sculptures were also intended to be seen in very different settings: the *Zuccone* high on the Cathedral bell tower; *Saint Louis* just above eye level on the main street leading to the Piazza della Signoria. In the case of the *Zuccone*, Donatello was sensitive to how the figure would look from a distance, excessively exaggerating the prophet's features so that they would remain powerful when seen from far below. *Saint Louis*, instead, was to be seen not only close at hand and from only slightly below, but even more significantly, in the context of other idealized figures that occupied the principal niches of Orsanmichele.

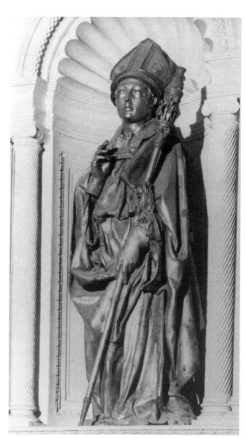

We have seen that the two earlier bronze figures at Orsanmichele had been created by Lorenzo Ghiberti. His *Saint Matthew* (1419–21) for the Bankers Guild was the more recent. In response, Donatello made his niche even more classicizing, the combination of Corinthian pilasters and smaller Ionic columns being the same used by Brunelleschi in the Barbadori Chapel (see Plate 25) and soon to be adopted by Masaccio for his *Trinity* (see Plate 13). The youthful and serene face of *Saint Louis* also shows Donatello's appreciation of classical, perhaps even Augustan, models of ideal beauty.

What may seem surprising, however, are the voluminous, figure-obscuring garments of *Saint Louis*. On one hand, they reflect the ample forms of a bishop's ceremonial garb. On the other, they are so large as to seem to have been designed for another, grander figure. The discrepancy can be explained in at least three distinct though not necessarily contradictory ways. One, Donatello may have made them so singularly extravagant in response to the nature of the commission, which, if it was like the contracts for

Plate 30. Donatello, *Saint Louis of Toulouse,* begun 1423, Florence, Museo dell'Opera di Santa Croce. (Photo: Antonio Quattrone)

prior sculpture at Orsanmichele, would
have stipulated that *Saint Louis* was to
exceed in size and splendor the other
works already there. Bigger was thought
to be better. In fact, Ghiberti's *Saint
Matthew* is larger than his earlier *Saint
John the Baptist*. Equally important, how-
ever, may have been Donatello's own
reading of the story of Saint Louis, a saint
who had church authority foisted on him
when all he wanted to do was seek a sim-
ple and pure life in God. His patrons
would have had their cake and eaten it,
too: While the statue of their patron saint
was distinguished by its size and gilding –
no other statue at Orsanmichele was
completely covered in gold – the saint
himself would still appear as the modest
and self-effacing individual he is known
to have been, burdened by his office but
rising above it.[46] Finally, the drapery
obscures the saint's anatomy under his
clothing and may have made him appear
desirably "medieval." Impassive and
somewhat iconic, the figure conformed
well to preestablished notions of saintly
decorum and may well have called to
mind the gilt and jewel-encrusted head
and arm reliquaries that were commonly
used for preserving and displaying the
relics of Christian saints. Indeed,
Donatello was at work on just such an
object, a reliquary for the head of Saint Rossore, around 1424.

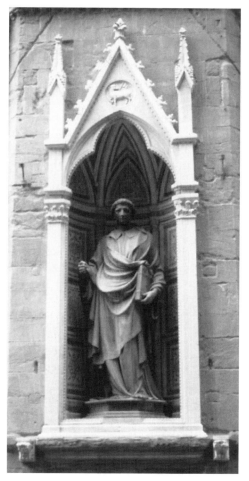

Plate 31. Lorenzo Ghiberti, *Saint Stephen*, begun
1425, Florence, Orsanmichele. (Photo: Sabine
Eiche, Florence)

A taste for – or at least the acceptance of and positive associations with
– the medieval may finally help us understand the stylistic peculiarities of
the last of the early fifteenth-century bronze sculptures at Orsanmichele:
Ghiberti's *Saint Stephen* for the Wool Producers Guild (Plate 31).[47] The
commission came to Ghiberti in 1425, just after he had completed his first
doors for the Baptistery and as Donatello was completing *Saint Louis*. The
sculpture was in place in 1428. The guild had set a marble sculpture of its
patron saint in its niche as early as 1340, but with other, more modern and
costly bronze works displayed at Orsanmichele, they decided to replace it.
According to deliberations from guild meetings, this was a matter of some
urgency insofar as the other works compromised "the splendor of this guild
which always has striven to be the mistress and head of all other guilds."

Thus the guild was consciously competing with others in the modernization of its niche with a new, gilt bronze statue by the same sculptor who had worked for the other major guilds. Guild records specifically note that the Wool Finishers' *Saint John the Baptist* and the Bankers' *Saint Matthew* niches "were much superior," and that the Wool Producers needed a work that would "exceed in beauty and ornament or at least equal in ornament the more beautiful ones."

Most modern criticism claims that Ghiberti fell short in meeting the guild's goals. "The statue . . . is ambiguous in quality," some say.[48] Others find it disturbingly medieval. Indeed, the figure is posed in a languid curve and wrapped in cascades of tightly wound fabric that completely disguise its underlying structure. Where the legs of *Saint Stephen* are actually located – let alone the precise position of his thighs and hips – is anyone's guess. This is a *very* different sculpture from Ghiberti's *Saint Matthew*. On the other hand, its elegant decorativeness distinctly recalls the International Gothic Style beauty of Ghiberti's earlier work, most notably the *Saint John the Baptist* he had completed around 1417 for the competing Wool Finishers Guild. It also, of course, shares common ground with Donatello's *Saint Louis*.

Since there is absolutely no evidence that the guild was displeased with Ghiberti's *Saint Stephen,* we must assume that it suited them well. In fact, Ghiberti probably intended the statue to be consciously archaicizing; that is, purposefully older-looking than it was. This is revealed by the fact that although its style is conservative, it is the first sculpture of the Renaissance to adopt the ideal sculptural proportions proposed by the ancient Roman writer Vitruvius and the fifteenth-century theorist Leon Battista Alberti.[49] In structure, then, it was very much in the avant-garde. At the same time, its conservative style would have recalled the statue of another major guild and would have referenced the statue the Wool Producers themselves were replacing: a Gothic work that had held pride of place as the first statue to have been placed on Orsanmichele by any guild. As with the voluminous, figure-obscuring drapery of Donatello's *Saint Louis,* its form signaled that the Gothic style had hardly outlived its popularity, let alone its usefulness – all this in the very year in which Masaccio died. Florence's civic style, if one can dare to try to define such a term, was not one style but many: Gothic *and* Renaissance, antique *and* medieval.

Florence at a Crossroads

Masaccio's city, then, was hardly what it is often claimed to be: a hotbed of nothing but radical innovation, outright rejection of the medieval past, and ineluctable progress toward the future. It was rather a city at a crossroads. Most signs seemed to indicate that the future would indeed lie with a renewed and reinvigorated encounter with classical antiquity.

Brunelleschi was engaged in projects that would mature into defining statements of the antique revival; Donatello raided a wide range of ancient prototypes for his sculpture (from warts-and-all Republican realism to serene Augustan classicism); and Ghiberti incorporated the proportions and recommendations of ancient writers into his works. At the same time, however, Brunelleschi adopted Gothic rib vaulting as one of the key elements in solving the engineering problem of the century (how to erect the dome of Florence Cathedral). Donatello and Ghiberti freely moved among stylistic possibilities, adjusting their works as the context demanded. People worshiped in Romanesque and Gothic churches and paid their taxes in a splendid, medieval fortress of a city hall. The new was added to the old; only rarely did it displace it.

Masaccio's Florence – that rich amalgam of numerous, overlapping eras and styles – has been cleaned up, regularized, and classicized, but fortunately, much of it is still there to be appreciated and experienced. Continuously inhabited and proudly preserved, it has necessarily changed since Masaccio's day, but many of its most powerful medieval and Renaissance works are still intact. They and the works known only from documents urge us to take time to think about the many different stylistic and expressive options that were open to artists in Masaccio's Florence. They make it clear, I believe, just how daring and unusual was his direct and honest portrayal of the events and emotions he saw around him, how precocious was his rendition of classical architecture, and yet how much he owed to those who had gone before him.

3 Painting in Masaccio's Florence

Ellen Callmann

Florence today is radically different from the city Masaccio discovered when he arrived there in the second decade of the fifteenth century. Painting, sculpture, and architecture expanded enormously during the course of that century, and much of what Masaccio knew has disappeared. Buildings have been extensively renovated or torn down and replaced; frescoes were overpainted in styles more attuned to later taste; altarpieces, too, were replaced or at times "renovated" and fitted into more modern frames. It has been estimated that the survival rate of early Renaissance paintings is in the range of 3 to 10 percent.

This chapter explores the artistic world of the young Masaccio – briefly, that of his childhood in San Giovanni Valdarno, but mainly the one he discovered once he went to Florence. The impact of other painters will be examined, including those long dead, first among them Giotto; those with whom he is known to have had direct contact, foremost Bicci di Lorenzo; and those most active and important at the time, such as Gentile da Fabriano and Fra Angelico. The artistic ambience of the Carmelites, who were his most important patrons, will be shown to have been crucial to him. Other equally or even more powerful influences are not addressed in this chapter, that is, the sway over him of sculpture, ancient, medieval, and contemporary; his contact with sculptors and their methodology, as in using models of drapery steeped in gesso; and the manner in which he applied and developed perspective, that essential scientific innovation of the age.

Origins and Early Training

As a child in his hometown of San Giovanni Valdarno, Masaccio had limited but formative opportunities to see works of art. As everywhere in Tus-

can towns and villages, there were paintings and sculptures in its churches and in those of the surrounding towns and villages as well as some murals and panels in public buildings. Ephemera, including processional banners, Easter candles, and shop and guild signs, abounded, and every home had one or more images for private devotion. Virtually nothing from Masaccio's childhood survives today, though there are somewhat later works by his younger brother, Giovanni di ser Giovanni (called lo Scheggia), and other minor fifteenth-century painters. There were probably also a few painters in the town who executed commissions too minor to order from Florence.

Trips to Florence were not easy. The distance of some forty-five kilometers over rough, hilly terrain took a full day on horseback, and so long a journey required at least an overnight stay in the city. It is nonetheless possible that his stepfather or grandfather took the boy along now and again when one of them had to go to Florence on business. Moreover, Masaccio may have learned something about pigments from his stepfather, who was an apothecary, since apothecaries were the purveyors of pigments.

His grandfather, Simone dei Cassai, was a maker of chests who was still alive in 1435 at age eighty-six. What he produced would not have been the luxurious, gilded wedding chests painted with complex narratives that were in vogue in Florence, but were ordinary domestic objects probably painted in solid colors or in the manner of the simpler fourteenth-century Tuscan chests. Some might have displayed a repeat pattern of a small heraldic device or an animal, or simple figural motifs in a dozen or so small compartments like those that alternately contain a couple at a fountain and an elegantly mounted gentleman or lady.[1] In Florence, woodworkers sent their chests to painters' workshops to be finished, but it is uncertain whether this was true of Simone or whether all work was done in his own shop where a small grandson could watch.

Apprenticeship

In the early Renaissance, boys began their apprenticeship at about twelve years of age, and give or take a year or so, this would have been true for Masaccio. Sons of artisans were often trained by their fathers, but how careers were chosen for those who did not follow in their fathers' footsteps has not been studied adequately. Masaccio may have had some preliminary training in San Giovanni Valdarno, as it was quite common for an artist to have been a pupil in more than one workshop. Essentially, however, it would have been in Florence that he received his training, and he probably arrived there by the beginning of the second decade of the fifteenth century.

Masaccio was probably in Florence by 1418. However, our first secure record of his residence in the city is not until January 7, 1422, when he was

admitted to the guild of the Medici e Speziali (the guild of artists, physicians, and apothecaries) and was living in the parish of San Niccolò sopr'Arno.[2] By that time, he had finished his apprenticeship, was a fullfledged master, and had therefore been in Florence some years.

Once Masaccio began his apprenticeship, he entered the world of the Florentine artist. In his master's shop, he was in touch with other pupils and assistants, as well as his master's various professional contacts: woodworkers, gilders, other painters, and the tradesmen who provided the various materials used by artists. During these years, Masaccio would have studied in depth the frescoes and altarpieces in Florentine churches. Apprentices had ample opportunity to see works of art outside their master's shop on the many feast days or when sent around town on errands. The churches were always open; there were tabernacles on many street corners; and often apprentices could visit the shops of sculptors, painters, woodworkers, and other artisans.

No contemporary document identifies Masaccio's teacher. Hence it has been suggested that Masaccio was trained and influenced by Mariotto di Cristofano, a deservedly obscure painter, for the simple reason that he was a native of San Giovanni Valdarno and a relative by marriage. Though Mariotto's family had moved to Florence when he was a child, he never lost touch with his native town: He owned property there, and he married Masaccio's stepsister. However, being only some five years older than Masaccio, Mariotto would not have finished his own training in time to have taken him on as a pupil.[3] Whatever Masaccio's beginnings, in my opinion, his chief teacher was Bicci di Lorenzo (1370/3–1452), a member of a family of artists with an exceptionally large, successful, and prolific workshop.

A superficial survey of Bicci's hieratic, flat, and formulaic paintings does not suggest an inspiring model for a young genius. But Bicci understood the needs of his clients, and through his consistent repetition of compositions and details established a formula guaranteeing that his clients would know in advance exactly what they were getting. Thus, the Virgin's throne with its spiral columns and sharply projecting base are virtually identical in many of his altarpieces, as in the Empoli *Madonna and Child* (dated 1423). This must have been reassuring to those of his clients who lacked creative imagination and did not have the ability to visualize what their painting would look like before it was executed. It was an exceptional patron, one deeply involved in the production of a work of art, who had this gift.[4]

In contrast to his finished works, Bicci's sinopie (underdrawings for frescoes) are outstanding in their energy and verve. The sinopie for frescoes on the Porta San Giorgio, on the Ponte a Greve, and for the *Madonnone*, as well as the fresco of *Pope Martin V Receiving the Florentine Notables before the Church of Sant'Egidio* (Plates 32 and 33) are examples.[5] This

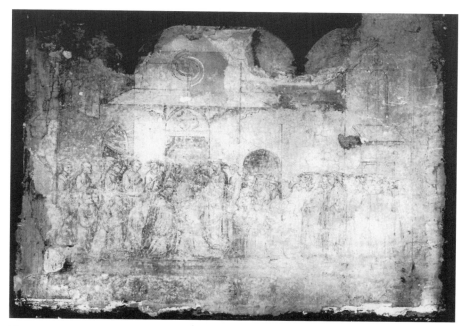

Plate 32. Bicci di Lorenzo, *Pope Martin V Receiving the Florentine Notables before the Church of Sant'Egidio*, sinopia, after 1424, Florence, Soprintendenza alle Gallerie. (Photo: Ministero dei Beni e le Attività Culturali, Firenze, Pistoia, e Prato)

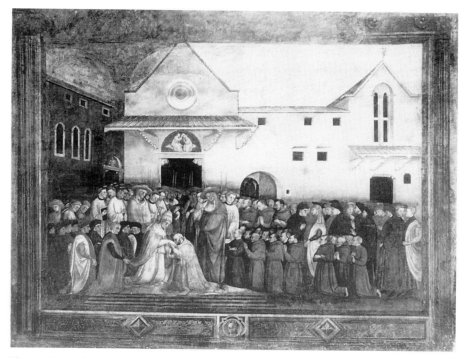

Plate 33. Bicci di Lorenzo, *Pope Martin V Receiving the Florentine Notables before the Church of Sant'Egidio*, after 1424, Florence, Spedale di Santa Maria Nuova. (Photo: Ministero dei Beni e le Attività Culturali, Firenze, Pistoia, e Prato)

discrepancy is the result of two conditions. First, spontaneity was not admired then as it is today and was expressly avoided in the finished state, as a comparison between detached frescoes and their sinopie reveals over and over again.[6] Second, such rigidity is also due to the manner in which a large, almost factory-like workshop operated. In it, much of the execution was inevitably left to assistants, a process that lent itself to mechanical repetition.

Sometimes, too, a patron whose other concerns overshadowed questions of artistic merit demanded changes. Thus, in the *Sant'Egidio* underdrawing, the subtle groupings of figures in the open space before the church lead the eye to the entrances of the church and the hospital of Santa Maria Nuova to which it was attached and hint at unexplored depths. A comparison with the fresco itself shows that this balance was destroyed by the addition of many more portraits, all of which depicted personages who had been present at or connected with the event. Presumably this was done at the behest of the patrons.[7] Such interference – or cooperation, depending on one's point of view – was probably quite common, though rarely put in writing. Many decades later, however, the same process was stipulated in the contract for Domenico Ghirlandaio's frescoes in the choir of Santa Maria Novella (completed 1490). There, the patron, Giovanni Tornabuoni, not only insisted that he approve each composition before it was executed, but he also required extensive additions of family portraits, again to the detriment of the compositions.[8] How frequent such demands by a patron were is not clear.

Bicci's underdrawings and preparatory drawing show that when his interest was engaged, he had considerable sensitivity and ability, and had much to teach a receptive pupil.

Naturally, Bicci's influence is strongest in Masaccio's earliest known work, the *Cascia di Reggello Altarpiece* (see Plate 1) for the church of San Pietro (then San Giovenale) in Cascia di Reggello,[9] which has much in common with Bicci's Empoli *Madonna and Child,* painted the next year. This is best seen in the architectural structure of the Madonna's heavy, stone throne – with spiral columns in Bicci's case, Cosmati-like mosaic inlay in Masaccio's – as well as in the proportions of the figures, the drapery of Bicci's Madonna and Masaccio's kneeling angels, and the solidly constructed Infants. Even here, Masaccio has progressed independently toward stronger, more volumetric forms. Unfortunately, we do not know what either of them painted during the previous few years. There is nothing earlier by Masaccio and no dated work by Bicci between the triptych of 1414 in the parish church of Stia in the Casentino and the Empoli panel of 1423.[10] However, it is unlikely that the influence went the other way, as by then Bicci was about fifty years of age.

Two other paintings, one by Bicci, the other by Masaccio, have much in common. In the so-called *Sagra* (Consecration), the lost fresco depict-

ing the consecration of Santa Maria del Carmine on April 19, 1422, Masaccio addressed the same artistic challenges and the same subject matter as did Bicci in the *Sant'Egidio* fresco.[11] As with the latter, Masaccio's fresco was in partial monochrome and over an outside door, this one leading from the cloister of the Carmine into the church. Both displayed a new fashion in Florentine painting: the recording of a contemporary, or at least very recent, event. Concomitantly, they initiate a growing interest in portraying leading Florentines who participated in the event, those still alive as well as their deceased predecessors. In both, portraits abounded.

Portraits

Masaccio was famous for his portraits,[12] as may be seen in the donors in the fresco of the Santa Maria Novella *Trinity* and in several figures in the Brancacci Chapel.[13] However, the large gaps in our knowledge of the early history of Italian portraiture make it difficult to determine to what models Masaccio might have turned. In most early Renaissance works, it is virtually impossible to tell a portrait from an individualized but imagined personage.

The outstanding exception is the long and rich tradition of portraits of Dante Alighieri (1265–1321), which can be followed from the time immediately after his death through the fifteenth century.[14] As in later representations of San Bernardino of Siena (1380–1444), Dante's physiognomy was recorded by men who had known him. As most of these representations are author portraits placed at the beginning of manuscripts of his works, there is no doubt as to his identity. This custom provided a series of images over a long period of time, images so lifelike that they are readily recognizable. Though less numerous, portraits of Boccaccio and Petrarch, too, became established.[15] Eventually the three great fourteenth-century poets also found their way into panel paintings and frescoes, where they often appeared together.[16]

The portrait of Dante in the chapel of the Bargello, Florence – now the Museo Nazionale, but in Masaccio's day, a prison – was among the works accessible to Masaccio.[17] Once attributed to Giotto, it is now thought to be by a follower, but it evidently was based on a portrait by Giotto, who surely knew Dante personally, since they were in Padua at the same time.

In the *Last Judgment*, Strozzi Chapel, Santa Maria Novella, from the 1350s, Nardo di Cione depicted Dante in a group of portraits among the Elect in which the other personages are not so readily identifiable. Other frescoes with groups of portraits are known, and some of the individuals in them have been identified tentatively. Still other portraits of notables that were not strongly individualized or familiar from other sources undoubtedly have eluded us.

These earlier groups differ from Bicci's and Masaccio's consecration

frescoes in that the portraits were subsidiary to the religious subject, whereas the sole purpose of the latter was the recording of a contemporary event of significance to both the church and the civic body of the city as a whole, and most of all, to the individuals involved.

Masaccio and Portraiture

The festive consecration of Santa Maria del Carmine occurred on April 19, 1422, but it is generally thought that Masaccio did not paint this event until 1424.[18] There is no copy of the fresco, and all that is known of it comes from Vasari's description and eight later drawings made after it, one with a single figure and the rest with small groups of the men who attended that day.[19]

The church of Sant'Egidio, too, had its consecration in 1422, and Bicci's fresco may have been painted soon thereafter, possibly at the same time or before Masaccio's, though it has also been dated much later, even in the 1430s. The relation of the two to each other is problematic, since a definitive judgment would have to depend on a secure date for both. Joannides, like some others, was convinced that Bicci was incapable of such invention.[20] However, I believe that it was within his scope because of the high quality of his underdrawings. No apparent reason for the delay has come to light. Over and over again as new and more precise evidence is discovered, it has been shown that in actual fact, more talented artists did not hesitate to use the inventions of earlier and less sophisticated practitioners. Historians are too often swayed by the inordinate value we today place on originality, a characteristic not highly prized in the early Renaissance.

Masaccio did not initiate the fashion of including contemporary personages in religious narrative. Yet through his fine portraits and his ability to integrate contemporary personages smoothly into the larger composition, he furthered a new trend that became important later in the century. His portraits of Carmelites in the *Raising of the Son of Theophilus* (see Plate 9) in the Brancacci Chapel provided a model for later generations. These figures also reflected those in the lost *Sagra* in their static solemnity, dramatic tension, and varied poses.

As for the vogue for depicting local events, the original impetus could not have come from a painter. The temptation is to think, of course, that an artist was inevitably the sole inventor responsible for a uniquely new work, but the position of painters, like that of other artisans, was such that a new subject had to have been introduced by the patron. In the case of a church's consecration, it would have been thought out by the church's authorities, possibly in conjunction with the leading citizens who were responsible for chapels in it. It is they who would have presented the painter with this new challenge, and it would have been he who then

worked out the specifics in his composition. The artist's contribution was that he achieved a much more dynamic composition than the rigid rows of the Elect in Last Judgments.

Hometown and Neighborhood Relations

In their daily lives and working arrangements, artists moved within close-knit groups of co-workers, often relatives or family connections through marriage and country neighbors, and they tended to work in small neighborhoods.[21] Thus, Bicci lived and worked in the parish of San Frediano and had close ties to the church of Santa Maria del Carmine, not far from his home base.

The complex artistic interactions between Masaccio and Masolino are discussed in Chapters 4, 5, 6, and 7 of this volume. Masolino's origins in Panicale, not far from San Giovanni Valdarno, fall within the context of the intricate webs formed by geographic proximity, neighborhood, and family relations.[22] Their relationship is in keeping with the close ties to their native countryside that regularly were maintained by Tuscans who moved to the city. In 1422, Masaccio was living near the church of San Niccolò sopr'Arno, and Masolino rented a house in the adjacent parish of Santa Felicita.[23] Rounding out these interconnections, the painter Francesco d'Antonio, who was associated with Masolino between 1422 and 1424, was also from the Valdarno.[24]

Masaccio and the Carmine

The role of the Carmelites in Masaccio's life was crucial. His two major commissions were for them: the fresco cycle in the Brancacci Chapel in Santa Maria del Carmine in Florence, and the altarpiece for the chapel of the degli Scarsi family in the Carmelite church in Pisa. Contacts with the Carmine in Florence during his formative years must have been of the greatest importance to his artistic development. These would have been made through Bicci di Lorenzo.

Bicci's long and close ties to the church of Santa Maria del Carmine are well documented. He executed extensive frescoes on the walls of the nave as well as the frescoes and the altarpiece for the Chapel of the Epiphany on the right wall not far from the entrance. None of them survived the devastating fire of 1771 and subsequent rebuilding.[25]

The fresco cycle of the life of Saint Cecilia that can still be seen in the sacristy of the Carmine is variously attributed to Bicci himself or a follower. This cycle is part of the late Trecento campaigns in the church, executed before Masaccio was born and came to Florence. Though Bicci's

relation with the Carmine spanned many decades, nothing he is known to have painted there is dated. Hence there is no telling whether he was actually painting any of them during the years that Masaccio would have been his pupil or assistant.

Bicci maintained his residence and his workshop in San Frediano,[26] near the Carmine, and his contacts with the church were not limited to professional commissions. For a great many years, he was a member of the confraternity of Sant'Agnese, and in 1448 and 1454, he was one of its officers. Every year, this confraternity staged an important drama that depicted the Ascension of Christ in the church, and its members had their own chapel, meeting room, and storage spaces for their bulky theatrical equipment there.[27] Later, Bicci's son, the artist Neri di Bicci, also played an important role in the confraternity.[28] Furthermore, Bicci is known to have been buried in the church, where the family had a tomb.[29] This suggests that his father, the painter Lorenzo di Bicci (1350?–1427), may also have been buried there,[30] and that three generations of the family were active in the congregation, another outstanding example of the close ties of artists to their communities.

Other important painters worked in the Carmine as well. Construction of the church having been completed around the middle of the Trecento, extensive decoration was undertaken during the last third of the century. It consisted of major campaigns with large fresco cycles and important altarpieces for many of its numerous chapels and for the walls of its nave. Nearly all of these prodigious endeavors were destroyed by the great fire of 1771 or during later redecoration of the nave. In his day, on the other hand, Masaccio could have seen the works of many of the leading painters of the late fourteenth century in the church. Contemporary and early descriptions are few and terse, being limited to the subjects of some of the cycles and the names of the painters to whom they were ascribed. Agnolo Gaddi (active by 1369, d. 1396) painted a now-lost cycle of the life of the Virgin in the choir.[31] Spinello Aretino (b. c. 1350, doc. 1373, d. 1410/11) worked there for many years, decorating at least three chapels: the ones of Saint John the Baptist[32] and the Virgin of the Assumption,[33] which flanked the choir, and the chapel of San Jacopo,[34] adjacent to the latter.

The Later Followers of Giotto

With their new interest in solid forms, deeper space, and more interactive figures, Agnolo Gaddi, Spinello Aretino, and Antonio Veneziano (doc. 1369/70–1413) are credited with being the leading exponents of the so-called Giotto revival that is said to have occurred at the end of the Trecento. Giotto, however, was too powerful a force ever to have been forgot-

ten, and each subsequent generation took from him whatever was most relevant to it, not all choosing the same elements, some being more interested in one aspect, some in another. In the course of the fourteenth century, this can be seen successively in the works of Maso di Banco, Bernardo Daddi, Taddeo Gaddi, Orcagna, and a host of minor painters. Hence, it cannot be taken for granted that in turning back to Giotto, this generation consciously rejected its immediate predecessors.

Agnolo Gaddi was steeped in the tradition of Giotto because he was the son of Taddeo Gaddi (b. c. 1300, d. 1366), who had himself been a pupil of the master.[35] This heritage is particularly evident in one of Agnolo's most important surviving works, the fresco cycle of the story of the True Cross in the choir of Santa Croce, Florence, painted between 1385 and 1390 (Plate 34). Agnolo was the head of a very large workshop that produced numerous fresco cycles, altarpieces, and even designs for stained glass, as well as the lost frescoes in the choir of Santa Maria del Carmine. Inevitably, however, a good part of the execution of many of his most ambitious enterprises was left to assistants, particularly in the fresco cycle of the life of Saint Anthony Abbot in the Castellani Chapel, Santa Croce.

Agnolo Gaddi can be distinguished from other artists of the last third of the Trecento in two respects. He was inordinately fond of genre detail and he was an innovator in landscape painting, contributing to the devel-

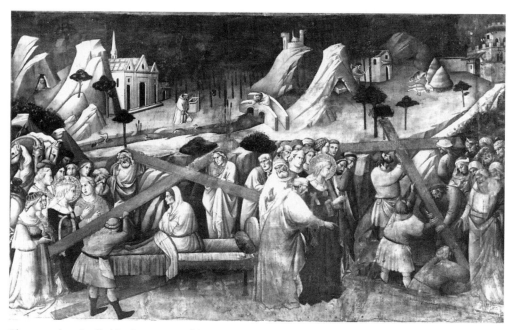

Plate 34. Agnolo Gaddi, *Discovery and Testing of the True Cross*, c. 1385–90, Florence, Santa Croce, Choir. (Photo: Alinari/Art Resource, New York)

Plate 35. Spinello Aretino, *Two Heads* (fragment from the *Burial of Saint John the Baptist,* Florence, Santa Maria del Carmine, Chapel of Saint John the Baptist), after 1387, London, National Gallery. (Photo: © National Gallery, London)

opment of the new spatiality and realism. It is this latter aspect that must have been of particular interest to Masaccio. Agnolo's preoccupation with the problems of space and depth, however, was limited to the landscape and did not extend to the figures, either in their three-dimensionality or in their grouping within the narrow foreground, both remaining comparatively flat.

As a follower and perhaps pupil of Orcagna, Spinello Aretino also worked in the tradition of the late followers of Giotto. Yet his approach to narrative was quite different from that of Agnolo Gaddi. As may be seen in the cycle of the life of Saint Benedict in the sacristy of San Miniato al Monte, Florence, and in that of the life of Saint Ephesius in the Camposanto, Pisa (the latter painted 1391–2), there is an overpowering sense of action. His scenes are crowded with people and buildings, and they have little or no natural landscape, depth, or breathing space. What strikes the spectator most forcefully is the excitement and drama of the story. His figures are expressive in their movements, often urgent, even violent; his faces are powerful and filled with strong emotions (Plate 35). It is a concern with dramatic tension that Masaccio shared with Spinello, though Masaccio's is more contained and austere. Bicci di Lorenzo, who was a full generation younger than Spinello and Agnolo, followed in their footsteps.

The last artist in this group of "Giotto followers" who worked at the Carmine is Gherardo Starnina (first documented 1387, d. c. 1413), but as

he returned to Florence and came to the Carmine only in the early fif-
teenth century, he is discussed later.

The International Gothic Style

While Masaccio was still a small child, a revolutionary change occurred in
Florentine painting. It was the advent of the so-called International
Gothic Style, which was, in fact, a Franco-Flemish innovation that spread
over much of Europe and developed local variants; it reached Florence by
the very first years of the fifteenth century. Most likely, it was brought
there by means of small, readily transportable objects such as goldsmiths'
work, illustrated manuscripts, and possibly drawings. Florentine artists did
not travel abroad regularly as a part of their training or, as fully formed
painters, to work; among the few who did so were Masolino and Starnina.
In contrast, Florentine merchants and bankers traveled widely, often stay-
ing away for long periods of time. When they returned home, they brought
with them many small treasures and, having become accustomed to for-
eign luxury goods, frequently ordered more from abroad.[36]

The first hints of the new manner appeared in Florence in 1401 in
Lorenzo Ghiberti's bronze competition relief for the North Doors of the
Florence Baptistery. In the earliest of his panels for the door itself, those
generally thought to date between 1404 and 1407, he had fully absorbed
that manner.[37]

To Florentine painters, it was Ghiberti's handling of drapery that was
most important. Folds were deeply modeled, even undercut, giving weight,
depth, and volume to cloth. In painting, this translated into strong model-
ing and deep shadows. At the same time, the Gothic calligraphy and its
flowing rhythms became increasingly pronounced, producing independent
patterns that soon ruled the compositions.

In painting, the leading exponents of this style were the Camaldolite
monk Lorenzo Monaco (b. c. 1365–mid–1370s, d. c. 1425), and the anony-
mous Master of the Bambino Vispo (Master of the Lively Child). Whereas
Lorenzo's career is exceptionally well documented, the opposite is true of his
contemporary, the Master of the Bambino Vispo. He was a painter of great
elegance and grace in a manner close to that of Lorenzo Monaco, but more
intense in his rich and deeply saturated palette. An identification of him with
Gherardo Starnina, who is discussed here later, is not convincing to me.[38]

Lorenzo Monaco accepted the new manner wholeheartedly and gradu-
ally made it his own so that its impact on him can be followed in a series
of dated works revealing his progress in the new fashion step-by-step. All
his life, Lorenzo Monaco showed a marked penchant for a dominant line,
expressed in large flowing curves. Line rules supreme even in his earliest
works, the half-length figures within the illuminated initials of the choir-

books he painted in 1394, 1395, and 1396 for the Camaldolese monastery of Santa Maria degli Angeli (Florence, Biblioteca Laurenziana), in which the influence of Agnolo Gaddi is still pronounced.[39]

The first intimation of Lorenzo's contact with the new style from the north appears in 1404 in the extravagant drapery folds of the Madonna's mantle in the *Madonna of Humility with Four Saints* (Empoli, Museo della Collegiata). The figures, however, still display the sturdy forms traditional in Florence. His calligraphic manner is developed further in the *Monte Oliveto Altarpiece* (Florence, Accademia), for which payments are recorded in 1407 and 1411. Any sense of depth is studiously avoided, and the swaying figures are much more elongated. This trend reached fruition in his *Coronation of the Virgin* of 1414 (Florence, Galleria degli Uffizi), and Lorenzo continued to develop it further in his last works, the *Adoration of the Magi* (Florence, Galleria degli Uffizi) and the pinnacles of Fra Angelico's *Descent from the Cross* (Florence, Museo di San Marco), both of which were painted between 1420 and 1422, before his death in c. 1425.

Lorenzo, like the Master of the Bambino Vispo, was at the height of his power and fame during the years that Masaccio was learning his trade. His works could be seen in many places in Florence, and in them, Masaccio would have been able to trace the progression of this style and no doubt did so.

Masaccio's reaction to Lorenzo Monaco and the Master of the Bambino Vispo seems to have been a profound lack of interest, probably even an outright rejection. That Masaccio would have felt this way is not surprising in light of the austere and volumetric style he created for himself. This natural bent received support by the fact that the vast complex of frescoes and altarpieces in the Carmine by which he was surrounded during his student days was dominated by artists steeped in the Giottesque tradition. The supposition is, moreover, supported by his reaction, only a few years later, to the new trends introduced by Gentile da Fabriano.

He was not alone. Not all painters shared Lorenzo's interests, and those grounded firmly in the tradition of Giotto, handed down by Maso di Banco, Agnolo Gaddi, and others, retained and enlarged on that manner, among them, Bicci di Lorenzo and Gherardo Starnina.

Starnina

Starnina is first mentioned c. 1387 when he enrolled in the Compagnia di San Luca (the painters confraternity). He is thought to have been a pupil of Agnolo Gaddi and one of his assistants in the Castellani Chapel.[40] He left for Spain not long after 1387 and must have been there for some time by June 1395, when he was paid for a large altarpiece. The last mention of

Plate 36. Séroux d'Agincourt, Engraving after Gherardo Starnina, *Death and Funeral of Saint Jerome,* 1404, Florence, Santa Maria del Carmine, Chapel of Saint Jerome, from Jean-Baptiste Séroux d'Agincourt, *Histoire de l'art par les monuments, depuis sa décadence au IVe siècle jusqu'à sa renouvellement au XIV siècle,* 7 vols. (Paris: Treuttel et Würtz, 1823), 2: p. cxxi.

him in that country is in June 1401, when he was paid for work done in connection with a visit of King Martin to Valencia. This visit was canceled because of an outbreak of plague that may well have been the reason Starnina fled, returning to Florence.[41]

In Florence, he was soon engaged on the major early fifteenth-century project at the Carmine, the Chapel of Saint Jerome, for which he supplied the altarpiece and fresco cycle of the saint's life,[42] completed by 1404.[43] All that remains are a few fragments, mainly of standing saints in niches (now detached and in the Sala della Colonna off the cloister of the Carmine), but there are engravings of two scenes, the death of Saint Jerome and his funeral (Plate 36).[44] Masaccio could see these frescoes regularly, and they

could have made a considerable impression on him. Hence, it becomes important to resolve the question of whether Starnina was an exponent of the International Gothic Style or continued to develop the Giottesque manner.

There are two theories about Starnina. One holds that he was, in fact, the painter called the Master of the Bambino Vispo and that he brought the International Gothic Style to Florence from Spain.[45] This is an enticing idea, as it would provide a well-documented identity for an outstanding anonymous master. The other is that Starnina and the Master of the Bambino Vispo are two distinct personalities, and that Starnina remained faithful to the Giottesque tradition all his life. Both theories depend on how one reads the style of the Carmine fragments, his only securely documented work.

Those who believe that Starnina imported the International Gothic to Florence do so for two reasons: They consider his drapery in the Carmine to reflect it, and they see in his work a strong, even foreign, interest in genre, citing the niche with books and the lost scene, described by Vasari, of a schoolboy being caned by his teacher.[46] However, the niche with books, the only surviving fragment of the *Death of Saint Jerome,* is not extraordinary. As early as 1328–30, Taddeo Gaddi had included similar fictive niches, though with more Gothicizing architectural surrounds, in the dado of the Baroncelli Chapel, Santa Croce, Florence.[47] Starnina's books are surely no more than a modest allusion to Saint Jerome's learned writings. In my opinion, the drapery of the saints also is typical of many Florentine painters of the second half of the fourteenth century.

This interpretation is supported by an early, and in my opinion, completely convincing hypothesis that the altarpiece in the Chapel of San Eugenio in the Cathedral of Toledo is Starnina's major work in Spain.[48] It defines the development of his artistic personality in the crucial period between the early, problematic work in Santa Croce and the later frescoes in the Carmine.

The *Retable of San Eugenio* (Plate 37) was thoroughly repainted and reworked in the late fifteenth and early sixteenth centuries,[49] but the compositions of the individual panels, most of the figures, some faces, as well as many details, are late Trecento Florentine. Only important personages were repainted to such an extent that their original appearance is largely obscured. In some panels, the landscapes were altered materially. The architecture, however, was changed very little, and most of the minor figures have been touched up only slightly.

The marked similarities between the San Eugenio retable and the Carmine fragments are best seen in the minor, less repainted figures, and are most evident in the structure of the heads, the broad, short-nosed faces with high cheekbones, and the method of drawing beards and eye-

Plate 37. Gherardo Starnina, *Circumcision*, from *Retable of San Eugenio*, c. 1395–1400, Toledo, Cathedral. (Photo: Institut Amatller d'Art Hispànic)

brows. Thus, the old man behind Simeon in the *Circumcision* is a counterpart to *Saint Benedict* in the Carmine (Plate 38). The figures in both works have the same proportions and sense of volume. Both scenes have a powerful but strictly limited sense of space. In many of the San Eugenio panels, the architecture has the same combination of simplicity and strength of design and restraint as in the Carmine.

The retable is a relatively youthful work in which Starnina's personality begins to emerge. In the Carmine, it is fully developed. He was a monumental painter, capable of expressing forceful personalities and deeply concerned with the problems of three-dimensional construction and the geometric relationships of volumes. As such, he must have had a considerable impact on Masaccio.

Plate 38. Gherardo Starnina, *Saint Benedict,* 1404, Florence, Santa Maria del Carmine, Refectory. (Photo: Antonio Quattrone)

The Carmine "House Style"

With Starnina firmly anchored within the tradition of the painters who had dominated the Carmine in the Trecento, there is no evidence that the style espoused by the Master of the Bambino Vispo was represented in the church. The situation is too consistent to have been the chance result of individual choices made by the various families responsible for the many chapels.

The monastic authorities – the Carmelite prelates who selected the painters to decorate their church and probably advised the patrons of the individual chapels – had a large stable of artists, all working in a stylistically compatible manner and with a strong professional network in place. To a

large extent, these ecclesiastical officials formed the artistic taste of the conventual community over the course of nearly half a century, thus ensuring that their successors shared their taste. Furthermore, they probably guided the leading local families who were responsible for maintaining and embellishing many of the chapels when they came to choose painters. The idea that religious foundations could have had a unified point of view and chosen a consistent artistic style both in the works paid for by the Order itself and those paid for by the patrons of its chapels was already suggested by Bruce Cole in his work on the Dominicans of Santa Maria Novella.[50] To what extent this consistency was due to Carmelite taste or to a lack of interest in style combined with a strong hold on ecclesiastical officials by a self-perpetuating group of artists who rejected the new style is at present unanswerable.

Innovations of the Twenties

In the early 1420s, two important occurrences drastically changed Florentine painting. One was the recent invention of perspective, the importance of which Masaccio immediately grasped and with which he revolutionized painting. The other was the arrival of Gentile da Fabriano from northern Italy. Gentile (b. c. 1385) may have been in Florence by 1419 and was certainly there by August 1420, but he did not remain long, for by June 1425, he had rented a house in Siena. From there, he went on to Orvieto and Rome, where he died in 1427, a year before Masaccio's arrival.[51]

Gentile brought with him a profound knowledge of the latest innovations in painting north of the Alps, innovations that he had absorbed into his own manner. He evinced a heightened emphasis on rich colors and a new interest in many aspects of nature. By May 1422, all of Florence could see this in his *Adoration of the Magi* in the church of Santa Trinita (Florence, Galleria degli Uffizi). He completed the *Quaratesi Altarpiece* in 1425 for the church of San Niccolò sopr'Arno, the parish in which Masaccio was living at the time.[52] There were the carefully observed plants, most appealing among them the flowers along the piers of the frame of the *Adoration of the Magi* (Plate 39), and a large array of birds and animals, both domestic and exotic, including leopards and monkeys. Only his concerns with ornamental patterns, for example, in the robes of the Magi and the saints in which the woven textile design often displaced volume, were not new to Florentine painters.[53] Gentile's continuous landscape and his rendering of its atmospheric conditions provided a new way of binding all the parts of the scene together. His paintings in Florence – the two just mentioned and others that are now lost – must have caused a considerable stir and endless discussions among artists, of which Masaccio could not have been unaware and in which he surely participated.

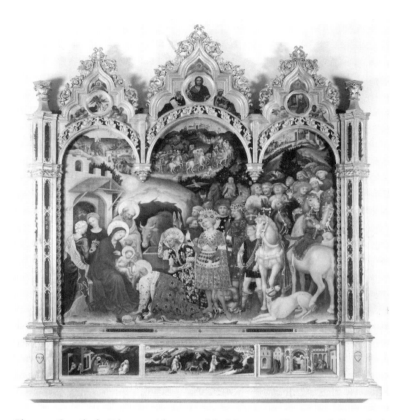

Plate 39. Gentile da Fabriano, *Adoration of the Magi,* 1423, Florence, Galleria degli Uffizi. (Photo: Antonio Quattrone)

Masaccio, however, seems to have been impervious to Gentile's charms and rejected what was most admired in him – the brilliant colors, the inordinate emphasis on luxurious fabrics, and the loving depiction of plants and animals – but he did not ignore Gentile completely. The aspect of Gentile's work that must have been of greatest interest to him was the expanded sense of space, the rendering of atmospheric conditions, and the use of light in his landscape. He may also have been impressed by Gentile's handling of volume and foreshortening, and his ability to place his figures within space, but if so, he rapidly advanced beyond this source and took Gentile's developments much further by means of independent studies of space, volume, and perspective.

Masaccio's limited interest in the depiction of many aspects of the world around him seems particularly noteworthy because Masolino, his partner, was one of the painters who did study Gentile and incorporated much of what he learned from him into his own style. The luminosity and intense colors of Masolino's panel paintings were perhaps not wholly new,

as they could also have come from the Master of the Bambino Vispo,[54] but they were surely reinforced by Gentile. He also felt the sway of Gentile's drapery – rich and voluminous but more naturalistic and volumetric in its fall and less calligraphic than Lorenzo Monaco's.

The most important painter among Masaccio's contemporaries was Fra Angelico (c. 1395/1400–55), a friar of the Dominican Order. Unfortunately, as is so often the case, nothing is known about Fra Angelico's artistic beginnings, and scholars attempting to identify his earliest works have offered widely divergent choices. Hence, no comparison can be made between Angelico's and Masaccio's work between 1417 and the early 1420s, the period during which they first must have known each other.

In his first secure works, three from the 1420s,[55] Fra Angelico showed that he was well acquainted with all the new ideas in Florentine painting. He was closest to, and perhaps deeply influenced by, both Gentile da Fabriano and Masolino, and showed his awareness of and concern with the invention of perspective, though he came to perspective later than Masaccio, used it less consistently, and often avoided it intentionally.

The earliest work in this sequence is the altarpiece he painted for his own Order. It is still in the church of San Domenico di Fiesole but was extensively "modernized" in 1501 by Lorenzo di Credi: It was enlarged, given a new landscape background, and reframed as a rectangular panel. The soft yet sculptural modeling of the faces with their luminosity shows a development that parallels Masolino's in his Bremen *Madonna of Humility* (1423) and Masaccio's *Cascia di Reggello Altarpiece* (1422). While there are some echoes of Lorenzo Monaco, the drapery is less extravagant, has an obvious sense of weight, and encases the figures solidly, not only in the ankle-length robes of the Dominicans that hang straight down, but also in the trailing mantle of the Madonna and robe of Saint Barnabas. The volumetric drapery of the Dominican saints shows a wholly new feeling of weight and density. Nonetheless, the figures do not stand with their feet firmly planted on the ground. In this respect, they are like Masolino's Adam and Eve in the Brancacci Chapel, and unlike Masaccio's.

The date of the *Annunciation* for San Domenico (Madrid, Museo del Prado) has been much disputed, as has the question of whether it is by Angelico's own hand or a shop work. In my opinion, it is an autograph work and was painted in the 1420s. Here again, the influence of Gentile is paramount as his decorative bent is taken up, a characteristic that was to become a major tool for Angelico in expressing otherworldliness. While Gentile's love of rich decoration and nature may have inspired the lush meadow and woods, Angelico chose to give such embellishments a different connotation. In place of Gentile's minute and detailed observation of real plants, Angelico turned to the highly stylized ones of French

millefleurs tapestries and created abstract patterns that suggest a celestial setting.

The *Saint Peter Martyr Triptych* (Florence, Museo di San Marco), painted for the Dominican convent of San Pietro Martire and probably completed by about 1429, may be Angelico's first datable work. The four standing saints of its main panel are quite similar to those in the *San Domenico Altarpiece,* but there is a gentle yet very real suggestion of depth of space so that it is a little later in date than the *San Domenico Altarpiece.* Depth is achieved by turning the lateral saints slightly sideways so that they look toward the Madonna, and by setting the two inner ones further back than the outer ones. It is in the small scenes of the life of Saint Peter Martyr in the spaces between the gables that the influence of Gentile's *Adoration* is strongest.

Florence was not a large city, and in his youth Angelico had belonged to the confraternity of San Niccolò di Bari, one of the confraternities housed in the Carmine.[56] It is hard to imagine that Masaccio and Angelico did not know each other at this stage in their lives. No matter how different their approach, as two of the most talented painters of the time, they must have respected each other and been interested in each other's work.

The Spread of New Ideas

No matter what revolutionary changes in style and taste Florentine painting experienced, many older artists continued in the manner in which they had been trained originally and no doubt found plenty of patrons who, like themselves, did not care to adjust to new ways. An interesting exception is Giovanni di Marco (1385–1437/8), better known as Giovanni dal Ponte because of his longtime residence on the Piazza Santo Stefano al Ponte. He was nearly a generation older than Masaccio and became a member of the Medici e Speziali about 1410 and of the Compagnia di San Luca in 1413, so that he was an independent master while Masaccio was still a boy.

Many altarpieces, images for private devotion, and *cassoni* have been attributed to Giovanni dal Ponte, but all of his securely dated works are from the last years of his life.[57] However, he was probably trained in the circle of Lorenzo di Niccolò and Niccolò di Pietro Gerini, and his *Coronation of the Virgin* (Chantilly, Musée Condé) was executed comparatively early in his career, as it shows the influence of the *Coronation of the Virgin* (Florence, Accademia) painted in 1401 by his teachers together with Spinello Aretino.[58]

Giovanni dal Ponte appears to have been firmly grounded in this milieu and did not lose touch with it, as is indicated by the fact that another minor painter, Smeraldo di Giovanni, who had been associated with this

older group of artists in the early years of the century, later became his partner. Nonetheless, Giovanni made every effort to move with the times as much as he could. For a while he displayed the influence of Lorenzo Monaco but accepted it only "reluctantly and partially," and by 1420, if not earlier, he gratefully joined the reaction against it.[59] During the mid-twenties, he turned to Masaccio and Masolino, as demonstrated in the *Saint Nicholas Enthroned* (San Donato, Porrona, near Cinigiano), in which his angels depend on those in the *Sant'Anna Metterza* (see Plate 2).[60]

Whatever the complexities of Masaccio's relations with his contemporaries, the next generation of painters could not have been untouched by him. At their head was Fra Filippo Lippi who was born in 1406, making him only some five years younger than Masaccio. His family lived in the immediate neighborhood of the Carmine and he came to the monastery as a young boy. Because of the importance placed on his religious education and his cloistered position, it is improbable that he would have been sent out as an apprentice in the regular manner and at the usual age, so that his training as a painter may have been delayed.[61] Given his youth and presumed slow start, he was an artist who would not have had any influence on Masaccio. Yet he was an important part of the artistic milieu at the Carmine and was a friar there during the time that Masaccio painted the *Sagra* and worked with Masolino in the Brancacci Chapel. The two would have known each other.

How profoundly Lippi came under the spell of Masaccio is evident in the fresco depicting the early history of the Order and the confirmation of the Carmelite rule that he painted in the cloister, of which only fragments survive (now detached and in the Sala della Colonna off the cloister). For his composition he drew on two sources: the imagery of the history of the Carmelites, as expounded in the predella of 1327–9 by Pietro Lorenzetti (Siena, Pinacoteca Nazionale) and the tradition of representations of the *Thebaid* (scenes from the lives of the early hermits in the desert around Thebes in Egypt).[62] In this way, he referred the knowledgeable viewer to the place of the Carmelites in monastic history. At the same time, his handling of landscape, space, and architecture reveals the influence of Masaccio. For the individual figures, too, he turned to Masaccio, whose simple and austere forms were so eminently suited to representing the lives of the monks.

The dominance of neighborhood and artistic networks was as powerful in the life of Masaccio as in that of other artists, but it was not overriding and, naturally, waned as he matured. Masaccio's positive response to the paintings around him and the style favored by the Carmine was in good part due to an inherent point of view that was compatible with them. When no works that he saw supplied him with what he needed, he did not hesitate to search for solutions elsewhere. Painting in Florence,

from Giotto and Maso di Banco to the latest works in churches or still in painters' workshops, did not always give him what he needed. Instead he turned to other sources of inspiration: to sculpture ranging from medieval works to Ghiberti's latest innovations, and to methods used by sculptors. He turned to Brunelleschi and the mathematicians for problems of perspective. In this broader approach he may have been encouraged by Bicci di Lorenzo, who himself had worked as an architect as well as a painter.

4 Collaboration in Early Renaissance Art

The Case of Masaccio and Masolino

Perri Lee Roberts

No surviving fifteenth-century document records the collaboration of Masaccio and Masolino. However, from the time of the earliest literary sources to the present day, their work together in the Brancacci Chapel has been the primary focus of most discussions about the two artists. This is understandable, given the importance of the Brancacci Chapel frescoes to the history of early Renaissance art. The myth of their master-pupil relationship, which originated in the mid-sixteenth century with Giorgio Vasari, endured until 1961, when Luciano Berti identified the *Cascia di Reggello Altarpiece* of 1422 as the earliest surviving work by Masaccio.[1] The style of the altarpiece, Berti argued, clearly demonstrated that Masaccio's artistic roots lay outside the workshop of Masolino. Modern scholars have accepted Berti's claim, but other aspects of Masaccio and Masolino's professional relationship continue to be the source of scholarly debate. The extent of their collaboration, the exact division of labor, the circumstances that brought about their partnership, and the chronology of their work together are issues that still dominate current scholarship.

A topic that has not been discussed in the scholarly literature is the professional association of Masaccio and Masolino within the broader context of early Renaissance artistic practices. It is the purpose of this chapter to explore the organization of workshops and the role of collaboration among Tuscan artists from the first half of the fourteenth century through the early 1420s to create a background for understanding the relationship between Masaccio and Masolino.[2] It will be shown that, contrary to Vasari's view of the artist as a solitary genius, collaboration was a common phenomenon of artistic life and a key factor in the efficient and economical operation of the Renaissance artist's workshop. In the second half of the chapter, the case of Masaccio and Masolino is considered in light of this history of workshop practices, and new insights are offered about their working relationship.

The Artist's Workshop in the Late Middle Ages and Early Renaissance

The growth of urban centers in the late thirteenth and early fourteenth centuries brought about an increased demand for works of art for churches, civic buildings, and private dwellings. In response to this new opportunity for employment, the number of artists burgeoned throughout Tuscany, especially in the cities of Florence and Siena. Painters and sculptors were not solitary individuals but artisans who relied on members of their workshop and specialized craftsmen to help in the manufacture of their creative product. Moreover, it was common for artists to employ a variety of media and to undertake a wide range of commissions.[3] Painting and sculpture in the early Renaissance was laborious, requiring purely technical preparatory and other subsidiary tasks. Therefore, the practice of art readily allowed for discrete phases of execution and the division of labor among multiple workers. To meet the demand for their services, early Renaissance artists developed procedures to maximize their productivity, thereby increasing their share of the available commissions and their income.

A single master artist (*capomaestro* or *maestro*), who was an experienced, independent craftsman, headed the workshop (*bottega*) in Trecento and Quattrocento Tuscany. The *maestro* obtained commissions and planned and supervised the execution of the work. He was responsible for the business dealings of the *bottega,* such as the rental of workshop space, the purchase of materials, the collection and payment of bills, and the representation of the shop in all legal matters (commissions and contracts). The *maestro* of the shop also supervised a number of employees, including young apprentices (*discepoli*), older apprentices (*garzoni*), and expert workers or specialists (*lavoranti*).[4] The number and skill level of workshop employees fluctuated, particularly in painters' workshops, depending upon the number of projects under way.[5] Although the master played the primary role in the conception of the work, it was not unusual for him to produce designs that were then turned over to another artist or artists.[6] The extent to which the master participated in the actual execution was determined by a number of factors: the size of the work, the amount of time available to complete the commission, the requirements of the patron, and his other commitments.

In early Renaissance contracts for paintings, generally only one artist (the *maestro*) is named as responsible for the commission. However, visual evidence suggests that most fourteenth- and early fifteenth-century Tuscan paintings were painted by more than one individual, even in cases where the master's name is inscribed on the painting or frame, or when the master's participation is stipulated in the contract for the commission.[7] In contrast with the modern notion of an autograph work, the handiwork

of the master and that of his workshop assistants was considered synonymous. This is not to imply, however, that Trecento and Quattrocento patrons were indifferent to artistic quality. A number of contracts stipulate the parts of the work to be carried out by the master, and the role and nature of workshop assistance.[8] Also common in agreements for commissions are precise instructions about the quality and quantity of the materials to be employed in the work.[9] Less frequently mentioned in the documents, but nonetheless noteworthy, is the requirement that the work be "beautifully painted" with "beautiful figures" as a condition of acceptance of the picture.[10]

Reconstructing the working conditions and professional practices of individual Trecento and early Quattrocento Tuscan artists is difficult because contracts and records of payment generally do not describe the composition of specific workshops in regard to assistants or collaborators. For this reason, art historians have relied primarily on visual evidence in their attempt to distinguish the "hands" evident in a work. Earlier in the century, the presumption of many connoisseurs of early Italian painting was that the master did the "best" parts of the painting, whereas assistants executed the weaker areas. More recent scholarship has revealed that the collaborative process was more complex.[11] Workshop assistants who aided the master were, in many instances, mature artists in their own right and not mere apprentices; therefore, the quality of their handiwork was more likely to be comparable to that of the *maestro*. It was also the case that other specialized workers from outside the workshop participated in the project.[12] Finally, Trecento and early Quattrocento paintings were sometimes produced by independent masters working together as equal partners, sharing the responsibility for design and execution.[13]

Within the artisan populations of fourteenth- and fifteenth-century Florence and Siena, artists formed a close-knit and distinctive social group that shared family and matrimonial connections. It was customary that sons were taught by their fathers, became their assistants, and eventually inherited the family workshop.[14] Duccio (active 1278–1318), for example, had six sons, three or possibly four of whom became painters. Moreover, his brother, Bonaventura, was probably an artist; Bonaventura's son Segna, and his two sons, Niccolò and Francesco, also were painters.[15] Other father-son artists include Taddeo and Agnolo Gaddi; Bartolo di Fredi and Andrea di Bartolo; Spinello Aretino and Parri Spinelli; Filippo and Filippino Lippi; Benozzo Gozzoli and Francesco and Alesso di Benozzo.[16] Brothers and brothers-in-law frequently followed the same artistic profession and often worked together as partners or occasional collaborators. The cases of Simone Martini, the Lorenzetti, the Cione, and Masaccio will be discussed here.[17]

In light of the fact that an artist's workshop generally represented a large-scale investment in property and equipment, it was clearly beneficial

for relatives to share the patrimony. Inheriting the clientele and reputation of a well-established shop was invaluable from the standpoint of business, but because of the unstable, competitive nature of the artistic enterprise, few family firms survived longer than two generations. The notable exceptions are the Bicci, Ghiberti, and della Robbia workshops.[18]

The life and career of Simone Martini (c. 1284–1344) provide an excellent example of the intersection of familial and professional relationships that characterized the Tuscan artistic community. Together with the Lorenzetti, Simone was the preeminent painter in Siena in the generation following Duccio. There is no question that he had an extremely active workshop, but the number and identities of most of his assistants and collaborators are unknown.[19] A notable exception is his brother-in-law Lippo Memmi (active 1317–47), with whom Simone appears to have collaborated even before they became related by marriage in 1324. Lippo was the son of the painter and miniaturist Memmo di Filippuccio (active 1288–1324), with whom he painted the fresco of the *Maestà* in the Palazzo Comunale, San Gimignano (1317).[20] He may have begun working with Simone in the early 1320s on the so-called *Monaldeschi Altarpiece* for the church of San Domenico in Orvieto (Orvieto, Museo dell'Opera del Duomo).[21] In 1327, Lippo received payment for a now-lost fresco of Saint Ansanus, painted by him and Simone in the tax office of the Palazzo Pubblico, Siena.[22]

There is no scholarly consensus about the role the two artists played in the *Annunciation* (Florence, Galleria degli Uffizi: Plate 40), painted for the altar of San Ansano in the Cathedral of Siena.[23] A fragment of the original inscription, with the names of both artists and the date 1337, is inserted in the nineteenth-century frame, and partial records of payments to the two painters survive. Lippo received an undisclosed sum of money for painting, as well as monies for the plentiful gold leaf employed in the altarpiece.[24] Many scholars have found the painting homogeneous in style and largely the work of Simone, with Lippo's participation evident only in the four roundels in the cusps of the altarpiece.[25] Some art historians, on the other hand, have stressed the impossibility of distinguishing the handiwork of Lippo, because he imitated Simone's style so closely.[26] In opposition to this view, Miklòs Boskovits presented new arguments relating to the style of the work in support of attributing the wing with *Saint Margaret* to Lippo Memmi.[27] He hypothesized that the commission was given to Simone alone in 1329, but that the completion of the work was delayed by the painter's other commitments. It may have been for this reason that Simone, who possibly left for Avignon as early as 1332–3, engaged Lippo to finish the job.

Simone's slightly younger contemporaries, Pietro Lorenzetti (active c. 1306–45) and his younger brother Ambrogio (active c. 1317–48), seem to have operated separate workshops throughout their careers, but at times they utilized each other's tools to make the punchwork patterns in their

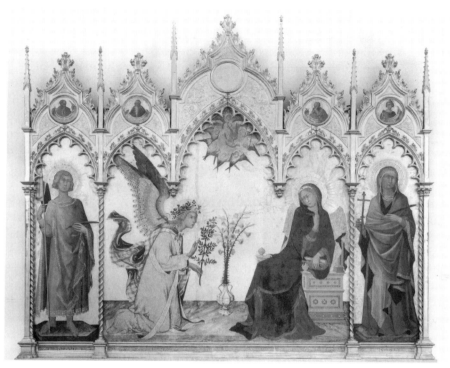

Plate 40. Simone Martini and Lippo Memmi, *Annunciation*, 1333, Florence, Galleria degli Uffizi. (Photo: Antonio Quattrone)

panel paintings.[28] They also collaborated on major projects in at least two instances. Sometime around 1326, Pietro painted a fresco of the *Crucifixion* as part of Ambrogio's decoration of the Chapter House of San Francesco, Siena. In 1335, the brothers are documented as having worked on the frescoes (now lost) of scenes from the life of the Virgin on the facade of the hospital of Santa Maria della Scala, Siena.[29] As far as the collaboration can be reconstructed, Pietro was responsible for the first scene of the cycle, and Ambrogio, the second.

In the second half of the fourteenth century, individual Tuscan masters began to collaborate with one another on equal terms with much greater frequency. This willingness to collaborate may have had something to do with the perceived, and oftentimes real, economic uncertainty following the advent of the Black Death. Partnerships were standard business practice in many industries of the period and were not permanent or exclusive. In most instances, collaborative associations in late Trecento Tuscany were temporary, initiated to undertake specific projects. Artists agreed to share the responsibilities and payment for the work, but they did not consolidate their workshops or their assets. Joint ventures allowed masters not only to take on a greater number of commissions but also to engage in major works

simultaneously. For a lesser-known artist, a partnership allowed him to gain experience and to participate in a project he might not have obtained otherwise. Most important, a short-term alliance helped to cushion the inherent risks of a commission. If the patron did not pay for the work as he had contracted to do, the economic impact was mitigated somewhat by the fact that the loss was absorbed by two or more workshops.

A representative example of a work that was produced as the result of a partnership is the *Saint Thomas Polyptych*, representing the *Madonna and Child Enthroned with Saints John the Baptist, Thomas, Benedict, and Stephen* (Siena, Pinacoteca Nazionale: Plate 41). The names of two Sienese artists, Niccolò di ser Sozzo (active 1350s–63) and Luca di Tommè (active 1356–84), are inscribed on the molding of the central part of the frame, as is the date 1362. The predella, separated from the altarpiece, consisted of scenes from the life of Saint Thomas (Edinburgh, National Gallery of Scotland) and the *Crucifixion* (Rome, Pinacoteca Vaticana). Although the original location of the work is unknown, the large size of the altarpiece (approximately 6 × 9 feet [183 × 275 cm]) suggests that it was a prestigious commission for either the Cathedral of Siena or some other major religious foundation in Siena, possibly the convent of San Tommaso degli Umiliati.[30] At the time the altarpiece was painted, Niccolò di ser Sozzo was a well-established master, whereas Luca di Tommè was a young artist in the early years of his career.[31] Because there is no documentary evidence, it is a matter of conjecture who received the commission, but the likelihood is that it was given to the more senior painter. Niccolò was not a member of the Sienese guild of painters, and it has been hypothesized that he collaborated with Luca, who was a guild member as of 1356, in order to establish a workshop acceptable to the local authorities.[32]

Various theories have been proposed about the division of labor in the *Saint Thomas Polyptych*. Cesare Brandi, who published the inscription with the dual signature, contended that Luca served primarily as an assistant, preparing the pigments, doing some of the detail work, and perhaps painting the panel with Saint John the Baptist.[33] Bernard Berenson suggested that Luca completed the altarpiece when it was already at an advanced stage, because Niccolò, who died in 1363, was incapacitated by illness.[34] Federico Zeri also felt that Luca's role in the project was limited, but credited him with the execution of the predella panels.[35] Sherwood A. Fehm, on the basis of stylistic analysis, argued persuasively that Luca's work on the altarpiece was extensive, despite the fact that he was the younger artist whose name appeared second to that of Niccolò in the inscription.[36] It included the design of the central panel with the Madonna and Child, the design and execution of the predella panels, and the painting (and perhaps design) of Saint John the Baptist, much of Saint Thomas, and perhaps part of Saint Benedict. In Fehm's opinion, the experience of working with Niccolò was so intense that it took several years for the styl-

istic influence of the older master on the younger artist to wane. Luca worked independently until 1389, when he was commissioned together with Bartolo di Fredi (active 1353–1410) and his son Andrea (active 1389–1428) to paint the *Calzolari Altarpiece* (lost) for the Chapel of Saint Agnes in the Cathedral of Siena.

Whereas Luca di Tommè appears to have rarely worked with partners, many of his Florentine colleagues were involved in numerous collaborative enterprises. The career of Jacopo di Cione (active 1365–1400) provides an excellent case study of the intricate network of professional relationships that was typical of late Trecento artistic practices and the benefits of a family workshop organization. Jacopo was the youngest of the four Cione brothers who dominated Florentine art in the last quarter of the fourteenth century.[37] Matteo (c. 1320/30–90) was a sculptor; Nardo (c. 1320–65/6) a painter; and Andrea (1315/20–68), also known as Orcagna, a painter, sculptor, and architect. Andrea and Nardo shared the large Cione workshop, where Jacopo and many other artists received their training. They mainly worked independently of one another, but they both worked with assistants and other master painters. The notable instances where they collaborated include the frescoes (destroyed) in the main choir of Santa Maria Novella, Florence; the frescoes in the refectory of Santo Spirito, Florence; and the decoration of the Strozzi Chapel in Santa

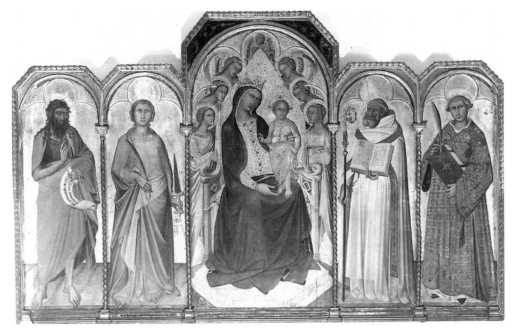

Plate 41. Niccolò di ser Sozzo and Luca di Tommè, *Madonna and Child Enthroned with Saints John the Baptist, Thomas, Benedict, and Stephen*, 1362, Siena, Pinacoteca Nazionale. (Photo: Fotografia Lensini, Siena)

Maria Novella, for which Nardo frescoed the walls and Andrea painted the altarpiece.

When Andrea became ill in c. 1367, Jacopo was asked to complete his brother's painting (now lost) of the Madonna in the audience chamber of the Capitani of Orsanmichele, and the commission for the altarpiece with *Saint Matthew* (Florence, Galleria degli Uffizi).[38] Upon Andrea's death in 1368, Jacopo inherited the prestigious Cione shop. Among his brother's former *compagni*, he maintained relationships with several artists, the best known of whom was Giovanni del Biondo (active 1356–99).[39]

Miklòs Boskovits attributed a half dozen paintings dating to the late 1370s and the early 1380s to Giovanni del Biondo and Jacopo di Cione.[40] In the majority, the division of labor was the same: Giovanni designed the paintings, and Jacopo executed the design, sometimes painting the entire surface and in other instances only parts of the composition. This working method may have been used to lower the cost of producing the painting, since the labor of Giovanni, the more senior artist, was more expensive than that of his junior partner.[41] For Giovanni, the experience of working with Jacopo led to a temporary alteration in his style. Once his association with the younger master came to an end, the older artist reverted to his earlier style for the remainder of his career.[42]

In addition to Giovanni del Biondo, Jacopo collaborated with other artists, some of whom are named in the documents associated with his works. Among these is a painter named "Niccolò" or "Niccolaio," who is generally assumed to be Niccolò di Pietro Gerini (active 1366–c. 1414/15), who was trained in the milieu of the Cione shop.[43]

Most scholars assume that Jacopo worked with Niccolò on a regular basis over two decades on a number of important commissions, including the very large *San Pier Maggiore Polyptych* (1370–1), and the *Coronation of the Virgin* (Florence, Accademia; 1372–3) for the Florentine mint.[44] Niccolò's responsibility in these altarpieces appears to have been the design of the composition with its frame.[45]

In 1383, Jacopo collaborated with Niccolò on the fresco of the *Annunciation with Four Standing Saints* in the Sala del Consiglio, Palazzo dei Priori, Volterra.[46] The fragmentary underdrawing (sinopia) shows that one artist, identified as Niccolò, was responsible for the design of all the architectural detail and the annunciate angel, whereas a second hand, that of Jacopo, drew the figures of the four standing saints.[47] The condition of the fresco is so poor that it precludes any firm attribution of the painted surface.[48] Jacopo also worked together with Niccolò on the triptych with the *Madonna and Child with Saints* (Florence, Accademia; 1383).[49] Niccolò played a minor role in the commission, contributing only the central predella with the *Adoration of the Magi*. For the remainder of his career, Jacopo di Cione worked on his own for the most part, but Niccolò Gerini continued to seek out other masters of independent workshops to partici-

pate jointly in fresco decorations and panel paintings. Ambrogio di Baldese, Tommaso del Mazza, Pietro Nelli, and Spinello Aretino all worked with Niccolò on more than one occasion.[50]

The Artist's Workshop in the Early Fifteenth Century

By the beginning of the fifteenth century, temporary partnerships of established, independent masters were common among Tuscan painters. This was especially true of commissions for large, complex polyptychs, such as the *Coronation of the Virgin* (Florence, Accademia; 1401) by Spinello Aretino, Niccolò di Pietro Gerini, and Lorenzo di Niccolò for the main altar of Santa Felicita, Florence.[51] As in the past, extensive fresco cycles were typically the product of a collaborative undertaking, such as the decoration of the Sala di Balia in the Palazzo Pubblico, Siena (1407), by Spinello Aretino, his son Parri Spinelli, and Martino di Bartolomeo.[52] Who initiated these short-term alliances is generally not known. In some instances, it was probably the artist or artists themselves, while in other cases, the patron decided whom he wanted for the job and what roles the artists should play.[53] This was the case in 1402, when the officials in charge of the Ospedale of Santa Chiara in Pisa commissioned Giovanni di Pietro of Naples (active 1402–5) and Martino di Bartolomeo of Siena (active 1398–c. 1434) to paint an altarpiece of the *Madonna and Child with Saint Mark and Saint Luke* (Pisa, Museo Nazionale di San Matteo) for the church of Santa Chiara, Pisa.[54] The contract specified the subject matter of the altarpiece, the time frame for the work to be completed, and the roles and remuneration of the two artists. Both were to be paid the same amount (95 florins in three installments), but Giovanni was responsible for the figures; the rest of the work was to be divided with his partner Martino. In this instance, the wishes of the client with regard to the division of labor were carried out.[55]

In fourteenth-century Tuscany, artists maintained long-term relationships with expert workers or specialists within their own workshops, but in general they did not form alliances with other independent masters on a permanent or semipermanent basis. When they did, it was usually to share workshop facilities, thereby reducing overhead.[56] This situation changed in the fifteenth century, especially in Florence, when competition led entrepreneurial painters to consolidate their workshops and commissions in what were called companies (*compagnie*). A typical case is that of Giuliano d'Arrigo, known as Pesello (1367–1446), who collaborated with a group of independent artists to undertake decorative banners for standard bearers, military regalia, and projects for decorative architectural settings.[57] He and his various partners shared a common workshop, equipment, materials, and profits. In the years from 1414 to 1434, Pesello formed different

alliances every three years, the number of his partners ranging from three to six. In addition to the relatively small-scale projects undertaken by his various *compagnie*, Pesello worked with other masters outside the partnership on designs for major projects.[58] The commercial enterprise that Pesello initiated to meet the stiff demands of the local marketplace became a permanent feature of Florentine artistic practices.[59]

Lorenzo Monaco (c. 1372–1423/4) dominated the pictorial arts in Florence in the first quarter of the fifteenth century.[60] Trained by Agnolo Gaddi, Lorenzo Monaco spent the first five to six years of his artistic career in the monastery of Santa Maria degli Angeli, where he was employed in the scriptorium. After he left the monastery in c. 1396 to operate his own shop, he continued to collaborate with scribes and other painters on the production of sacred illuminated manuscripts. From the outset of his independent career, Lorenzo Monaco was occupied with major commissions while his workshop concentrated on the production of small-scale devotional works based on his designs. He also relied on assistants, both monastic and secular, in carrying out his large-scale projects on panel and, at the end of his life, in fresco.[61] The important role played by his shop is acknowledged in Lorenzo Monaco's major work, the *Coronation of the Virgin* (Florence, Galleria degli Uffizi; 1414) painted for the high altar of Santa Maria degli Angeli.[62] The long inscription on the frame records the artist's name and the fact that monastic painters collaborated with him on the painting. The extent of the participation of the workshop in its execution is not known, but visual evidence suggests that assistants were responsible for painting the pilaster saints.[63] The variant copy of the altarpiece, the *Coronation of the Virgin* (London, National Gallery; after 1413: Plate 42) painted for the monastery of San Benedetto fuori della Porta a Pinti outside Florence, appears to have been designed and executed entirely by assistants.[64] Lorenzo Monaco's last major commission (c. 1420–2) was the altarpiece of the *Deposition* for the sacristy chapel in Santa Trinita, Florence, for which he painted the pinnacles (Florence, Museo di San Marco) and the predella (Florence, Accademia).[65] The work was almost certainly left unfinished at his death in c. 1425. It is noteworthy that the patron, Palla Strozzi, did not have the master's workshop finish the altarpiece but instead gave the commission to Fra Angelico, whose style was more up-to-date.[66] Upon Lorenzo Monaco's death, the *bottega* ceased production and the members dispersed.

The other major Florentine artist in the early years of the Quattrocento, Lorenzo Ghiberti (1378–1455), maintained a large workshop that was similar to Lorenzo Monaco's in its hierarchical organization. The stepson of the goldsmith Bartolo di Michele, Lorenzo was a goldsmith, draftsman, painter, architect, and sculptor.[67] When he was awarded the commission for the North Doors of the Florentine Baptistery in 1403, he was given control of the project and the responsibility for selecting assistants,

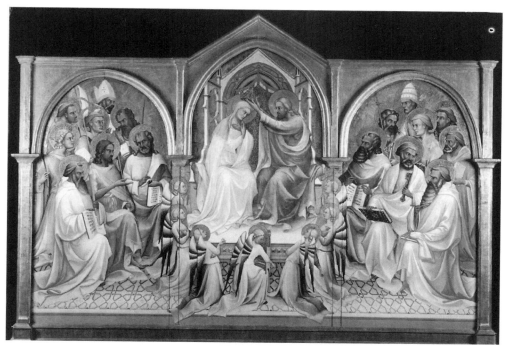

Plate 42. Lorenzo Monaco, *Coronation of the Virgin*, after 1413, London, National Gallery. (Photo: © National Gallery, London)

but was designated as Bartolo's partner in recognition of the fact that the workshop belonged to his stepfather.[68] In the second contract of 1407 for the doors, the commission was revised. Ghiberti was designated as the *maestro* in charge of the project, and Bartolo, his chief assistant.[69] Among his other lesser-paid shop assistants were Donatello, Masolino, and Paolo Uccello, all of whom went on to become independent masters in their own right.[70] Between 1417 and c. 1424, Michelozzo was employed as Ghiberti's chief assistant and worked on the doors as well as on the statue of *Saint Matthew* for Orsanmichele (see Plate 29).[71] When their association ended in c. 1424, Michelozzo formed a partnership with Donatello but later returned to work with Ghiberti in 1437 to assist in finishing and chasing the East Doors of the Baptistery.[72]

In addition to the design and casting of the two sets of bronze doors for the Florentine Baptistery, Ghiberti's workshop simultaneously took on a number of other projects, both major and minor. As of the 1420s and continuing through the 1440s, skilled craftsmen were hired by Ghiberti on a temporary basis to execute his designs for goldsmith work, tomb plaques, stained-glass windows, frames, and terra-cotta reliefs and statues of the Madonna and Child.[73] Throughout his career, the *maestro* collaborated with other important artists, including Donatello and Jacopo della Quercia on

the Siena Baptismal Font (1417–27), Brunelleschi on the construction of the dome for the Florence Cathedral (1419–36), and Fra Angelico on the *Linaiuoli Altarpiece* (Florence, Museo di San Marco; 1433).[74]

Ghiberti's two sons, Tommaso (b. 1417) and Vittorio (b. 1418–19), entered the workshop in the 1430s.[75] Although he was the older son, Tommaso apparently played only a minor role in the shop, whereas Vittorio became his father's assistant in 1437 and his junior partner as of 1444. Upon Ghiberti's death, Vittorio inherited the shop founded by his grandfather. Under his father's skillful management, it had expanded into the largest firm of sculptors in Florence and its premier foundry; moreover, it had served as a crucible for the development of early Renaissance art. Ghiberti's dynasty survived for two more generations and continued to play a major role in the city's artistic enterprises.

The Association of Masaccio and Masolino

It was in this milieu that Masaccio (1401–28) established his own workshop and pursued his brief career. Born in the hinterlands of the Arno River valley, he probably received his training as a painter in a Florentine workshop, possibly that of Bicci di Lorenzo (1370/3–1452).[76] From the time he became an independent master in 1422 until his early death, Masaccio's professional practices were typical for the period. He maintained an extremely modest *bottega* initially in the parish of Sant'Apollonia, and later (c. 1427) near the Badia.[77] His workshop included his own brother, Giovanni di ser Giovanni, known as lo Scheggia (1406–86), and Andrea di Giusto (c. 1400–55).[78] Andrea served as Masaccio's assistant on the *Pisa Altarpiece* of 1426, and was probably responsible for painting two of the predella panels, *Saint Julian Killing His Parents* and *Saint Nicholas Dowering the Daughters* (both Berlin, Gemäldegalerie).[79] Judging from the number of his surviving works, Masaccio attracted a fair number of commissions, but he was not a financially successful artist. At the time he filed his tax return in July 1427, the painter was in a very poor financial state; he was deeply in debt and no monies were owed to him.[80]

Masaccio's surviving work consists of paintings on panel and frescoes. However, there is archival evidence indicating that he, like other painters of his generation, undertook minor decorative commissions. A document dated June 1425 records the payment to Masaccio and another painter named "Niccholò" for gilding a pair of processional candlesticks for the canons of the cathedral in Fiesole.[81] "Niccholò" may be identified as the minor artist Niccolò di ser Lapo, whose name appears in Masaccio's 1427 tax return (*catasto*) as a substantial creditor. Niccolò had a workshop in the same building as Masaccio's first shop. On the basis of this fact and the amount of money that Masaccio owed to Niccolò, it is likely that the artists were partners for certain jobs over a period of several years. They

probably did not form an official *compagnia,* since there is no mention of it (as should have been the case) in their respective tax returns.[82]

It was in these very same years, the mid-1420s, that Masaccio collaborated with Masolino on at least three (surviving) works – the Brancacci Chapel frescoes, the *Sant'Anna Metterza,* and the *Santa Maria Maggiore Altarpiece.* Some scholars also contend that they collaborated on the *Carnesecchi Altarpiece* for Santa Maria Maggiore, Florence, and on the fresco decoration of the Castiglione Branda Chapel in San Clemente, Rome.[83] They also may have worked together on the lost frescoes of Saints Peter and Paul on the piers of the chapel directly opposite the Brancacci Chapel, which are attributed to Masolino and Masaccio, respectively, in all the early sources.[84]

Like Masaccio, Masolino da Panicale (1383/4–c. 1436) was born in the Tuscan countryside, in the Valdarno between Florence and Arezzo, and at an early age left his birthplace to pursue artistic training in Florence. Since the population of the city was not overly large and the community of artists was a close-knit one, the two countrymen may have met soon after Masaccio's arrival in Florence, some time before 1420.[85] They might have become acquainted through family contacts, since the banker to whom Masolino gave power of attorney in 1425 was the same man who had guaranteed a debt for Masaccio's mother in 1421.[86]

Vasari made no mention of Masaccio in his life of Masolino, but he suggestively began his biography of the former by stating that Masaccio began his career when Masolino was working in the Brancacci Chapel.[87] Vasari also said that in the commemorative fresco (the *Sagra*) Masaccio painted in the cloister of the Carmine, he included a portrait of Masolino, "his master," among the crowd of figures attending the consecration of the church. The master-pupil relationship implied in Vasari's 1568 biography of Masaccio was unequivocally stated sixteen years later by Raffaello Borghini in *Il Riposo* (1584).[88] The claim that Masolino taught Masaccio the art of painting was repeated thereafter in the literature for the next 350 years. Scholars first began to question the validity of this presumed relationship in the 1930s, but it was not until the discovery of the *Cascia di Reggello Altarpiece* that the notion of Masolino's tutelage of Masaccio was finally put to rest.[89] In his publication of the work, Luciano Berti persuasively argued that the styles of the two artists in their earliest surviving works were conceptually very different.

Masolino was some eighteen years older than Masaccio and was the more experienced and probably the better known of the two, since he had lived and worked in Florence for a longer period of time. As the senior, more established artist in the community, it is likely that Masolino received the commissions for the paintings on which he and Masaccio collaborated. Stylistic evidence suggests that their working relationship began sometime in 1424 on the fresco decoration of the Brancacci Chapel.[90] Like the collaboration of Donatello and Michelozzo, which was formed in these

very same years, the partnership of Masaccio and Masolino was probably not intended to be permanent or exclusive. However, there is no evidence to suggest that they either combined their workshops as did the two sculptors, or consolidated their assets.

What prompted Masolino to initiate the partnership is a matter of conjecture. It was probably because he had too much work to complete prior to his anticipated departure for Hungary in September 1425 for a three-year sojourn.[91] Like Masaccio, Masolino had a small workshop that apparently was not adequate to undertake the projects at hand.[92] Masolino may have chosen Masaccio as a partner on his own, but it is also possible that the resident community of Carmelites, for whom Masaccio painted the *Sagra* (c. 1422), recommended the young artist to the older master.[93] For Masaccio, the partnership was extremely beneficial. It gave him the opportunity to work on large-scale projects that he might otherwise not have obtained. There were undoubtedly financial incentives as well.

The recent recovery of the sinopie (see Plates 6 and 7) from the divided lunette of the window in the Brancacci Chapel, and fragments of a Gothic border on the window embrasure and the wall below (Plate 43), has reopened the discussion of the chronology of the artists' collaboration. The attribution of one of the underdrawings to Masaccio led the restorers, Ornella Casazza and Umberto Baldini, to suggest that the decoration was a joint project from the beginning.[94] In opposition to this view, Keith Christiansen (among other scholars) rejected the attribution of the underdrawing to Masaccio and argued that the younger artist began working on the project on the second register.[95] In his opinion, the older Gothic style of border would never have been employed on the upper register if the classicizing framework on the middle and lower registers had been envisioned from the beginning. This decisive change in the decorative scheme occurred after the completion of the vault and lunettes, and could only have been initiated by Masaccio.[96] Probably in deference to Masolino's wishes, the original border was continued below the window to frame the fresco above the altar; but otherwise the older master carried out his companion's revised scheme of a classicizing framework.[97]

There is no question that the highly innovative character of the Brancacci Chapel's decoration is more in keeping with Masaccio's than Masolino's artistic personality. From the beginning of his career, Masaccio demonstrated an assimilation of the new Renaissance style of sculpture and architecture as practiced by his friends (and possible advisers on this project), Brunelleschi and Donatello. In addition to playing a decisive role in the overall design of the decoration, Masaccio also painted the majority of the scenes. On the second register, the two artists worked simultaneously, dividing the design and execution of the six frescoes between them (see Plates 4 and 5). They began painting on the side walls, then exchanged places on the scaffolding after extending the backgrounds of the *Tribute Money* (see Plate 8) and the *Healing of the Lame Man at the Temple and the Raising of Tabitha* (see Plate 61)

around the corners and behind the fictive pilasters into the adjacent scenes on the wall with the altar. Masaccio seems to have painted the landscape in the upper half of *Saint Peter Preaching* (see Plate 10), and Masolino was responsible for the background of *Saint Peter Baptizing the Neophytes* (see Plate 11).[98] Other than these instances, however, they did not intervene in the execution of each other's narrative scenes as some scholars have contended.[99] Following Masolino's departure for Hungary, Masaccio (assisted by his workshop) was responsible for the third register, where he painted four more frescoes, including the now fragmentary scene above the altar (see Plates 43 and 62).

This is not to say that Masolino's participation in the decoration was minimal or insignificant. He was certainly not "terrorized" by his younger colleague, as one scholar characterized the collaboration a half century ago.[100] More recent scholarship has recognized that the two artists worked together amicably, designing and painting in concert in what has been called a "grand duet."[101] Before beginning to paint, they must have agreed that the lighting effects of their

Plate 43. Border from window, detail of PLATE 3. (Photo: Antonio Quattrone)

frescoes would be determined by the actual source of light within the chapel, and that they would employ a similar palette dominated by high-key colors. Last, the two painters chose the three scenes (on the second register) that were best suited to their respective artistic personalities and talents, and resolved to coordinate their compositions. Both artists maintained their individual styles, although Masolino was clearly affected by the work of his companion. Following Masaccio's example, Masolino significantly increased the volume and naturalism of the drapery, modeled with a greater range of tonal values in response to a directed light source, and employed a central vanishing point for the first time in his career.

The second project on which Masaccio collaborated with Masolino was the painting of Saint Anne enthroned with the Madonna and Child with five angels (c. 1424–5), known as the *Sant'Anna Metterza* (Florence, Galleria degli Uffizi: see Plate 2).[102] The panel is a large one (measuring approximately 6 × 3½ feet [175 × 103 cm]) and probably served as an autonomous altarpiece. Prior to the early twentieth century, the painting was considered

the work of Masaccio alone. Today, scholars are in general agreement that Masaccio and Masolino shared both the design and the execution of this painting. The overall composition and shallow space of the *Sant'Anna Metterza* are similar to those of Masolino's other paintings of the Madonna from the decade. The design specifically recalls the central panel of Gentile da Fabriano's *Quaratesi Altarpiece* (c. 1423–5). Saint Anne and the five angels are in keeping with Masolino's figural types, but the monumental Virgin and the robust Christ child are uncharacteristic of his oeuvre. They are broader, more muscular versions of the Madonna and Child employed by Masaccio in his earliest surviving work, the *Cascia di Reggello Altarpiece* (see Plate 1), and were likely designed by him. He was also responsible for the throne (including the posts and finials) and the curved platform, which are similar to the architectural elements in the earlier painting.

In their execution of the painted surface of the *Sant'Anna Metterza*, Masaccio and Masolino divided the responsibility more or less in half, painting those areas that they had designed. The one exception is the angel to the upper right, which may have been painted by Masaccio. They agreed upon the basic color scheme and the direction of the fall of light from the upper left, and they sought to reconcile their stylistic differences. Masolino attempted to imitate Masaccio's more pronounced light and dark modeling on the right-hand side of Saint Anne's mantle. Masaccio adopted his companion's system of modeling, in which contrasting colors are used for shading, for the robe of the angel at the upper right and for the headdress of the Madonna.[103]

The third, and in this author's opinion, final collaborative undertaking of Masaccio and Masolino was the large, double-sided polyptych for the Roman church of Santa Maria Maggiore (see Plates 15 and 16).[104] Scholars are divided in their dating of the work, favoring either a date in the early 1420s (connecting the commission with the anticipated Holy Year of 1423) or the late 1420s, following Masolino's return from Hungary and shortly before Masaccio's death. In the case of the latter scenario, the partnership, interrupted by Masolino's absence, was renewed following the older master's return to Florence in 1427/8.

As in the case of the *Sant'Anna Metterza*, Vasari attributed the altarpiece to Masaccio. In the late nineteenth century (by which time the polyptych had been dismembered and dispersed), the central panels with the *Miracle of the Snow and the Foundation of Santa Maria Maggiore* and the *Assumption of the Virgin* (both Naples, Museo di Capodimonte) were reattributed to Masolino. The panels have since been ascribed to Masolino by most scholars.

The attribution of the four wings (originally back to back), however, is more complex and extremely important in understanding the nature of Masaccio and Masolino's collaboration on the project. The wing with *Saints Gregory and Matthias* (London, National Gallery: see Plate 20) was designed and painted by Masolino. Its other side depicting *Saints Jerome*

and John the Baptist (London, National Gallery: see Plate 17) is regarded generally as the only one of the altarpiece's six surviving panels that was designed and painted (but not completed) by Masaccio.[105] The other two wings, *Saints Paul and Peter* (Philadelphia, Philadelphia Museum of Art, John G. Johnson Collection: see Plate 19) and *Saints John the Evangelist and Martin of Tours* (Philadelphia, Philadelphia Museum of Art, John G. Johnson Collection: see Plate 18), have been considered the exclusive work of Masolino. However, recent investigation by Carl Strehlke and Mark Tucker has provided new insight into the process of their production.[106] At some point after the wings had been designed, significant alterations were made to the composition. The figures of the saints were reversed in relation to one another, and such objects as Saint Paul's sword, Saint Peter's keys, and Saint Martin's crozier, which were originally depicted at various angles in depth, were redrawn more or less parallel to the picture plane.

In both wings, these changes were made when the execution of the panels already was under way. In the case of *Saints John the Evangelist and Martin of Tours,* the faces of the saints had been painted; the outlines of the original design were incised on the gessoed panel; and the gold already was applied for the halos and the orphrey worn by Saint Martin. In the panel with *Saints Paul and Peter,* the prepared panel had been scored, the gilding applied to the surface, the halos tooled, and the sheets of silver leaf for Paul's sword and the gold leaf for Peter's keys applied. In addition, the saints' feet and hands were painted according to the methods described by Cennino Cennini, whereby pink and white hues were applied on a green preparatory layer in order to suggest the appearance of skin.[107] Subsequent to the design change, the saints' faces were executed using a different method. This involved the application of a thin layer of tempera directly on the white gesso ground without an intermediate layer of green underpainting. The marked difference in design and techniques in the two phases of execution have led the researchers to conclude that Masaccio began the panels, but Masolino completed them.

Masaccio's limited contribution to the *Santa Maria Maggiore Altarpiece* suggests that work on the project probably began only a short time before his death. In notable contrast with their work together in the Brancacci Chapel and on the *Sant'Anna Metterza,* their collaboration may have been consecutive rather than concurrent. The influence of Masaccio's style on Masolino in the altarpiece was also much less marked. It is evident only in the central vanishing point for the composition of the *Miracle of the Snow and the Foundation of Santa Maria Maggiore,* in the voluminous draperies of Saint Matthias, and in the directed lighting employed for the wings. Perhaps because of Masolino's sojourn in Hungary, the death of his collaborator, the taste of his patrons, or a combination of these factors, his interest in Masaccio's style had waned considerably by the end of the 1420s.

Nothing about the working relationship of Masaccio and Masolino is unusual in the context of the artistic practices in Tuscany. As with most

partnerships of the fourteenth century and early fifteenth century, the collaboration is undocumented. Scholars have had to rely on stylistic evidence and, to a limited extent, on scientific evidence to decipher the attribution of the design and execution of their joint works. Like many other collaborative works of the fourteenth and fifteenth centuries, the projects that Masolino and Masaccio undertook were large-scale, major commissions. The fact that they shared responsibility for the design and execution of a work and collaborated on more than one occasion is in keeping with the history of partnerships in fourteenth- and early fifteenth-century Tuscan painting. And there is the precedent of Jacopo di Cione and Giovanni del Biondo's relationship for Masaccio's significant but ultimately short-lived influence on the style of his older partner.

What may seem surprising to the modern viewer is the collaboration of two artists whose styles are so different according to the current canons of western art history, with Masaccio being the representative of the new "Renaissance" style and Masolino, the old-fashioned "Gothic" style. Did the contemporaries of Masaccio and Masolino recognize their stylistic differences? This is a difficult question to answer, since there are very few records from the period recording the response of the public to works of art in general. Moreover, as in the present day, certain sectors of the population may have been more attuned to the reception (and perception, for that matter) of the pictorial arts. Obviously, artists had specialized visual skills and habits, as the following anecdote makes evident. In 1457, a painter was called as an expert witness in a court case in Padua to determine the amount of Mantegna's fee for part of a joint commission. He testified that although he did not see the artist do it, "Painters can always tell . . . whose hand has done something, especially in the case of an 'established master.'"[108]

Many Quattrocento patrons had the ability to discern individual styles and expressed their preference in the choice of artist(s) they made for their commissions. The two "art critics" of the fifteenth century who wrote about contemporary Florentine art, Leon Battista Alberti and Cristoforo Landino, both recognized and praised the novel aspects of Masaccio's style but did not make mention of Masolino.[109] In the sixteenth century, Vasari glorified Masaccio as the predecessor of Michelangelo; thereafter, in the literature of art and art criticism, Masaccio's brief but brilliant career obscured Masolino's legacy and reputation.[110] Different as their styles may be in the eyes of the modern viewer, what allowed Masaccio and Masolino to work together successfully on more than one occasion was the fact that they shared a common heritage of workshop habits and professional practices that had originated in the late thirteenth century and developed over time. If Masaccio had not died suddenly in 1428, his partnership with Masolino might very well have continued.

5 Masaccio

Technique in Context

Roberto Bellucci and Cecilia Frosinini

The study of Masaccio's artistic technique, despite occasional publications on the conservation of individual works, has never been considered in a systematic way.[1] This deficiency is probably due to the slight interest shown by art historians, until relatively recently, in the study of the specific technical characteristics of his works. This kind of indifference is undoubtedly due to the inadequate competence of many scholars on the subject and once again highlights the necessity of interdisciplinary studies that take into account different professional contributions, such as those of conservators.

In the case of Masaccio, however, there has also been a great imbalance on the part of critics who have always emphasized, with good reason, the intellectual contribution of his art to the detriment of understanding his personality as a whole. His technical competence, in fact, with its unique features and the contributions mediated by the world surrounding him, also opens up interesting ways to broaden our understanding in subjects that are strictly art historical, such as his formation, his collaboration with Masolino, his relationship with Brunelleschi, and the chronology of his works.

Origins and Early Training

One of the more obscure areas of Masaccio's artistic biography is surely the one related to his apprenticeship. Numerous hypotheses have been proposed by critics, inspired by the account of Giorgio Vasari (1568), which interpreted the Masolino-Masaccio relationship as a master-pupil one, including elaborate studies directed at identifying his teacher in the vast artistic panorama of Florence between the second and third decades of the

fifteenth century. Since there is clearly no possibility of finding a painter who aptly fit the bill of "master" in the full sense of the word, names such as Mariotto di Cristofano[2] and Bicci di Lorenzo[3] have been put forward. Though completely second-rate artists, they have, however, some remote documentary link with Masaccio and have been considered solely for the support, if nothing else, they might have offered the young artist who had just arrived from his native San Giovanni Valdarno. Mariotto di Cristofano had married the daughter of Tedesco di maestro Feo, the second husband of Masaccio's mother; Masaccio's brother, Giovanni di ser Giovanni (later known as lo Scheggia)[4] was among the various apprentices of Bicci di Lorenzo's workshop between 1421 and 1422.

To consider other hypotheses on Masaccio's training, we must keep in mind how the search for locating his artistic origins in Florence is flawed in two ways. On the one hand, it advocates a fairly "centralized," parochial vision of the reality of the profession; and on the other, it introduces a chronological problem that can be explained only with difficulty on account of fifteenth-century workshop practice. In the society of the time, apprenticeship began at an extremely early age and consisted of a fairly long period.

Cennino Cennini, whose *Il libro dell'arte* (*The Craftsman's Handbook,* c. 1390) is an invaluable guide to painters' lives and practice in the early Renaissance, advises young artists, "And begin to submit yourself to the direction of a master for instruction as early as you can; and do not leave the master until you have to."[5] At least seven years, according to the dictates of the Arte dei Medici e Speziali (the guild of artists, physicians, and apothecaries), were to be spent in apprenticeship to a master painter. Either Masaccio's arrival in Florence necessarily would had to have been extremely early, or the place of his apprenticeship has to be sought in San Giovanni Valdarno, where he was born.

Such a situation is certainly possible, given the multiple working relationships that Masaccio's family could have enjoyed with the world of painters. One such opportunity could have derived from the activity of the artist's paternal family, since in fact both his grandfather and uncle were carpenters. More specifically, they were *cassai,* or chest makers, a profession strictly related to that of painters. Not only did the *cassai* provide the "raw material" directly linked to painted decoration, but often the documents record the names of painters who defined themselves as *forzerinai* (chest or box makers) – hence, the custom for many of these masters to register themselves (in addition, or exclusively) in the Arte dei Maestri di Pietra e Legname (Stone and Woodworkers Guild) alongside the real *cassai,* a sign of their continuous interaction within the profession. Moreover, to reinforce the historical plausibility of Masaccio's apprenticeship under a *forzerinaio,* one should recall that his brother, lo Scheggia, subsequently enrolled himself at the very same Stone and Woodworkers Guild and to a

large extent developed much of his professional activity in connection with this type of employment.

Another place to search for Masaccio's possible apprenticeship is in the world of notaries. Indeed, the artist's father, despite his death at a very early age, exercised this profession, which, in addition to attesting to his high cultural and educational level (and consequent economic means and interest on the part of his family to expose Masaccio to it), placed him in contact with bookbinders and manuscript illuminators.[6]

What is more, there is a third family link that could have provided a professional relationship between the young Masaccio and an apprentice painter's ambience: the profession of his mother's second husband, the apothecary Tedesco di Maestro Feo, a wealthy widower from the same little town. However, since the marriage took place around 1412, it is likely that Masaccio already had begun his apprenticeship and therefore was under the aegis of his father's family. In this case, his stepfather's professional connections could have served to enlarge his circle of acquaintances, but they clearly were not the source of his training.[7]

Technical Characteristics of Masaccio's Earliest Works

Masaccio's initial apprenticeship under an artist who was dedicated to a specific branch of the "minor" professions could perhaps also explain a few of the technical characteristics of his earliest works. One example is his lack of familiarity with the fresco technique. Masaccio did not begin his activity as a painter in *buon fresco* (true fresco);[8] on the contrary, he seems to have learned the technique at a later stage, perhaps after coming into contact with Masolino. It must have been unusual for a painter to follow this type of "successive" approach to learning different pictorial techniques,[9] even if it was advisable to be acquainted with all of them. From this limitation, perhaps, came the necessity for the very young artist to move to Florence to further his own artistic education.

There is another technical detail, undoubtedly circumstantial but extremely specific, that points toward one of the previously suggested environments for Masaccio's training. In the *Cascia di Reggello Altarpiece* (see Plate 1), the first known autonomous work by the artist, the flesh colors of the figures in the main scene are outlined with a thin red line (Plate 44). Commonly, in painting of this time, one finds the use of a black line to mark contour lines;[10] the use of red seems to be more closely related to the tradition of manuscript illumination.[11] What does, however, differentiate this technical expedient employed by Masaccio from use of the black line is that it does not constitute an element of drawing. Rather, it is a true and proper phase of the painting and, what is more, a final phase. From the infrared investigation of the *Cascia di Reggello Altarpiece*, it is possible, in fact, to

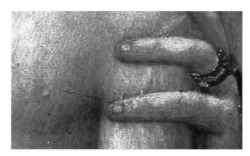

Plate 44. Red contour line, detail of Plate 1.
(Photo: Roberto Bellucci)

"read" both the traces of the underlying drawing and the superimposed layer of the skin tone of the figures, subsequently outlined in red, which does not coincide with the preparatory drawing. This could denote the use of a very refined and almost "luministic" style (hence the choice of red) to create an illusionistic effect that sets the two figures of Mother and Child on two different planes. At the same time, this line serves to enhance the constructive volumetric appearance of the bodies in a very naturalistic way: The black outline of the Florentine tradition, in fact, had the sole aim of separating the two different applications of juxtaposed color precisely. Here, instead, we are confronted with an element that additionally reinforces the fully evolved vibration of light and shadows that construct the forms. The fact that its presence has not until now been noticed by the numerous experts who have studied the painting is proof of its illusionistic and luministic function – an element that superbly fulfills its aim but is neither easily or immediately discerned.

In the *Cascia di Reggello Altarpiece,* the use of the red line is limited to the central panel, an aspect that should be examined both in the light of the problematic attribution of the painting[12] and with the aim of investigating the specific function that Masaccio assigns to this element: In the central section the artist was faced with the problem of differentiating between, and emphasizing, two extremely similar layers of skin tone. To such an innovative requirement of volume obtained through naturalistic lighting, Masaccio could not respond by using the conventional and unnatural black outline, traditional in such cases. The red line is probably his response to this requirement.

Our interpretation is further strengthened by the fact that this same technique may also be discerned in the *Sant'Anna Metterza* (see Plate 2), presumably the first collaborative work of Masaccio and Masolino that has come down to us, a painting closely following the *Cascia di Reggello Altarpiece.* Here again, we find the same need to differentiate between the two complexions and to emphasize the skin tones with respect to each other (Plate 45). In this painting, the red line seems to function more as a contour, given that another kind of study was being conducted by Masaccio at the same time. The sense of the figures' volume and their different planes, in fact, is achieved by strongly accentuating the intermediate area of shad-

Plate 45. Part of Virgin's hand grasping Christ's leg, detail of Plate 2. (Photo: Roberto Bellucci)

Plate 46. Virgin's hand grasping Christ's leg, detail of Plate 2. (Photo: Roberto Bellucci)

ing that the projection of one figure over another creates. This "medium value" almost appears to be joined in a certain area to reach a sfumato, where the boundary between one shadow and another is no longer clearly defined (Plate 46).

The Collaboration of Masolino and Masaccio

The *Sant'Anna Metterza* panel poses the question of collaboration between Masaccio and Masolino and the division of labor between them in this particular painting. Again something new may be added on this topic, even one so thoroughly discussed by scholars, from a technical point of view. The red "outline" is, in fact, discernible in both the figures of the Virgin and Child, whose execution is commonly attributed to Masaccio, but also in a few details, such as the angel with a censer to the right of the throne, executed by another hand (Plate 47). Upon closer examination of its technical characteristics, the attribution of the *Sant'Anna Metterza*, though appearing to be a homogeneous work, appears at the same time to be fairly complex. It is considerably difficult to distinguish between hands. We believe that the composition has been accurately studied and discussed by earlier critics. The traces of drawing on the gesso preparatory ground are, in fact, extremely limited and controlled. As to the actual execution of the painting, no qualitative advances are discernible, nor are there any distinct divisions between one area and another that would indicate a change of hands. The

final result is extremely controlled and offers the image of a professional "team" working in exceptional harmony. If we take into account the various hypotheses of attribution based on style, besides the traditional ascription of figures to either Masaccio or Masolino, we tend toward identifying a third artist for the censer-bearing angels and the likely intervention of Masolino on the Christ Child's body.[13] More than ever, we must appreciate the exceptional competence of a team that, working side by side on a relatively small area, succeeded in creating not only a very homogeneous artistic object but also one of very high quality.

The collaboration between Masolino and Masaccio must certainly have been a legally codified relationship according to the professional norms and laws of the time and not a simple, fortuitous, or spontaneous collaboration: Such a situation could never have occurred, considering the customs of the period and of the rigidly codified profession. After considering the documents, we can propose a chronological reconstruction of events that also, in some way, may contribute to clarifying the chronology of the

Plate 47. Angel with censer (left), detail of Plate 2. (Photo: Roberto Bellucci)

works by the two masters and to understanding reciprocal influences as well as stylistic and technical exchanges between them.

It therefore would appear that the return of Masolino to Florence coincided with the establishment of a professional association that preceded the one with Masaccio, an affiliation with Francesco d'Antonio, a minor artist from the circle of Lorenzo Monaco. The name Tommaso di Cristofano – Masolino – often recurs, in fact, in connection with that of Francesco d'Antonio, who acted as his guarantor in the very first of the Florentine documents for the lease on a house in 1422.[14] It is, on the other hand, more than likely that Masolino, absent from the Florentine scene until that date, and already thirty-eight years old, had been active outside the city and had only returned after a definite promise of work. Besides securing him the economic and professional support of an already well-established artist, a *compagnia* (professional affiliation) could also have freed Masolino from the burden of having to open a workshop and pay the considerable entry fee connected with this commercial practice.

Between the two artists, the business relationship (which should be common knowledge among scholars by now)[15] did not necessarily presuppose the joint running of the activity: The associates were only obliged to share profits and losses. But in the case of Francesco d'Antonio and Masolino, a possible artistic collaboration has been identified through the surviving fresco fragments (c. 1424) of the Cappella della Croce in the church of Santo Stefano degli Agostiniani in Empoli.[16] The association between the two artists was dissolved, perhaps upon natural expiration or maybe earlier, but certainly not on friendly terms, given that in March 1424, a legal transaction was required to settle a dispute between them.[17] The document is not specific as to the outcome of this litigation, but the fact that two artists were chosen as arbitrators clearly shows that they were considered competent to judge the subject of contention. The date of the document is evidently only the date the partnership was dissolved, but it attests to the fact that at that time, Masolino was definitely free of legal obligations and could, therefore, have established an association with another artist, this time with Masaccio. The fact that according to research, such associations were bound by a three-year renewable contract[18] inevitably brings us to the year 1425 as the expiration date of the new partnership, given that it coincides with Masolino's departure for Hungary.

In the *Sant'Anna Metterza,* there is another fairly specific technical element that in some way could confirm a few hypotheses regarding the origin of the "red line," and that also has implications for our attempt to trace Masaccio's likely formation. We are referring to the use of incision with a metal point to mark some of the internal graphic elements of the figures (Plate 48), a technique that has no precedent in underdrawings for panel painting.[19] This was, indeed, an extremely refined method, utilized for drawings on paper in addition to manuscript illuminations. It presupposed

Plate 48. Virgin's left eye (X ray), detail of Plate 2. (Photo: Roberto Bellucci)

a considerable mastery of the technique, since the incisions made by metal point could not be deleted later. Its use on a preparatory gesso ground could therefore:

1. reveal a habit of using the metal point so as to gain full mastery of the technique, in contrast to the more commonly used and easily correctible charcoal outline;[20]
2. indicate a confidence in the conception of the image to be outlined, probably presupposing the existence of a project separately and already worked out (given the impossibility of removing the incisions on the gesso without re-gessoing the panel from the beginning); and
3. allow us to hypothesize the artist's search for a more refined technique to outline details on the faces of the figures, perhaps in order to avoid any traces of drawing from showing through the flesh layers.

Technical Exchanges

The collaboration between Masaccio and Masolino encouraged many exchanges of a technical nature, which were far from being just one-way. Masolino, in fact, had considerable technical experience, presumably gained during the years of his travels outside of Florence, including technical acquisitions that did not belong to the Florentine tradition. If anything, they may be traced to the artistic culture of northern Europe. A few examples of this are the elaboration of flesh colors without the use of *verdaccio* (green underpaint); the introduction of different media, such as oil-based ones (perhaps the legendary *tempera grassa*, "fatty tempera");[21] and a distinctive use of metal leaf (gold leaf, silver leaf) beneath the colors for the execution of drapery. All these elements are, in any case, interpolated within a distinctively Florentine-based culture, and it is perhaps for this very reason that they were easily assimilated by a certain constituency of the Florentine artistic world, usually conservative and reluctant to respond to external influences.

In the very fertile years of association between Masolino and Masaccio (who had probably just experienced the influences and teachings of Brunelleschi), the two artists' diverse experiences and ideas were able to interpenetrate and, within an extremely limited period of time, produce a "single" culture sympathetic toward different needs. And it is here that, once more, the awareness of technical data may provide new avenues for further research. Indeed, Masolino's acquisition of a certain interest in perspective following his association with Masaccio has been easily recognized and understood, whereas Masaccio's parallel interest in his associate's non-Florentine culture has never been observed, nor has the significance of such an exchange been explored. What must, in fact, be taken into consideration is that in the artistic world of Florence during the very first decades of the Quattrocento, it became increasingly obvious that interests and innovative studies followed different paths, though they were not at the time experienced as antithetical. Foremost among these was the search for techniques that offered new aesthetic and expressive potential, no less significant than accurate spatial representation. From this point of view, therefore, both the offerings of Brunelleschi (which enabled Masaccio to overcome the inadequate spatial solutions of Lorenzettian origin in the *Cascia di Reggello Altarpiece*) and the most refined aesthetic proposals by Gentile da Fabriano (with the "variegated manipulation of materials . . . the constant interference of gold and silver, variously interspersed paint and varnish layers, informal incisions and punch marks"[22]) must have seemed equally interesting to a young man of the intellectual caliber of Masaccio on the brink of entering the professional limelight. Evidently, this was a question of two worlds that could only be reconciled if one of the two became the framing concept of the other. An increasingly elaborate attempt at this reconciliation continued throughout the duration of the partnership between Masaccio and Masolino.

Masaccio and Brunelleschi

If the *Cascia di Reggello Altarpiece* marked Masaccio's professional debut, surely in the very tight chronology separating it from the artist's subsequent production, some major event or significant experience must have occurred to explain his sudden artistic growth so soon after a beginning that, even though full of promise, was certainly still very rudimentary. This event cannot be explained other than by a sort of "apprenticeship" with Filippo Brunelleschi. Indeed, the close relationship between the two traditionally finds testimony from a very early date, beginning with the *Libro di Antonio Billi*, which, with great narrative succinctness, states, "He was loved by Filippo di ser Brunellesco, the great architect, because he saw that he was perspicacious of mind and he taught him many things in art."[23]

This relationship is the only explanation for an artistic change that has nothing evolutionary in it, but that presents all the energy of an electric shock.

Certainly the *Trinity* (see Plate 13), a work of controversial date, could be reread in this light. Nobody has ever doubted its strict Brunelleschian dependence, but careful scrutiny of its characteristic techniques, together with reconsideration of its creative genesis, could lead to considering it a fairly early work. From a technical point of view, in fact, the pictorial execution of the *Trinity* reveals the meager use of "San Giovanni white," a pigment notorious for its considerably difficult application in true fresco and requiring consummate skill in its mastery. In its place, Masaccio instead resorted to the expedient of exploiting the transparency of the white color of the plaster, a typical beginner's method in *buon fresco*.[24] Reconstructing the complex genesis of the *Trinity*, furthermore, allows us to reinterpret the relationship between Brunelleschi and Masaccio and, more generally, the relationship between the work's conception and its final realization. The complex illusionistic construction of a chapel that "breaks through" the wall and the first thorough application of Brunelleschi's theories to painting of course needed a precise preliminary study, which is unanimously attributed to the great architect. But what appears to be of particular, even obvious, interest, is that the study also evidently concerned the way to transfer the complex and theoretically constructed image to the wall. The discovery of various methods – snapped line, incision, pouncing, squaring, a few of which are found here for the first time, each one applied to conceptually different parts of the composition – may be interpreted as a demonstration of at least three different though perfectly complementary concepts:

1. that the creation of the perspective construction was left up to someone other than the artist who was responsible for putting it into practice and who, therefore, needed to follow a prototype in an almost obsessive way;
2. that the artist was new to mural painting and, therefore, needed to discover many means by which to ensure the precise enlargement of the model (note the different and multiple squaring of the chest and face of the Madonna: Plate 49);
3. that the "tutelage" of Brunelleschi was assiduously explicated in the preparatory phase and in the first half of the phase of transference to the wall (the left side of the wall painting), whereas the second half of this phase involved far less work, almost exclusively exploiting the symmetry of the architecture. But also from a pictorial point of view, with the passage of time, the artist seemed to appropriate the specific wall painting technique and almost entirely abandoned the "obsessiveness" of transferring the reference model.

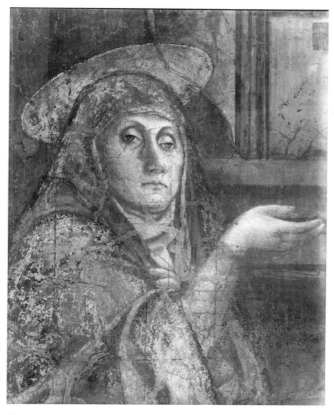

Plate 49. Virgin's face and perspective grid, detail of Plate 13. (Photo: Roberto Bellucci)

If the relationship with Brunelleschi and the possible consequences for Masaccio's artistic maturity are inserted within this brief moment, perhaps the kind of relationship created with Masolino (beyond the legal aspect of an association alone) becomes more comprehensible. It is indeed likely that the need to depend on another Florentine artist persisted for Masolino, who probably had no intention of settling permanently in the city, as shown by the later events of his life – his stay in Hungary and his subsequent travels to various parts of Italy. The extant documentation, for instance, makes no mention of his workshop, and it consequently could have proven very useful for him to rely on Masaccio. But from what could have been a purely practical expedient, the association evidently soon took on the form of a true and proper collaboration, with a reciprocal and notably advantageous exchange for both artists.

Besides the *Carnesecchi Altarpiece* (perhaps the first work from the association of Masolino and Masaccio, but of which there are, however, too few elements to evaluate), the *Sant'Anna Metterza,* as has already been

pointed out, shows an impressive formal unity and homogeneity of style, resulting from a consummate and perfectly adapted technique. The fact is particularly surprising since different techniques specific to each artist, belonging only to Masaccio (the red outline) or only to Masolino, are employed within the painting. Such is the case for the very refined cloth of honor with pomegranates, which hangs behind the sacred figures. It is executed with a semitransparent color (red lake) on a ground prepared with silver leaf and densely incised to simulate cloth. Of course, the use of metallic leaf as a base for the colors is not uncommon, and innumerable examples are found throughout Florentine painting up to this time. The special treatment of incision is, however, innovative and quite different from earlier techniques in its final effect. In fact, the incision is not carried out on the color so as to disclose the underlying silver, but directly on the metal leaf, even before the application of the pigment, in order to obtain the material effect of woven cloth, which may well have suggested the identity of a specific cloth, such as damask, to the contemporary observer.

The technical expedient of incising silver leaf and then glazing it, as we have just explained, was apparently unknown to Florentine painting prior to the arrival of Gentile da Fabriano and Masolino. The latter had put it into practice already in Saint Julian's garment of the dismembered *Carnesecchi Altarpiece*, whereas Gentile introduced it in his *Adoration of the Magi* (although he had already utilized it before his Florentine sojourn). For Gentile, a master from the Marches, this seems to be only one of many expedients of material enrichment in his artistic production. For Masolino, it is virtually the only late Gothic artistic effect.[25] Cennino Cennini's comprehensive *Il libro dell'arte* reveals that this technique was foreign to the Florentine ambience, for the practice is not mentioned. In fact, Cennini's precepts, given in Chapter LXXVI ("to paint a purple or turnsole drapery"),[26] and again in Chapter CXLIV ("how to do velvet, wool, and silk" on a wall and on a panel),[27] suggest completely different practical procedures. What remains to be understood is where Masolino learned this very distinctive treatment of silver leaf. The mystery that shrouds his activity before 1422 – certainly, years mainly spent away from Florence – does not help clarify the problem. The contemporaneous presence of Masolino and Gentile da Fabriano on the Florentine scene makes any attempt to establish the origins of the "incised silver leaf technique" futile on the basis of chronological precedents. Furthermore, in the same period (about 1423) its use is found, though purely sporadically and less skillfully, by other artists such as Alvaro Pirez (in the *Volterra Triptych*)[28] and the anonymous Maestro di Borgo alla Collina (in the work from which his name is taken),[29] both strongly influenced by Iberian contributions. In the current state of research, a non-Italian source for this unusual technique is not to be excluded.

The interesting aspect of this subject is that Masaccio would also adapt

this very particular and elegant motif during the years of his association with Masolino, as well as in autonomous moments of his artistic production. It is, in fact, found in the Washington *Madonna of Humility* and the London *Madonna and Child with Angels* (see Plate 14) from the *Pisa Altarpiece,* in addition to the *Sant'Anna Metterza* (Plate 50). In the first work, which is in very poor condition and therefore difficult to date,[30] the silver leaf has again been applied to the decorated hangings behind the Virgin. In the London *Madonna and Child* (1426), Masaccio exploits the technique acquired from Masolino in the Madonna's garment (Plate 51). We are here confronted with one of the more mature works of Masaccio's brief

Plate 50. Hanging behind Virgin's throne, detail of Plate 2. (Photo: Roberto Bellucci)

career, in which Brunelleschi's teachings are relived and flow into an autonomous vision, no longer didactic in its perspective. Having lost its aesthetic and material values, this refined late Gothic motif also is certainly employed to emphasize the regal character of the sacred figure as well as to serve as an expedient for her volumetric portrayal. In short, Masaccio, having fully understood the material significance of the "technical object," with intellectual devotion transforms it from a pure decorative and illusionistic element into one that portrays a body in space.

But another technical device from Masolino seems to strike a chord within Masaccio: the use of an oil-based binder. Despite what is generally believed, oil was well known in Italian art even in the Middle Ages, evidence of which is found in such technical sources as Heraclius and, yet again, Cennini. But what may be confirmed is that its use was fairly limited, coinciding with specific pigments that could only be employed with this medium. The use of oil, initially haphazard and later more common, as a true and proper pictorial medium, was established in Italy about the middle of the fifteenth century, even though it was often mixed with fatty temperas. From a historical point of view, studies are often still indebted to the myth created by Vasari that attributed the invention of the "secret" to Jan Van Eyck and its importation into Italy through the Venetian ambience.[31] On the other hand, more recent and systematic studies — for the most part, unknown to art historians — undertaken with the indisputable

Plate 51. Virgin's drapery, detail of Plate 14. (Photo: Roberto Bellucci)

support of scientific investigation, push the introduction of an oily binder (or an oily-resinous one) increasingly further back in time in Italy.[32]

From the oldest data, oil has been identified in the double-sided *Santa Maria Maggiore Altarpiece* by Masaccio and Masolino (see Plates 15 and 16).[33] On the basis, however, of analytical comparisons of an optical kind – infrared reflectography and radiography – it is possible to find the use of an oily medium even earlier by Masolino in works such as the *Carnesecchi Altarpiece*. And it is also possible to interpret its adoption by Masaccio in a few areas of the *Pisa Altarpiece*, though its use would appear to be limited to the architecture of the throne, where the ease of application conferred by this binder to the pigments allows the gray pigment to be spread with broad and covering brushstrokes (Plates 52 and 53). The fact that Masaccio utilizes it in such a selective way could be explained yet again by the great intellectual control of the artist, who probably intentionally chose to adopt it only in the wider, less modulated, and vibrant areas of

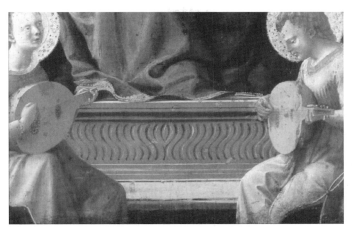

Plate 52. Step of Virgin's throne, detail of Plate 14. (Photo: Roberto Bellucci)

Plate 53. Step of Virgin's throne (X ray), detail of Plate 14. (Photo: Roberto Bellucci)

the pictorial representation. One of the typical uses of an oil binder by Masolino was, for instance, the skin colors, which instead were avoided by Masaccio, who preferred the more traditional tempera technique for these areas, even if – as already found on the *Cascia di Reggello Altarpiece* and indeed in all of his well-known works – the way in which he chose to do this considerably differed from that of Cennini, since he preferred to use a gray background color and reserved the green for areas in shadow.

A final note remains to be made concerning what infrared investigation has revealed of the complex alternation between Masaccio and Masolino in the *Santa Maria Maggiore Altarpiece*. The extraordinary research of Carl Strehlke and Mark Tucker has opened new possibilities of further in-depth study of this problem. From the simple confirmation of Masaccio's pres-

ence in the London *Saints Jerome and John the Baptist* (see Plate 17), our further study now suggests that he may also have participated in completing the other compartments, thus making the double-sided polyptych the last but most complete reiteration of the partnership between the two artists following Masolino's return from Hungary.

In addition to the alternation between the two artists during the first phase of the panel's execution – the Philadelphia *Saints Paul and Peter* (see Plate 19), as demonstrated by the discovery of "flesh" layers beneath the definitive version, executed in a different technique from the final one adopted by Masolino – it is possible to hypothesize Masaccio's participation even in the Philadelphia panel with *Saints John the Evangelist and Martin of Tours* (see Plate 18). Masaccio's intervention apparently ended even sooner here, although it is clearly seen, in our view, in the underdrawing of Saint John's face (Plate 54). Here Masaccio puts into practice

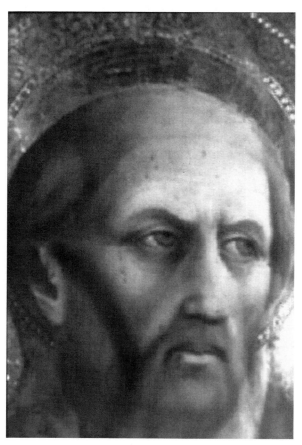

Plate 54. Face of Saint John (infrared), detail of Plate 18.
(Photo: Roberto Bellucci)

Plate 55. Croziers of Saints Blaise and Juvenal, detail of Plate 1. (Photo: Roberto Bellucci)

the same technique revealed in the *Cascia di Reggello Altarpiece* – in other words, strong, incisive outlining of the forms with chiaroscuro shading that constructs the volumes with an already strong plastic relief, striking enough to bring to mind only one other example, that of Giotto preceding him by a century. This justifies once and for all, and with technical evidence, the label of "Giotto reborn" so often applied to Masaccio.

This drawing, which the artist never intended to be seen by the public (destined as it was to remain hidden beneath the pictorial layers), probably only calls upon the rudimentary skills of the artist that were so deeply assimilated during the years of his apprenticeship and not subordinated to the rules of style and external influences. Therefore, for this very reason, it becomes an almost absolutely certain element in establishing attribution. On this basis, the Philadelphia *Saint John the Evangelist,* as well as the central and right-hand side panel of the *Cascia di Reggello Altarpiece,* may be ascribed to the same hand. Similarly, the comparison between two identical elements, such as the episcopal croziers of Saint Blaise and Juvenal in the *Cascia di Reggello Altarpiece,* becomes enlightening (Plate 55). Whereas that of Saint Juvenal is achieved with broad brushstrokes in the preparatory drawing, exploiting the transparency of the white preparation for the highlights and with a general, powerfully evocative effect of "architectural" volume of the structure, the pastoral staff of Saint Blaise is flatly and homogeneously portrayed. The preparatory drawing can, therefore, be compared to itself just as an expert in a law court can compare the handwriting in two different documents.

A Timetable for Masaccio's Chronology

Here we give an approximate estimate of the time actually required to complete the works of art definitely executed by Masaccio. It is, in fact, of considerable interest to be able to reconstruct the all-too-brief period, scarcely six years, of his artistic activity, one of a disconcerting intensity and fecundity. Considering the numerous debates, still ongoing, among critics partly on this aspect and on the place of his works, it will certainly prove a useful aid for future studies to shed light on such an important and often misunderstood technical aspect. Let us offer just a few preliminary remarks:

- the time to complete a panel painting excludes the making of the wooden structure, on the basis of the assumption that it was normally consigned to the artist already made; in case he had participated in its design, he was certainly not directly responsible for the actual construction of the support;
- the timetable also excludes the initial conceptual phase of the painting true and proper (preliminary studies on paper);
- it is usually inconceivable that long interruptions occurred during the painting stage: The preparatory layers are considerably fragile and easily susceptible to losing their optimal physical and mechanical properties (smoothness, elasticity, etc.), which were necessary for proper gilding and painting.

1. *Cascia di Reggello Altarpiece:* 3–6 months
2. *Carnesecchi Altarpiece:* 6 months
3. *Sant'Anna Metterza:* 3–6 months
4. Washington *Madonna of Humility:* 3 months
5. *Pisa Altarpiece:* approximately 1 year
6. *Trinity:* 23 giornate (plaster patches indicating a simple day's work) = 2–3 months' work
7. *Cardinal Casini Madonna:* 1–2 months
8. Brancacci Chapel: 100 days
9. *Santa Maria Maggiore Altarpiece:* approximately 1 year

6 The Altarpieces of Masaccio

Dillian Gordon

Only four altarpieces survive from Masaccio's short life, and yet, together with the frescoes of the *Trinity* and the Brancacci Chapel, they were enough to establish him as one of the most important artists of the Italian Renaissance, heir to Giotto, precursor of Michelangelo.[1] Of these four, only the one painted for Santa Maria del Carmine in Pisa in 1426 is documented, and it consequently forms the touchstone for all other attributions. The undocumented triptych for the parish church of San Giovenale, Cascia di Reggello, was painted four years earlier, in 1422. It is discussed first in this chapter since it shows the work of the young Masaccio with the nascent qualities and preoccupations that came to fruition in the *Pisa Altarpiece*, which is discussed next. In the period between the two works, Masaccio achieved an astonishing maturity and mastery in his painting. The reasons for this will be considered, including the influence of the sculptor Donatello, the architect Brunelleschi, and the painter Masolino, with whom Masaccio entered into partnership. Together they painted the Brancacci Chapel and the undated and undocumented altarpiece of *Sant'Anna Metterza*. Their collaboration continued with the double-sided triptych for Santa Maria Maggiore, Rome, which was almost certainly a papal commission and Masaccio's last surviving work before his death in 1428. Both altarpieces are problematic, since their date, original location, and patron are not certain. Although he may be better known today for his frescoes, Masaccio's altarpieces are crucial to understanding his origins, the development of his style, and his association with Masolino.

Masaccio's greatness was recognized by his contemporaries. And yet with each commission, at least one piece of the puzzle is missing. This chapter considers the four altarpieces with regard to their original location and patron, putting forward the arguments for the chronology followed here. It attempts to assess the formative influences on Masaccio's panel paintings

and discusses how far his frescoes influenced his altarpieces. Finally, it evaluates the influence that his altarpieces had on his contemporaries.

The *Cascia di Reggello Altarpiece*

The earliest dated altarpiece attributed to Masaccio first came to public attention in 1961 when Luciano Berti published a triptych (see Plate 1), shorn of pinnacles and frame, that was painted probably for the high altar of the small parish church of San Giovenale, Cascia di Reggello (now in the Pieve di San Pietro).[2] After cleaning, the fragmentary inscription with the date 1422, 23 April, became visible: [ANNO DO]MINI MCCCCXXII A DI VEN-TITRE AP[RILE]. Berti attributed it to Masaccio, and most scholars have accepted the attribution.[3] The altarpiece is fundamental to our understanding of Masaccio's formation and origins. In representing Masaccio's early style, it provides clues to his artistic training, which is unknown, as well as the artistic context in which he developed, and it demonstrates that by 1422, he was already an independent artist with his own workshop.

The Virgin and Child are enthroned in the center, the Child sucking his fingers and holding a bunch of grapes. The massive marble throne with decorative inlay dominates the central composition, which is united with the side panels by the floor, whose orthogonals finish at a single centric point.[4] Two angels dressed in pink are seen from the back, kneeling at the base of the throne, their faces in *profil perdu;* the left angel opens his arms, the right one folds his hands in prayer and adoration. The saints on either side are identified by fragmentary inscriptions and, as does the obligatory titular saint of the church, reflect the local cult and the devotion of private individuals. On the left, Saint Bartholomew holds a book and the knife with which he was flayed. Beside him is Saint Blaise (Biagio), whose cult was promoted at San Giovenale after a neighboring church dedicated to him was destroyed; he holds a bishop's crozier and a curry comb, symbol of his torture and martyrdom. In the right wing is Saint Juvenal (Giovenale), to whom the church is dedicated, and Saint Anthony Abbot holding a tau staff.

The presence of Saint Anthony helps to indicate that the triptych was almost certainly commissioned by a member of an important local family, probably Vanni di Michele di Vanni Castellani, who held many powerful positions in Florence, including master of the Zecca (mint), for the croziers in the painting form a V that alludes to his monogram.[5] When he died in March 1422, his sons inherited the patronage of the church of San Giovenale. The family had a particular devotion to Saint Anthony: Vanni's father commissioned Agnolo Gaddi's still extant frescoes for the Castellani Chapel dedicated to Saint Anthony Abbot in Santa Croce, Florence, and was obliged to make offerings to that church on the feast of Saint Anthony.

The presence of Saint Bartholomew is probably explained by the fact that the parish priest of San Giovenale was Francesco di Bartolomeo (= Bartholomew); he was also a canon at the church of San Lorenzo in Florence and may have taken charge of the commission, possibly keeping the altarpiece in Florence until 1441, when it is first recorded in an inventory of San Giovenale.

Until the discovery of the *Cascia di Reggello Altarpiece,* Masaccio's artistic origins were unknown, and the *Pisa Altarpiece* seemed, with the Brancacci Chapel frescoes, like a thunderbolt out of the blue. The *Cascia di Reggello Altarpiece* helped to contextualize Masaccio's early work. The similarities of this triptych to the *Vertine Triptych* of 1430 (Siena, Pinacoteca Nazionale) by Bicci di Lorenzo (1370/3–1452) suggest that Masaccio might have been in Bicci's workshop.[6] Not only the design of the altarpiece but also its iconography help to locate Masaccio's likely origins. The motif of the standing Child putting his fingers in his mouth while eating grapes occurs in the *Bibbiena Altarpiece* (Propositura dei Santi Ippolito e Donato)[7] by Arcangelo di Cola da Camerino, who worked with Bicci in 1421. Another painter in Bicci's shop was Masaccio's brother, Giovanni di ser Giovanni (lo Scheggia), who may have assisted Masaccio in Pisa in 1426, and who is documented working with Bicci in 1420–1.[8] Furthermore, Andrea di Giusto, later documented as Masaccio's assistant on the *Pisa Altarpiece,* was active in Bicci's shop during 1420–4. The connections with Bicci's shop are thus tantalizingly close. However, Masaccio's style of painting, with its formidable three-dimensionality, distinguishes his work from that of his contemporaries and cannot be explained merely in such a context: Only Giotto before him had achieved such monumental figures placed in a convincing space. The explanation probably lies partly in the influence of Giotto, compounded by Masaccio's profound response to sculpture.

Although it has been suggested that Masaccio may have worked as a sculptor in Bicci's shop,[9] this seems unlikely. An intimate knowledge of the work of Donatello is more plausible. Throughout his brief lifetime, Masaccio's debt to Donatello is prominent. It is evident as early as the *Cascia di Reggello Altarpiece:* Saint Juvenal's crozier (see Plate 55), for example, is held like that of Donatello's *Saint Louis of Toulouse* (see Plate 30), still unfinished in 1422, therefore implying that Masaccio had access to Donatello's workshop. The spread fingers of the Virgin closed protectively around her son's shoulder may be compared to a terra-cotta statue of the Virgin and Child (Washington, D.C., National Gallery of Art) attributed to Nanni di Bartolo or to Donatello.[10] The monumental, pyramidal mass of the Cascia di Reggello Virgin and Child could almost have been hewn from a single block of stone, and within the group, the Virgin's right hand firmly supports the weight of the Child with his feet shown in skillful foreshortening. The slanting of the crozier and tau staff is carefully positioned

to pinpoint the three-dimensional space in which the powerful figures of Juvenal and Anthony stand. This pair of saints is noticeably more monumental and more intensely characterized than Saints Blaise and Bartholomew, whose features and draperies are less sculpturally modeled, and they may have been painted by an assistant or collaborator.[11] The *Cascia di Reggello Altarpiece* is dated three months after Masaccio was admitted to the Painters Guild, the Arte dei Medici e Speziali, in Florence, and the presence of an assistant or collaborator indicates that he was by then an independent painter and had established a workshop. The *Cascia di Reggello Altarpiece* intimates the psychological realism that was to inform all of Masaccio's work: The angels, in turning their backs on the worshiper, engage the kneeling supplicant so that he or she is not just a spectator in the adoration of the Virgin and Child, but also a participant.

The *Pisa Altarpiece*

The next dated altarpiece, and the only documented work by Masaccio, is the altarpiece for Santa Maria del Carmine in Pisa painted in 1426.[12] There is likely to be a connection with the fact that the Brancacci Chapel was also a commission in a Carmelite church. In the *Pisa Altarpiece*, the latent qualities of the *Cascia di Reggello Altarpiece* reach their most powerful maturity. Although no contract survives, ample documentary evidence for this commission is provided by the detailed records of the patron, the Pisan notary Giuliano di Colino degli Scarsi, who kept accounts of the expenditures on his family funerary chapel.[13]

The altarpiece by Masaccio was part of a comprehensive program undertaken between 1414 and 1429 that involved the construction and furnishing of a family burial chapel.[14] Because the Carmine, a single-aisled, extremely tall church with a main chapel and two side chapels at the east end, was remodeled in the late sixteenth century,[15] it is impossible to ascertain the precise location and appearance of the chapel. However, from the documents one may deduce that it was a marble, vaulted baldachin that was placed against the choir screen and projected into the nave, on the south side.[16] The chapel had to meet the approval of the prior, Fra Antonio, as did the completed altarpiece,[17] and it is reasonable to assume that the design of the altarpiece and its program were decided by members of the Order, together with the patron, painter, and carpenter. The carpenter was a Sienese resident in Pisa, and it has been argued that Masaccio may not have been involved in the design.[18]

The first payment for the altarpiece was made to Masaccio on February 20, 1426,[19] and the final payment, bringing the total to 80 florins, was made on December 26 of the same year. Much of the altarpiece, which was com-

posed of at least three tiers, survives, although some panels, in particular the saints that flanked the Virgin and Child, are missing. Its original appearance has been reconstructed on the basis of Vasari's description (1568):

In the church of the Carmine in Pisa is a panel painting which is in a chapel of the roodscreen; it shows Our Lady with her son, and at her feet are some angels playing music, one of which is playing the lute and leans his ear with great attention towards the harmony of the sound; Our Lady is in the center with Saints Peter, John the Baptist, Julian, and Nicholas [on either side]; all the figures are very animated and lively. Below in the predella are small-scale narrative scenes from the lives of those saints, and in the center the three Magi are offering [gifts] to Christ; and in this part there are some horses, so beautifully depicted from life that one could not wish for better; and the courtiers of the three kings are dressed variously in the manner of those times. And above, at the top of the painting are several panels with many saints around a Crucifixion.[20]

The *Virgin and Child* (see Plate 14) formed the center of the altarpiece.[21] The Virgin is seated on a throne of gray stone ornamented by classical columns with Ionic, Corinthian, and composite capitals. She wears a dress of silver leaf with a red glaze, and a voluminous blue cloak; a transparent veil covers her head. Her halo contains lettering in pseudo-kufic script that approximates to the words AVE GRATIA PLENA (Hail [Mary] Full of Grace). On her knee is the naked Child, sucking his fingers and reaching for the bunch of grapes that his mother holds in her hand. At the base of the throne, two seated angels are playing lutes, and two angels, their hands joined in prayer, kneel at the sides. The four full-length saints who stood on either side – Peter, John the Baptist, Julian, and Nicholas – are lost. The predella (Berlin, Gemäldegalerie) below comprised three panels with narrative scenes from the lives of those saints. The *Adoration of the Magi* was below the Virgin and Child, and the two paired scenes below the standing saints showed the *Crucifixion of Saint Peter and the Decollation of Saint John the Baptist* and *Saint Julian Killing His Parents and Saint Nicholas Dowering the Daughters.*[22] The *Crucifixion* (Naples, Museo di Capodimonte) surmounted the main panel, as confirmed by the fact that it was painted on the same planks of wood as the Virgin and Child[23] and by the extreme foreshortening of the body of Christ, which was intended to be viewed from a kneeling position. Although Vasari does not identify the several saints that surrounded the *Crucifixion,* most scholars believe that they included two panels of similar format and carpentry to the *Crucifixion:*[24] *Saint Paul* (Pisa, Museo Nazionale di San Matteo) and *Saint Andrew* (Los Angeles, J. Paul Getty Museum). No other component from the upper tier is known to survive. Four small panels with *Saint Augustine* and *Saint Jerome* and two unidentified Carmelite saints (Berlin, Gemäldegalerie) are also thought to have come from the altarpiece, although opin-

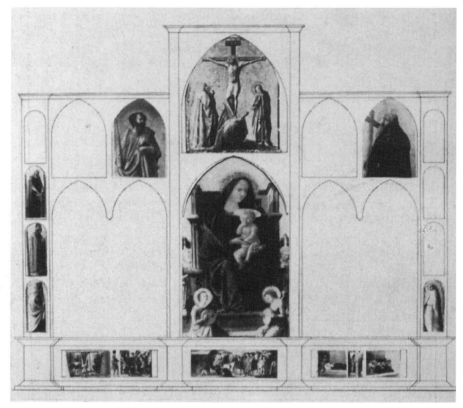

Plate 56. Reconstruction of *Pisa Altarpiece,* from Mario Salmi, *Masaccio* (Rome: Casa Editrice d'Arte Valori Plastici, 1932).

ions differ as to their position (Plates 56 and 57). Their presumed coun-
terparts, the Doctors of the Church, Gregory and Ambrose, are lost.

The program of the altarpiece was presumably determined by the
church's prior, who was closely involved with the commission, and the
patron, Ser Giuliano degli Scarsi, since it promoted name saints of Ser
Giuliano and his family. The altar itself was dedicated to Saints Julian and
Nicholas[25] in honor of the notary's patron Saint Julian (= Giuliano) and
the patron saint (Nicholas) of both his parents, who were buried in the
chapel with other members of the family; hence the choice of those saints
in the main tier. The scenes chosen from the lives of Saints Julian and
Nicholas in the predella both involve "family" incidents connected with
parents and with daughters. It has been proposed that the missing panels
of the upper tier could have represented Saint James (Iacopo), patron
saint of Giuliano's wife, Iacopa,[26] and Saint Mark for Giuliano's nephew.
John the Baptist, patron saint of Florence, may have been included in the
main tier because Florence at that time controlled Pisa, and Peter may

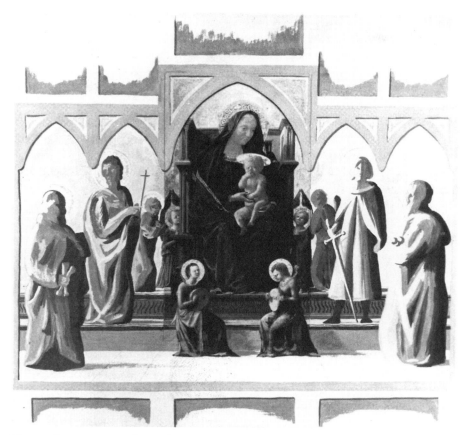

Plate 57. Reconstruction of *Pisa Altarpiece*, from John Shearman, "Masaccio's Pisa Altarpiece: An Alternative Reconstruction," *Burlington Magazine* 108 (1966).

have been depicted either as a reference to Giuliano's grandfather, Pietro, or to the papacy.[27] The small-scale panels of Carmelite saints, probably placed in the pilasters at the sides, may have been the only reference to the Carmelite location of the altarpiece.[28]

Although the component panels of the altarpiece are known, the form the altarpiece took – whether it was a comparatively old-fashioned, multi-tiered polyptych of several compartments or a more progressive altarpiece with a unified picture surface – and the related question of how the upper tier was completed have been the subject of debate. Most previous reconstructions of the altarpiece have proposed that it was a medieval polyptych with the main tier divided into three distinctive parts.[29] However, it has also been suggested that the Virgin and Child panel was originally part of a unified surface (see Plate 57) in which the coherent space and light with cast shadows drew the central figures and side saints into a revolutionary form of altarpiece, a *sacra conversazione*, which was to become common in the

Renaissance.[30] Although one cannot be sure, the most likely solution is that the altarpiece was indeed a conventional multitiered polyptych.[31]

Although the design may have been somewhat traditional, the symbolism of the Child sucking his fingers and holding grapes, recalling the Blood shed on the Cross, is extraordinarily developed. The eucharistic symbol of the grapes was especially significant to the Carmelites, whose litanies included the theme of the Virgin as a vine.[32] However, several surviving examples, including the *Cascia di Reggello Altarpiece,* suggest that it was a motif that evolved independently of a Carmelite context, even if chosen in this instance because peculiarly apposite to their liturgy. The eucharistic association is reinforced vertically,[33] from the *Crucifixion* above the main panel, to the step of the throne whose strigillated pattern is found on Roman and early Christian sarcophagi,[34] of which there were numerous examples in Florence and in the Pisa Camposanto.[35]

The imposing bulk and monumentality of Masaccio's figures show a response to sculpture that is characteristic of all of his paintings. The influence of the local sculpture of Giovanni Pisano, particularly in the Virgin and Child in both the main panel and the central predella, has been observed,[36] and some motifs have been taken from the Pisa Pulpit of Nicola Pisano, further demonstrating Masaccio's receptivity to local artistic tradition.[37] At the same time comparisons with Donatello's sculpture are again particularly close: *Saint Andrew* has been related to his *Saint Louis of Toulouse* (see Plate 30) and *Saint Paul* to *Jeremiah.* The relationship is not fortuitous: Donatello was working in Pisa at the same time as Masaccio,[38] preparing the tomb of Cardinal Rinaldo Brancacci for shipment to Naples.[39] On July 24, 1426, he collected a payment on behalf of Masaccio, and on December 18, 1426, he witnessed one of the payments due to Masaccio.[40]

No one has ever questioned that Masaccio himself was responsible for the central panel. Regardless of its damaged condition, the outstanding conception and quality of execution are apparent in the deep psychological insight in the depiction of the Virgin contemplating the future suffering of her baby; the harmonious palette of blues, pinks, and lilacs; the imposing monumentality of the figures; and the sculptural modeling of the anatomy and drapery. The central panel is revolutionary in many ways: the strong unifying directional light coming from the left, found also in the predella; the cast shadows on the back and steps of the throne; the glazes around the neckline of the Virgin's dress, and in the reflection of the Child's hair in his halo; the sense of three-dimensionality, most obvious in the elliptical halo that places the Child in space and whose forward rim is more densely punched than the rest in order to look like a disc; the organization of the few orthogonals around a somewhat approximate vanishing point converging on the heel of the Child's right foot; and the brilliantly foreshortened lute, whose pegs catch the light. The Corinthian and Ionic

columns and the gray stone of the throne reflect the interest in the classi-cizing architecture of Filippo Brunelleschi.[41] Although the overall quality of painting is high, some parts of the predella panels are less accom-plished. They may have been painted by assistants, possibly Andrea di Giusto, identified as Masaccio's *garzone* (apprentice) in a payment for the altarpiece.[42]

Only four years had elapsed between the *Cascia di Reggello Altarpiece* and the *Pisa Altarpiece*. What was it that precipitated Masaccio into such intellectual and formal maturity? Certainly the Pisan work reflected a deepening of the qualities and preoccupations nascent in the *Cascia di Reggello Altarpiece:* the study of sculpture; the exploration of single-point perspective; the unifying quality of light; and a deeper liturgical symbol-ism and psychological insight. Of major significance, however, is the symp-tomatic transformation from the Gothic marble throne of the *Cascia di Reggello Altarpiece* to the Brunelleschian, architectonic throne made of gray stone and incorporating classical columns. The influence of Brunelleschi, manifested first in the fresco of the *Trinity,* was radical. Of equal importance must have been Masaccio's partnership with Masolino, since this collaboration brought with it a major commission – the experi-ence of painting the Brancacci Chapel – that involved working on an extended monumental scale with all the discipline of design, lighting, and perspective that such a complex cycle entailed.

The *Sant'Anna Metterza Altarpiece*

It is not known when, how, and why Masaccio entered into collaboration with Masolino.[43] The close-knit association between the young Masaccio and his older contemporary Masolino is first indisputably in evidence in the *Sant'Anna Metterza* (see Plate 2), generally dated between 1423 and 1425. The altarpiece shows Saint Anne with the Virgin in her lap, and the Child on the Virgin's knee ("Saint Anne as three" = Sant'Anna Metterza) with angels on either side, two of whom swing censers. The altarpiece is not documented but is mentioned by Vasari, who saw it in the church of Benedictine nuns, Sant'Ambrogio, Florence, and in his life of Masaccio ascribed it to him.[44] It was probably (although not certainly) painted for that church, and was likely an independent panel. Its iconography, which had several precedents in Florence where the cult of Saint Anne was pro-moted, is also likely to have been chosen because it reinforced the Rule of Saint Benedict and obedience to the convent's Mother Superior, with the Child representing the fruits of monastic obedience. Inscribed on the throne step, AVE MARIA GR[A]TIA PLENA DOMINUS TECUM BE[N]EDICTA TU (Hail Mary full of grace, the Lord is with you, blessed art thou) refers to the conceiving of Christ, and the bodies of the three figures apparently

emerging one from the other reflect the mystery of the Incarnation. Additionally, its iconography alluded to the cults of Corpus Domini and the Immaculate Conception – the chief cults celebrated at Sant'Ambrogio – embodied later in Filippo Lippi's *Coronation of the Virgin* (1439–46) for the high altar of the church.[45]

The *Sant'Anna Metterza* is crucial to our understanding of the close relationship between Masaccio and Masolino. Although Vasari lists it in his life of Masaccio, stylistic distinctions between the figures indicate that this is a collaborative work. The passages painted by Masaccio reveal vigorous modeling in light and shade, convincing foreshortening, and a robust sense of form. By contrast, those parts executed by Masolino employ a lighter and more delicate palette and the figures are more flatly painted. The execution seems to have been equally divided. The cloth of honor, made of silver leaf with a red glaze, is not unlike the robe of the angel in the Washington *Annunciation* by Masolino, and is probably by him. Masaccio is usually given the Virgin and Child, and the middle angel on the right whose bold red and green dress, combining the colors of the uppermost angel, stands out among the pale yellows and pinks of the rest; attribution of the head of Saint Anne is debated. However, while the Child's head is vigorously modeled in emphatic light and shade and must be by Masaccio, there is a clear juncture at the base of the neck where the more flaccid body begins, and this part (even allowing for its poor condition) must be attributed to Masolino.[46] Experience in painting in fresco (and the divisions of labor of *giornate*) makes this type of piecemeal collaboration unexceptional. It is quite possible that the two artists were contemporaneously engaged upon the frescoes in the Brancacci Chapel. However, while distinctions can be made in the execution, it is impossible to say exactly who designed the whole altarpiece. The Virgin's eyes and mouth and some other parts of the painting have been drawn with something other than a brush, perhaps silverpoint, which may have been done by Masaccio over the first design by Masolino, while the other parts are drawn with a brush.[47] What is probably due to Masaccio is the concealing of part of the inscription by the curve of the throne's step, a device later to be used with exceptional brilliance on the Baptist's scroll in the *Santa Maria Maggiore Altarpiece*. It is reasonable to suppose that the older and more experienced Masolino received the commissions for both works and signed the contracts, but that the division of labor was equal.

The *Santa Maria Maggiore Altarpiece*

From September 1, 1425, to around the middle of 1427, Masolino was in Hungary.[48] This explains why he was not involved in the *Pisa Altarpiece* in 1426. It seems that when he returned from Hungary, he joined forces again

with Masaccio to paint a double-sided altarpiece for the Roman basilica of Santa Maria Maggiore. This was one of the most important churches in Roman sacred life: Not only was it one of the five papal basilicas in Rome, but it also held a sacred icon of the Virgin Mary and a relic of the holy crib, and as such was a major center for pilgrimage.[49] The altarpiece, which is attributable on stylistic grounds to Masaccio and Masolino, was described by Vasari in his life of Masaccio:

He also painted several panels in tempera, which in the troubles of Rome have all been lost or displaced. One [is] in the church of Santa Maria Maggiore, in a little chapel near the sacristy, in which there are four saints very well executed, who seem to be in relief; and in the center the Miracle of the Snow; and the portrait of Pope Martin as if from life, who is drawing the foundations of the church; and near him is the Emperor Sigismund II. . . .[50]

Reconstruction of the triptych (see Plates 15 and 16) has been proposed on the basis of Vasari's description, the common provenance of its components, its dimensions, and stylistic congruence.[51] The three panels of the main tier were originally painted on both sides of three single planks and subsequently sawn apart into six paintings: One lateral panel showed *Saints Jerome and John the Baptist* (see Plate 17) on one side, and *Saints Gregory and Matthias* (see Plate 20) on the other (both London, National Gallery), while the front and back of the other lateral panel showed *Saints Paul and Peter* on one side, and *Saints John the Evangelist and Martin of Tours* on the other (see Plates 19 and 18). In the center was the *Miracle of the Snow and the Foundation of Santa Maria Maggiore* on one side and the *Assumption of the Virgin* on the other (both Naples, Museo di Capodimonte).[52] The original combination of scenes and saints cannot be reconstructed precisely and therefore has to be hypothesized on the evidence offered by Vasari (who saw only one side), on the iconography, and on the patronage. It is likely that one side consisted of *Saints Jerome and John the Baptist,* the *Miracle of the Snow and the Foundation of Santa Maria Maggiore,* and *Saints John the Evangelist and Martin of Tours,* while the other showed *Saints Paul and Peter,* the *Assumption,* and *Saints Gregory and Matthias.*[53]

Double-sided altarpieces are relatively rare and occur either in response to a local tradition, such as those in Umbria,[54] or to a particular location, such as Duccio's *Maestà* for Siena Cathedral.[55] In this instance, the direct prototype was probably the *Stefaneschi Altarpiece* in the papal basilica of Old Saint Peter's in Rome, but it may also have owed something to Roman double-sided rectangular triptychs with standing figures in the shutters.[56] The narrative scenes and choice of saints in the altarpiece each had a particular relevance to the history and special devotions of Santa Maria Maggiore and to the likely patron. The *Miracle of the Snow* depicts the foundation of the church itself and commemorates one of the main feasts

celebrated at the basilica, the Feast of the Snow (August 5). The other side showed the Assumption, one of the major Marian feasts, celebrated on August 15 throughout Christian Europe, and with great ceremony at Santa Maria Maggiore.[57] The saints shown were also closely tied with Santa Maria Maggiore. The depiction of Saint Matthias, a saint rarely represented, is explained by the fact that his remains were among the principal relics of Santa Maria Maggiore,[58] while Saint Jerome is shown because his relics had been translated to Santa Maria Maggiore by the end of the thirteenth century, and an altar there was dedicated to him.[59] The identity of the papal saint shown with Saint Matthias is uncertain. Although in the past he has been identified as Pope Liberius (elected May 22, 352; d. September 24, 366), it has been plausibly suggested that he could represent Pope Gregory the Great (590–604), who had strong links with Santa Maria Maggiore and whose cult was promoted by Martin V, the reigning pope when the altarpiece was painted and probably the commissioner of the altarpiece.[60]

The other saints almost certainly relate to the patron of the altarpiece and its location. The patron is likely to have been Pope Martin V (elected November 11, 1417; d. 1431), a member of the Colonna family, whose traditional association with Santa Maria Maggiore dated back to the thirteenth century.[61] Cardinal Giacomo Colonna (d. 1318), cardinal deacon of Santa Maria Maggiore, who is shown kneeling in prayer in the apse mosaic of the *Coronation of the Virgin* (1295) by Jacopo Torriti, was buried in Santa Maria Maggiore.[62] He is represented kneeling opposite his brother, Pietro (d. 1326), who also was buried in Santa Maria Maggiore, on the mosaics of the facade, which include the Colonna arms and the scene of the Miracle of the Snow.[63] There was therefore an early and close association of the Colonna family with this theme and with the church itself. The heraldic references on the altarpiece are to the Colonna family: Saint John the Baptist's cross is unusual in being supported by a column (column = *colonna*); the cope of Saint Martin, embroidered with the letter "M," is decorated with the Colonna arms on the orphreys. Saint Martin, Bishop of Tours, shown in the right-hand panel, was the patron saint of Pope Martin, who was elected pope on Saint Martin's Day and whose portrait was said by Vasari to have been in the altarpiece. Martin V was in Florence from February 1419, where he could have had contact with Masaccio and Masolino. He returned to Rome in 1421 and concerned himself with the refurbishment and redecoration of Roman churches. Thus, the theme of renovation and beginning is prominent in the altarpiece. Jerome's text is from Genesis I and describes the beginning of the world. The *Miracle of the Snow* with the founding of the church of Santa Maria Maggiore is symbolically set against the Sabine hills, locating it topographically in Rome, where Martin V restored the papacy after the Schism (1378–1417) and began the renewal of the Church.[64] The altarpiece was probably painted for one of the Colonna family chapels, which was dedi-

cated to Saint John the Baptist; this would explain the presence of that saint. Although the Baptist is often balanced by Saint John the Evangelist, it has been suggested that John the Evangelist was included in the altarpiece for Pope Martin V's brother, Giovanni.[65]

The Colonna family chapel, situated in the southern transept, probably doubled as the chapel in which the canons of Santa Maria Maggiore said Mass. Although in the past it was thought that the altarpiece had been located on the high altar,[66] it is, in fact, more likely that the high altar had a ciborium over it, as in other papal basilicas. At Santa Maria Maggiore, only the pope was allowed to say Mass at the high altar, and so the canons needed an altar at which to celebrate Mass.[67] It is likely that the *Miracle of the Snow* showing the foundation of the basilica itself faced the nave of the church,[68] with the armorial devices thus prominent on the front of the altarpiece.[69] The celestial radiance framing the Virgin and Christ in the *Miracle of the Snow* would have provided a visual link with the apse mosaic above the high altar, in which starry orbs encircle the Mystic Lamb and Christ crowning the Virgin in the center of the triumphal arch.[70] For the canons, the link with the high altar would have been the subject of the *Assumption* itself, since the inscription beneath the apse mosaic of the *Coronation of the Virgin* derives from the liturgy of the Assumption: MARIA VIRGO ASSU[M]PTAE AD ETHEREV[M] THALAMV (the Virgin Mary taken up into her heavenly chamber);[71] the angels in the Assumption echo those in the mosaic.[72]

The date of the *Santa Maria Maggiore Altarpiece* has been disputed.[73] However, using the altarpiece painted for Pisa in 1426 as a comparison, one may argue that the powerful features of Saint Jerome are more advanced than those of Saint Paul.[74] This would mean that the altarpiece was probably begun after August 1427, when Masolino returned from Hungary after an absence of nearly two years. Technical analysis has shown that the altarpiece was begun by Masaccio, probably together with Masolino, and completed by Masolino alone, probably after the death of Masaccio in June 1428. By examining differences of style and technique within the painting, it is possible to distinguish which parts were painted by Masaccio and which by Masolino, and thus arrive at some hypotheses regarding the circumstances surrounding the commission. The hiatus in execution may be linked to one of the most unusual and puzzling features of this altarpiece, namely the major changes that were made when the actual painting was well under way.[75]

Most critics agree that the panel with *Saints Jerome and John the Baptist* is attributable on stylistic grounds to Masaccio.[76] Scientific examination has shown that the flesh painting in this panel has the customary underlayer of green earth (*verdaccio*), and that it is painted in the classic egg tempera technique throughout, whereas the panel showing *Saints Gregory and Matthias* is painted in a different technique called *tempera*

grassa, where a mixture of egg and oil is used to bind the pigment.[77] In the painting of the flesh, there is no green underpaint; instead it was done with a solid, very pale underlayer made up mainly of lead white with a trace of red lead, with the result that the flesh tones are ruddier in appearance. These differences in technique imply that a different painter was involved, who, on the basis of stylistic comparisons, is considered to be Masolino. Similar distinctions of technique and style are to be found in the panels in Philadelphia, complicated by the fact that when painting had already been begun, the identities of the four saints were switched: Saints Peter and Paul were reversed by changing attributes and physiognomies, and similarly Saints Martin and John the Evangelist changed places.[78] In accordance with contemporary practice, those areas that were to be gilded or silvered (keys, sword, crozier) had been executed before painting began: The shadow of Paul's silver-leaf sword can be detected in X-radiographs beneath the present Peter's robe, which is painted over it, and was originally held in the hand that now holds the keys. Similarly, the shadow and incisions of Peter's gilded keys, now painted over, can be detected in X-radiographs in the hand in which Saint Paul now holds his sword.[79] The figure of Saint Martin was originally intended to be Saint John the Evangelist: His miter has been painted over a tooled halo. The halo of the present John the Evangelist has been additionally tooled where a gap had been left for the mitre, and he originally carried a bishop's crozier.[80]

In the Philadelphia panels, scientific examination has shown that Masaccio had begun painting the hands and feet of Saints Peter and Paul in an egg tempera technique. When the identities were changed, the hands were scraped back in part and repainted in order to adapt them to holding different attributes. This was done by Masolino, who then completed the figures. The panel with *Saints John the Evangelist and Martin of Tours* was begun by Masolino, who first painted the faces; when the identities were switched, these areas were scraped and repainted in the same technique.

It is possible to argue that the whole panel with *Saints Jerome and John the Baptist* and parts of the Philadelphia panels were begun by Masaccio, who, for an unknown reason, possibly his death around June 1428, ceased to work on the panel. It was completed by Masolino, who alone designed and painted the central narrative scenes of the *Assumption of the Virgin* and *Miracle of the Snow.*[81] It is impossible to say whether Masaccio began the altarpiece alone or whether they began it together. In view of their previous collaboration, the latter is likely to be the case, in addition to the fact that Masolino was apparently responsible for both central panels alone, suggesting that he was involved from the beginning. It is also impossible to determine whether the changes made to the identities of the saints were made after, or occasioned by, Masaccio's death in June 1428, whether Masolino implemented them for aesthetic reasons,[82] or whether they were

instigated by the patron. Certainly the changes gave greater prominence to Pope Martin and the Church by moving Saint Martin forward and Peter into the place of honor (on the right of the Virgin).[83] The pope's armorial devices also achieve greater impact in their present position.

The altarpiece clarifies the full nature of Masaccio's genius cut short by death. Symptomatic of the new realism Masaccio brought to the art of painting is the incipient movement in the Baptist's legs as he begins to walk across the desert terrain dotted with flowers; his sorrowful expression, prescient of Christ's Passion; the extraordinary virtuosity of the painting of the letters around his curling scroll; and the way in which the light falls across Saint Jerome's book as its pages begin to open.

Masaccio's altarpieces were not at all remarkable in the design of their wooden structure: They were all traditional polyptychs of a type used until at least the middle of the fifteenth century. However, Masaccio used the polyptych format in an unprecedented way. He brought to the art of panel painting a new monumentality, a new gravity, and psychological and visual realism. Of course, previous painters had looked to sculpture for inspiration, and Giotto's painting, too, had been monumental, but Masaccio's response to sculpture in particular created a three-dimensionality in his paintings. Even when painting on a small scale, as in predella or pilaster panels, his figures were created with realistic modeling in light and shadow and stand in a measurable space. Likewise, he brought to panel painting the experience of working on a monumental scale, and of unifying complex scenes on the walls of chapels with a single light source and credible perspective. His influence on Florentine painters, including Masolino, was immediate. Images from the *Pisa Altarpiece* were especially important to contemporaries and later artists. The Virgin and Child in particular were widely imitated. In the later 1420s, Fra Angelico briefly took up a Masacciesque style of painting – as in the *Virgin and Child with Grapes* (Princeton, Barbara Piasecka Johnson Collection),[84] which is deeply derivative from Masaccio's *Pisa Altarpiece* – before reverting to a more elegant, elegiac sweetness and grace. In the 1440s, Piero della Francesca copied the *Crucifixion* in his *Misericordia Altarpiece* for Borgo San Sepolcro. It seems apt that when Vasari and Michelangelo studied the *Santa Maria Maggiore Altarpiece* together,[85] Michelangelo should have praised it highly, since it was he, perhaps more than any other painter/sculptor, who took up the inheritance of Masaccio.

7 Masaccio in the Brancacci Chapel

Diane Cole Ahl

> It is the habit of nature, that when she makes someone very excellent in
> any profession, he does not stand alone.
> Giorgio Vasari, *Life of Masaccio* (1568)[1]

Of all the works of Masaccio, the Brancacci Chapel in Santa Maria del
Carmine seems most crucial to our understanding of his contributions to
Renaissance art and his place within it (see Plate 3). Painted by Masolino
and Masaccio around 1425 and left unfinished until its completion by Fil-
ippino Lippi in the 1480s, the cycle portrays the original sin of Adam and
Eve and its redemption through the life of the apostle Peter, Christ's vicar
and first pope. To many, these scenes seem to illustrate the dichotomy
between tradition and innovation: what is generally deemed the late
Gothic style of the older Masolino, and the nascent Renaissance sensibil-
ity of Masaccio, an artist, Vasari proclaimed, "so far in advance of that
which had been painted until his time that his work surely can stand com-
parison in its drawing and color to anything modern."[2] For Vasari, who
devoted much of his life of Masaccio to praise of the chapel, the frescoes
became "a school of art for the most celebrated sculptors and painters,"
from Fra Filippo Lippi through Leonardo da Vinci, Raphael, and "the most
divine Michelangelo."[3] Vasari's glorification of the Brancacci Chapel – as
a monument so reflective of Masaccio's genius that it seemed to transcend
time instead of being a product of its moment – has decisively shaped the
way in which we have been led to think about the chapel to this day.

Our distance from the Brancacci Chapel has increased dramatically
since Vasari wrote his encomium in the mid-sixteenth century. Notwith-
standing his praise, the chapel was regarded as outmoded 200 years after
its completion.[4] In the 1670s, the vogue for *pietre dure* inspired the addi-
tion of marble wainscoting, an elaborate balustrade, and a new altar and

frame for the *Madonna del Popolo,* which had been installed in the chapel by 1454.[5] Between 1746 and 1748, the original vaults, painted with the four evangelists by Masolino, were replaced by Vincenzo Meucci's *Madonna Giving the Carmelite Scapular to Saint Simon Stock,* a fresco whose disproportionately large figures dwarf the scenes below.[6] Joining Meucci's dome to the walls, architectural vistas by Carlo Sacconi obliterated Masolino's lunettes of the *Calling of Peter and Andrew* and *Saint Peter Walking on Water.* Replacing the *Denial of Peter* and *Feed My Sheep,* known only through their sinopie,[7] a wide, arched window was installed above the original Gothic one. After the fire that swept the Carmine in 1771,[8] restoration was undertaken to recover a luminosity lost centuries earlier, with unsatisfactory results.

Throughout much of the twentieth century, the Brancacci Chapel was regarded primarily as a problem of connoisseurship – for Roberto Longhi, echoing Gaetano Milanesi, perhaps *the* single most important and intractable one in all of fifteenth-century art![9] – to which innumerable solutions were proposed. Restoration of the frescoes, undertaken between 1984 and 1990, has resolved many questions concerning its authorship while revealing new information about the style, technique, and collaboration of the artists.[10] Freed of the dirt of centuries and residue from the fire of 1771, the chapel's colors are no longer lugubrious but appear bright and luminous, in absolute accord with those found in late Trecento and early Quattrocento frescoes. The recovery of several fragments and of sinopie for the scenes above the window has brought us closer to the artists' intentions while raising new questions about their collaboration.[11] Over the past few decades, documents concerning both the artists and Felice Brancacci, the patron of the decoration, have come to light.[12] We now know more about the Brancacci Chapel as a work of art than earlier generations ever could have foreseen or imagined.

At the same time, much about the Brancacci Chapel eludes us as modern-day witnesses to its fame. We are precluded from knowing the work by our remoteness from the fifteenth century, our tendency to heroize Masaccio, and our obsession with attribution and dating, matters of less concern to its original audience. We can no longer view the church as it was when the murals were begun, for virtually nothing remains of the Carmine's original decoration: the Gothic vaults; the stained-glass windows of saints and martyrs; the chapels frescoed by such late Trecento masters as Agnolo Gaddi, Spinello Aretino, Lippo d'Andrea, and Starnina.[13] Finally, we cannot experience the Brancacci as did the devout in the Quattrocento or even as did scholars through the early 1980s. Isolated from the rest of the church and accessed by a separate entrance, the chapel is a monument that we now view as spectators who must pay to regard its display.

This chapter seeks to situate the Brancacci Chapel within the historical and patronal ambience of Santa Maria del Carmine and the artistic

practices of the early Renaissance. To create a context for understanding the Brancacci Chapel, we begin by discussing the Carmine and the art visible in the church at the time that Masolino and Masaccio painted the frescoes. We then turn to the history of the chapel and the Brancacci family, focusing on Felice Brancacci, under whose aegis the paintings were commissioned. Next, the iconography and program of the murals are considered. A discussion of the frescoes, their date, and the collaboration of Masolino and Masaccio follows. We conclude by placing the chapel within the devotional context of the Carmine and its decoration.

Santa Maria del Carmine and Carmelite Devotions

Founded in 1268 in the working-class parish of San Frediano, Santa Maria del Carmine was one of several monastic foundations established in Florence in the thirteenth century.[14] The special distinction of the Carmelites among all religious orders lay in its purported antiquity. The Carmelites professed their descent from the Old Testament prophet Elijah, who, they asserted, had originated an eremetic form of monasticism on Mount Carmel predating the birth of Christ.[15] To signify the Order's origins in the Holy Land, Carmelites followed the liturgy of the Holy Sepulcher in Jerusalem;[16] to honor their patron, the Virgin Mary, alleged to have visited the early hermits on Mount Carmel, the monks celebrated her feasts with special ceremony and displayed icons of the Madonna and Child.[17]

Notwithstanding papal approval of the Order in 1226, the legend of its descent from Elijah was challenged frequently. As early as the *Historia orientalis* of Jacobus de Vitry (c. 1250), the Carmelite claim to antiquity was denied and its origins dated only to the Crusades (begun 1096).[18] Throughout the Middle Ages and Renaissance, the Order sought to assert its venerable foundation by Elijah, as attested by public disputations as well as by its art.[19] In Carmelite churches, icons and panels of the Madonna and Child were venerated as ancient images brought from the Holy Land, in evident testimony to the Order's antiquity.

From its foundation, the Florentine church of Santa Maria del Carmine was renowned for its possession of the monumental *Madonna del Popolo,* then believed to have been transported from the Holy Land before its occupation by the Muslim infidels in the seventh century.[20] The original location of the *Madonna* within the church is unknown. Although it generally has been assumed that the panel once was placed on the high altar, it instead may have served as *la tavola di nostra Donna* (the painting of our Lady) for the chapel of an important confraternity, the Compagnia di Santa Maria del Carmine.[21] This confraternity, established by 1280, was a *laudesi* (laud-singing) brotherhood, whose members met to pray, sing songs of praise to the Virgin on selected church feasts, and commemorate their dead brethren. Believed to possess great miracle-working powers,[22]

the *Madonna del Popolo* received pleas for grace from the populace and the prayers of women who sought cure of their infertility. In 1406, the spoils of war from Florence's defeat of Pisa were placed before the image. At that point, the *Madonna* may already have been moved to the Brancacci Chapel. By 1454 if not earlier, a sodality of pious women had been founded to care for both the image and the chapel.[23]

The Carmine also was famous for its performance of the *sacra rappresentazione* (mystery play) of the Ascension of Christ. This mystery play was performed on the feast of the Ascension as early as the 1390s by the Compagnia di Sant'Agnese, a confraternity that maintained an altar in the Carmine and counted many artists among its members.[24] Performed in the nave outside the Brancacci Chapel, the sacred spectacle was described with great admiration by Bishop Abraham of Suzdal, the Byzantine prelate who visited the city during the Council of Florence (1439).[25] The play was a multimedia event involving boy actors in festive costumes, a choir of singers, dancing and music-making "angels," and scenery illuminated by lanterns, lamps, and candles. The performance climaxed in a glorious blaze of light as Jesus, surrounded by a radiant aureole, ascended to heaven – the vaults of the Carmine. This fantastic illusion was given reality with ingenious stage machinery designed by Brunelleschi and elaborate scenery that in 1425 was painted by Masolino.[26]

Although the theatrical spectacle commemorated the feast of the Ascension, it inevitably would have inspired other associations because of its performance in a Carmelite church. The text of Elijah's ascent to heaven in a fiery chariot (2 Kings:11–12) evidently was the basis of the account of Christ's ascension (Acts 1:9–11);[27] the prophet's return to earth in witness of the Transfiguration (Mark 9:4) also was considered a prefiguration of this event. Attracting countless spectators and dignitaries, the Ascension play established the Carmelites' prominence among the city's churches. Propagandistically, it also reinforced the Order's association with Elijah and confirmed as truth the legend of its antiquity.

Santa Maria del Carmine before the Brancacci Chapel

Little remains of Santa Maria del Carmine as it existed in the early Quattrocento, when decoration of the Brancacci Chapel was begun. To ascribe this to the fire of 1771 alone would be erroneous. Long before then, liturgical reform, modernization, changes of taste, and restorations had transformed the original Gothic church.[28] Descriptions of the Carmine prior to these renovations are recorded in extant documents. They suggest that much of the church already had been decorated by the time the Brancacci Chapel, prominently located on the right transept, was painted. An image of the Virgin, Saint Agnes, and John the Baptist "bella e di bello colore" (beautiful and beautifully colored) was commissioned for the facade.[29] Tall

stained-glass windows with "immagini di santi e di sante" (images of male and female saints) once lined the nave; saints and their martyrdoms were portrayed on the walls.[30]

By the early years of the Quattrocento, several chapels already had been decorated with frescoes and altarpieces. Virtually all of these have been destroyed over time. As is known from Vasari's admiring description, the high altar chapel was decorated by Agnolo Gaddi with scenes from the life of the Virgin, to whom the Carmine was dedicated;[31] immediately to the right was the chapel of John the Baptist, thought by Vasari to have been painted by Giotto but actually by Spinello Aretino, Agnolo's contemporary (see Plate 35).[32] Spinello frescoed two other chapels in the church, as Vasari recounted in vivid detail, one dedicated to James and John the Evangelist, the other representing scenes from the life of the Virgin that culminated in her Assumption, the chief Marian festival of the liturgical year.[33]

On the left aisle, an altarpiece by Lorenzo Monaco (documented in 1400) adorned the chapel, frescoed by Lorenzo di Salvo, where the *laudesi* Compagnia di Sant'Agnese worshiped.[34] Its walls resonated with the confraternity's lauds, songs that were transcribed in a beautifully illuminated choirbook.[35] The oratory belonging to the Compagnia di San Niccolò di Bari (founded in 1334) was located beneath the high altar and transept chapels. Its walls were decorated with monochrome scenes of the Passion of Christ from the late Trecento.[36] The young Fra Angelico (then the lay painter Guido di Pietro) joined the confraternity in 1418 before he became a Dominican friar.[37] It might be proposed that his panels of *Saints Catherine of Alexandria and John the Baptist* and *Saints Nicholas of Bari and Agnes* (New York, Private Collection) once formed part of an altarpiece for this chapel, paying homage to the saints most revered in the Carmine.[38]

The fresco that Masaccio painted of the Carmine's ceremonial consecration on April 9, 1422, was destroyed in renovations during the early seventeenth century.[39] The mural of the *Sagra* (Consecration) was executed in *terra verde* (green monochrome) and located above a door in the monks' cloister. There the image was continuously visible to the friars, bidding them to recall an illustrious moment of the church's history. The *Sagra* is known by Vasari's moving description and through several drawings by later artists.[40] Vasari praises the verisimilitude of its portraits, which represented Brunelleschi, Donatello, and eminent Florentine statesmen. He commends Masaccio's great skill (*discrezione*) in distinguishing their physique, height, and appearance. Notwithstanding the great loss of this fresco, its appearance is likely to have been reflected in the varied groups of apostles and neophytes in the Brancacci Chapel. The date that Masaccio painted the fresco is unknown, although along with the Brancacci Chapel itself, it was executed in the 1420s and thus was later than most of the works in the Carmine.

Sadly, as we have seen, much of the Carmine's original decoration has

been destroyed. Only a few frescoes have survived from the early Quattro-
cento. They include the wrenching Flagellation and Crucifixion from the
Chapel of the Passion (documented in 1402) by Lippo d'Andrea; the exten-
sive cycle recounting the life of Saint Cecilia, also ascribed to him, in the
sacristy; and the fragmentary saints by Starnina in 1404 for the Chapel of
Saint Jerome (see Plates 36 and 38), scenes of which were engraved by
Thomas Patch and Séroux d'Agincourt.[41] Painted in the opening years of
the Quattrocento, these frescoes incipiently reveal some of the same ten-
dencies that would be developed in the Brancacci Chapel: clarity of dra-
matic exposition, concern with representing architecture in perspective,
sculptural drapery, luminously modeled facial features, and bright colors.
Along with the *Madonna del Popolo;* the lost works by Agnolo Gaddi,
Spinello Aretino, and Lorenzo Monaco noted previously; and earlier
works, including the Accademia *Crucifixion* (1343) by Bernardo Daddi;[42]
they shaped the visual culture of the Carmine of which the Brancacci
Chapel was to be a part.

A crucial point must conclude this consideration of the church and its
art. Many of the chapels in the Carmine, including the high altar chapel
and the sacristy, had been decorated by wealthy families from the parish
by the late 1390s (if not earlier) or in the opening years of the Quattro-
cento. Not so with the chapel of the Brancacci family. Its lack of adorn-
ment would have been embarrassingly conspicuous, given its prominent
position. Located on the south transept, the Brancacci Chapel faced the
high altar, confronted the chapel of the wealthy Serragli family across the
nave, and was adjacent to the Chapel of the Passion. Considering the com-
petitive momentum that characterized relationships between Florentine
families of this time and the importance of private chapels as indicators of
status, its bare walls would have been unacceptable. Its decoration was a
strategy critical to the social and religious standing of the Brancacci
among their peers and, as we will see, to the fulfillment of a long-standing
family commitment. This obligation must have seemed especially pressing
in light of the Carmine's consecration in 1422, which elevated the church's
prestige in the city, and the chapel's visibility during the Ascension plays
performed in the nave.

The Brancacci Family and Santa Maria del Carmine

The Brancacci had been worshiping in the Carmine for more than 130
years by the time that the family's chapel was frescoed in the mid-1420s.[43]
The family, comprised of wealthy cloth merchants, became active in the
church within years of its foundation in 1268. In 1290, Branca di Brancacci
served as one of two *capitani* (directors) of the confraternity of Santa
Maria del Carmine, the *laudesi* confraternity that met in the church to
sing hymns to the Virgin.[44] Branca initiated an association with the con-

fraternity that his male descendents were to follow for generations: From his son Piuvichese through Felice Brancacci, the men were members of this sodality, several becoming *gonfalonieri* (officers and bearers of the group's processional standard). In addition, Brancacci men were active in Florentine government on the highest level, many serving terms as prior or *gonfalonieri* of the republic.[45]

Economically and politically, the most successful of the fourteenth-century Brancacci was Piero di Piuvichese.[46] It was he who established the family chapel in the Carmine and, consequently, he whose patron saint had to be honored in the frescoes. This prosperous merchant was married to a daughter of the wealthy banking family, the Bardi, whose own chapel in Santa Croce had been painted by Giotto. The esteemed Piero served once as *capitano* of the Parte Guelfa, three times as prior of Florence, and six times as *gonfaloniere* of the Compagnia di Santa Maria del Carmine. In 1367, Piero wrote his testament, in which he endowed a chapel in the Carmine, promising the church five florins a year for forty years. His bequest was administered by his son Antonio, who died in 1391.[47] In his own testament, Antonio bequeathed an additional 200 florins for its completion.[48] By 1387, construction of the chapel was under way; in 1389, 50 florins were left by Serotino di Brancacci "for the adornment of, and to make paintings in, said chapel."[49] Notwithstanding these bequests, more than a quarter of a century would transpire before the chapel actually was frescoed.

Felice Brancacci and the Brancacci Chapel

As Richard Goldthwaite has demonstrated, the fifteenth century saw an unprecedented demand for private chapels in churches, even for those who were not extremely wealthy.[50] Chapels commemorated the deceased, perpetuated their memory, and publicly demonstrated the status of the family. No surviving documents prove that Felice Brancacci paid for the chapel's decoration himself. However, it is probable that this was the case, since Felice by then had inherited rights to the chapel.[51] By 1422, when he wrote his first testament, Felice referred to "the chapel of said testator and his predecessors" in the Carmine; a decade later, its decoration still unfinished, his will requested that it be completed by his heirs.[52]

Felice Brancacci experienced success as well as tragedy.[53] He enjoyed his wealth as a silk merchant and commanded respect as the descendent of a venerable family. He received meteoric public acclaim after he won a joust celebrating Florence's defeat of Pisa in 1406. His fall from renown was equally dramatic. In 1436, he was formally expelled from the city by Cosimo de' Medici, de facto ruler of Florence and his one-time friend. Because of his marriage to the daughter of Palla Strozzi, Cosimo's great enemy, and his involvement in a plot against the Medici, Felice was pro-

hibited from ever returning to his native city. In 1447, he died impover-
ished and in exile. His only son, Michele, died in 1455.

Felice Brancacci served in a variety of prominent governmental and
diplomatic positions in the years before his exile, especially during the
1420s.[54] He became governor, vicar, and ambassador to several Tuscan
towns from 1407 through 1421. In 1422, he was appointed ambassador in a
dangerous mission to Cairo, the intriguing events of which he recorded in
his diary. Indicating how greatly he was trusted, he became treasurer of
communal accounts in 1425. In the Carmine, he twice served as *gon-
faloniere* of the confraternity of Santa Maria del Carmine, following the
tradition established by his ancestors.

Many documents concerning Felice's life have survived. However, none
relate to the decoration of his family chapel. In the absence of any docu-
ments, it has been contended that funds for the frescoes were obtained
from the fourteenth-century endowments of his ancestors[55] and that Felice
had very little to do with the chapel. However, funds for the chapel's con-
struction are likely to have been exhausted by this time, as suggested by
the long delay in decorating the chapel from the time of the bequests. Fur-
thermore, there is evidence suggesting that Felice may have raised special
funds to pay for the frescoes himself.

As Felice's tax declarations reveal, he was well-to-do but not among the
richest men in Florence. In 1427, he ranked 516th in terms of financial
worth, as is known from his tax return.[56] Between 1423 and 1425, he sold
three houses belonging to the Brancacci family (including the ancestral
home), forcing his family to rent lodging and liquidating a patrimony that
custom required him to preserve.[57] Indeed, his pressing need for money,
for which no other explanation apart from decoration of the chapel has
been found, led him to embezzle funds from the communal treasury in
1425, a crime that was not discovered until seven years later.[58] This period
coincides precisely with the time that Masolino and Masaccio were likely
engaged in painting the chapel. Rights to the chapel by then had passed
to Felice, as is known from his testament of 1422, which, as we have seen,
designates it as his and his predecessors' place of burial.[59] Decoration
therefore must have occurred under his auspices and was undertaken to
fulfill a family obligation.

The Iconography of the Chapel

Several critics have proposed that the life of Saint Peter was chosen for the
chapel's decoration to demonstrate support for the prevailing government
or the papacy.[60] However, such arguments are inevitably problematic. The
theme of the frescoes was not conceived as a response to contemporary
circumstances or politics. Rather, it was determined by the *obligation* to

honor the apostle Peter because he was the patron saint of Felice's ances-
tor, Piero di Piuvichese, who had founded the family funerary chapel in
1367. While scholars have sought allusions to Felice's beliefs or the events
of the day in certain episodes, it is mistaken to read these scenes as social
commentary. The life of Saint Peter was portrayed on the walls of this
funerary chapel in order to commemorate Piero di Piuvichese and to pro-
cure salvation for his descendants. In every respect, the scenes comprise
a canonical account of the apostle's life, from his calling to his martyrdom.
In a narrative mode followed throughout late medieval and Renaissance
painting, their sequence is thematic rather than strictly chronological to
create a unity of meaning and compositional harmony.[61] The only anachro-
nistic elements in the cycle of the saint's life are the Carmelite friars wit-
nessing the preaching and chairing of Peter – a necessary, propagandistic
affirmation of the Carmelite Order's antiquity – and the portraits in the
scenes on the bottom register that were finished by Filippino Lippi.[62] Such
inclusions would have made the scenes relevant to the Carmine's history
and the lay patrons.

It is erroneous to suppose, as Frederick Antal contended, that the
scenes in the chapel were intended to advocate an "egalitarian point of
view . . . which proclaimed in principle the equality of men."[63] Such an ide-
ology may have been propounded in humanist writings but was inconceiv-
able in Florentine society of the early Quattrocento. Moreover, the *Call-
ing of Peter and Andrew* and *Saint Peter Walking on Water* were portrayed
not as allusions to Felice's dangerous sea voyage to Egypt or his one-time
service on the Board of Maritime Consuls, as has been stated, but because
they were crucial episodes in the apostle's life that initiated his ministry
and tested his faith. Similarly, the story of the tribute money – in which
the saint, at Christ's command, retrieved money from a fish's mouth to pay
the Roman tax collector – was chosen as a paradigm of Peter's obedience
to Christ and his primacy in the Church. Recounted in Matthew 17:25–7
immediately after Jesus' prophecy of his own death and resurrection, this
subject would have had special relevance in a funerary chapel. Most cer-
tainly, the representation of the tribute money was never intended, as has
been proposed, as a prophetic endorsement of the Florentine *catasto* (the
city's first graduated income tax), not even instituted until 1427.[64] Contrary
to what has been asserted,[65] the subject is not rare. Every scene in the
Brancacci Chapel emerged from a rich legacy – artistic, liturgical, and tex-
tual – that long predated the frescoes.[66]

Iconographically, the illustrious prototype for the Brancacci Chapel
was the now-destroyed cycle of the lives of Saints Peter and Paul, frescoed
on the portico of Old Saint Peter's, Rome, around 1280.[67] This extensive
series was copied by artists as the authoritative version of the lives of both
apostles.[68] Five scenes from the Roman cycle were quoted in the transept
of San Francesco, Assisi, around the same time. About two decades later,

a complete and authentic copy – a true facsimile – was made by Deodato
Orlandi for the church of San Piero a Grado, Pisa. It was painted in honor
of Peter's arrival in Pisa prior to his journey to Rome, an auspicious event
immortalized in local legend. The still-preserved frescoes comprehensively
recount the life of the apostle Peter, from his calling by Christ through his
martyrdom. Except for three episodes – the saint's denial of Christ,
preaching, and baptism of the neophytes – each scene in the Pisa cycle,
including the tribute money, was represented in the Brancacci Chapel.

The textual sources for the Brancacci Chapel include the Bible, the
liturgy for the three feasts of Saint Peter,[69] and most important of all, the
Legenda Sanctorum (known today as *The Golden Legend*), compiled by
Jacobus de Voragine, Bishop of Genoa, in the mid–thirteenth century.[70] *The
Golden Legend* is a lectionary of liturgical readings that recounts the lives of
the saints in order of the Church's calendar of feasts. It was extraordinarily
popular in the Middle Ages and Renaissance.[71] It served as the literary
source for many fresco cycles, from the Arena Chapel in Padua by Giotto (c.
1305) through the Legend of the True Cross by Piero della Francesca in
Arezzo (c. 1455–60), and was used by preachers in preparing sermons.

As is known from an inventory of 1390, *The Golden Legend* was acces-
sible in the library of Santa Maria del Carmine.[72] It seems to have been the
primary source for the chapel's iconography. Voragine's excursis on the
Feast of Saint Peter (June 29) lists every event that was portrayed in the
Brancacci Chapel except the episodes with Theophilus and the chairing at
Antioch.[73] These are included in the reading for the Feast of the Chairing
of Saint Peter (February 22). The apostle's liberation from prison by an
angel is celebrated by the Feast of Saint Peter in Chains (August 1). The
epistle to this feast commemorates the saint's deliverance from bondage
and his power to absolve humanity of its sins,[74] a relevant theme for a
funerary chapel. As proclaimed in the lesson for the Feast of Saint Peter,
the apostle loosened "the fetters of our sins with the keys which he
received from the Lord"[75] and knew the glory of eternal life through his
martyrdom.

The only scenes in the chapel not taken directly from Peter's life are
the *Expulsion of Adam and Eve* (Plate 58) and the *Temptation of Adam and
Eve* (Plate 59) on the piers at the chapel's entrance, a "deviation" that has
long troubled scholars.[76] Here we point out that Adam's example is invoked
by Peter himself in Voragine's lesson for the Feast of Saint Peter. As Peter
is being crucified, head downward, before a weeping crowd, he cries out:

Lord, I have desired to follow Thee, but I did not wish to be crucified upright.
Thou alone art erect, upright, and high. We are children of Adam, whose head was
bowed to the ground: his fall denotes the manner in which men are born, for we
are born in such wise that we are let fall prone upon the ground. . . . Lord, Thou
art my all and other than Thee have I naught. I thank Thee with all my soul, with
which I live, understand, and call to Thee.[77]

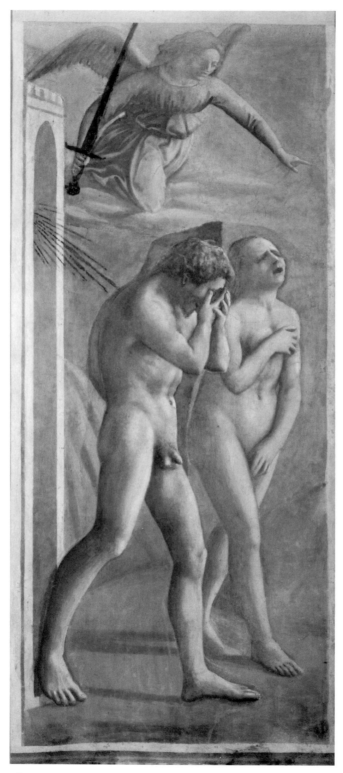

Plate 58. Masaccio, *Expulsion of Adam and Eve,* detail of Plate 3.
(Photo: Antonio Quattrone)

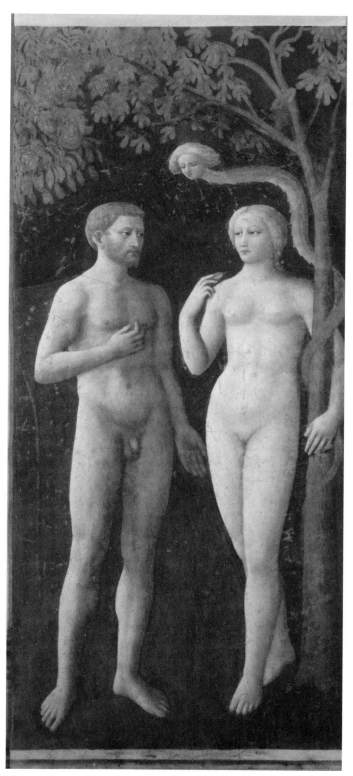

Plate 59. Masolino, *Temptation of Adam and Eve,* detail of Plate 3. (Photo: Antonio Quattrone)

The presence of Adam and Eve is not an intrusion into the story of Peter, but is essential to its meaning. It is a reminder of humanity's sin, of the necessity for Christ's sacrifice, and of the redemption obtained through Peter's martyrdom. The advocacy of so worthy a saint, who exceeded "all the other apostles in his faith," as Voragine proclaims,[78] would ensure the salvation of the Brancacci.

Organization of the Narrative

Following the time-honored traditions of Tuscan mural painting, the cycle of the saint's life was organized in three registers below the vaults (see Plates 4 and 5).[79] On the highest row, the narrative was initiated by Peter's calling to the apostolate and his rescue from drowning in the Sea of Galilee, represented in the now-lost lunettes. On the altar wall between them were two scenes whose sinopie have been preserved: the *Denial of Saint Peter* (see Plate 6), signifying a human weakness which later would be redeemed by faith, and *Feed My Sheep* (see Plate 7), in which Christ charges Peter to minister to the Christian flock.

The cycle continues on the middle register, with Jesus delegating Peter to pay the Roman tax collector money, miraculously retrieved from the mouth of a fish. It proceeds to the saint's apostolate in which Peter assumes the ministry of Jesus by preaching, baptizing, healing, and resurrecting. In the lowest register, the altar wall portrays the saint's acts of charity, including his healing of the lame with his shadow and his distribution of alms to the poor. The last episodes of Peter's life, witnessed by Saint Paul, are represented on the side walls. These include his imprisonment by Theophilus, whose son he resurrects; his chairing at Antioch; his confrontation with Nero and Simon Magus; and his martyrdom by crucifixion. The narrative thus traced Peter's apostolate from its doubt-ridden beginnings through his assumption of Christ's ministry and his martyrdom. These proved his worthiness to lead the Church.

The arrangement of the narrative did not follow strict chronological order. Instead, the scenes were disposed so they would balance each other thematically and compositionally. Thus, in the highest register, the lunettes of the *Calling of Peter and Andrew* and *Peter Walking on Water* faced each other as the cycle's only maritime episodes. On the altar wall, the episodes portrayed the apostle in his mission as he preached, baptized, healed, and gave charity in the name of Christ. Compositionally, the walls of the chapel are united. The arrangement of figures in the episodes balances each scene, as is especially evident in the episodes of the altar wall. Landscape extends across three scenes in the middle row, and urban settings predominate in the register below.

Attribution and Dating

Collaboration between artists was the norm rather than the exception in the Middle Ages and Renaissance, forming the financial and professional basis of the master/teacher relationship and the workshop system.[80] It was often a temporary affiliation, according flexibility and economic advantage to artists. Such arrangements allowed masters to respond expediently to the demands of the marketplace, to share the cost of renting shops and buying materials, and to benefit from one another's reputation and expertise. The professional association of Masolino and Masaccio was typical of the 1420s, a decade that also saw the productive affiliation of Donatello and Michelozzo.[81]

Vasari's *vite* of Masolino, Masaccio, and Filippino Lippi provide the foundation for attributing individual scenes.[82] Vasari assigns the earliest parts of the chapel – the now-lost vaults and lunettes – to Masolino, describing the four Evangelists, the *Calling of Peter and Andrew* (known from a copy in the Matteini Collection: Plate 60), the *Denial of Peter* (known from its sinopia), and *Peter Walking on Water*. *Saint Peter Preaching* and the *Healing of the Lame Man at the Temple and the Raising of Tabitha* (called "Saint Peter curing his daughter Petronilla") are noted on

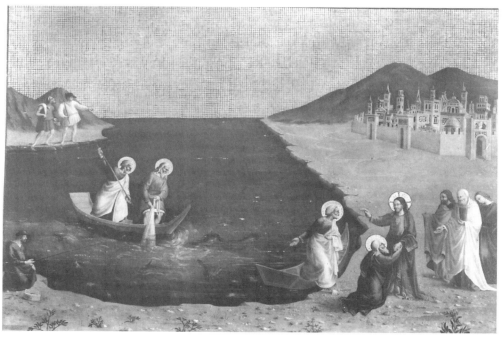

Plate 60. After Masolino, *Calling of Peter and Andrew,* Florence, Ezio Matteini Collection. (Photo: Antonio Quattrone)

the second tier. The scenes on the second and third tiers by Masaccio
include "the installation of Saint Peter as the first pontiff, the healing of
the sick, the raising of the dead, curing the lame by his shadow falling on
them as he approaches the Temple with Saint John"; the *Tribute Money*,
which is praised effusively; and *Saint Peter Baptizing the Neophytes*, with
its "very celebrated figure of a naked youth shivering with the cold."
Vasari's discussion of the chapel concludes with his *vita* of Filippino Lippi,
who, as a young artist, had "completed the unfinished picture of Saint
Peter and Saint Paul restoring the emperor's nephew to life" and the scene
on the opposite wall showing Peter and Paul disputing with Simon Magus.

Vasari is accurate yet selective in discussing the chapel. His apprecia-
tion omits some scenes. He does not mention Masolino's now-lost *Feed My
Sheep* opposite the *Denial of Peter* or Masaccio's *Distribution of Alms and
the Death of Ananias,* nor does he describe the *Temptation of Adam and
Eve* and *Expulsion from Paradise*. What remains important is not only the
accuracy of his attributions but the sequence of execution that they imply.
From Vasari's account, it may be assumed that Masaccio's collaboration
with Masolino began only on the second tier.[83] By the time this was com-
plete, Masolino evidently had relinquished the chapel to Masaccio.
Decades later, the frescoes of the bottom tier – and presumably, the dado,
now covered by marble panels – were completed by Filippino Lippi.

Since the chapel is undocumented, its chronology is problematic.
Widely divergent opinions have been proposed, with some scholars postu-
lating a long-protracted execution spread over several years and as many
as three separate campaigns, concluding with Filippino Lippi's interven-
tion.[84] More recent critics, aided by conservation reports, have reevaluated
the physical and documentary evidence to hypothesize a different sce-
nario.[85] Close study of the frescoes reveals a total of ninety-two *giornate*[86]
– a *giornata* is a plaster patch indicating a single day's work – on the sec-
ond register, which both artists frescoed. This signifies about forty-six days
of labor for each. Masolino and Masaccio must have painted simultane-
ously on the same scaffolding, virtually matching each other's work day by
day. In addition to the forty-six days required for the second register, there
are fifty-four *giornate* in Masaccio's frescoes on the row below. Perhaps
somewhat less than twice as many *giornate* can be reckoned for Masolino's
lunettes and for the lost Evangelists – single figures against a starry blue
ground – in the vaults. Taking into account the erection of scaffolding and
the preliminary plastering of the wall (neither of which had to involve the
painters directly), the preparation of drawings and sinopie, and the prohi-
bition against working on church holidays, the frescoes could have been
painted in forty weeks or less. Only forty-six days are certain to have been
spent in actual collaboration on the scaffolding.

Indeed, it seems that the one-on-one collaboration of Masolino and
Masaccio on this commission may have been confined to a relatively brief

and intense period during the summer of 1425. Given guild regulations, it must have followed the dissolution of Masolino's partnership with the painter Francesco d'Antonio sometime after March 23, 1424.[87] Only then would the artist have been legally free to collaborate with Masaccio. It also came after Masolino completed his frescoes for the church of Santo Stefano in Empoli, for which he received payment in November 1424.[88] Thus, Masolino could have begun his association with the Carmine any time from late winter 1424 through spring 1425. Since he painted scenery for the Ascension play performed on May 17, 1425,[89] he had to have been there earlier. Indeed, he might have frescoed the now-lost *Saint Peter* at the entrance to the Cappella del Crocifisso as a trial piece, the counterpart to the remarkably foreshortened *Saint Paul* by Masaccio that Vasari describes.[90] In any event, Masolino's presence in the Carmine seems to have been brief. In all probability, it had ended by September 1, 1425, when he departed for Hungary, expecting not to return to Florence for at least three years.[91] From that point on, Masaccio worked without him.

The Collaboration in Practice: The Artists and Their Frescoes

The frescoes of the second register reveal the extraordinarily intense collaboration between Masolino and Masaccio as they worked together on the scaffolding. The scenes are unified chromatically, and compositional solutions seem to have been decided in concert. Thus, on the altar wall, the disposition of figures and landscape in *Saint Peter Preaching* (see Plate 10) and *Saint Peter Baptizing the Neophytes* (see Plate 11) seems deliberately alike, with the apostle flanked by a similarly composed group of standing, seated, and kneeling figures. At times, the artists even exchanged places on the scaffolding. This evidently was done to ensure visual and stylistic coherence between the scenes. Thus, Masaccio extended the stark landscape of the *Tribute Money* into the adjacent scene of Masolino's *Saint Peter Preaching,* while Masolino painted the peaked mountain range behind Masaccio's *Saint Peter Baptizing the Neophytes.*[92] The perspective construction of the *Healing of the Lame Man at the Temple and the Raising of Tabitha* is identical to that of the *Tribute Money* on the opposite wall.[93] Again, this was intentional, evidently devised to create unity within the cycle.

Such accommodations notwithstanding, the artists approached narrative and the figure in fundamentally different ways. In *Saint Peter Preaching,* Masolino massed the crowded audience into the foreground, their unvarying expressions showing little interest in the apostle's sermon. By contrast, in *Saint Peter Baptizing the Neophytes,* Masaccio placed the circle of men deep in the landscape, their bodies turned in different directions, from the shivering nude to the man whose clenched fingers seem

about to unfasten his garments. In the *Healing of the Lame Man at the Temple and the Raising of Tabitha* (Plate 61) – the latter inspired by Giotto's authoritative *Raising of Drusiana* in the Peruzzi Chapel, Santa Croce – Masolino subordinated the figures to an ambitious architectural setting against which their gestures and expressions cannot clearly be read. Although a single-point perspective system – assuredly designed by Masaccio and virtually identical to that of the *Tribute Money* – is employed, its centric point lies between the two dandies in the center, who have no discernible relationship to the narrative. By contrast, in the *Tribute Money* (see Plate 8), the multiepisodic narrative, galvanized by Christ at its center, is supported by the dramatic landscape and architecture, which frame the figures and direct the viewer's gaze. The centric point of the perspective, appropriately, is Jesus; gestures and expressions are solemn and dramatic; drapery appears weighty; and anatomy is modeled fully in light, suggesting the inspiration of sculpture.[94]

The most striking difference in the approach of the two artists may be seen in the *Temptation* and *Expulsion* at the entrance to the chapel, executed after the narratives to which they are adjacent. The courtly elegance of Masolino's Adam and Eve contrasts paradigmatically to Masaccio's huddled, weeping figures. Their soft, pearly flesh serves as a foil to the vigorously modeled, sculptural anatomy of Masaccio's progenitors, a visual encapsulation of their prelapsarian indolence on the one hand, and a prophecy of their toil after their expulsion on the other. As the *giornate* prove, these were the last of the scenes to have been painted on this register. From then on, Masaccio worked alone.

A different, more somber conception of narrative is apparent in the third register. Here the figures, their expressions weary and inscrutable, are subordinated to setting, their scale and proportions diminished in accord. Architecture is rendered in greater detail, from the classicizing portico in *Saint Peter Healing with His Shadow* (see Plate 12) to the partly rusticated tower in *Saint Peter Distributing Alms*.[95] In the former, Masaccio shows the lame at progressive moments of their cure, from the once-crippled man who now stands, his hands clasped in prayer, to the youth still hunched on the ground. In *Saint Peter Distributing Alms*, Masaccio paints the crowded ranks of the poor as they stand in mute patience to receive charity, oblivious to the corpse of Ananias, struck dead for withholding his tithe from the church. Masaccio's models were the lame and destitute of the city, who impart an extraordinary sense of realism to these scenes. This is further enhanced by his depiction of Peter in the *Healing,* who seems to be walking toward the worshipers as if to cure them as well. Although the two urban scenes were divided by the original window, their architecture recedes toward a single vanishing point to enhance their thematic coherence.

The dramatic immediacy of these two scenes is without precedent in

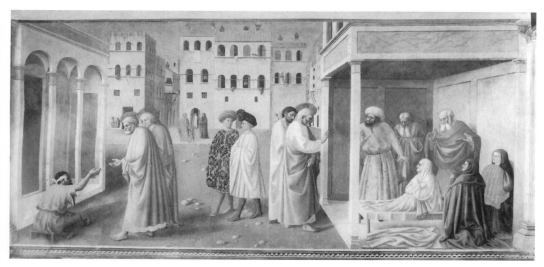

Plate 61. Masolino, *Healing of the Lame Man at the Temple and the Raising of Tabitha,* detail of Plate 3. (Photo: Antonio Quattrone)

Florentine mural painting. They seem likely to have been painted some time later than the register above, for Masaccio's understanding of narrative and space is more advanced, the scale of figures to setting diminished, the rendering of figures more restrained. Only fragments remain of the scene between them, which was discovered by conservators during the chapel's restoration. Portions of an atmospheric sky and a freely painted landscape with trees, the luminously modeled knee of one man (Plate 62), and part of the jerkin and britches of another (see Plate 43), are all that are left of the original fresco. The style unmistakably is that of Masaccio; the subject is uncertain.[96]

Masaccio's contributions after this point remain problematic. Although he painted a substantial part of the *Raising of the Son of Theophilus* (see Plate 9), the remainder of the scene was completed by Filippino Lippi half a century later, along with *Saints Peter and Paul Debating with Simon Magus before Nero and the Crucifixion of Saint Peter.* This has inspired speculation that the former once may have included portraits of the Brancacci that were destroyed in a *damnatio memoriae* after Felice's expulsion by the Medici.[97] According to this hypothesis, Filippino was compelled to replace the alleged deletions with contemporary portraits. As intriguing as this argument might seem, such instances of literal defacement by the Medici are in fact unknown.[98] Even after the restoration, there is no unequivocal evidence to support the proposal. It might be suggested that Masaccio never finished the scene, for he clearly left the opposite wall of the chapel unfinished. He may have abandoned the commission for financial reasons. Either he had not been paid, or, as was assuredly the case

Plate 62. Masaccio, Fresco fragment from below window, detail of Plate 3. (Photo: Antonio Quattrone)

with Masolino, more lucrative opportunities presented themselves. On February 19, 1426, Masaccio received his first payment for the *Pisa Altarpiece,* painted for the chapel of Giuliano degli Scarsi in Santa Maria del Carmine in Pisa.[99]

To what degree the scenes by Filippino followed the drawings or sinopie from the original project cannot be determined with certainty. However, it is important to note the compositional and iconographic coherence as well as the inventiveness of their conception. With their simplified, two-figured compositions, Filippino's scenes on the piers complement those by Masolino and Masaccio above them. *Saint Paul Visiting Peter in Prison* and the *Liberation of Saint Peter* complete each other iconographically and compositionally, the angle of the prison walls directing the beholder to the adjacent scenes and toward the altar. On the left, the noble image of Saint Peter in the bishop's cathedra, revered by the devout, serves as a foil to the irate Emperor Nero, enthroned on the opposite wall. Peter's miraculous resurrection of the son of Theophilus, deceased for fourteen years, posits a contrast to his own ignominious crucifixion at Nero's command, a death redeemed by martyrdom. Such symmetry of meaning could not have been fortuitous and must have been intended from the beginning. Indeed, it has been argued that even the location of this Petrine cycle in the right transept chapel was deliberate, for it followed the venerable example of Saint Peter's in Rome and San Francesco in Assisi.[100] If this is true, then its associations would have been even more resonant.

The Brancacci Chapel within the Carmine

The Brancacci Chapel must be understood as a participant within the dialogue of sacred ceremonies and images that shaped the experience of the worshiper within the church of Santa Maria del Carmine in the early Quattrocento, from the *sacra rappresentazione* of Christ's ascension, performed in the nave outside the chapel, to the depictions of martyrs, saints, and the Passion of Jesus that adorned its windows, chapels, and walls. The

life of Peter, beginning with his calling and progressing through his assumption of Christ's ministry and his martyrdom, honored the patron saint of Piero di Piuvichese Brancacci, the chapel's founder, and served as an exemplar for the faithful to follow. For the Carmelite friars themselves, the depiction of their forebears witnessing Saint Peter as he preached, raised the son of Theophilus, and was chaired as Bishop of Antioch attested the Order's antiquity. They would have beheld these images as they passed the chapel to enter the cloister, frescoed by Masaccio with the *Sagra,* which commemorated a less distant moment in their history. When the miracle-working *Madonna del Popolo* was transferred to the chapel, it would have amplified these associations, recalling the Carmelites' devotion to Mary, reminding the worshiper of her infinite mercy and of the sacrifice of her son.

Too often, the Brancacci Chapel has been isolated as a monument to be studied or a problem of attribution to be solved. This approach impoverishes our understanding of the spiritual, artistic, and patronal ambience that inspired Masaccio and Masolino. By situating the Brancacci Chapel within these broader contexts of the history and devotional practices of the Carmine, we can reintegrate the frescoes into the artists' work and world.

8 Masaccio's *Trinity*

Theological, Social, and Civic Meanings

Timothy Verdon

This chapter reflects on the most impenetrable of Christian mysteries, the coexistence of three distinct but equal Persons in one God, and – in particular – on the way this mystery of faith was illustrated by Masaccio on the western wall of a Florentine church served by the Dominican Order, Santa Maria Novella.

Both aspects of the subject seem important: the universal religious theme developed in a centuries-old tradition, and the specific – one might say "local" – implications of the theme and tradition in Florence in the 1420s, in a church of the Order of Preachers (as the Dominicans are properly called). It is in fact in this intersection of universal with local that the relationship of Masaccio's fresco with other works made in early Quattrocento Florence becomes clear: works by Filippo Brunelleschi, Lorenzo Ghiberti, Donatello, and others taken as defining a renascence in the arts, different in style and function but linked by their common character as monumental icons, at once Christian and Antique, eloquent with public meaning.

Reading the Image

The hermeneutic (interpretative) history of Masaccio's fresco is quite recent, dating only from 1950–1, when Ugo Procacci found fragments of a skeleton and illusionistic altar painted on the wall below the original position of the *Trinity*. Like the rest of the mural, these had been covered by

This chapter has been developed from a talk I gave in 1986, while a Fellow at the Harvard Center for Renaissance Studies, Villa I Tatti, Florence. My thanks are due to two members of the Dominican Community at Santa Maria Novella: Father Salvatore Camporeale, O.P., for carefully reading and commenting on an earlier version of the text, and Father Eugenio Marino, O.P., for illuminating conversation on this and related subjects.

Giorgio Vasari in the 1560s, when he directed the modernization of the church interior. The upper part of Masaccio's work had been discovered in the nineteenth century, detached from the wall, and moved to the back of the church, alongside the door. Only with the discovery of the lower portion and the reintegration of the upper fresco with the lower in the original position did the total image become available for interpretation.[1]

The "total image" (see Plate 13) shows God the Father on a raised platform, supporting the cross with – between the Father's beard and Christ's halo – the Holy Spirit in the form of a descending dove. On the cross hangs Christ, beautifully modeled in light, Masaccio's masterful response to the famous wooden crucifixes carved by Donatello and Brunelleschi some years earlier. At the foot of the cross stand Mary and Saint John the Evangelist, she gazing at the viewer and gesturing toward her son, while John wrings his hands in grief as he looks at Christ.

All these figures are inside a magnificent niche or chapel, articulated in classicizing architecture and illusionistic perspective, both features clearly dependent on Brunelleschi. Outside the niche, to left and right, kneel two figures in contemporary costume, taken to be the donor and his wife. And finally, supporting the whole composition is the fictive altar over a sarcophagus with, on its lid, the skeleton. Above the skeleton an inscription states: IO FUI GIÀ QUEL CHE VOI SIETE, E QUEL CH'IO SON VOI ANCO SARETE: "I once was what you are now, and what I am, you too will be."

This composite image has been read in different ways, and – among efforts to grasp its specifically religious meaning – several approaches have been developed.[2] Ursula Schlegel saw the fresco in devotional terms, as a "Calvary altar" – that is, the kind of shrine common in medieval and fifteenth-century churches, usually situated midway down the nave, to one side (as is Masaccio's *Trinity*), and meant for private prayer, for reflection on Christ's Passion, and for masses commemorating deceased loved ones.[3] Otto von Simson interpreted the fresco in light of a known iconographic scheme, the *Gnadenstuhl* or "Mercy Seat," used throughout Europe in the fourteenth and fifteenth centuries: God the Father holding out a crucifix to sinners, who are thus emboldened to hope for mercy, confident of pardon through Christ's atoning death.[4] And Rona Goffen discerned parallels with the issues discussed in an important New Testament text, the Pauline Letter to the Hebrews.[5]

The question has also been raised whether this image should be understood primarily as altarpiece or as funerary monument.[6] A sixteenth-century source speaks of an altar dedicated to the Holy Trinity in the western aisle, in front of Masaccio's fresco, and of a large crucifix that stood there.[7] These several components may have constituted a single program, with the altar as centerpiece. But another source speaks of a tombstone at the foot of the fresco, inscribed DOMENICO DI LENZO ET SUORUM – "Domenico di Lenzo and his family members" – with the date 1426.[8] It is thus reason-

able to assume that Masaccio's fresco was intended to commemorate this man and his family, and that the people shown kneeling to the left and right of the niche are Domenico Lenzi and his wife. Domenico was a linen manufacturer, cousin to the Lorenzo di Piero Lenzi who in 1425 was elected mayor of Florence (Gonfaloniere di Giustizia); this dignity within the Lenzi clan might well have been the stimulus to commission a work of public art.[9]

It is generally assumed, however, that the choice of subject was due to the Dominicans, sophisticated theologians and active promoters of devotion to the Trinity. Even if one attributes the choice of subject to the lay patron, it is likely that Domenico Lenzi consulted the friars, just as Masaccio must have done. The following reading of the image in theological terms takes such consultation for granted. In this fresco, I see an instance of the stated mission of the Dominicans – the Order of Preachers – to "communicate to others the spiritual insights vouchsafed in contemplation" (contemplata aliis tradere), as the Order's motto puts it.[10] Whoever explained to Masaccio what the friars wanted did so with this objective in mind.

In many ways, the iconographic scheme of Masaccio's fresco is traditional. As noted, the Trinity in the form of a "Mercy Seat" was a common devotional type in late medieval art and often included figures of Mary and Saint John the Evangelist.[11] Bartolo di Fredi's tympanum for an altarpiece (Plate 63) made for the church of San Domenico, Siena, illustrates this tradition and suggests an early fifteenth-century source in the Tuscan Dominican network for Masaccio's unusual figure of Mary gesturing toward the cross while she looks out at the viewer (see Plate 49).[12] Even Masaccio's inclusion of donor figures is not novel, for Mariotto di Nardo's Trinity (1418) in Impruneta (near Florence) shows two donors in the same symmetrical disposition at the right and left of the cross (Plate 64).

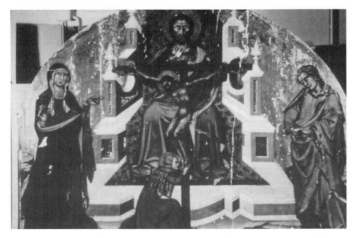

Plate 63. Bartolo di Fredi, *Tympanum with Holy Trinity*, c. 1396, Chambéry, Musées d'Art et d' Histoire. (Photo: Timothy Verdon)

Plate 64. Mariotto di Nardo, *Trinity*, 1418, Impruneta,
Basilica di Santa Maria. (Photo: Timothy Verdon)

The one striking innovation in the fresco at Santa Maria Novella,
beyond the classical architecture and perspective, is the *equality of scale*
Masaccio gives all his figures.[13] Unlike medieval religious images, which
normally differentiate the size of contemporary human beings from that of
sacred personages – and unlike images of the "Mercy Seat" that some-
times introduce a third scale in the miniaturized cross of Christ – Masac-
cio's *Trinity* keeps the same scale for Domenico Lenzi and his wife as for
the Father, Christ, John, and Mary. Even though the donors remain out-
side the niche and do not look at the figures inside, there is no hierarchi-
cal separation of the human and contemporary from God and sacred his-
tory. Rather, as one scholar put it, all Masaccio's figures are "of the same
family according to scale."[14]

The Trinity as "Family"

This formal innovation is consonant with a feature of Catholic thought on the Trinity current in the later Middle Ages and early fifteenth century: the idea of *family* as an analogy for the inner life of the three Persons who, somehow, constitute one God, and who are traditionally discussed in terms of family relationships. Scripture calls God "Father" and Christ his "Son," and the Holy Spirit has been thought of as their shared life, the "bond of love" between them, *"vinculum caritatis."* So, too, the other personages Masaccio put inside the niche are "family": Mary is Jesus' mother and, mystically, also his "spouse." And Christ himself redefined Saint John's role when, from the cross, he entrusted his friend to Mary's care, and Mary to John's, in an adoptive parent-child relationship. The Gospel tells us that "seeing his mother and the disciple he loved standing near her, Jesus said to his mother, 'Woman, this is your son.' Then, to the disciple, he said, 'This is your mother.' And from that moment the disciple made a place for her in his home" (John 19:26–7).[15]

In Masaccio's fresco, one may in fact speak of two interrelated families inside the niche. The first is that 'family' of distinct and equal Persons united from all eternity in harmony and love, the Trinity; the second is Jesus' human family, comprised of Mary, his natural mother, and John, his adoptive "brother." Their placement in the pictorial composition makes it clear that what these heavenly and earthly personages have in common is Jesus himself, son of God and son of Mary, who occupies the center both of the vertical axis on which the Trinity is arranged – defined by the upright beam of the cross – and of the horizontal axis articulated in the lower molding of the Father's platform, which visually links Mary and John "through" the cross.

This compositional arrangement seems to illustrate Jesus' hope for a future union and indeed interpenetration of his two families: the hope he expressed in confident prayer at the Last Supper, the night before he died.

> Holy Father,
> keep those you have given me true to your name,
> so that they may be one like us . . .
> I pray not only for these,
> but for those also
> who through their words will believe in me.
> May they all be one.
> Father, may they be one in us,
> as you are in me and I am in you,
> so that the world may believe it was you who sent me.
> I have given them the glory you gave to me
> that they may be one as we are one.
> With me in them and you in me,

may they be so completely one
that the world will realize that it was you who sent me
and that I have loved them as much as you loved me . . . (John 17:11–23)

This all-inclusive vision, which brings Jesus' expanded human family into his personal relationship with the Father, had been depicted twenty years earlier in an altarpiece showing the Trinity with Mary and donors (Plate 65). This work, in Masaccio's day conspicuously positioned at the main door of Florence Cathedral, emphasizes the interrelationship of Christ's two families, showing Jesus besought by his earthly mother to intercede with his heavenly Father on behalf of a human family whom

Plate 65. Attributed to Lorenzo Monaco, *The Intercession of Christ and the Virgin*, c. 1400, New York, The Metropolitan Museum of Art, The Cloisters Collection, 1953. (Photo: The Metropolitan Museum of Art, The Cloisters Collection, 1953 [53.37])

Mary presents to her Son. Texts painted on the image supply the dialogue of a true "family drama," leaving no doubt as to the interrelatedness of the human-divine personages. As she presents the kneeling donor group, Mary lifts one of her breasts toward Christ and says: "Most sweet Son, for the milk that I gave you, have mercy on these people." And Christ, indicating his mother with one hand, and the wound in his side with the other, looks up at God and says: "My Father, let these people be saved, for whom you wanted me to suffer the Passion."[16] In response, the Father sends the Holy Spirit upon Christ and – if we follow the compositional lines – *through* Christ to Mary, and *through* Mary to the donors.

This picture, dating from the first years of the fifteenth century, is still medieval in composition and format. The figures, against a dark blue and gold background, are arranged on the surface of the image in a zigzag pattern, with the donors smaller in scale than God, Christ, and Mary. Yet the message is not unlike what Masaccio's *Trinity* later conveyed with "modern" formal means (illusionistic spatial depth, symmetrical figure placement, parity of physical scale). Both works show us God as Father, Christ as his Son, and the Love that the Father pours out on his Son – the Holy Spirit – going beyond Christ and beyond those who, like Mary or Saint John, knew Christ personally, reaching out to "those also who through their words will believe. . . ." In the case of Masaccio's fresco, this means that Jesus transmits the love his Father has for him not only to those inside the niche – Mary, his mother, and John, his adoptive brother – but to the Lenzi, as well, who thus join the family of God.

In that "perspective," their large scale implies a specific dilation of human dignity in intimacy with God, the "glory" Jesus claims to give those whom the Father entrusts to him. In visual terms, the human couple, Domenico and his wife, are part of a descending pyramid with, at its apex, "the Father from whom every family, whether spiritual or natural, takes its name," as the New Testament calls God (Ephesians 3:14–15). The pyramid comes down and out, through Christ, Mary, and John, to Domenico and his wife, and beyond. Continued, this descending pyramid of God's love embraces spectators standing or kneeling before the fresco, and does so credibly, since the people in the fresco are the same size as people standing or kneeling in front of it. That is, the equality of scale that imparts visual and psychological stability to the composition includes viewers also, inviting them to perceive themselves as part of an infinite extension through space and time of the family love of God.[17]

The Theological Tradition

The key indeed is love. Saint Augustine (354–430), in a closely reasoned argument in the Eighth Book of his treatise on the Trinity, *De Trinitate*,

wove Scripture texts together to demonstrate the affinities between human love and the life of God. "The first thing to look for, in this question of the Trinity and on the way of knowing God," he said, "is what true love might be."[18] According to Augustine, true love involves relationships: specifically, the interaction of man's 'vertical' love of God and his 'horizontal' love of neighbor (cf. Matthew 22:40; Deuteronomy 6:5; Leviticus 19:18). God's charity is diffused in our hearts by the Holy Spirit (Romans 5:8), precisely so that we may love one another and, by loving, come to know God, "since love comes from God and everyone who loves is begotten of God and knows God," for "God is love" (1 John 4:7; 4:16). Practically speaking, love of neighbor is the proof of one's love of God, for "a man who does not love the brother that he can see, cannot love God whom he has never seen" (1 John 4:20).

In the Ninth Book of his treatise, Augustine then developed these insights into a systematic vision that would profoundly influence medieval and Scholastic thought. Man is made in the image and likeness of the tri-une God, he argued, and thus "resembles" the Trinity. For Augustine, this resemblance is apparent above all in the structure of human knowledge, since this involves three things: the mind, the idea or "word" generated by the mind, and the love that the mind has for its ideas, implicit in the desire to express them. "Hence the mind, its notions . . . and love are already a certain image of the Trinity, since these three realities are also a single reality, a single substance. . . ."[19] Commenting on this passage seven centuries after it was written, the Scholastic theologian Peter Lombard (1100–60) underlined the equality of the three mental "family members": "the off-spring is not less than its parent, nor love less than parent and offspring."[20]

Augustine's interpretation implied not only an epistemology but a social anthropology as well, in which the union of three distinct persons in one God structures and informs all human experience. That is, men and women seek the fellowship of other men and women because we are all made "in the image and likeness" of a "social" God.[21] Following Augustine, the twelfth-century Benedictine theologian Richard of Saint Victor († 1173) sought to "explain" the Trinity in light of this social orientation in human beings. Perfect love, he said, cannot merely be love of self. Love must extend to another person, equal in dignity to the "lover"; in God, therefore, there are necessarily at least two persons.

"But in true love," Richard then argued, "the supreme excellence is the desire that another be loved as one is loved oneself. In burning, mutual love, nothing is rarer and nothing more admirable than to want the one whom we love supremely, and by whom we are supremely loved, to love another with equal love. The proof of consummate love," he continued, "is the desire that the love with which we are loved be shared." Thus there are perforce *more* than two persons in God: there are three. Richard in fact spoke of the Trinity as a "society" or "community" of love, *consortium amoris*.[22]

Yet this line of reasoning calls for prudence. The Dominican thinker Saint Thomas Aquinas (whose ideas have particular relevance, since Santa Maria Novella is a Dominican church), citing Richard of Saint Victor's arguments, warned that "nothing can be posited univocally of both God and creatures."[23] For, while the ultimate meaning of human family life is found in the Trinity, the full meaning of the Trinity is not exhausted by the metaphor of human family relationships. A fifteenth-century French miniature illustrates the dangers of too close a parallel. The Trinity, in a nimbus at the left, has entered a bedroom and, with the words of Genesis 1:26, "Let us make man in our image and likeness," sends a child to the couple under the blankets, who thus become "three in one" just like God (Plate 66). Saint Augustine had long before criticized the absurdities that arise from overworking the metaphor: "I pass over in silence those who claim that the Holy Spirit is the 'mother' of God's Son, and the 'wife' of the Father; they commit the sin of materialism."[24]

It was Aquinas who clarified the extent to which the family analogy might be used. With typical precision, the Dominican pointed out that whereas in created beings relationships are an accidental part of their contingent nature (i.e., a man can be a father without fatherhood being necessary to his manhood), in God there is neither accident nor contingency. Whatever *is* in God is of his essence.[25] Thus divine fatherhood *is* God the Father, a divine person. Divine personhood means that relationships are part of the very substance of the person. A Florentine follower of Saint Thomas, Fra Remigio de' Girolami – a friar of Santa Maria Novella in the late thirteenth and early fourteenth centuries and one of Dante's teachers – put it succinctly when he said that with regard to personal relationships with the Trinity, "the Father and the Son are closer to each other than two brothers."[26]

This "closer" relationship is thus *like* but also *unlike* human family. It connotes a spiritual family that transcends and subsumes natural family ties. When Jesus designated Mary as John's "mother" and John as her "son," he was not creating a physical bond but a network of reciprocal support. Christian tradition in fact has taken this episode as signifying the creation of the Church, the institution that extends God's care for humankind through history, promoting relationships rooted in selfless love: the same love shown by Christ on the cross.[27] Yet membership in this spiritual family (the Church) does not lessen the dignity of natural family ties: Saint Paul said that "husbands should love their wives just as Christ loved the Church and sacrificed himself for her" (Ephesians 5:22–5). Indeed, the most intimate natural relationship, marriage, finds deeper meaning in the new ecclesial bond. Commenting on the passage in Genesis, "a man must leave his father and mother and be joined to his wife, and the two will become one body," Saint Paul said simply, "it applies to Christ and the Church" (Ephesians 5:31–2; cf. Genesis 2:24).

Plate 66. Folio from Jean Mansel, *Vita Christi*, Paris, Bibliothèque de l'Arsénale, MS 5206, fol. 174. (Photo: Cliché Bibliothèque nationale de France, Paris)

Masaccio's *Trinity* and the "Families" of Santa Maria Novella

Masaccio's unusual figure of Mary stands for the Church, therefore, austere and authoritative, as she directs the viewer's attention to the ideal expressed in Christ's self-sacrifice. As another medieval theologian, Rupert of Deutz (c. 1075–1130), explained, "since in her only son's passion the blessed Virgin gave birth to all our salvation, she is the mother of us all," and "what was said of this disciple [John] is rightly ascribed to any other disciple."[28] That is, Mary is also "mother" of the Lenzi and all believers in all times. She points to the cross because it is her job to teach her children the harsh facts of eternal life.

Giovanni Dominici (1357–1419), prior of Santa Maria Novella at the beginning of the fifteenth century, made the same point in a dramatic ser-

mon. He invited his listeners to imagine a woman whose husband had been murdered; then, playing on the lurid Florentine experience of family feuds, he said that the woman saved her husband's bloodstained shirt in order to show it to their children. Finally he explained:

for this woman, let us understand the holy Church; for the husband, let us understand our Lord Jesus Christ; for the children, let us understand ourselves. . . . Therefore, when we are asked to make peace with the accursed vices that have murdered our Father, we should take counsel with this holy mother Church of ours, the wife of Jesus. And she, as you see, places before you his blood-stained shirt, the holy Gospel of the Passion.[29]

Masaccio's fresco was not the first effort of the Dominicans of Santa Maria Novella to expound a theology of the Church in art. Fifty years earlier, Andrea di Bonaiuto (known as "Andrea da Firenze") had painted a monumental description of the role of the Church in society, and of the mission of the Dominicans in the Church, in the friars' Chapter House, about fifteen yards away from where Masaccio would later paint the *Trinity*. The importance of this earlier program cannot be underestimated, since it includes a fresco celebrating Saint Thomas Aquinas as the foremost theologian of Christian history and evinces a fully professional interest in "ecclesiology," the theological interpretation of the meaning of Church life.[30]

In effect, a highly developed Dominican ecclesiology probably determined the later program of which Masaccio's fresco was the focus. Ecclesiological thinking, which relativizes physical relationships in favor of spiritual family, is a standard feature in monasteries and convents, part of the conceptual structure of a world whose inhabitants address each other as "brother" or "sister" and call their superiors "father" or mother."

This at times confusing use of language derives from the New Testament, where it is ascribed to Jesus himself: "His mother and his brothers came looking for him, but they could not get to him because of the crowd. He was told, 'Your mother and brothers are standing outside and want to see you.' But he said in answer, 'My mother and my brothers are those who hear the word of God and put it into practice'" (Luke 8:19–21; Matthew 13:18–23; Mark 4:14–20). Other Gospel texts similarly support this expanded concept of "family," but the starkest distinction between physical and spiritual family is found in Luke 11:27–8: "Now as he was speaking, a woman in the crowd raised her voice and said, 'Happy the womb that bore you and the breasts you sucked!' But he replied, 'Still happier those who hear the word of God and keep it!'"

And in this church of preachers, Santa Maria Novella, precisely that text from Luke is carved on the base of the pulpit alongside Masaccio's image of "spiritual family": "Beatus venter qui te portavit et ubera quae suxisti. Beati qui audiunt verbum Dei et custodiunt illud" (Plate 67). The

pulpit was commissioned fifteen years after Masaccio's death, and by a different donor, but the consonance of message suggests a continuity of program in the Dominican community. The pulpit's design is in fact attributed to Brunelleschi, who probably had helped Masaccio with the perspective and architecture of the *Trinity,* and the work's execution was entrusted to Brunelleschi's collaborator and adopted son, Andrea Cavalcanti called "Buggiano."[31]

The exaltation of spiritual family implied in the text on the pulpit, and – in our reading – in Masaccio's *Trinity,* would have made sense to several groups using Santa Maria Novella. First, as noted, there were the friars. Giovanni Dominici had drawn a precise parallel between the ideal of harmony in monastic communities and the perfect accord that characterizes the life of the Trinity. Writing to the Dominican nuns of Venice, Dominici said that in monasteries and convents, the leading members should avoid rivalry and dispute, governing rather "with a single will and sole intention

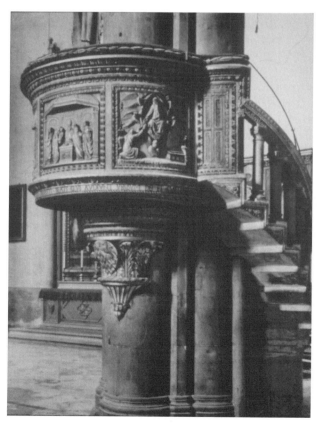

Plate 67. Filippo Brunelleschi, Giovanni di Pietro del Ticcia, and Buggiano, Pulpit, completed 1448–52, Florence, Santa Maria Novella. (Photo: Timothy Verdon)

. . . because Christ will be there . . . together with the Father and Holy Spirit, who rule the world as one." Speaking to the nuns, he insisted that "you should do the same thing, Mother Prioress, Mother Vicar and Mother Subprioress: not contradict each other but pull together, standing as one and not openly reprimanding each other, but – if need be – in private, and with love and unity and peace."[32] The idea was not new, and had even been illustrated in a thirteenth-century treatise on convent life, where the "horizontal" relationship of the sisters with their mother superior unfolds beneath the vertically aligned paradigm of Son, Father, and Spirit.[33]

It might be objected that while such ideas appealed to monks and nuns, Masaccio's fresco was painted for the laymen's area of Santa Maria Novella, below the rood screen (the partition that formerly separated the laity from the friars' choir). Could layfolk really have understood any of this? Evidence suggests they could. The mid-fourteenth-century act of foundation of a confraternity in Pisa (Plate 68) shows pious laymen kneeling before an altar with purses in their hands: their willing sacrifices for the good works of the brotherhood. Above the altar there is another "society of love" practicing voluntary sacrifice: the Trinity, in which the Father freely gives his Son and the Son freely gives his life. The analogy between charitable human association and the eternal model is unmistakable.[34]

By the late fifteenth century, several Florentine lay confraternities used Santa Maria Novella for their services, and such brotherhoods normally had a chaplain drawn from the monastic or mendicant community that sponsored them. There is thus little reason to doubt that a broad public existed for messages of the kind we find in Masaccio's *Trinity*.

The Trinity and Belief in Life after Death

At the bottom of the Pisan document, just as later in Masaccio's fresco, there is a memento mori (reminder of death): in the document, a skull; in the fresco, a skeleton. Developing our reading, we may say that a radical aspect of the spiritual family created by Jesus is that it survives the grave. Death has no victory over the believer who, having died with Christ in baptism, hopes one day to rise with him and return to the Father (cf. Romans 6:3–9). The elaborate funeral rituals of medieval and Renaissance Europe generally, and the emphasis on commemorating deceased members within lay confraternities, bear eloquent witness to the conviction that the living are spiritually united with dead family members and friends.[35]

This Christian understanding of death was important for the program of which Masaccio's fresco was the focus. As early as Boccaccio's day, Santa Maria Novella was renowned as a mortuary church. The *avelli* (arched tombs) around the outer facade were part of Florentine urban culture, as was the large exterior cemetery, which contained family tombs and

Plate 68. Pisan, *Statutes of Confraternal Foundation,* c. 1390, Pisa, Museo Nazionale di San Matteo. (Photo: Timothy Verdon)

tombs erected by confraternities for their members.[36] "Santa Maria Novella, thus girdled with graves, became one of the most important and interesting burial areas in Italy," concludes a historian of the complex.[37]

The door that gave access to the basilica from the cemetery was located on the building's eastern flank. Old photographs, made before the cypresses planted in the nineteenth century had grown, afford a clear view of this high Gothic portal. Worshipers using it entered the church exactly opposite the western aisle bay where Masaccio would paint the *Trinity,* and where, as noted, there was also an altar.[38] This grand medieval door was walled up by Vasari when he redesigned the liturgical space of Santa Maria Novella after the Council of Trent, but its outline is still visible in the church interior. And − at least in Vasari's day − the axial relationship

between the cemetery door and Masaccio's fresco was considered mean-ingful. The document that records alterations to the church states that the fresco of the *Trinity* "is opposite the walled-up portal."[39]

Masaccio's fresco thus served as the destination of a lugubrious but impressive journey. It began in the square on the side of the church, where believers passed before the ranged tombs of the perimeter wall. Going through the gate, they traversed the cemetery, also filled with wall tombs, many with images of the crucifixion painted beneath the arches.[40] Some vis-itors would have paused to pray for the repose of the soul of deceased rel-atives or confraternity brothers. Then, at the high eastern door, those enter-ing the church found themselves across the nave from Masaccio's fresco.

The innovative Brunelleschian architecture and the perspective origi-nally must have set this image off from the older decoration on the west wall, creating the illusion of a truly deep, modern chapel (Vasari says the wall appeared to be cut through at this point).[41] The total effect would have been similar to what Brunelleschi's adoptive son, Buggiano, executed in actual architecture twenty years later for the chapel of the Cardini fam-ily, in the church of San Francesco, Pescia.[42] And, as at Pescia, the real altar that stood before Masaccio's fresco was in all likelihood a table altar detached from the wall and open beneath so that visitors entering from the cemetery could see the painted skeleton through the colonnettes. It is an arrangement we find in Santa Maria Novella itself fifty years later in the Strozzi Chapel, where the sarcophagus visible beneath the altar table helps us imagine how Masaccio's skeleton was meant to be seen.

While private altars, like those in the Cardini and Strozzi chapels, were used for masses to free deceased members of the donor family from Pur-gatory, the Trinity altar in Santa Maria Novella must have had a more pub-lic purpose. Placed where all who came in from the cemetery could see it, the altar and accompanying fresco were probably meant as a visual sermon on Christian death and hope of a hereafter. The grieving viewer would have understood that faith opened the way to resurrection, which in prac-tical terms overcame the awful separation of death and restored the believer to life in the family of God, where earthly loved ones would one day join him.

An extraordinary painting by Jacopo del Sellaio (Plate 69), clearly inspired by Masaccio's fresco, suggests that this in fact is one of the ways Florentines of the later Quattrocento had come to think of death, resur-rection, and quite possibly, Masaccio's *Trinity*. It shows, in the lower area, a woman and her daughter, dead, laid out in winding sheets at the foot of Christ's cross. At the left, we see the woman's widowed husband, mourn-ing, while behind him, Mary holds out arms of consolation: the consola-tion of the Church. At the right, the woman's teenage son buries his face in Saint John's robes, overcome with grief. Finally, in the upper zone, there is another 'family': the "Father from whom every family, whether spiritual

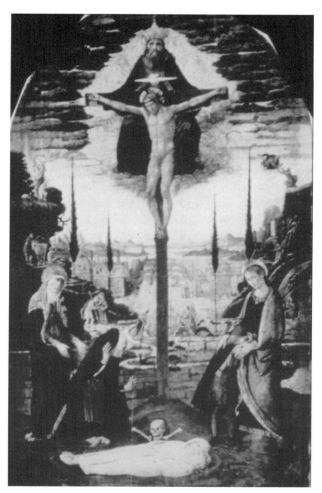

Plate 69. Jacopo del Sellaio, *Trinity*, 1483–90, Munich, former private collection.

or natural, takes its name," supporting his dead Son, raising him, breathing the life of the Spirit upon him. Seen in this way, Masaccio's *Trinity* must have served those coming from the cemetery as an icon of Christian hope in a final 'family reunion' in heaven, *in pectore Trinitatis* – in the bosom of the Trinity.[43]

The Space of the Church, the Space of the City

The itinerary I propose implies a basic reorientation of the space of Santa Maria Novella, or, rather, an alternative interior orientation: widthwise, from the cemetery door to the Trinity altar, as well as lengthwise, from

front door to high altar. Archival sources confirm that until modern times, Florentines used the cemetery portal with frequency, and a seventeenth-century source speaks of a holy water font beside the pier just inside the cemetery door, on a short column with the date 1302.[44] For those entering through this door, moreover, any view of the high altar and friars' choir to the right was cut off by the rood screen, which then stood in the bay beyond the holy water font.[45] That high and deep structure stretched across the entire width of the church and must necessarily have redirected the attention of all entering from the cemetery (which was at the east) to the west wall and Masaccio's fresco. This kind of "crossroads" arrangement meant that some people used the church lengthwise, moving from front door to rood screen and choir, while others might enter through a side door and cross to pray at one or another of the aisle altars.[46]

At Santa Maria Novella, the alternative orientation – obtained when one entered by the cemetery door at the east – was a vestige and reminder of the history of the building. The first church, constructed before the Dominicans took over the property in 1221, had faced the cemetery to the east. It was reoriented only in the late thirteenth century, when the building was enlarged at right angles to its existing structure and the original nave became the transept of a grander church.[47] That is, what visitors see today as the east transept wall was originally the front facade of Santa Maria Novella. This older orientation was embedded in the friars' institutional memory and in the communal memory of Florentines, who until the nineteenth century called the large square east of the church (originally in front of the church) the "Piazza Vecchia di Santa Maria Novella," the "Old Square of Santa Maria Novella." The monumental scale of the cemetery portal, constructed in 1301 and thus within living memory of the old orientation of the building, should probably be understood in this light, as a memorial of the old principal facade and, in functional terms, part of an established traffic pattern.

The decision to put an altar and image honoring the Holy Trinity on axis with this door and the old square suggests a wider application of the ideas we have adduced. The Piazza Vecchia, beyond the cemetery, had for centuries been the meeting place between the Dominicans and the *comune* (city), where the friars preached their ecclesial vision of unity to the warring factions of Dugento and Trecento Florence. At the height of the city's troubles with warring factions in 1278–9, it was in this square that the "Cardinal Conciliator," Latino Malabranca – a Dominican prelate and former friar of Santa Maria Novella appointed by Pope Nicholas III to settle the disputes – called a parliament of the people and civil and church authorities, and urged them to make peace.

Describing what must have been a dramatic ceremony, the somewhat later chronicler Giovanni Villani (c. 1280–1348) says that when the leaders of the factions agreed to the cardinal's terms, "he made them kiss each

other on the mouth . . . and make peace," 150 per side! The Dominican prelate also pacified conflicts among the great families – the Adimari, the Tosinghi, the Donati, the Pazzi – by persuading them to intermarry: "facendo più parentadi insieme" (forming numerous family relationships among them).[48] The new nave of Santa Maria Novella – significantly begun the day after this parliament, with Cardinal Latino Malabranca laying the first stone – was probably meant as a sign of the Dominican mission to preach peace. When, twenty-two years later, another peace conference was needed, it was held in the friars' newly built nave.

The choice of Santa Maria Novella for these ceremonies was not accidental. The Dominicans played an active role in the political and social struggles of Florence in this period. The aforementioned Fra Remigio de' Girolami, himself a member of a politically active Florentine family, wrote a treatise "On the Common Good" (1301–2), warning citizens against internecine strife. He preached before the elected government and condemned factionalism, renouncing his own family's political ties. The way to social peace, as he preached it, parallels the vision of unity within the Church described in the Acts of the Apostles. Like the first Christians, Florentines should join their hearts and minds to achieve unity.[49] Another Dominican, Giordano da Pisa (1260–1311), gave a series of sermons in Florence between 1302 and 1307 against particularism and family feuds.[50] In the early fifteenth century, then, Giovanni Dominici preached that Florentines could learn citizenship from Christ, and later in the century, another friar of Santa Maria Novella, Giovanni Caroli (1429–1503), would call his cloister a microcosm of the city.[51]

It is thus possible to speak of a body of Dominican social teaching, strong at Santa Maria Novella, in which an ecclesial model of peaceful coexistence was preached by the 'brothers' of a religious community to the powerful families of the civil community. And the friars' decision to erect an altar and image of the Trinity may have been part of that teaching. Masaccio's fresco was to speak to Florentines not only individually, of private life and death, but collectively – politically – of the citizen's equal place in a system of relationships with its origins in eternity: the Trinity, that "society of love" that Dante had called "the first equality" and the "first and ineffable value."[52]

Masaccio's authoritative Mary – holy mother Church – was to show all who entered from the cemetery the cost of fellowship: the "blood-stained shirt," the Gospel of Christ's death. Individually and collectively, membership in God's spiritual family in fact calls for sacrifice, for the gift even of one's life.

But this family lasts. This bond endures beyond the grave, opening an infinite perspective on the significance both of family and of life. Indeed, at a level too deep for words, human nature and the very machinery of mind and heart summon humankind to join this fellowship. By their inner-

most constitution, human beings yearn to share in the fullness of God's love as it extends through space and time, beyond the natural social unit of generative family to society as a whole, and further still: beyond the earthly city to that 'heavenly Jerusalem' on the far horizon of Judeo-Christian thought.

And – to the extent that they respond – individuals, families, confraternities, religious communities, and the corporate family of the State can pass from division and death to a hard-won harmony: foretaste, in this life, of the life of God himself, Father, Son, and Spirit.

9 Masaccio and Perspective in Italy in the Fifteenth Century

J. V. Field

It has often been implied, and occasionally actually stated, that Masaccio was responsible for the introduction of perspective construction in art. This is true only in the very limited sense that Masaccio's works provide the earliest surviving evidence of the use of formal perspective in Renaissance paintings. That is, they provide pictorial evidence. There is convincing literary and documentary evidence that points very strongly to a perspective technique having been invented by Filippo Brunelleschi (1377–1446), in the sense that he devised some method of using a geometrical construction to obtain a convincing illusion of a third dimension in a flat picture. A document written in 1413 refers to Brunelleschi as "gran prospettico." This suggests that his invention dates from that year or shortly before. What Brunelleschi invented is apparently a real mathematical rule, that is, one that can be demonstrated to be mathematically correct. This interpretation of events is the most natural reading of what Antonio di Tuccio Manetti (1423–97) says about the matter in his biography of Brunelleschi.[1]

There is no good reason to doubt that Manetti is correct in presenting Brunelleschi as having invented a "rule" for perspective, but in interpreting the document of 1413, we need to bear in mind that the word we translate as "perspective," that is "perspectiva" or "prospectiva" in Latin ("perspettiva" or "prospettiva" in the vernacular), actually refers to the whole science of sight, which deals not only with the nature and properties of light but also with such matters as the functioning of the human eye. Describing Brunelleschi as "prospettico" thus meant he was considered an expert on what would now be called "optics." The term "optics," derived from Greek, began to replace the Latin *perspectiva* in the sixteenth century. This was not on account of the rediscovery of any important new Greek work on the subject. Greek optical work, largely that of Euclid (fl. c. 300 B.C.E.), formed the basis of *perspectiva* in the fifteenth and sixteenth centuries as it had in the thirteenth, when the

standard textbooks used in the fifteenth century had been written. As what we now call "perspective" came to be used in the visual arts, it acquired names such as "artificial perspective" (*perspectiva artificialis*) to distinguish it from *perspectiva* proper.

Brunelleschi would probably have called himself an engineer (*ingegniere*), and he is now best remembered for his architectural activity, but he was trained as a goldsmith. There is no evidence that he ever practiced as a painter, except to paint two panels designed to demonstrate the effectiveness of his perspective technique. Moreover, there is no indication that painters felt any immediate need for the technique Brunelleschi had invented. Our first surviving evidence for its use is in the sculptured relief of *Saint George and the Dragon* by Donatello (1386–1466), in which the "picture," designed to decorate the base of Donatello's statue of the saint on Orsanmichele, Florence, is of course not quite flat, and, some years later, in paintings by Masaccio. Since interpreting the evidence provided by Donatello is somewhat difficult, Masaccio's work provides our most useful testimony in any attempt to understand what Brunelleschi may have invented. As evidence, Masaccio's work also has the recommendation of antedating the probably influential descriptions of perspective by Leon Battista Alberti (1404–72) in his treatise on painting, *De pictura* (1435), and its vernacular version, *Della Pittura* (1436), which was dedicated to Brunelleschi. The extent of Alberti's debt to Brunelleschi will be explored later in this chapter.

Brunelleschi's Invention

A good case has been made for supposing that a major reason for Brunelleschi's interest in optics and the apparent changes in size that natural optics introduces in what we see was his concern with proportions in architecture. He wanted to know how the proportions seen between various members would be affected when a building was viewed from different positions.[2] It is possible that this concern led him to make some drawings of building designs and to draw lines of sight on them in order to see the changes caused by a change of viewpoint. What we know of Brunelleschi's other work suggests he was good at mathematics – and we know apprentice goldsmiths were taught what was then a considerable amount of mathematics – so it may well be that making such drawings led him to notice some general mathematical rules. However, we do not know what they were. Nor is it overwhelmingly helpful that we know that the first of the two demonstration pieces he made was a picture of the Baptistery of Florence, and the second showed the Palazzo della Signoria (now called the Palazzo Vecchio) seen diagonally across the square in front of it. The choice of these subjects mainly tells us that his perspective technique worked well for buildings, particularly ones with a simple, regular shape. A glance at any

perspective picture will demonstrate that this is true of all perspective tech-
niques. Even a superficial study of any book on perspective addressed to
painters reveals the same story. Many such books were printed in the six-
teenth century, and it is very probable that they preserve the rules followed
in painters' workshops in the fifteenth century.[3] However, in analyzing a fin-
ished picture, from which construction lines will usually have been erased,
it is important to recognize that it is only for simple objects containing a
suitably large number of straight lines that one can actually check whether
the representation is in correct perspective or not. The ideal and favorite
object for perspective construction by artists, and for measurement by
investigators, is the horizontal, tiled pavement. Such pavements are fairly
common in fifteenth-century pictures. As Alberti makes clear in *De pictura*,
the introduction of a pavement provides what is effectively a coordinate
system for positioning objects in depth in the pictorial space.[4]

Many surviving works of art show Albertian pavements, which indicate
that artists found them useful. It may be an indication of Brunelleschi's
lack of engagement with painting that, from what we can learn of it, his
technique does not seem to have been particularly well adapted to con-
structing such a pavement. For a start, the subjects of Brunelleschi's two
demonstration panels suggest a method for constructing images of
straight-edged shapes directly, rather than in relation to a ground plan laid
out on a square grid. For instance, however the grid was laid out, the posi-
tions of some of the corners of the ground plan of the Baptistery could not
be made to coincide with points easily defined in relation to a coordinate
system. This is a consequence of a mathematical property of the regular
octagon, and Brunelleschi's grasp of mathematics was assuredly good
enough to understand it. Essentially, the difficulty is that while one can
give a very simple geometrical construction for the regular octagon, it
requires using a length that involves the square root of two, which cannot
be expressed exactly in numerical terms. This means that one cannot give
a simple arithmetical description of the positions of the corners of the
octagon relative to a horizontal grid. It is possible that Brunelleschi's tech-
nique involved constructing the shape corner by corner, which would
mean using sightings (real or simulated in a drawing) somewhat in the
manner of a surveyor. However, this method would be tedious and does
not really explain the choice of buildings that have a simple shape with
straight edges that can be grouped into sets of parallel lines. It accordingly
seems more likely that Brunelleschi's invention consisted in some rela-
tively easy way of finding the images of sets of parallel lines.

We know now that if lines are parallel in the real three-dimensional
scene, then their images in the perspective picture of it will be lines that
meet at a point on the horizon, the horizon being defined as a horizontal
line in the picture at the level corresponding to the height of the eye of the
ideal observer. However, this result was first published by Guidobaldo del
Monte (1545–1607) in 1600. We have no reason to suppose it was known to

artists in this general form in the fifteenth century.[5] However, a special case of this general theorem may have been well known. A rather casual reference in Alberti's *De pictura* (§19) suggests that it was well known that if the real scene contained a set of lines that were perpendicular to the picture plane ("orthogonals"), then the images of such lines in the perspective picture would be lines that converged to a "centric point" on the horizon (in the picture).[6] This convergence of the images of orthogonals may have been what Brunelleschi discovered and used as the basis for his construction technique. However, by the very nature of the optics and mathematics concerned, it is difficult to see how one might both discover and prove the theorem about the convergence of images of orthogonals without at the same time finding the more general theorem that is stated by Guidobaldo del Monte. In this case, what historians of science warily call "rational reconstruction" unhelpfully tends to lead us to something that seems to have been unknown. Several imprecise or untenable suggestions by art historians are better left uncited. I have suggested, somewhat speculatively, a possible derivation of the convergence of the images of orthogonals from the geometry of the planispheric astrolabe (an astronomical instrument well known to the learned of the time). This still seems to me to be more a mathematical possibility than a plausible historical explanation, but it does have the merit of being mathematically tenable.[7] However, in view of the mathematical traps inherent in this particular rational reconstruction, it is probably safer for the historian to fall back on the pictorial evidence.

Unfortunately, pictorial evidence on perspective needs to be handled with extreme care. Two cautionary examples will suffice. The first is the pair of pictures of chapels (c. 1305), shown in illusionistic style, on either side of the chancel arch in Giotto's fresco decoration of the Scrovegni Chapel, Padua (Plate 70). There is little doubt of Giotto's intention that these chapels should be read as "real" or of his skill in making them look so. Whether he did this by applying mathematical rules or merely by his customary skill in observation and draftsmanship is not known. The other example dates from some years later. An altarpiece by Ambrogio Lorenzetti, the *Presentation of Christ in the Temple* (signed and dated 1342; Florence, Galleria degli Uffizi), shows a fairly complicated tiled pavement that is in correct perspective if we assume the ideal observer is at a distance of about half the picture's width from the painting. This viewing distance is unrealistic, but similarly short ideal viewing distances are found in many fifteenth-century pictures, perhaps because if one uses the so-called distance-point method of construction, such a short viewing distance allows the construction to be carried out entirely within the picture field. However, we do not know whether Ambrogio used this construction, or indeed any construction that he knew to be mathematically correct. He may simply have been applying a construction rule that was known to work.[8] This seems to have been the attitude adopted by most fifteenth-century painters. On the whole, they seem to have used perspective constructions as simply

Plate 70. Giotto, *Illusionistic Niche,* 1305, Padua, Scrovegni Chapel. (Photo: Assessorato alla Cultura di Padova, Cappella degli Scrovegni, Padua)

one more tool in the making of pictures. The most obvious exceptions to this rule are Paolo Uccello (1397–1475), whose perspective constructions are often highly visible, Piero della Francesca (c. 1412–92), who wrote a treatise on perspective (see later discussion), and Andrea Mantegna (1431–1506), whose work belongs to a humanistic milieu, the ideas of which were expressed in, or maybe indebted to, the works of Alberti (both his writings and his construction projects).

Masaccio's Practice

Masaccio's case is simpler in the sense that in Florence in the 1420s, he was working in an environment where using perspective was not an established artistic fashion but an innovation. As a painter, he was thus out on his own, though there is good reason to suppose he turned to Brunelleschi for advice, and perhaps also to Donatello. Masaccio's work thus provides

very important pictorial evidence for the use of perspective construction. Some exact geometrical investigation of the pictures is therefore in order.

Running taut strings along straight lines in the frescoes in the Brancacci Chapel provides convincing evidence of Masaccio's use of the convergence of images of orthogonals. Moreover, "snapped" lines in the plaster suggest Masaccio used this technique himself in drawing the lines.[9] Similar convergence can be seen in the lines of the throne of the London *Madonna and Child with Angels* from the *Pisa Altarpiece* (see Plate 14), but in this case, the lines are very short and thus need to be extended by many times their original length in order to reach their potential point of convergence in the heel of the Child's foot. As drawn on photographs, all these convergent lines look extremely convincing. However, one must allow for scale: If the photographs were magnified to make them the same size as the original pictures, the lines drawn on some of them would become unacceptably thick. This is particularly marked for the frescoes, in which the figures are roughly life-size. The use of string held up to the actual painting – which today, as in the fifteenth century, is a convenient way of obtaining a straight line – has shown that the convergent images of orthogonal lines in the *Tribute Money* (see Plate 8) from the Brancacci Chapel have not one convergence point but two. One is on the bridge of Christ's nose, that is, midway between his eyes, and the second is in the middle of his forehead. The first convergence point apparently conforms to Alberti's recommendation that the height of the "centric point" be that of a standing figure in the painting (one presumes he means the height of the eye of such a figure: It is of course possible that this picture inspired Alberti's rule).[10]

The second point seems, in perspective terms, to be a gross and elementary error.[11] The likeliest explanation is carelessness. The fixed end of the string was tied to a nail, which may have been removed between the periods during which the two parts of the painting were executed. However, the mistake or oversight does suggest that mathematical correctness may not have been the foremost consideration in Masaccio's use of perspective in his contributions to the decoration of the Brancacci Chapel (see Plate 3). The error does not have any noticeable effect of weakening the illusion of the third dimension that is conveyed by the scene. This effect is no doubt aided by the convergent images of receding orthogonals, but it is also a result of the very strong sculptural modeling of the figures. Indeed, the use of formal perspective, employing straight lines, is really rather discreet, being confined to the building on the right of the picture. This pattern of using perspective images of rectilinear forms to establish a sense of depth on one side, while constructing a less formal sense of space by means of landscape on the other, is used by many later artists, including Piero della Francesca in the middle register of the left wall in his Story of the True Cross, San Francesco, Arezzo.

In the frescoes in the Brancacci Chapel, all one can meaningfully study is the convergence of images of sets of lines that look as though they should be read as orthogonals.[12] However, a more detailed investigation

becomes possible once we have a way of estimating the depth of objects in the pictorial space, that is, their distance behind the picture plane. The most revealing objects are horizontal squares with one side parallel to the picture plane. To see why this is so, we shall look at a type of perspective construction known as the "distance-point method" (Figure 1, a–d). To use this method to construct the image of a horizontal square, we need first, as with any perspective construction, to decide upon the position of the eye of the ideal observer. Let us assume it is at a distance d from the picture plane, which is assumed to be at right angles to the line of sight, and the eye is at a height h above the ground line (that is, the line at which the picture plane cuts the ground, which is assumed horizontal). As the square can easily be subdivided, we shall take the simplest case in which the square has one edge along the ground line and is the same width as the picture. The construction is then as shown in Figure 1a.

We first join the two near corners of the square, the points A and B, to the point directly opposite the eye, that is, the foot of the perpendicular from the eye to the picture plane. This point has been called C because Alberti was to call it the "centric point."[13] We then mark the point that represents the position of the eye, the point O, at a distance d from point C and a height h above the ground line AB. We join O to the corner B, and through the point in which OB cuts AC, the point D, we draw a horizontal line to cut the line BC in the point E. The line ED will be the perspective image of the far edge of the square. There is nothing special about the fact that the diagonal of the image of the square, the line BD, can be extended to go through the so-called distance point O. The diagonal of the image of any square with one edge parallel to AB can also be extended to pass through O. We can use this property to subdivide our large square $ABDE$ into smaller ones, as shown in Figure 1c, in which, for the sake of clarity, construction lines have been shown dashed. Since it clearly does not matter whether the distance point O is placed to the left of the picture or to the right, we can also put in a distance point on either side and allow the intersecting diagonals to give us points on the horizontal lines ("transversals"), thus avoiding the necessity of using a separate construction to obtain lines parallel to AB. Constructing such lines is of course easy on paper, but painters were concerned with making rather large drawings on a wall. This double-sided version of the distance-point construction is found in an underdrawing by Paolo Uccello for a fresco in San Martino alla Scala, Florence.

The distance-point construction is, in fact, a theorem about the working of natural optics, which is to say that if a picture is in correct perspective, the diagonals of suitably oriented squares can all be extended to pass through a distance point, thereby allowing one to find the position of the ideal eye. This inversion of the distance-point construction is shown in Figure 2. The method used in constructing the perspective picture that is being analyzed is irrelevant to this result. One can use the inverse of the distance-point method to find the position of the camera from a photograph. So, if we can

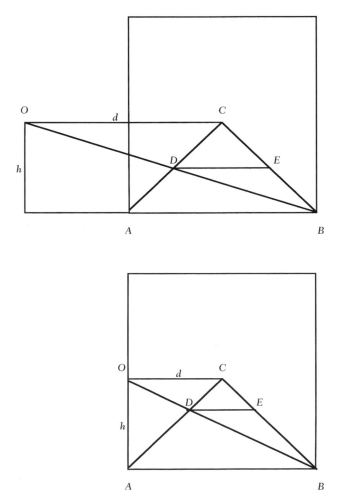

Figure 1. (a) *(Top)* Distance-point construction. The point *O*, called a distance point, represents the eye, at a distance *d* from the picture and at a height *h* above the ground line. The distance of the eye from the picture is *OC*. *ABED* is the perspective image of a horizontal square with one side along the ground line. (b) *(Bottom)* Distance-point construction, as Figure 1(a), but with the viewing distance *d* equal to half the width of the picture, so that *O* lies on the edge of the picture field. *(continued)*

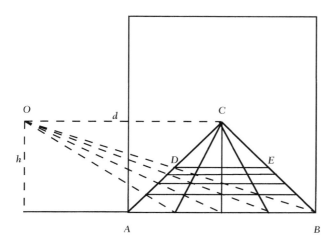

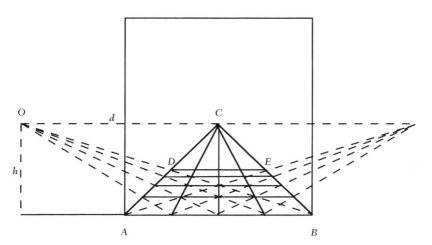

Figure 1. (c) *(Top)* Distance-point construction, as Figure 1(a), with additional lines drawn to the centric point, C, and lines drawn from the distance point, O, to construct additional images of orthogonals and transversals and thus divide the large square into smaller ones. (d) *(Bottom)* Distance-point construction, as Figure 1(c), with an additional distance point added on the right of the picture. Using two distance points gives two points on each transversal, thus avoiding the use of an additional construction to make them parallel to the ground line. © J. V. Field

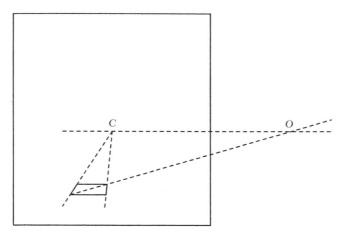

Figure 2. Inverse distance-point construction. Construction lines have been shown dashed. The image of a square is used to find the centric point, C; then a horizontal line is drawn through C, and its point of intersection with the extended diagonal of the square is the distance point, O. © J. V. Field

find a horizontal square in a picture that seems to be in correct perspective, we can find a possible position for the eye of the ideal observer; and if we can find several such squares, which all give the same position of the ideal eye, we can be fairly sure the picture actually is in correct perspective.

For Masaccio's fresco of the *Trinity* (see Plate 13) in Santa Maria Novella, there is, however, little doubt that the perspective is correct, at least in the simple sense that it conveys a very strong illusion of the third dimension. As Vasari noted, it is as if the wall were pierced.[14] Since there are plenty of orthogonals, provided by the receding lines of the ribs of the barrel vault and the moldings at its base, the position of the centric point is well defined – though to judge by slight inaccuracies in the convergence, Masaccio may have used a fairly large knot in securing his coarse string to the nail. In this case, we decided the letter C stood not for "centric point" but for *chiodo* ("nail").[15] Since the position of the centric point on the wall is well defined, and since we know it is the foot of the perpendicular from the ideal position of the eye to the picture plane, all that we need to find is the viewing distance. This can be done by simple observation. In effect, the ideal viewing distance of a perspective picture acts as a minimum viewing distance; that is, there is an effect of visual discomfort if one stands too close, whereas standing too far away makes surprisingly little difference.[16] For the *Trinity*, experimentation shows convincingly that the ideal viewing distance is very close to the width of the aisle, which is 686.25 cm[17] at this point. This is an entirely reasonable result, since it is possible that, as in some other churches, there was a railing to prevent the public from coming any closer than this.

Since the picture shows the two most obvious characteristics of perspective, the illusion of depth and the existence of a point of concurrence

for images of orthogonals, there have been numerous attempts to recon-
struct the three-dimensional, imaginary scene to which the painted view
corresponds. Curiously, in view of the impracticality of carrying out such
a procedure accurately, most of these reconstructions seem to have been
based upon photographs of the picture. Only three serious attempts have
been made to measure the actual fresco,[18] and one more involved using
very large photographs,[19] though the size of the fresco ensures that mea-
surements taken from small photographs cannot be very accurate.

There are four solid forms shown in the *Trinity* that include horizontal
squares having one edge parallel to the picture plane. These are the four
abaci, the shallow impost blocks resting on top of the capitals of the
columns at the front and back of the imaginary "chapel." However, all
scholars who have used these squares have obtained an unconvincingly
short viewing distance from them. The squares associated with the front
columns give a viewing distance about a meter too short, and the ones
associated with the back columns give one about three meters too short.[20]
This inconsistency between the two sets of squares is so marked that it can
even be seen by placing a ruler across a 14 × 10 cm photograph.

The squares are partly outlined by engraved lines, but the only possible
conclusion to be drawn from these measurements is that they have not
been drawn correctly. It turns out that a much more convincing viewing
distance can be obtained by looking at the transverse ribs of the barrel
vault.[21] Their outlines are marked with engraved arcs, apparently made by
compasses. However, in order to get a viewing distance, one needs to make
an assumption about the "true" shape of the coffers in the vault, that is, the
shape they would have if the cylindrical vault of the architecture shown in
the picture were imagined to be unrolled, becoming flat. The most natural
assumption is that the coffers would then be square.[22] If we make this
assumption, we can obtain a sensible viewing distance, that is, one close to
the observed correct distance, the width of the aisle. In fact, we also need
to assume that the coffers are all meant to be equal in width (that is, as
measured along the semicircular ribs), though they are not shown that way
in the painting, where the bottom row on each side is almost exactly half
as wide again as the six middle coffers (see the following discussion).

If we assume that the coffers are square, we find that the ground plan of
the imaginary "chapel" is oblong. The short edge faces us, and the ratio of
the sides is very close to 4:3.[23] However, we have a choice: We can assume
instead that the ground plan of the "chapel" is square. This assumption gives
us a reasonable viewing distance, but coffers that are not square. If we want
to draw a ground plan and section of the imaginary architecture, then we
need to make a decision between these two schemes.[24] However, it is not
certain that Masaccio did use a consistent model (three-dimensional or con-
sisting of drawings). Our only direct evidence is the fresco.

The perspective of the *Trinity* has, in fact, many features that remind us
that Masaccio was concerned with the composition of his picture in the plane.

One such feature has already been mentioned, the excessive width of the lowest row of coffers on each side of the vault. The difference in size is visible from the floor of the church and indeed in photographs (once one knows one is looking for it); it is very striking when seen from scaffolding, so there is no possibility of its being attributable to a mistake on the painter's part. Moreover, the positions of the longitudinal ribs have been carefully marked on the plaster, clearly with the intention of preventing mistakes. The explanation for the positions of the lowest longitudinal ribs seems to be that as shown, they make compositional lines linking Christ's hands to the capitals of the columns.[25] Analysis of the positions of the transverse ribs shows that they, too, have been adjusted: The first visible rib has been moved up, so that it is partly hidden behind the pink marble molding of the entrance arch, and the next rib has been moved up a little to make the coffers more even in apparent size. The motivation is presumably compositional, since the wider band of gray that would have resulted if the nearest rib were shown correctly (in the mathematical sense) would possibly have been too prominent and thus have interfered with the reading of the relationship between the entrance arch and the barrel vault.[26] In view of these departures from mathematically correct perspective, it seems worth asking whether some similar adjustment of the shapes of the square *abaci* may account for the misleading viewing distances one deduces from their shapes. It does, in fact, seem possible that the receding edges of the *abaci* on the front columns have been lengthened slightly in order to make them – that is, their shape as painted – cut into a transverse rib and thus make less of an interruption in the reading of the vault.[27]

The *Trinity* shows us a painter using perspective as merely one element in organizing his picture – strongly illusionistic though the picture is. Masaccio is a craftsman using a technique, not a mathematician displaying the scientific construction of a pictorial space. Perhaps it was a recognition of this – though doubtless conceived in other terms – that explains why Manetti does not mention Brunelleschi's having any connection with Masaccio or any of his works, while Vasari, in his *Life* of Brunelleschi (1550, 1568), merely makes the general remark that Brunelleschi taught Masaccio about perspective and about architecture.[28] In his *Life* of Masaccio, Vasari merely repeats that Masaccio learned from Brunelleschi (and Donatello), but does not mention Brunelleschi in connection with the *Trinity*.[29]

Masaccio's use of perspective in the *Trinity* indicates that we need to ask not only how he knew the rules of perspective, but also how he knew that one could depart from them without noticeably weakening the illusion of the third dimension.

Masaccio's Sources

It has long been recognized that the likeliest source for Masaccio's understanding of perspective was Filippo Brunelleschi. There can be no doubt that

the architecture shown in the *Trinity* and the architectural framing elements in the Brancacci Chapel are markedly Brunelleschian in style, though Masaccio uses pink where Brunelleschi shows a preference for gray. There is, however, no literary evidence that Brunelleschi made a direct contribution to the *Trinity,* say by making a *modello* (model or drawing) for the architecture it shows or by constructing its perspective. All the same, it seems highly probable that whatever method Masaccio used in constructing the perspective of the *Trinity* was at least closely similar to that employed by Brunelleschi. It is therefore interesting that Masaccio seems to have felt free to adjust the perspective images of the square shapes of the *abaci.* This suggests that he did not regard squares as particularly important. Nor indeed are they in the *Trinity.* Insofar as it depends upon the architecture, the weight of the illusion is, manifestly, carried by the rendering of the barrel vault.

It has sometimes been suggested that the basis for the perspective of the barrel vault may have been the construction of a set of straight transversals whose intersections with the moldings at the base of the vault then gave the ends of the arcs of the transverse ribs. Such a procedure is not very practical; the transversals would come out very close together (notice the closeness of the ribs in their lower parts), and tiny errors in finding the points of intersection with the molding would lead to large errors in the pattern of ribs. Any craftsman surely knew in the fifteenth century, as today, that one does not work from the small to the large if one can help it. Moreover, the incised compass sweeps that mark the outlines of the transverse ribs (and their center lines in the left side of the vault) do not actually reach as far as the molding at the base of the vault. Thus, the sup-

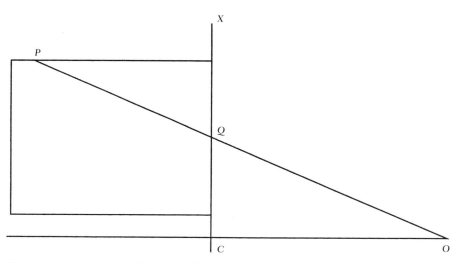

Figure 3. Simple projection for images of points. The rectangle represents a longitudinal section of the imaginary chapel. The line *XC* represents the picture plane. *C* is the centric point, and the eye is at the point *O.* If *P* represents a point on the vault, its image in the picture will be the point *Q.* © J. V. Field

posed points of intersection do not appear. It consequently seems exceedingly unlikely that Masaccio used this kind of method to construct the ribs. In fact, a much simpler method could have been employed. In analyzing the drawing of the vault, the obvious method is to construct a longitudinal section of the imaginary scene, including the architecture, as shown in Figure 3. Masaccio might have made calculations based on a sketch like this, or he may have made an accurate drawing from which he took lengths off with compasses. Making a drawing would, of course, enable him to notice, as he seems to have done, that there was an impending collision between the images of the molding of the entrance arch and that of the first visible transverse rib. In any case, the evidence is strongly against Masaccio having used a construction that starts with a horizontal grid and privileges the construction of accurate squares. The method shown in Figure 3 might best be called "simple projection."

Besides simple projection, the other piece of mathematics Masaccio seems to have used is the convergence of images of orthogonals. The lines of the moldings at the base of the vault and the lines of the longitudinal ribs converge with sufficient accuracy to suggest very strongly that the snapped lines that mark their positions were made by a string tied to a nail hammered into a centric point. Unfortunately, this point is in a part of the picture where Masaccio's intonaco has not survived.[30] The height of this meeting point above the present floor level is about 172 cm, which is a reasonable height for the eye of a standing observer. This suggests that Masaccio knew that the images of orthogonals should meet at a point corresponding to the foot of the perpendicular from the eye of the ideal observer to the picture plane. The evidence is not absolute because we do not know what the floor level was at the time the picture was painted; the present floor dates from the nineteenth century. Nonetheless, taken together with the fact that one of the meeting points of images of the orthogonals in the *Tribute Money* also seems to be related to eye level (this time, that of a standing figure in the picture), it is fairly certain that Masaccio knew about the properties of the centric point. This knowledge, together with the use of simple projection, would have sufficed to construct the perspective of the *Trinity*. It represents the minimum that would be required, but there is no evidence that anything more was used. Thus, if we assume, as seems only reasonable, that Masaccio's understanding of the "rule" for perspective came from Brunelleschi, then Brunelleschi's invention must have included the properties of the centric point. Moreover, the perspective of the *Trinity* suggests also that Brunelleschi's method did not involve the construction of series of transversals like those we find in the square-tiled pavements of many later pictures. Masaccio's figures of the Virgin and Saint John may well be supposed to be standing on such a classical floor, but it and their feet are not shown in his painting.

We may also note that the perspective of the *Trinity* is more daringly naturalistic than that of the *Tribute Money,* or any of the other scenes in the Brancacci Chapel, in that the scene is shown as if one were looking up at it, that is, as if the pictorial space were a continuation of the space of the church. This is probably an indication that the *Trinity* was painted later. In any case, such illusionism must always be approximate, since pictures are bound to be seen from a variety of positions, but the illusion is surprisingly robust. Brunelleschi had clearly discovered this, since his second panel (unlike his first one) did not need to be viewed through a peephole. However, in the *Trinity,* Masaccio is exploring a different kind of robustness: His picture is mathematically incorrect even when seen from the ideal viewing position. This is a different matter from relying upon the robustness of an illusion generated by a picture that is seen from a position different from that for which it was constructed. The likeliest source for Masaccio's knowing that the illusion would survive deviations from correct construction is Donatello.

Donatello

Vasari tells us that Masaccio sought to emulate Donatello, and there is indeed no difficulty in seeing Masaccio's human figures as elements in a visual dialogue with Donatello. In its turn, the perspective scheme of the *Trinity* suggests the dialogue also extended to the use of perspective construction. Sculptors were aware that their works would be seen at awkward angles, since most sculptures were designed to be attached to buildings. Donatello, in particular, was well aware of the various means that could be used to make figures look right under such circumstances.[31] The "corrections" made for visual effect seem to have been ad hoc, and making them was helped by the fact that sculptors usually held their workpiece at an angle, which would allow them to see how it would look when in its final position. Donatello's work is so adventurous in its use of incorrect perspective that one must suppose a few failed trial pieces were happily consigned to the rubbish bin in the course of experimentation. The anarchic nature of the mathematics in so many of the finished works, such as the roundels made for the Old Sacristy of San Lorenzo, Florence, is rather disconcerting, since in artistic terms, they are extremely successful.[32] However, this increases rather than decreases the likelihood of Donatello's example or advice having been a source of Masaccio's willingness to depart from mathematical correctness.

Donatello's own practice in the use of perspective is as impossible to characterize in simple terms as is his notoriously variable artistic style. The characteristic they share is that each work seems to have been thought out afresh, so that each solution (usually of a kind to completely conceal the

Plate 71. Donatello, *Saint George and the Dragon*, 1414, from base of *Saint George*, Florence, Bargello. (Photo: Diane Cole Ahl)

existence of any initial problem) applies only to the work in question.[33] This apparent rejection of generalization makes Donatello a profoundly non-mathematical soul, the whole basis of mathematics being the willingness to throw away the particular in order to be able to arrive at generalizations. In fact, most of the geometry of the time dealt with two-dimensional entities and thus might well seem rather uninteresting to a sculptor capable of thinking directly in three dimensions.[34] There are, nonetheless, several reliefs by Donatello that show what seem to be substantially correct perspective constructions, one of the most substantial being in the marble relief of *Salome Dancing before Herod* (Lille, Musée des Beaux Arts), in which a large expanse of square-tiled floor is visible.[35] This relief has a viewing distance about two and a half times the picture width (as can be deduced from the representation of the square-tiled floor), but it is carved so delicately, and to such a shallow depth that, when viewed from the ideal distance for the perspective, the scene itself is almost invisible.[36] The correct perspective drawing in the bronze reliefs for the Santo Altar in Sant'Antonio, Padua (1443–53), is also seen under awkward conditions, but in these reliefs, gold leaf has been used to pick out details and improve legibility.

All the same, in most of Donatello's reliefs, any perspective lines may be expected to play some additional part in the composition in the plane, such as leading the eye to particular figures, as well as serving to construct a pictorial space. That is, in a sense, to put things backwards, because the theory behind perspective was that the construction gave one the geometry of a single glance, directed to the centric point. Thus, the centric point tends to have compositional significance for all artists, and it normally lies fairly close to the geometrical center of the picture.[37] There are a few pathological examples that may be cited to make Donatello seem less out of line, but he still remains the clearest case of an artist who knew the rules and, more often than not, decided to ignore most of them. However, he provides us

with one of the earliest known examples of the use of what is probably Brunelleschian perspective. In his relief of *Saint George and the Dragon* (Plate 71) on the plinth of the statue of *Saint George* (formerly Florence, Orsanmichele; now Florence, Bargello), we have a case of his deciding the rules would serve his turn. The images of receding orthogonal lines in the small portico and in its tiled floor (on the right of the picture) can be extended to meet in the body of Saint George. The convergence is far too good to be due to accident, but most of the lines themselves are very faint, so the brunt of the illusion of the third dimension is borne by the modeling of the figures, though the portico does contribute something (in an area lacking figures) and the lines at the top and bottom of it serve to take the eye to Saint George. The transversals in the tiled floor inside the portico are short and very faint, so here too, we have evidence against Brunelleschi's method prescribing a grid of squares as the basis for a perspective scheme.

Paolo Uccello

It may, of course, be objected that an outside scene such as *Saint George and the Dragon* provides little opportunity for using a square grid. However, this does not defeat a determined practitioner.[38] The vegetation in

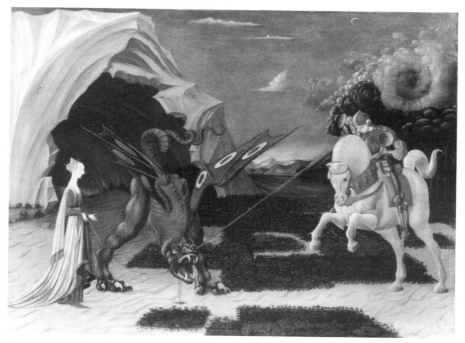

Plate 72. Paolo Uccello, *Saint George and the Dragon*, c. 1460, London, National Gallery. (Photo: © National Gallery, London)

Uccello's small panel of this subject (London, National Gallery: Plate 72) shows a disconcerting tendency to define orthogonals and transversals, as if it were growing in the cracks of an unseen pavement. The broken lances scattered on the ground in Uccello's London *Rout of San Romano* also have grid-forming tendencies. The visibility of his use of perspective is, in fact, a leading characteristic of Uccello's style,[39] and it is an element for which it is very difficult to recover a period eye. At the time they were painted, these pictures may well have had something of the fascinating novelty that in our own time was associated with the first truly three-dimensional visual images, namely holograms.

Since Uccello's use of perspective is so visible, it is tempting to try to reconstruct the perspective schemes of particular pictures. However, in my experience, there tend to be too few visible transversals to make reconstruction feasible. Luckily, when one fresco, the *Nativity*, in San Martino alla Scala, Florence, was removed from the wall, a sinopia (underdrawing in sinoper) of the perspective construction was found on the rough plaster underneath. The drawing, which is too faint to show well in photographs, has a symmetrical two-sided scheme of diagonals converging at distance points, as in Figure 1b earlier in the chapter. The scheme preserved in the sinopia, which corresponds closely with what can still be seen in the fresco, gives an unrealistically short viewing distance. Though he was enthusiastic about perspective, Uccello seems to have shared the widespread recognition that the ideal viewing distance could be too short without detriment to the illusion.

Since Uccello apparently used the distance-point method in this particular fresco, it seems likely that he also used it in other pictures. However, one panel painting that has been much studied in the search for a grid, namely the *Hunt in the Forest* (Oxford, Ashmolean Museum), has proved to have been constructed rather differently. A recent investigation associated with restoration of the panel shows that the pictorial space was constructed by putting in figures that are close copies of one another but in different sizes to indicate different depths in the picture space.[40]

This method of constructing a pictorial space may be directly derived from Euclid's optics, where the effect of distance on perceived size is considered in some detail. Euclid was known to all educated people as the author of the *Elements,* which formed the basis of all academic study in geometry.[41] As the large number of surviving manuscripts attests, his optical work was very widely known in the Middle Ages and Renaissance, usually under the title *De aspectuum varietate.*[42] However, the use of this method by Uccello, who is known to have been much concerned with perspective, may perhaps be more naturally traced back to the passage in the second book of *De pictura* (or its vernacular version *Della Pittura*), in which Alberti considers the heights of objects placed in various positions

in depth on his square grid (§33). Although he does not explain it in those terms, Alberti's procedure in fact involves drawing similar triangles, which is equivalent to simple scaling of sizes.

Alberti On Painting

Alberti's interest in perspective seems to have been in its link with the science of optics. He apparently perceived it as an aid to making paintings that might emulate the naturalism of ancient painting as described by Pliny (Gaius Plinius Secundus, 23/4–79 C.E.) in his *Natural History*.[43] This linking of perspective (with its attendant emphasis upon mathematics) with the humanist program of the reform of the arts was to prove of huge historical importance. However, our present concern is not with Alberti's Plinian aspirations, but rather with the narrower matter of the technical means he suggested for attaining these ideals. The cultural matrix in which these instructions were embedded was, of course, significant in defining the readership of the work.

Alberti is manifestly not writing for practitioners. He explains the mathematical background and the construction in a tentative and incomplete manner, employing similes to make things seem clearer. With the hindsight provided by later works, one can more or less reconstruct the entire process he is describing. Scholars continue to argue over details, but there is general agreement that the construction can be summarized in a diagram like that in Figure 4. Here the square (or it might be a rectangle) *ABXY* represents the picture; the point *O* represents the position of the eye, its perpendicular distance from the edge of the picture being the distance of the eye from the picture in the three-dimensional setup. The problem is to construct the image of a square-tiled pavement lying with one edge along the ground line. *C* is the centric point, defined as the point of concurrence of the images of the orthogonal edges of the tiles. Alberti does not explain how we know that these images converge, which suggests that he regarded the result as "well known." On the other hand, he presents his method of construction as if it were new but makes no specific claim that it is original. Originality was much less prized in the fifteenth century than it was to be later, so Alberti's silence is not strong evidence against the otherwise reasonable hypothesis that he did indeed invent this method of constructing a perspective image of a horizontal grid by putting in a series of images of transversals. Since the construction is asserted to be connected with the science of sight, Alberti does imply that the method is mathematically correct – which it indeed is, though he presents no proof. There is accordingly a shadow of justification for Alberti's method becoming known, in the seventeenth century, as the *costruzione legittima* ("legitimate construction"),

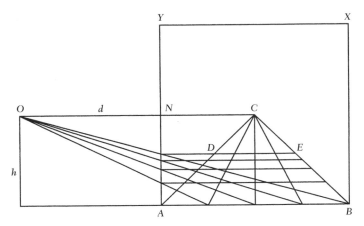

Figure 4. Alberti's construction (after *De pictura*, 1435). The point *O* represents the eye, at a distance *d* from the picture and at a height *h* above the ground line. The distance of the eye from the picture is *ON*. *ABED* is the perspective image of a horizontal square with one side along the ground line. © J. V. Field

though this name is based upon a false belief that Alberti's was the only correct construction among those current in the 1580s.[44]

The Albertian construction is somewhat awkward in practice because the construction of each image of a transversal involves using the point *O*, which lies outside the field of the finished picture. Panels were generally supplied to the painter with framing elements already in place, and it was highly unlikely that a painter would have free use of the area of wall next to the proposed fresco. Accordingly, using Alberti's construction would require the use of preliminary drawings and a consequent risk of error in transferring lines to the picture. It is, however, possible that the misapprehension about Alberti's method being the only correct one antedates the appearance in print of the term *costruzione legittima*, which may have led to the construction being more widely used than these practical considerations seem to suggest. On the other hand, there is good evidence that Uccello, a known enthusiast for perspective, used the distance-point construction. This construction has the practical advantage that if the ideal viewing distance is made equal to half the picture width, the distance point lies on the edge of the picture field (see Figure 1b), thus allowing construction to be carried out directly on the surface to be painted. The very large number of pictures with such viewing distances suggests the distance-point method was used in this very way. There is, in fact, an echo either of this method, or of an otherwise unrecorded workshop rule, in Alberti's proposing that one should check the correctness of the positions of the images of the transversals by drawing a diagonal of the finished

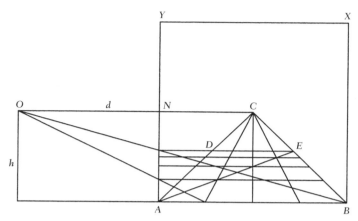

Figure 5. Alberti's construction with the diagonal line *AE* used to check the accuracy of the positions of the transversals. For the sake of clarity, some lines have been omitted. © J. V. Field

pavement. If the drawing is correct, the diagonal of the image of the complete square (the image of the complete pavement) will also be a diagonal of the images of the small squares (the images of tiles) that it intersects (Figure 5). As may be seen from the diagram, the diagonal could be used not merely as a check but as a means of constructing the images of the transversals from the image of the large square. In the perspective treatise of Piero della Francesca, a diagonal is indeed used in this way.

Piero della Francesca

Piero della Francesca stands alone among the painters of the fifteenth century in having an independent reputation as a mathematician. His mathematics is, in fact, as "state of the art" as his painting, and his three known mathematical treatises bear out Vasari's assertion that he might well have had a career as a mathematician had he chosen to do so. Internal evidence, such as the choice of worked examples in the third book, suggests that Piero's treatise on perspective *De prospectiva pingendi* ("On perspective for painting")[45] was written after he had completed the preliminary drawings for the fresco cycle depicting the Story of the True Cross in San Francesco, Arezzo, probably in the 1460s. As far as we know, and as far as Piero himself knew, this was the first attempt at a full mathematical treatment of "perspective for painting."

Piero tells us in his introduction that he will deal only with perspective drawing, not with such matters as color or drawing in general. In effect, what he writes is the equivalent for teaching perspective of the workshop

manuals that were used to instruct apprentices in the standard drawing skills. Once we get to worked examples, the reader is familiarly called "tu" and addressed almost entirely in the imperative. As mathematics, Piero's work is orderly and rigorous, which is to say that all results are proved before they are used. The single exception, a use of the distance-point construction at the end of Book 1, section 23, was removed – presumably by Piero himself – when the treatise was translated into Latin.[46] There are numerous references to Euclid, both to the optical works and to the *Elements*.

Piero's treatise is divided into three books. The first presents mathematical preliminaries and then deals with plane figures. In the second book, some of these plane figures are used as bases for images of right prisms and combinations of prisms (such as a hexagonal wellhead surrounded by steps). In the third book, a different method of construction is introduced, and the examples include the capitals of columns and human heads. Some of the examples in the third book cover five or six sides (folios) with repetitive drawing instructions. There is, however, little doubt that they reflect Piero's own practice.[47]

Piero's construction of the image of a square-tiled pavement is divided into several propositions and includes a proof that the image so obtained is mathematically correct.[48] This is the first known proof of the correctness of a perspective construction. Piero's construction is shown in Figure 6a, in which we have adopted his lettering. The image of the back of the square is found by Alberti's method, but the images of transversals inside the square are found by putting in parallels to the ground line through the points of intersection of the diagonal with the images of orthogonals (the lines converging to the point A inside the picture).

Piero's treatise looks intimidatingly mathematical and its drawing instructions are so repetitive as to be almost unreadable. The crushing quantity of detail does, however, serve to make the work truly applicable, and the survival of a number of manuscripts, both in the vernacular and in a fifteenth-century Latin translation, indicates that the work did find a readership (at least in principle).[49] In fact, Piero's work was used by Sebastiano Serlio (1475–1554) in his book on perspective (Paris, 1545), and much of it was reproduced verbatim in Daniele Barbaro (1513–70), *La pratica della perspettiva* (Venice, 1568, 1569). Both these works seem to have been widely read, and Piero's examples continue to appear in perspective treatises well into the seventeenth century.

Piero thus appears as the founding father of a long line of perspective treatises. His practice as a painter shows an extensive and careful use of construction, and his *Flagellation* (Urbino, Galleria Nazionale delle Marche)[50] is always paraded as an example of correct perspective (Figure 6b). However, contrary to what is sometimes implied, this picture is highly unusual in being so correct, and Piero's own works show

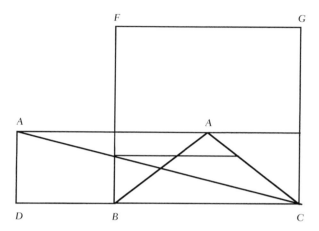

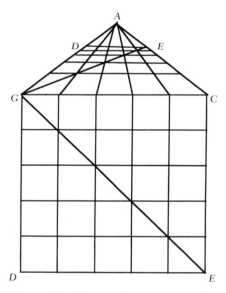

Figure 6. (a) *(Top)* Piero della Francesca's construction of the image of a square (after *De prospectiva pingendi,* Book 1, section 13, with some lines omitted for clarity). This resembles the Albertian construction, but the significance of several components of the diagram is different from that of corresponding parts of the Albertian one. The square *BCGF* is the figure to be represented. The line *FB* represents the picture plane. The lettering is Piero's. (b) *(Bottom)* Piero della Francesca's division of the square into smaller squares (after *De prospectiva pingendi,* Book 1, sections 14 and 15, some lettering omitted). Piero shows the original ("perfect") square below, similarly divided into smaller squares. © J. V. Field

many departures from mathematical rigor. A simple example is provided by his *Resurrection of Christ* (Sansepolcro, Museo Civico), in which the figures of the sleeping soldiers are seen from below whereas the figure of Christ is seen straight on. Piero's use of perspective is in fact generally rather discreet, the strong sense of solidity being mediated also by his rendering of the fall of light. This is true of the *Resurrection* also, so the departure from mathematical correctness does not thrust itself upon the viewer.

Andrea Mantegna

The case is somewhat different in the occasional departures from correctness that are found in the work of Piero's younger contemporary Andrea Mantegna (1431–1506), whose adherence to Albertian prescriptions for the making of pictures is generally somewhat visible. Mantegna's sometimes fierce use of color tends to throw attention onto his drawing. The archaeological detail of his classical settings and the repeated appearance of square-tiled pavements reflect the Plinian ideals of Alberti, though it is not clear how far there is direct influence. Mantegna is known to have had some personal engagement with humanist scholarship, and his accomplished use of perspective is, in his milieu, a natural concomitant of this. However, there are also marked departures from his naturalistic ideal, most notably in various figures being portrayed as seen at different angles (as in Piero's *Resurrection*), for instance in Mantegna's small altarpiece of the *Virgin and Child with Saints John the Baptist and Mary Magdalene* (London, National Gallery: Plate 73) in which the flanking figures are seen from below while the central group is seen straight on.

Masaccio as Model?

Vasari tells us a story of the pursuit of an increasing mastery of what one might call a scientific naturalism, in which Masaccio appears as a hero, one whose work was carefully studied by his successors, one whose achievement the great Michelangelo admired. It has sometimes been assumed that Renaissance naturalism, what I have been calling the Plinian ideal, regularly involved the use of correct perspective constructions. Close examination of surviving works indicates that most of them either cannot be assessed for correctness (not containing a suitable quantity of shapes with straight edges) or turn out to contain notable departures from correctness.[51] With a touch of irony that Vasari might well not have enjoyed, this pragmatic attitude to perspective, which goes with a proper

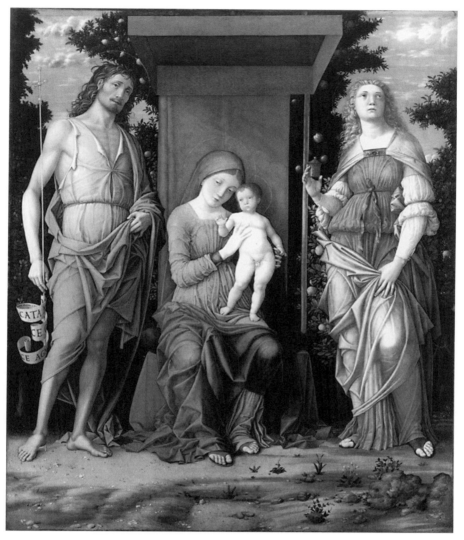

Plate 73. Andrea Mantegna, *Madonna and Child with Saints John the Baptist and Mary Magdalene*, 1500, London, National Gallery. (Photo: © National Gallery, London)

respect for the composition of the picture in its own plane, can also be traced back to Masaccio. It remains an open question whether painters of later generations, making copies of figures in the Brancacci Chapel or in Santa Maria Novella, noticed any of these departures from correctness. If they did not, then the last laugh is with Vasari.

10 Masaccio's Legacy

Francis Ames-Lewis

This concluding chapter is an assessment of the critical responses to Masaccio, in both textual and visual forms, from the 1430s to the full establishment of his place in the history of Italian art in Giorgio Vasari's biography in the second edition of his *Lives of the Artists* (1568). In some senses, this process is tantamount to sketching the development of the belief that the early fifteenth century saw the beginnings of a new artistic endeavor that culminated in the overwhelming achievement of Michelangelo. Vasari stated, for example, that "to Masaccio especially we are indebted for the good style of modern painting,"[1] and the epitaph written by Annibale Caro (1507–66), a Florentine man of letters, published in Vasari's first edition of the *Lives* (1550), shows how the mid–sixteenth century viewed the relationship between Masaccio and Michelangelo:

> I painted, and my picture was like life;
> I gave my figures movement, passion, soul:
> They breathed. Thus, all others
> Buonarroti taught; he learned from me.[2]

Masaccio was only just beginning to become a significant figure in Florentine painting when in late 1427 he left for Rome, never to return.[3] The painter most widely respected throughout the Italian peninsula during Masaccio's lifetime was undoubtedly Gentile da Fabriano. He worked in Florence in 1423–5, painting altarpieces for two of the richest men in the city,[4] whereas Masaccio's only autograph large-scale altarpiece was painted for a mere notary's chapel in the Carmelite church of provincial Pisa.[5] With hindsight, the *Pisa Altarpiece* (1426: see Plates 56 and 57) may look to us more innovative, more "advanced" in structure, design, and execution than the altarpiece commissioned from Gentile da Fabriano by Bernardo di Castello Quaratesi for the high altar of San Niccolò

sopr'Arno. It is however clear that the *Quaratesi Altarpiece* – to say noth-
ing of the sumptuous *Adoration of the Magi* (see Plate 39) for Palla
Strozzi's sacristy-chapel in Santa Trinita – was, in both patronage and
location, much more prestigious at the time.

Although executed in the relatively inexpensive medium of fresco, the
Trinity (see Plate 13) in Santa Maria Novella, probably painted in summer
1427, is a much bolder, more public statement of artistic achievement than
the *Pisa Altarpiece,* painted during the previous year. Significantly also,
this work aligns Masaccio not with Masolino (with whom he worked on
the earlier parts of the Brancacci Chapel), but now with Filippo
Brunelleschi. The latter was a rising architect whose new sacristy at San
Lorenzo for Giovanni di Bicci de' Medici, the head of another principal
family of Florence, was nearing completion as a rival sacristy-chapel to
that of Palla Strozzi. The Santa Maria Novella *Trinity* suggests that Masac-
cio's career had reached a crucial stage, and that during the year before
his death, he was developing a novel artistic manner in association with
other innovative artists.

The Literary Record: The Early Fifteenth Century

Gentile da Fabriano and Masaccio both died in Rome in 1427 and 1428,
respectively, but Gentile's career had been longer and his output was con-
siderably more substantial and better known. He was highly praised by the
Neapolitan court historian Bartolommeo Fazio, in his biography in the *De
viris illustribus* (*On Famous Men*) in 1456, but although Donatello and
Ghiberti were recorded as the principal sculptors of the day, Masaccio was
not mentioned in that text.[6] Indeed, except for being briefly named in 1436
by Leon Battista Alberti, Masaccio was not discussed until Alamanno Rin-
uccini wrote of him in 1472.[7] By that time, his work was held in increas-
ingly high regard in Florence, whereas Gentile da Fabriano's reputation
had already waned. It was presumably Masaccio's alignment with
Brunelleschi, in both the perspective design and the architectural vocab-
ulary of the Santa Maria Novella *Trinity,* that led Alberti to include his
name in his dedication of the 1436 vernacular translation of the treatise on
painting, *Della Pittura,* to Brunelleschi:

But after I came back here to this most beautiful of cities from the long exile in
which we Albertis have grown old, I recognized in many, but above all in you, Fil-
ippo, and in our great friend the sculptor Donatello, and in the others, Nencio,
Luca, and Masaccio, a genius for every laudable enterprise in no way inferior to
any of the ancients who gained fame in these arts.[8]

Masaccio's name is here bracketed with those of Brunelleschi and the
three great Florentine sculptors of the mid-1430s, Donatello, Ghiberti, and

Luca della Robbia. It was primarily this brief reference that established Masaccio as one of the triumvirate (along with Brunelleschi and Donatello) to whom the initiation of the Italian Renaissance has often been attributed. Paradoxically, Masaccio is the only painter among the five dedicatees of *Della Pittura,* and ironically, he had already been dead for eight years at the time the dedication was written.

Crucial though it was later, Alberti's reference to Masaccio's name does not appear to have established Masaccio's reputation immediately. Since very few manuscripts of the vernacular version of Alberti's treatise survive (only three, two of which are "very poor," compared with ten fifteenth-century manuscripts of the original Latin version),[9] it is a text that may have had rather limited circulation. It is worth noting, moreover, that in the Louvre panel painting apparently showing portraits of five early masters of Florentine Renaissance art, Masaccio does not appear alongside Brunelleschi and Donatello: According to the inscriptions, they are accompanied by Giotto, Paolo Uccello, and Antonio Manetti.[10] Although Lorenzo Ghiberti made no mention of his artist contemporaries in his *Commentarii,* written in the early 1450s, the Florentine sculptor and architect Filarete briefly referred to Masaccio in his *Trattato di architettura (Treatise on Architecture),* dedicated to Piero de' Medici in 1463–4: "Some who would have come died in Florence. They were all good masters. [There was] one called Masaccio, another called Masolino, another who was a monk called Fra Giovanni[.]"[11] Filarete's brief list is the earliest comment on Masaccio that seems to imply his primacy in the development of a new, modern manner of painting. This position was soon to be firmly established as his.

The Literary Record: The Late Fifteenth Century

By the last decades of the fifteenth century, commentators on Florentine art had begun to construct a scheme of the development of early Renaissance painting and of the relative importance of painters within that development, in which Masaccio appeared more prominently as a major figure in the early years of the century. As noted, Masaccio was not named among the painters "who have been illustrious in our age" in Fazio's *De viris illustribus.*[12] Nor was Masaccio included among "the best masters who have existed for a good while back" in the list of artists by whom the Florentine merchant Giovanni Rucellai owned works in c. 1470.[13] This omission, however, presumably reflected the difficulty of acquiring panel paintings by Masaccio, which inevitably have always been rare, rather than an opinion that Masaccio was not one of "the best masters." On the other hand, his name was recorded by another Florentine merchant and chronicler, Benedetto Dei, in his list of painters who, he claimed, had workshops in Florence in 1470.[14] This list is, in fact, a more or less chronological

inventory of the principal painters of Florence from the 1420s to 1470. By omitting both Masolino and the great late Gothic painter of Florence, Lorenzo Monaco, and by starting his list with the names of Fra Filippo Lippi and Masaccio (who appear in that order), Dei seems by implication to have accepted the Albertian notion that Masaccio and his principal follower had opened a new chapter in the history of Florentine painting.

Masaccio is also listed with a group of Florentine artists, although out of chronological order, by the Umbrian painter and poet Giovanni Santi (Raphael's father), in his *Cronaca rimata (Rhymed Chronicle)* dedicated to Federigo da Montefeltro around 1480.[15] For Santi, the greatest painter of the day was Andrea Mantegna, who is discussed at length. Masaccio, and Florentines of the following generation, are cursorily listed by name alone, and only after Santi had commented favorably on the four painters of Fazio's biographies. Santi's emphases reflect aesthetic preferences, different from those of Florentine intellectuals, generally to be found in the later fifteenth-century Italian courts.

In the last quarter of the century, individual characteristics of Masaccio's work were more clearly recognized and acknowledged as Florentine writers began to develop a critical vocabulary. Critical comment appears in writings by the Florentine humanists Alamanno Rinuccini and Cristoforo Landino, and by Brunelleschi's biographer, Antonio Manetti. As early as 1472, in a discussion of the well-worn question of the relative superiority of the moderns and the ancients, Rinuccini wrote about "the painters who have flourished in our age [i.e., in the preceding half century]."[16] After noting "the genius of Cimabue, Giotto and Taddeo Gaddi previously," he continued, "Close to our own age, Masaccio in painting expressed the likeness of everything in nature so well that we seemed to see the things themselves with our eyes, and not images of the things[.]" This may be a conventional rhetorical cliché but one that nevertheless recognizes Masaccio's important place in the development that has "led the arts of painting and sculpture . . . to so much greatness and goodness, that they can deservedly be compared with the ancients." Rinuccini also considered that Masaccio initiated this development, preceding Domenico Veneziano, "Fra Filippo [Lippi]," and "Giovanni, of the Dominican order [Fra Angelico]," who "are all considered different among themselves in their variety, yet very alike in excellence and goodness."

Cristoforo Landino took up the theme in his commentary (1481) on Dante's *Divine Comedy*. His introduction lists Florentine painters from Giotto to his own day, including Masaccio, who

was a first-rate imitator of nature, presented great depth of relief without any lapses, good in composing and simple without elaboration (*puro senza ornato*), because he devoted himself solely to the imitation of reality and to relief in figures; he was certainly as good a master of perspective as anyone of those times, and of great facility in his work, being very young, as he died at twenty-six.[17]

This lengthy and critically astute assessment once more precedes equally perceptive comments on Filippo Lippi, Andrea del Castagno, Paolo Uccello, and Fra Angelico. By 1480, Masaccio's place at the head of the development of what has come to be known as early Renaissance painting was clearly established. Shortly after Rinuccini's and Landino's accounts, Leonardo da Vinci also proclaimed Masaccio's place in the pattern of artistic revival and decline. After discussing Giotto, who "surpassed not only the masters of his age but all those of many centuries before," Leonardo wrote that

after this, art fell back into decline, because everyone copied the pictures that had already been done, and thus from century to century the decline continued until Tom[m]aso the Florentine, nicknamed Masaccio, showed to perfection in his work how those who take as their authority any other than nature, mistress of the masters, labor in vain.[18]

Cristoforo Landino's critical commentary on Masaccio's style also became a template for the analysis of early Renaissance paintings, and as such, was important for the development of Vasari's language of criticism. Building on theoretical precepts in Alberti's *Della Pittura,* Landino established the importance of perspective, pictorial composition, depth of relief, the imitation of nature, surface embellishment, and technical facility as standard analytical criteria that are still in use today.

Another late fifteenth-century commentary on Masaccio exploited a second, more conventional type of writing about art that Vasari later used in the *Lives.* Including Masaccio among "XIV Outstanding Men in Florence from 1400 on" in a text dating between 1494 and 1497, Antonio Manetti's descriptive method was to make a list of the painter's works:

Masaccio, painter, an amazing man, painted in Florence and elsewhere, he died at about 27 [on December 15, 1472, his brother, lo Scheggia, told me he was born on St. Thomas Day in 1401, which is December 21]. He made in Florence in the Carmine a St. Paul between the chapel of the Serragli, where the Crucifix is, and the chapel with the story of St. Jerome painted in it, a wonderful figure. He painted in the Brancacci Chapel various scenes, the best of those there, it is painted by three masters, all good, but he is wonderful. He painted in the same church, in the cloister, over the door where you go into the church, in monochrome, a scene wonderful in construction to every expert, where he shows the Carmine square, with many figures, and he made things also in other places in Florence, and for private persons, and in Pisa and Rome and elsewhere, considered the best painter of whom there is knowledge up to his time.[19]

This text is important not, clearly, for Manetti's commonplace, uncritical words of praise, but for his identification for the first time of Masaccio's authorship of frescoes at Santa Maria del Carmine. The "guidebook mentality" shown here perhaps stimulated, and certainly was echoed in, a

process of recording works of art in Florentine churches in two guidebooks written probably in the early sixteenth century. Francesco Albertini (1510) adds a painting in the second cloister of Santa Maria degli Angeli and a panel in Santa Maria Maggiore,[20] and both the Anonimo Magliabecchiano and the "Libro di Antonio Billi" (both written in the early sixteenth century) note the shivering man in the *Saint Peter Baptizing the Neophytes* (see Plate 10) to whom Vasari later called special attention.[21]

Vasari and Masaccio

Surprisingly, perhaps, after the serious and critically sensitive comments on Masaccio and other fifteenth-century Florentine painters in texts of the last quarter of the century, there is no further critical discussion of Masaccio before the 1550 edition of Giorgio Vasari's *Lives of the Artists*. Indeed, aside from Vasari, there is little written on Masaccio's status as innovator during the sixteenth century. This may suggest that by the High Renaissance, his reputation was so firmly established that it went without saying, or that later in the century, critical interest in Masaccio and his works had declined. Benvenuto Cellini, for example, cites Masaccio as a parallel to Leonardo and Michelangelo, but merely as an exponent of the practice of making small models for copying.[22]

Vasari was, of course, the principal sixteenth-century biographer of Masaccio, and clearly, it was he who, in the *Lives of the Artists*, provided the later history of Italian art with the strongest statements about Masaccio's place in the development of Italian painting. Working on the basis of earlier accounts and greatly expanding on them through his own knowledge of Masaccio's work, he enshrined the tradition that has prevailed to the present day, of Masaccio as the initiator of the style that reached its zenith in the work of Michelangelo. Masaccio is the only painter of Vasari's "second period" who is named and discussed in the Preface to Part Two of the *Lives*:

... [W]e still have today some exceptionally fine examples left by artists of the second period; such are the works executed in the Carmine by Masaccio, including the figure of a naked man shivering with cold, as well as other lifelike and vigorous pictures.[23]

Later in the Preface, Vasari continued:

During this period painting progressed in the same way as sculpture. The superb Masaccio completely freed himself of Giotto's style and adopted a new manner for his heads, his draperies, buildings, and nudes, his colors and foreshortenings. He thus brought into existence the modern style which, beginning during his period, has been employed by all our artists until the present day.[24]

Finally, he stated, "[when] we come to Masaccio, the first of the painters to improve design . . . we shall see how greatly he was responsible for the rebirth of painting,"[25] thus giving Masaccio the prime role in that "rebirth" that was later to be called the "Italian Renaissance."

The Visual Legacy

So much for Masaccio's legacy as it was propounded in the textual record up to the time of Vasari. But what of the visual record? Which of Masaccio's works may in particular have been studied and reinterpreted by later artists? Vasari discussed what must have been the most important panel painting on which Masaccio worked, the double-sided altarpiece commissioned by Pope Martin V for a chapel in Santa Maria Maggiore, Rome (see Plates 15 and 16). "One day," Vasari recounted, "after Michelangelo and I had been studying this work he praised it very highly[.]"[26] However, Vasari described only the front of the altarpiece, with the miraculous foundation of the church (Naples, Capodimonte) and the panels with pairs of saints on either side (London, National Gallery, and Philadelphia, Philadelphia Museum of Art). Paradoxically, Masaccio's only contribution – the London *Saints Jerome and John the Baptist* (see Plate 17) – was on the back of the altarpiece and apparently not visible to them. Nevertheless, the anecdote indicates that Michelangelo took an interest in Masaccio's work. Elsewhere, Vasari implied that it was Masaccio's figure style that constituted his principal contribution and legacy:

. . . [H]e matched the flesh-tints of his heads and nudes with the colors of his draperies, which he loved to depict with a few simple folds just as they appear in life. All this has been of great benefit to later artists, and indeed Masaccio can be given the credit for originating a new style of painting[.][27]

In discussing the influence of the Brancacci Chapel frescoes (see Plate 3), Vasari once more stressed the later importance of Masaccio's figure style. "Because of Masaccio's work, the Brancacci Chapel has been visited from that time to this by an endless stream of students and masters," Vasari tells us, and he goes on to list the names of

all the most renowned sculptors and painters who have lived from that time to this [who] have become wonderfully proficient and famous by studying and working in that chapel. . . . In short, all those who have endeavored to learn the art of painting have always gone for that purpose to the Brancacci Chapel to grasp the precepts and rules demonstrated by Masaccio for the correct representation of figures.[28]

If we may take these statements at face value, we should seek Masaccio's artistic legacy principally in the early and High Renaissance representation of the human figure, both nude and draped. This appears to be borne

out by Vasari's anecdote about Perino del Vaga: After his return from Rome to Florence in 1522, Perino undertook to challenge the standard Florentine view that Masaccio's style could not be equaled, by painting a Saint Andrew (lost) opposite a Saint Paul (lost) painted by Masaccio in the Carmine.[29] Surprisingly, however, despite Vasari's references to extensive artistic study and work in the Brancacci Chapel, hardly any drawings that are clearly copies after the frescoes survive. One candidate is a drawing that shows the figure of Saint Peter baptizing the neophytes (Plate 74). Not well known (perhaps on account of its poor condition), this sheet was included in the 1992 exhibition of Florentine drawings at the Uffizi, where it was catalogued as a copy after Masaccio by Filippo Lippi.[30] However, George Goldner has pointed out that the differences in the morphology of the drapery folds between the drawing and the frescoed figure are sufficiently significant as to make it more likely that the drawing is by Masaccio himself in preparation for the fresco (see Plate 10).[31] In technique, it conforms with what one might expect of a drapery study by Masaccio, showing the exploration of "great depth of relief without any lapses," as Landino expressed it. The draftsman worked with the brush and brown wash

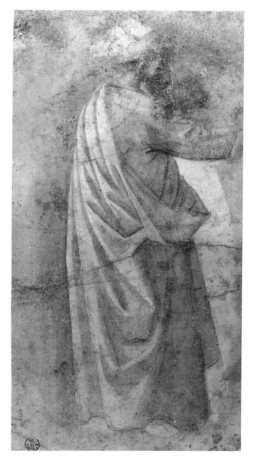

Plate 74. Masaccio (?), *Saint Peter Baptizing the Neophytes,* brush and brown wash, with white heightening over black chalk underdrawing on paper, 276 × 139 mm, c. 1424–6, Florence, Galleria degli Uffizi, Gabinetto Disegni e Stampe, inv. 6S. (Photo: Antonio Quattrone)

over a black chalk sketch of a freedom perhaps not to be expected in a copy, and defined the fall of light by heightening the crests of the folds with white pigment. If this is indeed a preparatory drawing by Masaccio for *Saint Peter Baptizing the Neophytes,* it cannot, of course, have been made in the Brancacci Chapel. Acceptance of the attribution provides us, however, with an important new addition to the Masaccio corpus, and perhaps the only surviving drawing by the master.

Although not copies of Brancacci Chapel frescoes, other early to mid-Quattrocento drawings suggest Masaccio's inspiration. Vasari recorded "a panel picture showing two life-size nudes, a man and a woman, which is now in the Palla Rucellai palace,"[32] but he rather surprisingly failed to comment on Masaccio's *Expulsion* (see Plate 58), which must be one of the

most expressive paintings of nude figures from the Renaissance. Perhaps he found its direct, raw power offensive to his mid-sixteenth-century aesthetic sensibilities and preferred to praise Masaccio's treatment of the nude in

the figure of a naked man [in the scene showing Saint Peter baptizing] who is trembling and shivering with cold as he stands with the others who are being baptized. This is very highly regarded, being executed in very fine relief and in a very charming style; it has always been praised and admired by artists.[33]

Praised and admired perhaps, but no figure in Renaissance paintings or drawings was demonstrably based on this celebrated figure. A pen-and-ink drawing of two nude figures (Plate 75) may be a drawing after Masaccio,[34] maybe by a follower of Donatello, but perhaps more probably, it is either

Plate 75. After Masaccio (?), perhaps by a follower of Donatello, *Male and Female Nude Figures (Expulsion of Adam and Eve)*, pen and ink, with traces of white heightening, on paper, c. 1424–6, 193 × 98 mm (maxima), Florence, Galleria degli Uffizi, Gabinetto Disegni e Stampe, inv. 30F. (Photo: Ministero dei Beni e le Attività Culturali, Firenze, Pistoia, e Prato)

a copy of the painting that Vasari saw in the Palazzo Rucellai, or it represents the Expulsion and is a later variant prompted by the Brancacci Chapel fresco. A parallel instance of this type of derivation is a drawing of the *Expulsion* (Plate 76) of around 1460 by Maso Finiguerra.[35] Although the poses of Adam and Eve here differ from those of Masaccio's fresco, Finiguerra appears to be drawing inspiration from the Brancacci Chapel *Expulsion*.

The only surviving drawing that was closely based on a figure from the Brancacci Chapel fresco is Michelangelo's early study in Munich (Plate 77) after the figure of Saint Peter handing the tribute money to the tax collector.[36] The graphic handling of this study, with its dense web of pen-and-ink cross-hatching, was one current in Domenico Ghirlandaio's workshop at the time of Michelangelo's apprenticeship there in 1488. It is therefore possible that Michelangelo was copying a Ghirlandaio drawing rather than Masaccio's original. But the survival of other copies by Michelangelo – after figures in Giotto's *Ascension of Saint John the Evangelist* in the Peruzzi Chapel, Santa Croce, and Masaccio's lost *Sagra,* a monochrome fresco of the consecration of Santa Maria

Plate 76. Maso Finiguerra, *Expulsion of Adam and Eve,* pen and ink, with wash, over traces of black chalk underdrawing on paper, 177 × 100 mm, c. 1450, Florence, Galleria degli Uffizi, Gabinetto Disegni e Stampe, inv. 44F. (Photo: Ministero dei Beni e le Attività Culturali, Firenze, Pistoia, e Prato)

del Carmine painted in the cloister[37] – suggests that Michelangelo may indeed, in Martin Kemp's words, have been purposefully "turning in the early 1490s to the study of the past masters Giotto, Masaccio, and Donatello [as] a fashionable act of Florentine traditionalism."[38]

As noted earlier, the pace of humanist interest in Masaccio's position as the initiator of a "modern" style quickened in the last quarter of the fifteenth century. Similarly, as Michelangelo's drawing suggests, renewed artistic interest in Masaccio, and especially in his figure style, can be found in Florentine art of the same decades. The first obvious place to find close reflections of Masaccio's draped figure style is in the Brancacci Chapel itself. There can be no doubt that in his work on the Brancacci frescoes (1480–1), Filippino Lippi modified his individual figure style, which was at this date reaching full maturity, to conform as closely as possible with Masaccio's own style. This is most evident in the scene of the *Raising of the Son of*

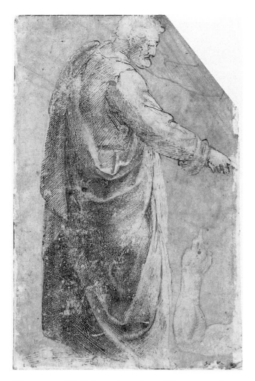

Plate 77. Michelangelo, after Masaccio, *Saint Peter Handing the Tribute Money to the Tax Collector,* pen and ink on paper, 315 × 197 mm, c. 1488–95, Munich, Staatliche Graphische Sammlung, 2191r. (Photo: Engelbert Seehuber)

Theophilus (see Plate 9), where figures by both painters are seen side by side. That Filippino made a conscious attempt to match what Vasari described as Masaccio's "very simple" drapery is clear when a comparison is made between the group of figures by Filippino at the far left of this scene first with standing figures by Masaccio in the same scene, or in the *Tribute Money* above it; and second with Filippino's drapery style in such nearly contemporary paintings as the *Magrini Altarpiece* for San Michele in Foro, Lucca.[39] Filippino also reflects Masaccio's drapery style in drawings of c. 1480, such as the study of *Two Standing Men Turned to the Left* in Chatsworth (Plate 78).[40] Perhaps significantly, Vasari attributed another Filippino Lippi drapery study of about the same date to Masaccio when it was in his own collection.[41]

In his independent work, Filippino developed from his training with Botticelli an idiosyncratically florid way of articulating drapery folds, encouraging them to cascade in complex, sometimes sinuous, sometimes angular patterns which suggest that their light fabrics are whipped up by a brisk breeze. This style echoes Cristoforo Landino's comments on Filippino's father, Fra Filippo Lippi, who, despite having been (according to Vasari) a pupil of Masaccio, "was graceful and elaborate and skillful in the highest degree; he was strong . . . in ornaments of all sorts."[42] However, in the Brancacci Chapel, Filippino constructs the robes of his figures "with a few simple folds just as they appear in life," as Vasari says of Masaccio's: long, almost monotonously repetitive folds that flow uninterruptedly down from shoulders to feet. Filippino's figures may be distinguishable from Masaccio's by their relatively large, sallow-colored heads, but his draperies are almost identical to those of his model. Something of the same relative simplicity of figure articulation and fold pattern can be seen throughout Filippino's complete frescoes on the piers and on the lower level of the chapel's right wall.

This is, of course, a particular case of an artistic response that was necessary to the occasion. It was Filippino Lippi's contemporary, Domenico Ghirlandaio, who more thoroughly integrated Masaccio's figure style into his artistic practice. This practice then served as a recent source for the

High Renaissance reinterpretation of Masaccio, in part through Michelangelo's early association with Ghirlandaio's workshop. Ghirlandaio looked to the foundations of the Florentine artistic tradition when, for example, he based the composition of his *Saint Francis before the Sultan* in the Sassetti Chapel, Santa Trinita, on Giotto's version of the scene in the Bardi Chapel, Santa Croce. Likewise, the figure of the sultan himself (Plate 79) may be seen as a recasting both of Giotto's sultan and of Masaccio's enthroned Saint Peter in the Brancacci Chapel (see Plate 12). This treatment of the monumental enthroned figure offered Michelangelo a long Florentine lineage that he extended when he generated his own, even grander, seated figures like the *Jeremiah* of the Sistine Ceiling. Many figures in Ghirlandaio's Sassetti Chapel frescoes wear robes whose folds fall with the simplicity and relief-creating power that was praised in Masaccio's style by writers from Landino to Vasari.[43] Although the fold morphology may be subtly different, some of the drapery appears directly to acknowledge figures from the Brancacci Chapel. The carefully structured composition of Ghirlandaio's *Resurrection of the Spini Boy* compares closely with that of the *Raising of the Son of Theophilus,* and is

Plate 78. Filippino Lippi, *Two Standing Men Turned to the Left,* silverpoint with white heightening on salmon pink prepared paper, 197 174 mm, c. 1490, Chatsworth, Devonshire Collection, 886B. Reproduced by permission of the Duke of Devonshire and the Chatsworth Settlement Trustees. (Photo: Courtauld Institute of Art, Photographic Survey)

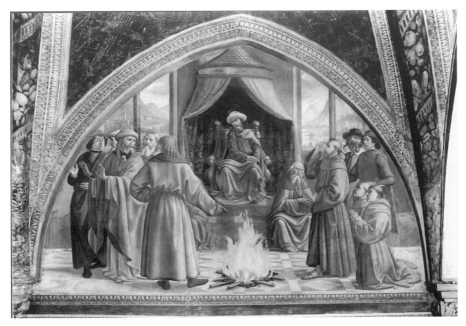

Plate 79. Domenico Ghirlandaio, *Saint Francis before the Sultan*, 1483–6, Florence, Santa Trinita, Sassetti Chapel. (Photo: Antonio Quattrone)

similarly replete with portraits. Equally, the most prominent standing figure at the right of the *Resurrection* (Plate 80), for example, may be seen as Ghirlandaio's tribute to Masaccio's contribution to Florentine tradition in his Saint Peter from the *Tribute Money,* the very figure that Michelangelo copied in the Munich drawing. Moreover, the drapery patterns of figures such as those at the right of the Sassetti Chapel *Renunciation of the Worldly Goods* also recover the bold simplicity of Masaccio's drapery style, in contrast to the more florid, copious treatment of drapery by Botticelli and Filippino Lippi. Although the acknowledgment is less direct, it is difficult to imagine that Raphael could have evolved his monumental figure style in, for example, Saint Paul from the Sistine tapestry of *Saint Paul Preaching in Athens,* or the apostles in the *Death of Ananias,* without experience of the paradigmatic example of Masaccio. This bears out Vasari's statement that Raphael "studied the old paintings of Masaccio in the city of Florence."[44]

It is in the work of these and other major High Renaissance painters that Masaccio's artistic legacy can most clearly be identified. Vasari includes neither himself nor any painters of his generation in his long list of "renowned sculptors and painters" who studied in the Brancacci Chapel. This implies that by the time of Vasari's apprenticeship in the 1520s, Masaccio was no longer considered a valuable model for the novice painter to copy; this also is suggested by his previously recounted anecdote

Plate 80. Domenico Ghirlandaio, *Resurrection of the Spini Boy*, detail of figures at extreme right, 1483–6, Florence, Santa Trinita, Sassetti Chapel. (Photo: Antonio Quattrone)

about Perino del Vaga's challenge to Masaccio's authority. But Masaccio's artistic legacy was by then firmly entrenched, and it lived on through the traditions established in their turn by Michelangelo and Raphael. Nevertheless, it is an open question as to whether Masaccio and his Brancacci Chapel frescoes would be so celebrated today were it not for the prominent roles with which he was credited in texts from Alberti through Rinuccini to Vasari. But as the first painter who Rinuccini considered to have been comparable with the ancients, and as the originator (for Vasari) of the "good style of modern painting" who was greatly "responsible for the rebirth of painting," Masaccio's has securely maintained his high reputation through later centuries and into our new century.

Notes

INTRODUCTION

1. Leon Battista Alberti, *On Painting,* trans. Cecil Grayson with notes by Martin Kemp (London: Penguin Books, 1991), 21–2, 34.

2. Leonardo da Vinci, *Leonardo on Painting,* ed. Martin Kemp, trans. Martin Kemp and Margaret Walker (New Haven and London: Yale University Press, 1989), 193: "from century to century the decline continued until Tommaso the Florentine, nicknamed Masaccio, showed to perfection in his work how those who take as their authority any other than nature, mistress of the masters, labour in vain."

3. Giorgio Vasari, *Le vite de' più eccellenti pittori, scultori ed architettori,* ed. Gaetano Milanesi, 9 vols. (Florence: G. C. Sansoni, 1906), 2: 107.

4. Vasari 2: 287.

5. Vasari 2: 288.

6. Masolino, "his master" *(suo maestro),* was represented by Masaccio in the *Sagra,* the lost fresco that portrayed the consecration of Santa Maria del Carmine. See the extended description in the *vita* of Masaccio, Vasari 2: 295.

7. The most recent monographs in English are Paul Joannides, *Masaccio and Masolino. A Complete Catalogue* (London: Phaidon Press, 1993); and Perri Lee Roberts, *Masolino da Panicale* (Oxford: Clarendon Press, 1993).

8. For these and other attributions to Masaccio, see Vasari 2: 290–4.

9. Vasari 2: 263–4.

10. Vasari 2: 265–6.

11. Vasari 2: 292.

12. Vasari 2: 291.

13. See Vasari 2: 295–7, and the most recent study by Divo Savelli, *La Sagra di Masaccio* (Florence: Giampiero Pagnini editore, 1998).

14. Vasari 2: 297–9.

15. Masaccio's death in Rome is recorded by a later notation in his tax declaration of 1427, which tersely states "dicesi è morto a Roma." The declaration of Niccolò di ser Lapo, one of Masaccio's creditors, in 1431 similarly records the painter's death in Rome. The question is considered by Jacques Mesnil, "La

data della morte di Masaccio," *Rivista d'arte* 8 (1912): 33–4; and James H. Beck with the collaboration of Gino Corti, *Masaccio. The Documents* (Locust Valley, N.Y.: J. J. Augustin, 1978), comment to doc. XXVIII, 27–30.

16. Paul Barolsky, *Giotto's Father and the Family of Vasari's Lives* (University Park, Pa.: Pennsylvania State University Press, 1992), 39.

17. All dates cited here are given in common-style reckoning rather than Florentine-style or Pisan-style. In addition to the documents gathered by Beck, see Richard Fremantle, "Some Documents Concerning Masaccio and His Mother's Second Family," *Burlington Magazine* 115 (1973): 516–19; Ugo Procacci, "Nuove testimonianze su Masaccio," *Commentari* 27 (1976): 223–37; Richard Fremantle, "Riferimenti ai membri della famiglia Brancacci da parte dello stesso notaio Filippo di Cristofano," *Antichità viva* 17 (1978): 50; idem, "Note sulla parentela di Mariotto di Cristofano con la famiglia di Masaccio," *Antichità viva* 17 (1978): 52–3; Charles Randall Mack, "A Carpenter's *Catasto* with Information on Masaccio, Giovanni dal Ponte, Antonio di Domenico, and Others," *Mitteilungen des Kunsthistorischen Institutes in Florenz* 24 (1980): 366–8; Ugo Procacci, "Masaccio e la sua famiglia negli antichi documenti," in *La storia del Valdarno*, 4 vols. (Florence: Luciano Landi, 1980–3), 2: 553–4; and idem, "Documenti e ricerche sopra Masaccio e la sua famiglia: le portate al catasto di Giovanni di ser Giovanni detto lo Scheggia," *Rivista d'arte* 38 (1984): 231–57. Roberts, 167–74, includes all known documents on Masolino.

18. The altarpiece is discussed in this book by Dillian Gordon, who reviews the literature, and by Roberto Bellucci and Cecilia Frosinini. Luciano Berti published its discovery in "Masaccio 1422," *Commentari* 12 (1961): 84–107. Among those disputing Masaccio's authorship are Roberto Longhi, "Incontro col 'Maestro dei Santi Quirico e Giulitta,'" in his *'Fatti di Masolino e di Masaccio' e altri studi sul Quattrocento 1910–1967* (Florence: G. C. Sansoni, 1975), 90; and James Stubblebine et al., "Early Masaccio: A Hypothetical Lost Madonna and a Disattribution," *Art Bulletin* 62 (1980): 217–25.

19. On the career of Giovanni di ser Giovanni, known as "lo Scheggia," see the most recent monograph, Luciano Bellosi and Margaret Haines, *Lo Scheggia* (Florence and Siena: Maschietto & Musolino, 1999).

20. On the typical curriculum of the Renaissance student, see Paul F. Grendler, *Schooling in Renaissance Italy: Literacy and Learning 1300–1600* (Baltimore: Johns Hopkins University Press, 1989). Francis Ames-Lewis, *The Intellectual Life of the Early Renaissance Artist* (New Haven and London: Yale University Press, 2000), 17–60, discusses the education of several fifteenth-century artists.

21. See Ellen Callmann's chapter in this book.

22. For art in the region, see Luciano Berti, *Il Museo della Basilica di San Giovanni Valdarno* (Florence: Poligrafo Toscano, 1959); Paolo dal Poggetto, *Arte in Valdelsa dal sec. XII al sec. XVIII*, exh. cat. (Florence: S.T.I.A.V., 1963); idem, *Il Museo di Fucecchio* (Florence: n.p., 1969); *Arte nell'Aretino: recuperi e restauri dal 1968 al 1974*, eds. Lionello G. Boccia et al., exh. cat. (Florence: Edam, 1974); and Stefano Casciu, *Il Museo della Basilica di Santa Maria delle Grazie. Guida alle opere e itinerario storico-artistico nelle chiese di San Giovanni Valdarno* (Montepulciano: Editori del grifo, 1993).

23. On October 14, 1418, Masaccio acted as guarantor on behalf of a woodworker

from his native town, San Giovanni Valdarno, who applied for membership in the Arte de' Legnaioli (Guild of the Woodworkers). The document was published by Fremantle, 1973, 518. To have served in this capacity, Masaccio must have established himself prior to this time; see Luciano Berti, citing Ugo Procacci, in "Donatello e Masaccio," *Antichità viva* 5 (1966): 7, who dates his presence in Florence to 1417.

24. Beck, docs. V–VI, 9, 11; Cecilia Frosinini in Anna Padoa Rizzo, "Stefano d'Antonio di Vanni (1405–1483): opere e documenti," *Antichità viva* 22 (1984): 27 n. 2.

25. Beck, doc. VII, 11–12.

26. See n. 18.

27. Beck, doc. XI, 14–15. Roberts, doc. VI, 169, publishes Masolino's registration, which occurred after March 24 of that year.

28. Roberts, doc. V, 168, provides a complete transcription. The arbitration has been associated with the painters' collaboration in Empoli, which evidently ended unpleasantly; see the chapters by Perri Lee Roberts as well as Bellucci and Frosinini in this volume.

29. Beck, doc. XII, 15–16. This type of a commission, although it may seem menial to modern sensibilities, was accepted by artists of great repute, including Fra Angelico, Michelozzo, and Ghirlandaio.

30. Beck, docs. XIII–XXVI, 17–24, publishes all relevant documents. See also the discussion of Dillian Gordon in this volume.

31. Beck, doc. XIX, 19–20; doc. XXIII, 22.

32. Beck, doc. XXIV, 22. Andrea di Giusto had been in Bicci di Lorenzo's shop at the same time as Masaccio's brother; see Beck, doc. V, 9–10.

33. Beck, doc. VII, 11–12; Masaccio paid another two lire on October 2, 1422, as reported in Beck, doc. X, 14.

34. Beck, doc. XIII, 17; doc. XX, 20–1.

35. Beck, doc. XXVII, 24–5; doc. XXVIII, 25–9, also includes an analysis of the tax return. Ugo Procacci, "Documenti e ricerche sopra Masaccio e la sua famiglia (continuazione)," *Rivista d'arte* 17 (1935): 91–111, discusses Masaccio's finances at length.

36. Beck, 28.

37. See the extensive discussions with notes in this book by Roberts, Bellucci and Frosinini, and Gordon.

38. Roberts, 100–20, 195–7, analyzes the Castiglione Branda Chapel and reviews the literature on its authorship.

39. See n. 15; Richard Krautheimer in collaboration with Trude Krautheimer-Hess, *Lorenzo Ghiberti,* 2nd ed., 2 vols. (Princeton: Princeton University Press, 1970), 1: 319 n. 20, questions the general acceptance of the date of 1428.

40. Beck, doc. XXIX, 29–30, reviews the sources.

41. Alberti, 34; quotation from the dedication of the Italian text to Filippo Brunelleschi. For the critical reception of Masaccio through Vasari, see the chapter by Francis Ames-Lewis in this book.

42. Ottaviano Morisani, "Art Historians and Art Critics – III: Cristoforo Landino," *Burlington Magazine* 95 (1953): 267–70. Landino's characterization of Masaccio's art is analyzed at length in Michael Baxandall, *Painting and Experience in Fifteenth-Century Italy. A Primer in the Social History of Pictorial Style* (Oxford: Oxford University Press, 1972), 118–28.

43. For Fazio, see Michael Baxandall, *Giotto and the Orators: Humanist Observers of Painting in Italy and the Discovery of Pictorial Composition* (Oxford: Clarendon Press, 1971), 103–9; for Leonardo, see n. 2.

44. On Vasari's renovation of Santa Maria Novella, see Marcia B. Hall, *Renovation and Counter-Reformation. Vasari and Duke Cosimo in Sta Maria Novella and Sta Croce 1565–1577* (Oxford: Clarendon Press, 1979), 115; and relatedly, Ugo Procacci, "Il Vasari e la conservazione degli affreschi della Cappella Brancacci al Carmine e la Trinità in S. Maria Novella," in *Scritti di storia dell'arte in onore di Lionello Venturi,* 2 vols. (Rome: De Luca, 1956), 1: 212–13.

45. See Ornella Casazza, "Masaccio's Fresco Technique and Problems of Conservation," in *Masaccio's Trinity,* ed. Rona Goffen (Cambridge: Cambridge University Press, 1998), 69–85.

46. Quotation from Ornella Casazza, "The Brancacci Chapel from Its Origins to the Present," in Umberto Baldini and Ornella Casazza, *The Brancacci Chapel,* trans. Lysa Hochroth with Marion L. Grayson (New York: Harry N. Abrams, 1990), 309. Casazza, 1990, 306–18, traces the history of the chapel's many renovations and restorations; see also Ugo Procacci, "L'incendio della chiesa del Carmine del 1771," *Rivista d'arte* 14 (1932): 157–9; and the chapter by Diane Cole Ahl in this volume.

47. Procacci, 1932, 149–51, 158, describes the damages.

48. On the *Pisa Altarpiece,* see John Shearman, "Masaccio's Pisa Altarpiece: An Alternative Reconstruction," *Burlington Magazine* 108 (1966): 449–55; Christa Gardner von Teuffel, "Masaccio and the Pisa Altarpiece: A New Approach," *Jahrbuch der Berliner Museen* 19 (1977): 23–68; Luciano Berti and Rossella Foggi, *Masaccio. Catalogo completo dei dipinti* (Florence: Cantini, 1989), 45–74; and Joannides, 153–72; cat. 21, 382–98. For the *Santa Maria Maggiore Altarpiece,* see Kenneth Clark, "An Early Quattrocento Triptych from Santa Maria Maggiore, Rome," *Burlington Magazine* 93 (1951): 339–47; Roberts, 86–99; cat. I, 189–92; Carl Brandon Strehlke and Mark Tucker, "The *Santa Maria Maggiore Altarpiece*: New Observations," *Arte cristiana* 75 (1987): 105–24; and Joannides, 72–80; cat. 23, 414–22. Both works are discussed in the chapter by Dillian Gordon in this book.

49. In his notes to Vasari 2: 292 n. 2, Milanesi describes the *Pisa Altarpiece* as "lost," and the *Santa Maria Maggiore Altarpiece,* 2: 293–4 n. 1, as "destroyed or lost."

50. Vasari 2: 306.

51. Vasari 2: 306–24.

52. Joseph Archer Crowe and Giovanni Battista Cavalcaselle, *A New History of Painting in Italy,* 3 vols. (London: John Murray, 1864), 1: 509–12, 528–41.

53. Henrik Lindberg, *To the Problem of Masaccio and Masolino,* 2 vols. (Stockholm: P. A. Norstedt & söner, 1931), 1: 50, 53–5, 174–8, 197–210; and Mario Salmi, *Masaccio,* 2nd ed. (Milan: U. Hoepli, 1947), 38–55, 63–7, 114–19, 121–2.

54. Roberto Longhi, "Fatti di Masolino e di Masaccio," *Critica d'arte* 25–6 (1940): 145–91; rpt. in Longhi, 1975, 3–65.

55. Eve Borsook, *The Mural Painters of Tuscany from Cimabue to Andrea del Sarto,* 2nd ed. (Oxford: Clarendon Press, 1980), 60.

56. See the references in Joannides, 368, and the chapter by Timothy Verdon in this book.

57. See n. 18.

58. See n. 17.

59. See Baldini and Casazza, passim; Keith Christiansen, "Some observations on the Brancacci Chapel frescoes after their cleaning," *Burlington Magazine* 133 (1991): 5–20; and Ornella Casazza, "Operatività e risultanze del restauro," in *La chiesa di Santa Maria del Carmine a Firenze,* ed. Luciano Berti (Florence: Giunti, 1992), 235–58.

60. The friezes and heads within them have been ascribed to Masolino alone, as well as to both artists. For the range of opinions, see among others Umberto Baldini, "Nuovi affreschi nella Cappella Brancacci, Masaccio e Masolino," *Critica d'arte* 49 (1984): 65–72; Miklòs Boskovits, "Il percorso di Masolino: Precisazioni sulla cronologia e sul catalogo," *Arte cristiana* 75 (1987): 64; Berti and Foggi, 84; and Roberts, 65, 187, who summarizes critical opinion. Ornella Casazza, "La grande gabbia architettonica di Masaccio," *Critica d'arte* 53 (1988): 84 n. 11, and Berti, 1988, 38, believe that the fragments below the window depict the Crucifixion of Saint Peter; Paul Joannides, "Masaccio's Brancacci Chapel: Restoration and Revelation," *Apollo* 133 (1991): 26–32; idem, 1993, 319–20; and Christiansen, 8, identify the subject as the conversion of Saint Paul.

61. Ornella Casazza, "Il ciclo delle storie di San Pietro e la 'historia salutis.' Nuova lettura della cappella Brancacci," *Critica d'arte* 51 (1986): 69–70.

62. In addition to a book on the chapel by Baldini and Casazza and a volume of essays edited by Berti, they include Berti and Foggi; Joannides, 1993; Roberts; and John T. Spike, *Masaccio* (New York: Abbeville Press, 1996). Relatedly, see *L'età di Masaccio. Il primo Quattrocento a Firenze,* eds. Luciano Berti and Antonio Paolucci, exh. cat. (Milan: Electa Editrice, 1990); and *"Masaccio 1422/1989". Dal trittico di San Giovenale al restauro della Cappella Brancacci. Atti del Convegno del 22 aprile 1989* (Pieve di San Cascia-Reggello, Figline Valdarno: n.p., 1990).

63. Joannides's monograph is exemplary in its synthesis of earlier scholarship.

64. On the *Cascia di Reggello Altarpiece,* see Ivo Becattini, "Il territorio di San Giovenale ed il Trittico di Masaccio. Ricerche ed ipotesi," in *Masaccio 1422/1989,* 17–26; on *Sant'Anna Metterza,* see Timothy Verdon, "La Sant'Anna Metterza: riflessioni, domande, ipotesi," in *I pittori della Brancacci agli Uffizi: Gli Uffizi. Studi e ricerche* 5, eds. Luciano Berti and Annamaria Petrioli Tofani (Florence: Centro Di, 1988), 33–58.

65. Carmelite patronage and iconography most recently have been investigated by Miklòs Boskovits, "Fra Filippo Lippi, i carmelitani e il Rinascimento," *Arte cristiana* 74 (1986): 235–52; Creighton E. Gilbert, "Some Special Images for Carmelites, circa 1330–1430," in *Christianity and the Renaissance. Image and Religious Imagination in the Quattrocento,* eds. Timothy Verdon and John Henderson (Syracuse, N.Y.: Syracuse University Press, 1990), 161–207; and Megan Holmes, *Fra Filippo Lippi. The Carmelite Painter* (New Haven and London: Yale University Press, 1999). Another important contribution is the study on the Brancacci family by Leonida Pandimiglio, *Felice di Michele vir clarissimus e una consorteria. I Brancacci di Firenze* (Milan: Olivetti, 1987/89), which builds upon the extensive research by Anthony Molho, "The Brancacci Chapel: Studies in Its Iconography and History," *Journal of the Warburg and Courtauld Institutes* 40 (1977): 50–98.

66. Hans Baron, *The Crisis of the Early Renaissance. Civic Humanism and Republican Liberty in an Age of Classicism and Tyranny,* rev. ed. (Princeton: Princeton University Press, 1966).

67. See *Maestri e botteghe. Pittura a Firenze alla fine del Quattrocento,* eds. Mina

Gregori, Antonio Paolucci, and Cristina Acidini Luchinat, exh. cat. (Milan: Silvana Editoriale, 1992); Anabel Thomas, *The Painter's Practice in Renaissance Tuscany* (Cambridge: Cambridge University Press, 1995); and Ames-Lewis.

68. See *Painting and Illumination in Early Renaissance Florence: 1300–1450,* eds. Laurence B. Kanter et al., exh. cat. (New York: Metropolitan Museum of Art, 1994), the most comprehensive study in English of this important phenomenon.

69. These works include the Altenburg *Agony in the Garden and the Penitence of Saint Jerome,* the Berlin *desco da parto* (birth salver) of a birth scene, and the Florence *Casini Madonna and Child.* All of these have been associated with – as well as denied to – Masaccio. For a review of the literature, see Joannides, 274–5, 277–9, and 373–4, respectively.

CHAPTER 1. MASACCIO'S FLORENCE IN PERSPECTIVE

1. Hans Baron, *The Crisis of the Early Renaissance. Civic Humanism and Republican Liberty in an Age of Classicism and Tyranny,* rev. ed. (Princeton: Princeton University Press, 1966), 419.

2. For an analysis of the background of Capponi's statement, see Alison Brown, "City and Citizen: Changing Perceptions in the Fifteenth and Sixteenth Centuries," in *City States in Classical Antiquity and in Medieval Italy: Athens, Rome, Florence and Venice,* eds. Anthony Molho, Kurt A. Raaflaub, and Julia Emlen (Stuttgart: F. Steiner, 1991), 93–111, esp. 104.

3. Matteo Palmieri, *Libro della vita civile,* ed. Gino Belloni (Florence: G. C. Sansoni, 1982), 161.

4. Bonnie A. Bennett and David G. Wilkins, *Donatello* (Mt. Kisco, N.Y.: Moyer Bell, 1984), 66.

5. Giovanni di Paolo Morelli, *Ricordi,* ed. Vittore Branca (Florence: Felice Le Monnier, 1956), 251–3.

6. This passage is quoted and discussed in John Najemy, "Arti and ordini in Machiavelli's *Istorie Fiorentine,*" in *Essays Presented to Myron P. Gilmore,* eds. Sergio Bertelli and Gloria Ramakus (Florence: La Nuova Italia, 1978), 167.

7. David Herlihy and Christiane Klapisch, *Les Toscans et leurs familles. Une étude du Catasto florentin* (Paris: Fondation nationale des sciences politiques, 1978), 176; for mortality rates in one sample of the population, see Alan Morrison, Julius Kirshner, and Anthony Molho, "Epidemics in Renaissance Florence," *American Journal of Public Health* 75 (1985): 528–35. Much useful information is also found in Ann G. Carmichael, *Plague and the Poor in Renaissance Florence* (Cambridge: Cambridge University Press, 1986), while David Herlihy, *The Black Death and the Transformation of the West,* ed. Samuel Kline Cohn, Jr. (Cambridge, Mass.: Harvard University Press, 1997), contains many suggestive ideas.

8. Franco Franceschi, "Istituzioni e attività economica a Firenze: Considerazioni sul governo del settore industriale (1350–1450)," in *Istituzioni e società in Toscana nell'età moderna* (Rome: Ministero per i beni culturali e ambientali, Ufficio centrale per i beni archivistici, 1994), 80.

9. Raymond de Roover, *The Rise and Decline of the Medici Bank* (Cambridge, Mass.: Harvard University Press, 1963); George Holmes, "How the Medici Became the Pope's Bankers," in *Florentine Studies: Politics and Society in Renaissance Florence,* ed. Nicolai Rubinstein (London: Faber, 1968), 357–80.

10. Anthony Molho, *Florentine Public Finances in the Early Renaissance, 1400–1433* (Cambridge, Mass.: Harvard University Press, 1971), 153 n. 1.

11. Richard A. Goldthwaite, *The Building of Renaissance Florence. An Economic and Social History* (Baltimore: Johns Hopkins University Press, 1980).

12. Herlihy and Klapisch, 251; see also Elio Conti, *L'imposta diretta a Firenze nel Quattrocento (1427–1494)* (Rome: Nella Sedia dell'Istituto, 1984), esp. 319. Without having undertaken a systematic statistical analysis of the sort carried out by Herlihy and Klapisch and by Conti, Lauro Martines, *The Social World of the Florentine Humanists* (Princeton: Princeton University Press, 1963), had forcefully and convincingly argued the case for the progressive aristocratization of fifteenth-century Florentine society.

13. Herlihy and Klapisch, ch. 9.

14. Giuliano Pinto, "I livelli di vita dei salariati cittadini nel periodo successivo al tumulto dei Ciompi (1380–1430)," in *Il Tumulto dei Ciompi. Un momento di storia fiorentina ed europea* (Florence: Leo S. Olschki, 1981), 161–98, esp. 186.

15. Molho, 1971, 151. One should note that this decree notwithstanding, Jews did not actually settle in Florence until 1437. For an older but still very useful treatment of the history of Jewish settlements in late medieval Florence, see Umberto Cassuto, *Gli ebrei a Firenze nell'età del Rinascimento* (Florence: Tipografia Galleti e Cocci, 1918).

16. Lorenzo Fabbri, "Autonomismo comunale ed egemonia fiorentina a Volterra tra '300 e '400," *Rassegna volterrana* 70 (1994): 97–110, esp. 105–6.

17. For an authoritative recounting of Florentine foreign policy and the insidious problems it created, see Gene Brucker, *The Civic World of Early Renaissance Florence* (Princeton: Princeton University Press, 1977), chs. 3, 6–8.

18. Molho, 1971, passim.

19. Herlihy and Klapisch, 251.

20. Quoted in Conti, 116.

21. Molho, 1971, 62, table 62.

22. Quoted in Brucker, 472.

23. Quoted in Gene Brucker, *Renaissance Florence* (New York: John Wiley & Sons, 1969), 100.

24. Brucker, 1969, 99.

25. Brucker, 1977, 303.

26. This point is central to Dale V. Kent, *The Rise of the Medici: Faction in Florence, 1426–1434* (Oxford: Oxford University Press, 1978), esp. 20–1.

27. Cited by Brucker, 1969, 139.

28. Cited by Brucker, 1977, 251.

29. For what follows, see Anthony Molho, "Lo Stato e finanza pubblica: un' ipotesi basata sulla storia di Firenze tardo medievale," in *Origini dello stato: processi di formazione statale in Italia fra medioevo ed età moderna*, eds. Giorgio Chittolini, Anthony Molho, and Pierangelo Schiera (Bologna: Il Mulino, 1994), 225–80; this volume was partially translated as *The Origins of the State in Italy*, ed. Julius Kirshner (Chicago: University of Chicago Press, 1996).

30. For this paragraph and what follows, see Herlihy and Klapisch, chs. 1–3. Conti is fundamental for the institutional and social history of Florentine public finance.

31. Anthony Molho, *Marriage Alliance in Late Medieval Florence* (Cambridge, Mass.: Harvard University Press, 1994), esp. ch. 2.

32. For what follows, see Franco Franceschi, "Intervento del potere centrale e ruolo delle arti nel governo dell'economia fiorentina del Trecento e del primo Quattrocento. Linee generali," *Archivio storico italiano* 151 (1993): 863–909.

33. On this mission, see Felice's own account in his "Diario di Felice Brancacci, Ambasciatore con Carlo Federighi al Cairo per il Comune di Firenze (1422)," ed. Dante Castellani, *Archivio storico italiano,* ser. 4a, 8 (1881): 157–88.

34. Portions of the government decision are printed in Franceschi, 1993, 904.

35. For these initiatives, see the essays of David Herlihy, Riccardo Fubini, John Najemy, and Giorgio Chittolini, in Molho et al. See also Andrea Zorzi, "Lo stato territoriale fiorentino (secoli XVI–XV): aspetti giurisdizionali," *Società e storia* 13 (1990): 790–825, and the essays by Giorgio Chittolini, Elena Fasano, Riccardo Fubini, Anthony Molho, John Najemy, and Lauro Martines, in Chittolini et al. On comparable trends in the history of the Florentine church, see Roberto Bizzocchi's contribution to Chittolini et al., and David S. Peterson, "Electoral Politics and the Florentine Clergy: A Meeting of the *Maius Consilium* of 1424," *Renaissance Studies* 5 (1991): 359–97.

36. Michael Rocke, *Forbidden Friendships: Homosexuality and Male Culture in Renaissance Florence* (Oxford: Oxford University Press, 1996), esp. 27–36; Maria Serena Mazzi, "Il mondo della prostituzione nella Firenze tardo medievale," *Ricerche storiche* 14 (1984): 337–63; idem, *Prostitute e lenoni nella Firenze del Quattrocento* (Milan: Saggiatore, 1991); Richard C. Trexler, "La prostitution florentine au XVe siècle: patronages et clientèles," *Annales ESC* 36 (1981): 983–1015; idem, "Infanticide in Florence: New Sources and First Results," *History of Childhood Quarterly: The Journal of Psychohistory* 1 (1973): 98–116; idem, "The Foundlings of Florence, 1395–1455," *History of Childhood Quarterly: The Journal of Psychohistory* 1 (1973): 259–84; and Philip Gavitt, *Charity and Children in Renaissance Florence: The Ospedale degli Innocenti, 1410–1536* (Ann Arbor, Mich.: University of Michigan Press, 1990).

37. See Eve Borsook, *The Mural Painters of Tuscany from Cimabue to Andrea del Sarto,* 2nd ed. (Oxford: Clarendon Press, 1980), 60, 62–3 n. 53–9; and Ornella Casazza, "Masaccio's Fresco Technique and Problems of Conservation," in *Masaccio's* Trinity, ed. Rona Goffen (Cambridge: Cambridge University Press, 1998), 69–77.

CHAPTER 2. MASACCIO'S CITY

1. This process can be best studied in Florence at the city's topographical museum, Firenze com'era. Piero Bargellini, *Com'era Firenze 100 anni fa* (Florence: Casa Editrice Bonechi, 1977), offers an accessible compendium of photographs. For those who can read Italian, see Giovanni Fanelli, *Firenze, Le città nella storia d'Italia* (Rome and Bari: Giuseppe Laterza & Figli, 1985).

2. For the earlier Medici houses on this site, see Howard Saalman and Philip Mattox, "The First Medici Palace," *Journal of the Society of Architectural Historians* 44 (1985): 329–45.

3. The single best study of the shape and development of the city up to Masaccio's day is the unpublished dissertation by Paula Lois Spilner, "'Ut Civitas Amplietur': Studies in Florentine Urban Development, 1282–1400," Ph.D. diss., Columbia University, New York, 1987. Also very informative are Tim Benton, "The Three Cities Compared: Urbanism," in *Siena, Florence and Padua: Art, Society and Religion 1280–1400,* ed. Diana Norman, 2 vols. (New Haven and London: Yale University Press, 1995), 2: 7–27; and Howard Saalman, "The Transformation of the City in the Renaissance: Florence as

Model," *Annali di architettura* 2 (1990): 73–82. For the earliest surviving description of the city's major monuments, see Creighton E. Gilbert, "The Earliest Guide to Florentine Architecture, 1423," *Mitteilungen des Kunsthistorischen Institutes in Florenz* 14 (1969): 33–46.

4. Quoted in Gilbert, 44: "non pare che e' sia ponte se non in sul mezzo d'esso, dove è una piazza con le sponde, che dimostra il fiume sopra e di sotto" (it doesn't appear to be a bridge except in the middle of it, where there is a piazza with parapets that shows off the river above and below).

5. The church became an important site for Medici patronage, especially after 1434. The family already possessed sole patronage rights in 1348. See John T. Paoletti, "Cosimo de' Medici, Patronage and the Church of San Tommaso in the Mercato Vecchio," *Pantheon* 58 (2000): 54–72.

6. See Richard C. Trexler, "Florentine Prostitution in the Fifteenth Century: Patrons and Clients," in his *Dependence in Context in Renaissance Florence* (Binghamton: Center for Medieval and Early Renaissance Studies, State University of New York at Binghamton, 1994), 343–72, and Michael Rocke, *Forbidden Friendships: Homosexuality and Male Culture in Renaissance Florence* (Oxford: Oxford University Press, 1996).

7. For this and other dating of Brunelleschi's projects, I follow Howard Saalman, *Filippo Brunelleschi, The Buildings* (London: A. Zwemmer, 1993).

8. Tellingly, Goro Dati, in his early description of Florence, said that San Giovanni was the Duomo (Cathedral) of Florence. See the Italian text in Gilbert, 45.

9. For this and what follows regarding medieval urban planning in Florence, see Marvin Trachtenberg, *The Dominion of the Eye. Urbanism, Art, and Power in Early Modern Florence* (Cambridge: Cambridge University Press, 1997), esp. 27–62.

10. Trachtenberg, 87–147. For a more compact and preliminary presentation of this material, see idem, "What Brunelleschi Saw: Monument and Site at the Palazzo Vecchio in Florence," *Journal of the Society of Architectural Historians* 47 (1988): 14–44.

11. Spilner, 234.

12. For a very useful overview of the typology and characteristics of mendicant architecture, see Wolfgang Braunfels, *Monasteries of Western Europe: The Architecture of the Orders* (Princeton: Princeton University Press, 1972), 125–52.

13. Most exhaustively studied by Marcia B. Hall, *Renovation and Counter-Reformation. Vasari and Duke Cosimo in Sta Maria Novella and Sta Croce, 1565–1577* (Oxford: Clarendon Press, 1979).

14. *Ricordi storici di Filippo di Cino Rinuccini dal 1282 al 1460 colla continuazione di Alamanno e Neri, suoi figli fino al 1506*, ed. Giuseppe Aiazzi (Florence: Piatti, 1840), cxxxviii. Rinuccini reported that he found the Baptistery more beautiful cleaned out but that there were those whom it greatly displeased.

15. The most comprehensive source is the bilingual volume *Orsanmichele a Firenze/Orsanmichele Florence*, ed. Diane Finiello Zervas (Modena: F. C. Panini, 1996).

16. Saalman, 1993, 32–81.

17. Saalman, 1993, 128, writes, "The longer one studies Brunelleschi's development and ideas, the more inevitably one concludes: the Baptistery was his school and his point of departure." John Onians, "Brunelleschi: Humanist or

Nationalist?" *Art History* 3 (1982): 259–72, has proposed the intriguing possibility that Brunelleschi may have known full well the difference between Roman and Romanesque forms and therefore chose to study the Baptistery because of its positive associations with earlier Florentine attempts to maintain the city's independence.

18. Saalman, 1993, 106–44.

19. Saalman, 1993, 82–105. See also his "Form and Meaning at the Barbadori-Capponi Chapel in Santa Felicita," *Burlington Magazine* 131 (1989): 532–9, which discusses the later renovations.

20. Saalman, 1993, 90–5, gives the most comprehensive analysis of surviving documentation. For women as patrons of art in the Renaissance, see the entire issue of *Renaissance Studies* 10 (1996), ed. Jaynie Anderson; Catherine King, "Medieval and Renaissance Matrons, Italian-Style," *Zeitschrift für Kunstgeschichte* 55 (1992): 372–93; and idem, *Renaissance Women Patrons, Wives and Widows in Italy ca. 1300–1550* (Manchester: Manchester University Press, 1998).

21. We do not know whether any male members of the family were buried there.

22. For a very useful discussion of the nature of the Gothic in Italy, see Marvin Trachtenberg, "Gothic/Italian Gothic: Towards a Redefinition," *Journal of the Society of Architectural Historians* 50 (1991): 22–37.

23. For the tolerance of and indeed preference for the Gothic in certain circumstances, see the excellent essay by Christine Smith, "*Varietas* and the Design of Pienza," in her *Architecture in the Culture of Early Humanism, Ethics, Aesthetics, and Eloquence 1400–1470* (Oxford: Oxford University Press, 1992), 98–129.

24. The best and most thorough considerations of the sculptors' work continue to be two monographs produced in the mid–twentieth century: Horst W. Janson, *The Sculpture of Donatello*, rev. ed. (Princeton: Princeton University Press, 1963), and Richard Krautheimer in collaboration with Trude Krautheimer-Hess, *Lorenzo Ghiberti*, 2nd ed., 2 vols. (Princeton: Princeton University Press, 1970). See also Bonnie A. Bennett and David G. Wilkins, *Donatello* (Mt. Kisco, N.Y.: Moyer Bell, 1984), and John Pope-Hennessy, *Donatello: Sculptor* (New York: Abbeville Press, 1993).

25. Horst W. Janson, "The Birth of 'Artistic License': The Dissatisfied Patron in the Early Renaissance," in *Patronage in the Renaissance*, eds. Guy Fitch Lytle and Stephen Orgel (Princeton: Princeton University Press, 1981): 344–53.

26. Donatello's use of optical corrections in this and other works is fully considered in Robert Munman, "Optical Corrections in the Sculpture of Donatello," *Transactions of the American Philosophical Society* 75 (1985).

27. Janson, 1963, 12–16. See also the very important analysis in Charles Seymour, Jr., *Sculpture in Italy: 1400–1500* (Baltimore: Penguin Books, 1966), 54–8.

28. Janson, 1963, 7–12.

29. John T. Paoletti, "Wooden Sculpture in Italy as Sacral Presence," *Artibus et historiae* 26 (1992): 85–100, explores the importance of naturalism and life-size scale to the efficacy of these images.

30. Krautheimer 1: 101–34.

31. Janson, 1963, 29–32.

32. See Michael Godby, "A Note on Schiacciato," *Art Bulletin* 62 (1980): 635–7, for an interesting history of the term.

33. The sculptor's most active modern proponent has been Manfred Wundram, *Donatello und Nanni di Banco* (Berlin: de Gruyter, 1969), who urges readers

to consider that Nanni, not Donatello, may have been the greatest innovator of the early fifteenth century. Mary Bergstein, *The Sculpture of Nanni di Banco* (Princeton: Princeton University Press, 2000), has an equally high opinion of the sculptor and explores the relationship between his art and his own rise in Florentine politics. Unfortunately, there are very few firm dates for Nanni's works. More reasonable is the suggestion made by Seymour, 59, of an artistic dialogue between Nanni and Donatello.

34. Thus, in conceiving his detailed survey of Italian sculpture, John Pope-Hennessy, *An Introduction to Italian Sculpture*, 4th ed., 3 vols. (London: Phaidon Press, 1996), put all of Ghiberti's works in the Gothic volume and Donatello's in the early Renaissance. Somewhat confusingly, he also confined Nanni to the Gothic volume, even though his works are among the most archaeological of his generation.

35. The phrase and its popularization are due to Hans Baron, *The Crisis of the Early Renaissance. Civic Humanism and Republican Liberty in an Age of Classicism and Tyranny*, rev. ed. (Princeton: Princeton University Press, 1966).

36. Seymour, 59–60, gives a very useful analysis.

37. Most famously expressed by Frederick Hartt, "Art and Freedom in Quattrocento Florence," in *Marsyas: Studies in the History of Art (Suppl. 1), Essays in Memory of Karl Lehmann* (New York: Institute of Fine Arts, New York University, 1964), 114–31.

38. Hartt, 119, was very careful to note, and in fact explain, that the new style appeared first in sculpture and not in painting. His observation that sculpture, as a civic and public art, was more likely to be addressed to the general citizenry than paintings in private chapels remains sensible.

39. See Gene Brucker, *The Civic World of Early Renaissance Florence* (Princeton: Princeton University Press, 1977), 60, and John Najemy, *Corporation and Consensus in Florentine Electoral Politics, 1280–1400* (Chapel Hill, N.C.: University of North Carolina Press, 1982).

40. Janson, 1963, 16–21, and Krautheimer 1: 71–85.

41. See for example, the widely adopted textbook by Frederick Hartt, *History of Italian Renaissance Art,* 4th ed., rev. David G. Wilkins (Englewood Cliffs, N.J.: Prentice-Hall, and New York: Harry N. Abrams, 1994), 172–5.

42. Krautheimer 1: 86–93.

43. See the detailed analysis by Diane Finiello Zervas, "Ghiberti's St. Matthew Ensemble at Orsanmichele: Symbolism in Proportion," *Art Bulletin* 58 (1976): 36–44.

44. Janson, 1963, 45–56.

45. Janson, 1963, 33–41.

46. This reading was first suggested by Bennett and Wilkins, 212.

47. Krautheimer 1: 93–100.

48. Krautheimer 1: 97.

49. Piero Morselli, "The Proportions of Ghiberti's *Saint Stephen*: Vitruvius' *De Architectura* and Alberti's *De Statua*," *Art Bulletin* 60 (1978): 235–41.

CHAPTER 3. PAINTING IN MASACCIO'S FLORENCE

1. For the type with the *giglio* (the Florentine lily), see a *cassone* in Florence, Palazzo Davanzati, illustrated in Luciano Berti, *Il Museo di Palazzo Davanzati a Firenze* (Florence: Cassa di Risparmio, n.d. [c. 1972]), cat. 51, 203, and fig. 48;

for the type with compartments, see one in London, Victoria and Albert Museum, illustrated in Paul Schubring, *Cassoni, Truhen und Truhenbilder der italienischen Frührenaissance,* 2 vols. (Leipzig: Hirseman, 1915), 2: cat. 16, pl. II.

2. Masaccio is mentioned as a witness in an undated document known only from a lost copy; it cannot have been earlier than October 1418, but may have been quite a bit later. See Ugo Procacci, *Masaccio* (Florence: Leo S. Olschki, 1980), 11–12; and James H. Beck with the collaboration of Gino Corti, *Masaccio. The Documents* (Locust Valley, N.Y.: J. J. Augustin, 1978), doc. IV, 8–9.

3. Cecilia Frosinini, "Alcune precisazioni su Mariotto di Cristofano," *Rivista d'arte* 39 (1987): 443–55; Miklòs Boskovits, "Mariotto di Cristofano: un contributo all'ambiente culturale di Masaccio giovane," *Arte illustra* 13/14 (1969): 4–13.

4. On the distinction between active patrons, concerned clients, and passive customers, see Creighton E. Gilbert, "What did the Renaissance Patron Buy?" *Renaissance Quarterly* 51 (1998): 392–450.

5. Ugo Procacci, *Sinopie e affreschi* (Milan: Electa Editrice, 1961), figs. 54, 55.

6. See Millard Meiss, *The Great Age of Fresco* (New York: George Braziller in association with the Metropolitan Museum of Art, 1970).

7. Procacci, 1961, 60: Pope Martin V confirmed the consecration by Cardinal Antonio Correr that had taken place the day before. According to Giorgio Vasari, *Le vite de' più eccellenti pittori, scultori ed architettori,* ed. Gaetano Milanesi, 9 vols. (Florence: G. C. Sansoni, 1906), 2: 55, he and other cardinals were present that second day, and Michele di Fruosino da Panzano, the rector of the hospital for which Sant'Egidio was the church, is shown kissing the pope's hand while the members of the hospital line up behind him. There appears also to have been portraits of members of the Portinari family, who were patrons of the church.

8. Francis Ames-Lewis, *Drawing in Early Renaissance Italy* (New Haven and London: Yale University Press, 1981), 146. See also Jean K. Cadogan, *Domenico Ghirlandaio. Artist and Artisan* (New Haven and London: Yale University Press, 2000), 87–90, 240–3.

9. Dated April 23, 1422, by inscription. It was in Florence, Galleria degli Uffizi, for some years, but was recently returned to its original home. Luciano Bellosi, in Luciano Bellosi and Margaret Haines, *Lo Scheggia* (Florence and Siena: Maschietto & Musolino, 1999), 22–3, does not consider it an autograph work and calls it "workshop of Masaccio (?)."

10. Bernard Berenson, *Italian Pictures of the Renaissance, Florentine School,* 2 vols. (London: Phaidon Press, 1963), 1: pl. 498.

11. Paul Joannides, *Masaccio and Masolino. A Complete Catalogue* (London: Phaidon Press, 1993), 443–6, reviews the extensive bibiography. See also Divo Savelli, *La Sagra di Masaccio* (Florence: Giampiero Pagnini Editore, 1998).

12. Vasari 2: 294–7.

13. Peter Meller, "La Cappella Brancacci: problemi ritrattistici e iconografici," *Acropoli* 1 (1960–1): 186–227; 273–312. Joannides, 335–6, however, refutes many of Meller's identifications but accepts the proposal of Mario Salmi, "L'autoritratto di Masaccio nella Cappella Brancacci," *Rivista storica carmelitana* 1 (1929): 99–100, of Masaccio's self-portrait in *Saint Peter Preaching.*

14. Millard Meiss in Peter Brieger, Millard Meiss, and Charles S. Singleton, *Illuminated Manuscripts of the Divine Comedy,* 2 vols. (Princeton: Princeton University Press, 1969), 2: 40–2.

15. Victoria Kirkham, "A Preliminary List of Boccaccio Portraits from the 14th to the mid-16th Centuries (Pt. 4), Boccaccio visualizzato," *Studi sul Boccaccio* 15 (1985–6): 167–88.

16. For example, they are among the great of this world on a *cassone* panel by Masolino (New Haven, Yale University Gallery); see Ellen Callmann, "Masolino da Panicale and Florentine Cassone Painting," *Apollo* 150 (1999): 44, 48, fig. 10. Portraits of them and other contemporary or near-contemporary heroes may have been included among series of *uomini famosi* (famous men).

17. Brieger et al. 1: fig. 16.

18. Joannides, 443.

19. Vasari 2: 295–6, describes the fresco. The drawings are in Florence, Casa Buonarroti; Florence, Procacci Collection; Florence, Galleria degli Uffizi, Gabinetto dei disegni; Folkestone, Museum and Art Gallery; England, Private Collection; Vienna, Albertina; whereabouts unknown; see Luciano Berti, *Masaccio* (University Park, Pa.: Pennsylvania State University Press, 1967), figs. 43–7, and Joannides, pl. 456. See also the discussion by Francis Ames-Lewis in Chapter 10.

20. Joannides, 442.

21. Ugo Procacci, "Di Jacopo di Antonio e delle compagnie di pittori del Corso degli Adimari nel XV secolo," *Rivista d'arte* 35 (1960): 3–70; Annamaria Bernacchioni, "Botteghe di artisti e artigiani nel XV secolo," in *Gli antichi chiassi tra Ponte Vecchio e Santa Trinita,* ed. Giampaolo Trotta (Florence: Messaggerie toscane, 1992), 209–13. On the role of neighborhood for other artisans, see also Richard A. Goldthwaite, *The Building of Renaissance Florence. An Economic and Social History* (Baltimore: Johns Hopkins University Press, 1980); Dale V. and F. William Kent, *Neighbours and Neighbourhood in Renaissance Florence: The district of the Red Lion in the fifteenth century* (Locust Valley, N.Y.: J. J. Augustin, n.d. [1982]); and Nicholas A. Eckstein, *The District of the Green Dragon: Neighbourhood Life and Social Change in Renaissance Florence* (Florence: Leo S. Olschki, 1995). For clusters of patrons, see John R. Spencer, *Andrea del Castagno and his Patrons* (Durham, N.C.: Duke University Press, 1991), 120–30.

22. Vasari had been misled into thinking that Panicale was in the Valdelsa, but later historians placed Masolino in Panicale in the zone of the Renacci in the territory of San Giovanni Valdarno. However, there is no documentary evidence, as pointed out by Perri Lee Roberts, *Masolino da Panicale* (Oxford: Clarendon Press, 1993), 6.

23. The contract of September 7, 1422, stipulates occupancy begining November 1; see Roberts, doc. II, 167.

24. Joannides, 28. See also the discussion in chapters 4 and 5 in this volume.

25. Ugo Procacci, "L'incendio della chiesa del Carmine del 1771," *Rivista d'arte* 14 (1932): 164, 190.

26. Anabel Thomas, *The Painter's Practice in Renaissance Tuscany* (Cambridge: Cambridge University Press, 1995), 31.

27. Nerida Newbigin, *Feste d'Oltrarno, Plays in Churches in Fifteenth-Century Florence,* 2 vols. (Florence: Leo S. Olschki, 1996), 2: 45–155.

28. Cyrilla Barr, "A Renaissance Artist in the Service of a Singing Confraternity," in *Life and Death in Fifteenth-Century Florence,* eds. Rona Goffen, Marcel Tetel, and Ronald Witt (Durham, N.C.: Duke University Press, 1989), 105–19, nn. 216–24.

29. Gaetano Milanesi, in Vasari 2: 58 n. 2; and Procacci, 1932, 1969.

30. Barr, 108.

31. Procacci, 1932, 176.

32. Procacci, 1932, 153: It was located to the right of the choir with frescoes of the life of Saint John. Spinello may also have executed the altarpiece depicting a Madonna and Child with saints. The frescoes were begun some time after the patron's death in August 1357; in 1772, Thomas Patch, *Selections from the Works of Masaccio, Fra Bartolommeo and Giotto,* 4 vols. (Florence: n.p., 1770–2), 3: pls. II–VII, published copies of the frescoes that he had made shortly before the fire. These, however, reflect the extensive restorations of 1763–4 (for which see also Procacci, 1932, 215–32). Of the surviving fragments, six are now in Pisa, Camposanto; one in London, National Gallery; two in Liverpool, Walker Art Gallery; and one in Rotterdam, Museum Boijmans van Beuningen. Another, a *Head of Herod,* was on the art market in 1963 (for which see Federico Zeri, "Italian Primitives at Messrs. Wildenstein," *Burlington Magazine* 107 (1965): 255, fig. 55; and Adams, Davidson & Company, [Catalogue], [no title] (Washington, D.C.: n.p., n.d. [1965 or 1966]), 29). Finally, one in Pavia, Museo Civico Malaspina, may also belong with them.

33. Procacci, 1932, 175.

34. Procacci, 1932, 174.

35. Andrew Ladis, *Taddeo Gaddi* (Columbia, Mo.: University of Missouri Press, 1982), 17 ff.

36. For the example of Francesco Datini, see Iris Origo, *The Merchant of Prato, Francesco di Marco Datini* (New York: Knopf, 1957; rpt. New York: Octagon Books, 1979), 236.

37. Richard Krautheimer in collaboration with Trude Krautheimer-Hess, *Lorenzo Ghiberti,* 2nd ed., 2 vols. (Princeton: Princeton University Press, 1970), 1: 122. For the imitation of his compositions by others before the doors were installed, see Krautheimer 1: 116–18.

38. This identification with Starnina was first made by Jeanne van Waadenoijen, "A Proposal for Starnina: Exit the Maestro del Bambino Vispo?" *Burlington Magazine* 116 (1974): 89, and expanded in her book *Starnina e il Gotico Internazionale a Firenze* (Florence: Istituto universitario olandese di storia dell'arte, 1983). See also Cornelia Syre, "Studien zum 'Maestro del Bambino Vispo' und Starnina," Ph.D. diss., University of Bonn, 1979.

39. These figures would be in the style of the lost altarpiece he is documented to have provided for the second Ardinghelli Chapel in Santa Maria del Carmine in January 1399, that is, some years before he encountered the International Gothic Style. For Lorenzo's work, see Marvin Eisenberg, *Lorenzo Monaco* (Princeton: Princeton University Press, 1989).

40. Work was under way around 1384; see Bruce Cole, *Agnolo Gaddi* (Oxford: Clarendon Press, 1977), 78.

41. Van Waadenoijen, 1983, 26.

42. Procacci, 1932, 171–2. For the building history of the chapel, see Procacci, 1932, 194 ff.; Walter and Elisabeth Paatz, *Die Kirchen von Florenz,* 6 vols. (Frankfurt am Main: Klostermann, 1952–5), 3 (1952): 214, 232, 278 n. 155.

43. Ugo Procacci, "Gherardo Starnina," *Rivista d'arte* 17 (1935): 166.

44. Jean-Baptiste Séroux d'Agincourt, *Histoire de l'art par les monuments, depuis sa décadence au IVe siècle jusqu'à sa renouvellement au XIVe siècle,* 7 vols. (Paris: Treuttel et Würtz, 1823), 2: pl. CXXI.

45. First propounded by van Waadenoijen, 1974, and enlarged in her book, 1983.

46. Vasari 2: 7. The latter is an incident known only from Vasari, as no record of the scene has survived. Vasari reveled in this kind of anecdote, as when he asserted, 2: 292, that the musical angel who looks down at his lute in Masaccio's London *Madonna and Child* is different from earlier ones in that he seems to lend an ear to the sound of his instrument. But Vasari read more into the turn of the head than I am able to see.

47. Ladis, 1982, figs. 4a–12.

48. First suggested by Chandler Rathfon Post, *A History of Spanish Painting*, 14 vols. (Cambridge, Mass.: Harvard University Press, 1953), 2: 404; and discussed in greater detail in Ellen Callmann, "The Thebaid in Tuscan Painting of the Fourteenth and Fifteenth Centuries," M.A. thesis, New York University, Institute of Fine Arts, New York, 1956, 41–6; the attribution has since been reiterated by Miklòs Boskovits, *Pittura fiorentina alla vigilia del Rinascimento 1370–1400* (Florence: Edam, 1975), 156–8, as "Starnina," and has found new support in a document showing he was in that city on December 22, 1395, published by van Waadenoijen, 1983, 24.

49. There were campaigns to renovate the retable in 1493 and 1498 (Post 4: 646; 9: 171), and it was heavily overpainted by Juan de Borgoña in 1516. The whole was reframed and the central statue added, probably during one of these restorations. In its overall conception, the retable is Spanish, the main part divided into six nearly equal sections, the center slightly higher and with a niche for a statue. The predella consists of five panels, each higher than wide, and neither their proportions nor their subjects depend on the scenes above them as they would in an Italian altarpiece.

50. Bruce Cole, *Giotto and Florentine Painting 1280–1375* (New York: Harper & Row, 1976), 138–9.

51. Keith Christiansen, *Gentile da Fabriano* (Ithaca, N.Y.: Cornell University Press, 1982), 160–7, brings together all the documents: Gentile may have traveled to Florence in late 1419; he rented a house in the Santa Trinita quarter in August 1420, where he was still living in 1423; he enrolled in the guild of the Medici e Speziali, November 1422; he completed the San Niccolò altarpiece and was paid for it in June 1423.

52. Now dispersed among several museums: Hampton Court, Collection of Her Majesty the Queen; Florence, Galleria degli Uffizi; Vatican, Pinacoteca; and Washington, D.C., National Gallery of Art.

53. Brigitte Klesse, *Seidenstoffe in der italienischen Malerei des 14. Jahrhunderts* (Bern: Verlag Stämpfli, 1967).

54. It appears to be the result of a greater use of oils, as has been shown in the recent cleaning of the panels in Philadelphia and the studies of his techniques under way at present. See the panel depicting Saint Lawrence, *The Treasury of Saint Francis of Assisi*, eds. Giovanni Morello and Laurence B. Kanter (Milan: Electa Editrice, 1999), 102.

55. Diane Cole Ahl, "Fra Angelico: A New Chronology for the 1420s," *Zeitschrift für Kunstgeschichte* 43 (1980): 368, and Berti, 1967, 60.

56. He joined the confraternity October 30, 1417, and is last mentioned by the name he bore as a layman, Guido di Piero, in early 1418; see Ahl, 361–2. By June 1423, he had become a Dominican friar; see Creighton E. Gilbert, "The Conversion of Fra Angelico," in *Scritti di storia dell'arte in onore di Roberto Salvini* (Florence: G. C. Sansoni, 1984), 281.

57. The *Annunciation* in Rosano, redated from 1430 to 1434 by Fabrizio Guidi, "Per una nuova cronologia di Giovanni di Marco," *Paragone* 19 (1968): 36; the *Madonna and Child* (Florence, Museo di San Marco), dated 1434; work on the *Santa Trinita Altarpiece,* documented in 1434; the frescoes of Saint Bartholomew in the Scali Chapel, Santa Trinita, Florence, documented in 1434 and 1435; and the triptych in Rome, Pinacoteca Vaticana, dated March 26, 1435.

58. Guidi, 30–1, rightly disputed the reading of 1410 in the inscription of the Chantilly *Coronation.* In my opinion, a date soon after 1401 and well before 1410 is reasonable on stylistic grounds.

59. Curtis Howard Shell, "Giovanni dal Ponte and the Problem of Other Lesser Contemporaries of Masaccio," Ph.D. diss., Harvard University, Cambridge, Mass., 1958, 19.

60. Fabrizio Guidi Bruscoli, "Una tavola di Giovanni di Marco da San Donato a Porrona," in *Scritti di storia dell'arte in onore di Federico Zeri,* 2 vols. (Milan: Electa Editrice, 1984) 1: 60–7, dates the *Saint Nicholas* after 1425.

61. Megan Holmes, *Fra Filippo Lippi. The Carmelite Painter* (New Haven and London: Yale University Press, 1999), 14–18.

62. For the early Tuscan Thebaids, one or more of which he evidently knew, see Ellen Callmann, "Thebaid Studies," *Antichità viva* 14 (1975): 3–22.

CHAPTER 4. COLLABORATION IN EARLY RENAISSANCE ART

1. Luciano Berti, "Masaccio 1422," *Commentari* 12 (1961): 84–107. For arguments against the attribution, see James H. Stubblebine et al., "Early Masaccio: A Hypothetical Lost Madonna and a Disattribution," *Art Bulletin* 62 (1980): 223–5; Luciano Bellosi and Margaret Haines, *Lo Scheggia* (Florence and Siena: Maschietto & Musolino, 1999), 23–5, 31–3. Berti considers the altarpiece a workshop production.

2. Regarding artists' workshops and professional practices in early Renaissance Tuscany, see Anabel Thomas, *The Painter's Practice in Renaissance Tuscany* (Cambridge: Cambridge University Press, 1995); and Martin Wackernagel, *The World of the Florentine Renaissance Artist,* trans. Alison Luchs (Princeton: Princeton University Press, 1981), 299–370.

3. Regarding the variety of commissions undertaken by painters and sculptors, see Bruce Cole, *The Renaissance Artist at Work from Pisano to Titian* (New York: Harper & Row, 1983), 16–18.

4. Documentary evidence shows that titles of shop workers were frequently interchangeable and did not necessarily indicate age, status, or experience; see Thomas, 1–4, 75–88.

5. The 1356 statutes of the Sienese painters' guild mention "workers by year, month, or day, and workers engaged for specific projects"; see Hayden B. J. Maginnis, "The Craftsman's Genius: Painters, Patrons, and Drawings in Trecento Siena," in *The Craft of Art. Originality and Industry in the Italian Renaissance and Baroque Workshop,* eds. Andrew Ladis and Carolyn Wood (Athens, Ga.: University of Georgia Press, 1995), 26–7.

6. Ugo Procacci, "L'affresco dell'oratorio del Bigallo e il suo maestro," *Mitteilungen des Kunsthistorischen Institutes in Florenz* 17 (1973): 319–20.

7. Charles Harrison, "Giotto and the 'rise of painting,'" in *Siena, Florence and*

Padua: Art, Society and Religion 1280–1400, ed. Diana Norman, 2 vols. (New Haven and London: Yale University Press, 1995), 1: 79; Maginnis, 29; and Thomas, 77.

8. Thomas, 256–9. As of the mid-fifteenth century, many more contracts stipulate the master's personal touch; see Michael Baxandall, *Painting and Experience in Fifteenth-Century Italy* (Oxford: Oxford University Press, 1972), 18–23.

9. Maginnis, 30; Baxandall, 6, 14.

10. Maginnis, 30.

11. Thomas, 2, 76. New insights into the technical aspects of the collaborative process have been provided by the scientific investigations of early Italian paintings by the Department of Conservation, National Gallery, London, and by the study of punchwork and tooling in Tuscan art. See, for example, David Bomford, Jill Dunkerton, Dillian Gordon, et al., *Art in the Making: Italian Painting before 1400,* exh. cat. (London: National Gallery Publications, 1989), 69, 86–8, 153–5, 185–9; Erling S. Skaug, *Punchmarks from Giotto to Angelico: attribution, chronology, and workshop relationships in Tuscan panel painting c. 1330–1430,* 2 vols. (Oslo: IIC [International Institute for Conservation of Historic and Artistic Works], Nordic Group, 1994), 1: 19–20, 25–30, 36–48.

12. Specialized workers are rarely mentioned in contracts. A notable exception is the contract for Spinello Aretino's *Monte Oliveto Maggiore Altarpiece* (now dispersed) of 1384. Spinello was to receive 100 florins for the painting; Simone Cini, a carpenter, 50 florins for the frame; and Gabriello Saracini, 100 florins for the gilding. For the document, see Giorgio Vasari, *Le vite de' più eccellenti pittori, scultori ed architettori,* ed. Gaetano Milanesi, 9 vols. (Florence: G. C. Sansoni, 1906), 1: 688 n. 1. According to Mojmír S. Frinta, "Observations on the Trecento and Early Quattrocento Workshop," in *The Artist's Workshop: Studies in the History of Art* 38 (Washington, D.C.: National Gallery of Art, 1993), 26–7, Gabriello was a mediocre painter who specialized in gilding the work of other artists.

13. Maginnis, 27, observed that such partnerships occurred in Siena as early as the last quarter of the Dugento.

14. In Florence, a son did not have to pay an entry fee to the guild if his father were already a member; see Bomford et al., 10.

15. See John Larner, *Culture and Society in Italy 1290–1420* (New York: Charles Scribner's Sons, 1971), 290, for Duccio's genealogy.

16. In the second half of the fifteenth century, there were also Cosimo Rosselli and Cristofano, Giovanni, and Girolamo Rosselli; and Francesco Botticini and Raffaello Botticini. On family dynasties of painters in the second half of the fifteenth century, see *Maestri e botteghe. Pittura a Firenze alla fine del Quattrocento,* eds. Mina Gregori, Antonio Paolucci, and Cristina Acidini Luchinat, exh. cat. (Milan: Silvana Editoriale, 1992), 91–124.

17. In the second half of the fifteenth century, sibling painters included Antonio and Piero Pollaiuolo; Francesco and Alesso di Benozzo; Piero and Polito del Donzello; Cosimo, Francesco, and Chimenti Rosselli; Bartolomeo, Gherardo, and Monte di Giovanni; Domenico, Davide, Benedetto, and Giovambattista Bigordi (Ghirlandaio); Donnino, Domenico, and Agnolo Mazziere; Giuliano and Benedetto da Maiano; and Bernardo and Antonio Rossellino.

18. The Bicci workshop of painters was founded by Lorenzo di Bicci (active

1370–1427), inherited by his son Bicci di Lorenzo (1370/73–1452), and contin-
ued by Neri di Bicci (1419–91); see Thomas, xviii, and passim. The so-called
Ghiberti shop was inherited by Lorenzo Ghiberti from his stepfather Michele
di Bartolo, and continued for three more generations in the hands of Vittorio
(1418/19–96), Buonaccorso di Vittorio (1451–1516), and Vittorio di Buonac-
corso (1501–42); see the discussion in the text. The Della Robbia shop, which
specialized in the production of glazed terra-cotta sculpture, was initiated by
Luca della Robbia (1399/1400–82), inherited by his nephew Andrea
(1435–1525), and carried on by his third-born son (out of six), Giovanni
(1469–1529); see Giancarlo Gentilini, *I Della Robbia: la scultura invetriata nel
Rinascimento,* 2 vols. (Florence: Cantini, 1992).

19. On the complicated issue of Simone's workshop, collaborators, and followers,
see Andrew Martindale, *Simone Martini* (New York: New York University
Press, 1988), 55–62; Giovanni Previtali, "Introduzione," in *Simone Martini e
'chompagni,'* eds. Alessandro Bagnoli and Luciano Bellosi, exh. cat. (Flo-
rence: Centro Di, 1985), 11–32; and Angelo Tartuferi, "Appunti su Simone
Martini e 'chompagni,'" *Arte cristiana* 74 (1986): 79–92. Among Simone's
many works in which collaborators played a significant role by painting major
figures are the *Santa Caterina Polyptych* (1319), Pisa, Museo Nazionale di San
Matteo; *Beato Agostino Novello Altarpiece* (c. 1328), Siena, Sant'Agostino; and
the frescoes in the Chapel of Saint Martin, San Francesco, Assisi; see Mag-
innis, 27.

20. On Lippo Memmi, see Bonnie A. Bennett, "Lippo Memmi, Simone Martini's
'fratello in arte': the image revealed by his documented works," Ph.D. diss.,
University of Pittsburgh, 1977. Gaudenz Freuler, "Lippo Memmi's New Testa-
ment Cycle in the Collegiata in San Gimignano," *Arte cristiana* 74 (1986): 94,
100, notes judiciously that Lippo Memmi's reputation has been overshadowed
by that of his more famous brother-in-law. He emphasizes the fact that Lippo
was not merely Simone's alter ego (his *"fratello in arte"*) as described by Ben-
nett and Previtali, 27–8, but was an original artistic personality in his own
right; for this revised view of Lippo, see also Tartuferi, 84–5.

21. Irene Hueck, "Simone attorno al 1320," in *Simone Martini: atti del convegno:
Siena 27, 28, 29 marzo 1985,* ed. Luciano Bellosi (Florence: Centro Di, 1988),
52–4.

22. Hayden B. J. Maginnis, "Chiarimenti documentari: Simone Martini, i
Memmi e Ambrogio Lorenzetti," *Rivista d'arte* 41 (1989): 6–7.

23. For the work, see Luisa Marcucci, *Galleria Nazionale di Firenze. I dipinti
toscani del secolo XIV* (Rome: Istituto Poligrafico dello Stato, 1965), cat. 108,
149–52; and Luciano Bellosi in *Gli Uffizi. Catalogo generale,* ed. Luciano Berti
(Florence: Centro Di, 1979), P 1024, 372.

24. For the documents, see Pèleo Bacci, *Fonte e commenti per la storia dell'arte
senese* (Siena: Accademia degli intronati, 1944), 163–73. Martindale, 55, 88,
notes that more than half the total cost of the altarpiece passed through
Lippo's hands in the transaction for the gold leaf.

25. For the history of the attribution, see Marcucci, 150–2, and Miklòs Boskovits,
"Sul trittico di Simone Martini e di Lippo Memmi," *Arte cristiana* 74 (1986): 70.

26. See Boskovits, 1986, 70; cf. Previtali, 28. If the *Saint Ansanus Altarpiece* is
solely the work of Simone Martini, the question arises of how to account for
the inclusion of Lippo's name in the inscription. Martindale, 55, notes that
double signatures are unusual on works of art from this period and generally

indicate a family relationship. In his opinion, the double signature on the altarpiece may stem solely from the fact that Simone Martini and Lippo Memmi were related by marriage. Luciano Bellosi, in Bagnoli and Bellosi, 98–100, proposes that the prominence given to Lippo's name in the inscription was a deliberate attempt to legitimize him as Simone's successor before the latter's departure for Avignon.

27. Boskovits, 70–4. This attribution was first proposed some thirty years ago by Klara Steinweg, "Beiträge zu Simone Martini und seiner Werkstätt," *Mitteilungen des Kunsthistorischen Institutes in Florenz* 7 (1953/6): 167 n. 22.

 Both Simone Martini and Lippo Memmi employed their own brothers as assistants. Donato Martini (active 1339–47) appears to have served primarily in an administrative capacity; out of Simone's large workshop, Donato was the only one who accompanied the artist to Avignon in the final years of his career. Lippo collaborated with his brother, Tederigho (active 1345), on a number of works, none of which have survived. They included an unidentified and perhaps never completed project for the tower of the Palazzo Pubblico (1341); a tripych for the Ospedale di Santa Maria della Scala, Siena (1344); and a Madonna and Child, signed by both brothers and dated 1347, recorded in a Franciscan church in Avignon. See Bagnoli and Bellosi, 110, 124–5.

28. Erling S. Skaug, "Notes on the Chronology of Ambrogio Lorenzetti and New Paintings from His Shop," *Mitteilungen des Kunsthistorischen Institutes in Florenz* 20 (1976): 317. Frinta, 22–3, observes several of Ambrogio's punches side by side with Pietro's punches in the large altarpiece for the Carmine, Siena (Siena, Pinacoteca Nazionale; 1329), and a few of Pietro's punches alongside Ambrogio's own in the latter's *Maestà* (Massa Marittima, Palazzo Pubblico).

29. Hayden B. J. Maginnis, "The Lost Facade Frescoes from Siena's Ospedale di S. Maria della Scala," *Zeitschrift für Kunstgeschichte* 51 (1988): 180–94. Maginnis suggests that Simone Martini may have also collaborated on the frescoes.

30. For a thorough discussion of the work, see Sherwood A. Fehm, Jr., *Luca di Tommè, A Sienese Fourteenth-Century Painter* (Carbondale, Ill.: Southern Illinois University Press, 1986), 16–23.

31. On Niccolò di ser Sozzo, see Giulietta Chelazzi Dini, in *Il Gotico a Siena: miniature, pitture oreficerie, oggetti d'arte* (Florence: Centro Di, 1982), 229, 236–46.

32. Fehm, 19.

33. Cesare Brandi, "Niccolò di ser Sozzo Tegliacci," *L'arte* 3 (1932): 234–5.

34. Bernard Berenson, *Pitture Italiane del Rinascimento* (Milan: U. Hoepli, 1936), 269.

35. Federico Zeri, "Sul problema di Niccolò di ser Sozzo Tegliacci e Luca di Tommè," *Paragone* 9 (1958): 5–8.

36. Fehm, 20–3. Fehm's opinion is supported by Frinta, 22, who concludes that Luca played a leading role in the execution of the *Saint Thomas Polyptych* based on the fact that his punchwork is predominant in the work.

37. On Jacopo di Cione, see Richard Offner and Klara Steinweg, *A Critical and Historical Corpus of Florentine Painting, Jacopo di Cione*, Section IV, Volume III (New York: New York University, 1965).

38. Offner and Steinweg, 1, 17–18, contend that Jacopo and his workshop were responsible for the execution of *Saint Matthew*, whereas Miklòs Boskovits,

Pittura fiorentina alla vigilia del Rinascimento 1370–1400 (Florence: Edam, 1975), 51, argues against Jacopo's direct participation in favor of the Master of the Ashmolean Predella, another member of the Cione shop.

39. On Giovanni del Biondo, see Richard Offner and Klara Steinweg, *A Critical and Historical Corpus of Florentine Painting, Giovanni del Biondo,* Section IV, Volumes IV–V (New York: New York University, 1967).

40. Miklòs Boskovits, review of Richard Offner and Klara Steinweg, *A Critical and Historical Corpus of Florentine Painting, Giovanni del Biondo,* in *Art Bulletin* 54 (1972): 206; idem, 1975, 94–6.

41. Boskovits, 1975, 178.

42. Boskovits, 1972, 206; idem, 1975, 97.

43. See Offner and Steinweg, 1965, 2; Bomford et al., 185.

44. On the paintings, see Offner and Steinweg, 1965, 37–8, 86; Bomford et al., 185–6. Offner and Steinweg, 1965, 2, contend that the association began in 1369. Dillian Gordon, in Bomford et al., 95, dates it even earlier, to 1366; she identifies Niccolò as the "Niccolò dipintore" who collaborated with Jacopo on frescoes (destroyed) for the guildhall of the judges and notaries in Florence.

45. Offner and Steinweg, 1965, 86. Boskovits, 1975, 51, 98, 209 n. 33, firmly dismisses Niccolò's participation in either of these two works because he finds the documentary and stylistic evidence unconvincing.

46. See Offner and Steinweg, 1965, 115–19; Boskovits, 1975, 85.

47. Bomford et al., 186.

48. Boskovits, 1975, 98, attributes the central scene to Niccolò and the flanking saints to the Master of the Ashmolean Predella.

49. Boskovits, 1975, 98.

50. Niccolò's collaborative works include the *Madonna and Child with Angels and Saints* (d. 1375), Collegiata di Santa Maria, Impruneta, with Pietro Nelli; *Crucifix* (d. 1380), Castellani Chapel, Santa Croce, Florence, with Pietro Nelli; fresco (d. 1386), Bigallo, Florence, with Ambrogio di Baldese; frescoes (1390–5), Sala Capitolare, San Francesco, Prato, with Lorenzo di Niccolò; frescoes (1395), Santa Brigida (ex-convent), Bandino (outskirts of Florence), with Ambrogio di Baldese; *Madonna and Child with Saints* (1395–1400), Santa Croce, Florence, with Lorenzo di Niccolò; *Madonna and Child* (c. 1400), Yale University Art Museum, New Haven, with Spinello Aretino; and *Coronation of the Virgin* (d. 1401), Accademia, Florence, with Spinello Aretino and Lorenzo di Niccolò. See Boskovits, 1975, 58–9, 406–14.

51. On the *Santa Felicita Altarpiece,* see Marcucci, 110.

52. Regarding the Sala di Balia frescoes, see Margaret T. Rajam, "The Fresco Cycle by Spinello Aretino in the Sala di Balia, Siena: Imagery of Pope and Emperor," Ph.D. diss., University of Michigan, Ann Arbor, Mich., 1977.

 Other significant collaborative works from this period include Andrea Vanni and Antonio Veneziano, frescoes (1367–70), Siena, Cathedral; Spinello Aretino and Lorenzo di Niccolò, *Madonna and Child with Saints* (1393), Santa Maria a Quinto, Florence; Spinello Aretino, Pietro Nelli, and the Master of Barberino, frescoes (1390–5), Oratory of Santa Caterina all'Antella, Ponte a Ema, Florence; and Lorenzo di Bicci and Bicci di Lorenzo, *Tabernacle of the Madonnone* (1405–10), Florence.

53. That the patron's role in establishing partnerships was recognized by artists is evident from a letter written in April 1438 by Domenico Veneziano to Piero de'

Medici, seeking to obtain a commission for an altarpiece from Piero's father, Cosimo. "And if the work were so large that Cosimo decided to give it to several masters, . . . I beg you . . . that you may be pleased to enlist your strength favorably and helpfully to me in arranging that I have some little part of it." Creighton E. Gilbert, *Italian Art 1400–1500. Sources and Documents* (Englewood Cliffs, N.J.: Prentice-Hall, 1980), 5.

54. For the documents, see Gaetano Milanesi, *Documenti per la storia dell'arte senese,* 2 vols. (Siena: Onorato Porri, 1854), 2: 8–11.

55. Miklòs Boskovits, *Katalog der Gemälde: Frühe italienische Malerei* (Berlin: Gebr. Mann, 1987), 105–6. Thomas, 258, notes that the painters later worked for the hospital of Santa Chiara individually. By the time Martino carried out his independent work in 1405, the client was willing to entrust him with thirty figures.

56. Bartolo di Fredi, for example, rented a workshop with Andrea Vanni (c. 1332–1413/14) from the Casa della Misericordia in Siena, in December 1353. The two did not, however, share commissions; see Maginnis, 1995, 26.

57. For an in-depth study of the history of Pesello's collaborations, see Yael M. Even, "Artistic Collaboration in Florentine Workshops: Quattrocento," Ph.D. diss., Columbia University, New York, 1984, 15–29.

58. These projects included designs for the painted sepulchral monuments of Sir John Hawkwood and Pietro Farnese for the Florence Cathedral, with Agnolo Gaddi, and the design for the staircase in the papal apartment at Santa Maria Novella, with Lorenzo Ghiberti and Pippo di Giovanni; see Even, 30–42.

59. The most outstanding example is the company of painters whose workshops were near the Cathedral of Florence, headed by Jacopo di Antonio (1427–54); see Ugo Procacci, "Di Jacopo di Antonio e delle compagnie di pittori del Corso degli Adimari nel XV secolo," *Rivista d'arte* 35 (1960): 3–70. Apollonio di Giovanni (1415/17–65) and Marco del Buono (1402/3–89) maintained a partnership from 1446 to 1463 that specialized in the production of painted *cassoni* (marriage chests). Their shop also produced portraits, birth salvers, and devotional pictures; see Ellen Callmann, *Apollonio di Giovanni* (Oxford: Oxford University Press, 1974). For examples of other partnerships, see Thomas, 44–5, 207–9.

60. On Lorenzo Monaco, see Marvin Eisenberg, *Lorenzo Monaco* (Princeton: Princeton University Press, 1989); *Painting and Illumination in Early Renaissance Florence: 1300–1450,* eds. Laurence B. Kanter et al., exh. cat. (New York: Metropolitan Museum of Art, 1994), 11–12, 220–306.

61. The number and names of these assistants are unknown. Eisenberg, 143, 164, identifies the handiwork of two primary assistants.

62. Eisenberg, 24–30, 121–4.

63. Eisenberg, 29.

64. Eisenberg, 138–45. Thomas, 215–19, observes an inconsistency of style in the London *Coronation* that suggests the artists responsible for the work were copying parts of the Uffizi *Coronation* without understanding them. Although they probably had workshop drawings to assist them, their misperception of the original may have been due to the fact that they had to "peer up" at the dimly lit altarpiece already installed on the high altar of Santa Maria degli Angeli.

65. Eisenberg, 113–17.

66. Eisenberg, 117. When a work was left unfinished at the death of an artist, it was usually the case that the work, for the sake of stylistic consistency, was completed by the remaining workshop organization or, less often, by previous associates of the shop; see Thomas, 159. Fra Angelico, who probably trained with Lorenzo Monaco, fits within the latter category.

67. On Ghiberti, see Richard Krautheimer in collaboration with Trude Krautheimer-Hess, *Lorenzo Ghiberti,* 2nd ed., 2 vols. (Princeton: Princeton University Press, 1970).

68. Krautheimer 1: 4, 105.

69. Krautheimer 1: 4, 107.

70. Krautheimer 1: 108–9.

71. Krautheimer 1: 6, 87.

72. Krautheimer 1: 109–11. On the collaboration of Donatello and Michelozzo, see Ronald W. Lightbown, *Donatello and Michelozzo: An Artistic Partnership and its Patrons in the Early Renaissance,* 2 vols. (London: Harvey Miller, 1980), 1: 1–2.

 The painter Benozzo Gozzoli (c. 1420–97) also worked with Ghiberti on the East Doors for three years; his duties are not specified in the 1443 contract, but based on the generous salary he received, he must have been a primary assistant. See Krautheimer 1: 6, 212, and Diane Cole Ahl, *Benozzo Gozzoli* (New Haven and London: Yale University Press, 1996), 13.

73. See Krautheimer 1: 7–8, 203–13.

74. Krautheimer 1: 6, 139–41, 254, 264–5. Ghiberti provided the design of the large marble tabernacle for the guildhall of the linen merchants, which was sculpted by others. He has been credited also with supplying Fra Angelico with preparatory drawings for the large-scale saints on the wings; see Kanter et al., 322. For the influence of Ghiberti's sculpture on Fra Angelico's painting, see Ulrich Middeldorf, "L'Angelico e la scultura," *Il Rinascimento* 1 (1955): 179–94.

75. Krautheimer 1: 5–6.

76. James H. Beck with the collaboration of Gino Corti, *Masaccio. The Documents* (Locust Valley, N.Y.: J. J. Augustin, 1978), 9.

77. Beck, 25.

78. On Masaccio's brother, see Bellosi and Haines, 7–13, 35–64. Lo Scheggia is documented as working in Bicci di Lorenzo's shop in 1421; see Beck, 9, 11. Although there is no documentary evidence for lo Scheggia's participation in Masaccio's shop, it is likely that he occasionally worked with his older brother. Lo Scheggia worked with his son, Antonfrancesco (1441–76), as of 1460/5; see Bellosi and Haines, 29.

 Keith Christiansen, "Some observations on the Brancacci Chapel frescoes after their cleaning," *Burlington Magazine* 133 (1991): 15, considered the two portraitlike heads to the left of Saint Peter in Masolino's fresco of *Saint Peter Preaching* one of lo Scheggia's earliest works.

79. Andrea is referred to as a *garzone* in a document for the *Pisa Altarpiece*; see Beck, 22.

80. Beck, 27.

81. James H. Beck, "Masaccio humanized," *Art News* 74/3 (1975): 82–3; Beck, 1978, 15–16. No works by Niccolò have been identified.

82. Rules governing the declaration of income from partnerships were established by the *catasto*; profits were recorded in common from the moment a partnership came into existence, and each partner was designated a half-

share creditor for work in progress. See Harriet M. Caplow, "Sculptors' Partnerships in Michelozzo's Florence," *Studies in the Renaissance* 21 (1974): 147.

83. See Paul Joannides, *Masaccio and Masolino. A Complete Catalogue* (London: Phaidon Press, 1993), 64, 69, 350, 353, 402–3.

84. Perri Lee Roberts, *Masolino da Panicale* (Oxford: Clarendon Press, 1993), 207.

85. Regarding the approximate date of Masaccio's arrival in Florence, see Joannides, 27, 51.

86. Richard Fremantle, "Some New Masolino Documents," *Burlington Magazine* 117 (1975): 658–9.

87. Vasari 2: 284, 294, 295.

88. Raffaello Borghini, *Il Riposo,* ed. Mario Rosci (Milan: Labore riproduzioni, 1967), 312–13.

89. See Mary Pittaluga, *Masaccio* (Florence: Felice Le Monnier, 1935), 3, 99; and Roberto Longhi, "Fatti di Masolino e di Masaccio," *Critica d'arte* 25–6 (1940): 150; Berti, 1961, 84–107.

90. The dating of their initial collaboration is based on the observation that Masolino's documented work in Santo Stefano, Empoli of 1424 shows no influence of Masaccio's style. Masaccio's style in the frescoes on the upper register of the Brancacci Chapel and the *Sant'Anna Metterza* is less mature than in his *Pisa Polyptych* of 1426.

 For a different view of the dating, sequence, and scope of Masaccio and Masolino's collaboration, see Joannides, 64–5, 69, 72, 79. He traces a linear development in their relationship: Masaccio played a minor role in the *Carnesecchi Altarpiece* (1423), a more extensive role in the *Santa Maria Maggiore Altarpiece* (dated 1423 by Joannides), and finally, a dominant role in the Brancacci Chapel and the *Sant'Anna Metterza*. See also the discussion by Cecilia Frosinini and Roberto Bellucci in this volume.

91. See Luciano Berti, *Masaccio* (University Park, Pa.: Pennsylvania State University Press, 1967), 69–70; and Roberts, 10. The contract for his services in Hungary was terminated prematurely because his patron died in December 1426. It is not known exactly when Masolino returned to Florence, but it was some time before May 1428 and perhaps as early as July 1427.

92. The location of Masolino's shop is not known, but it may have been in the same place as his home. In 1422, he lived in the parish of Santa Felicita, and in 1425, in that of San Firenze. Among his workshop assistants in the 1420s was Francesco d'Antonio; see Roberts, 9, 43.

93. For the Carmelites' possible involvement in the choice of Masaccio as Masolino's *compagno,* see Miklòs Boskovits, "Il percorso di Masolino: Precisazioni sulla cronologia e sul catalogo," *Arte cristiana* 75 (1987): 56; John Pope-Hennessy, "Unveiling Masaccio's Radical Masterpiece in Florence," *Architectural Digest* 47/3 (1990): 38, 40; and Christiansen, 16.

94. Umberto Baldini, "Nuovi affreschi nella Cappella Brancacci, Masaccio e Masolino," *Critica d'arte* 49 (1984): 70; Ornella Casazza, "Il ciclo delle storie di San Pietro e la 'historia salutis.' Nuova lettura della cappella Brancacci," *Critica d'arte* 51 (1986): 69–70; and Umberto Baldini and Ornella Casazza, *La Cappella Brancacci* (Milan: Electa Editrice, 1990), 292, 323.

95. Christiansen, 11–12. For a summary of the history of the attribution, see Roberts, 187.

96. For a summary of other opinions regarding the chronology of the Brancacci Chapel decoration, see Roberts, 187–8, and Joannides, 321–2.

97. The restorers contend that Masaccio also carried out Masolino's Gothic border, including the male head in the roundel to the right of the window. The *giornate* indicate that this section was painted at the same time as the lower register; see Baldini, 1984, 70; and Baldini and Casazza, 1990, 292. For a summary of opposing opinions, see Roberts, 65.

98. Luciano Berti, *Masaccio* (Florence: Cantini, 1998), 44–5; Luciano Berti and Rossella Foggi, *Masaccio. Catalogo completo dei dipinti* (Florence: Cantini, 1989), 19, 104; Pope-Hennessy, 40; and Christiansen, 15.

99. Longhi's attribution, 158, to Masolino of the head of Christ in the *Tribute Money,* and of the background of Masolino's *Healing of the Lame Man at the Temple and the Raising of Tabitha* to Masaccio, has been soundly rejected by restorers. See Umberto Baldini, "Dalla scoperta di San Giovenale a quella della Brancacci," in *I pittori della Brancacci agli Uffizi: Gli Uffizi. Studi e ricerche* 5, eds. Luciano Berti and Annamaria Petrioli Tofani (Florence: Centro Di, 1988), 13, 16, 17–18; idem, "Del 'Tributo' e altro di Masaccio," *Critica d'arte* 54 (1989): 29–38; and Baldini and Casazza, 43, 71 n. 74, 76 n. 85, 124. For a summary of other opinions, see Roberts, 187.

100. Longhi, 152, 155, 157.

101. Berti and Foggi, 41. See also Berti, 1967, 70; Baldini, 1988, 12–13; and Ornella Casazza, "La grande gabbia architettonica di Masaccio," *Critica d'arte* 53 (1988): 78.

102. For a comprehensive discussion of the work, see Roberts, 182–3; Joannides, 369–72; and Timothy Verdon, "La Sant'Anna Metterza: riflessioni, domande, ipotesi," in Berti and Petrioli Tofani, 33–58.

103. The angel's robe is red and green, and the Madonna's headdress is blue and white. This technique, known as *cangiantismo* (changing colors), is a variation of Cennino Cennini's style of modeling in which pure color is employed in the shadows, with gradations of white added to it for the midtones and lights. In *cangiantismo,* the areas of midtones/lights and those in shadow are rendered in contrasting colors in imitation of the effects of shot silk. See Marcia B. Hall, *Color and Meaning, Practice and Theory in Renaissance Painting* (Cambridge: Cambridge University Press, 1992), 20–1.

104. For a comprehensive discussion of the work, see Roberts, 189–92, and Joannides, 414–22.

105. Berti and Foggi, 138.

106. Carl Brandon Strehlke and Mark Tucker, "The *Santa Maria Maggiore Altarpiece:* New Observations," *Arte cristiana* 75 (1987): 105–24. See also the chapter in this volume by Bellucci and Frosinini.

107. See Bomford et al., 96–7.

108. Creighton E. Gilbert, "What did the Renaissance Patron Buy?" *Renaissance Quarterly* 51 (1998): 410.

109. For the texts, see Leon Battista Alberti, *On Painting and On Sculpture,* ed. and trans. Cecil Grayson (London: Phaidon Press, 1972), 33; and Baxandall, 118.

110. Cf. Henk van Os, *Studies in Early Tuscan Painting* (London: Pindar, 1992), 8.

CHAPTER 5. MASACCIO: TECHNIQUE IN CONTEXT

1. For the individual contributions, see Umberto Baldini, "Restauri di dipinti fiorentini in occasione della mostra di quattro maestri del Rinascimento," *Bollettino d'arte* 39 (1954): 221–40; Joseph Polzer, "The Anatomy of Masaccio's Holy

Trinity," *Jahrbuch der Berliner Museen* 13 (1971): 18–59; Law Bradley Watkins, "Technical Observations on the Frescoes of the Brancacci Chapel," *Mitteilungen des Kunsthistorischen Institutes in Florenz* 17 (1973): 65–74; Ornella Casazza, C. Castelli, Francesca Ciani Passeri, and Massimo Seroni, conservation file of the *Cascia di Reggello Altarpiece,* in *Capolavori e Restauri,* exh. cat. (Florence: Cantini, 1986), 59–61; Ornella Casazza, "Al di là dell'immagine," in *I pittori della Brancacci agli Uffizi: Gli Uffizi. Studi e ricerche* 5, eds. Luciano Berti and Annamaria Petrioli Tofani (Florence: Centro Di, 1988), 93–101; Keith Christiansen, "Some observations on the Brancacci Chapel frescoes after their cleaning," *Burlington Magazine* 133 (1991): 5–20; Marcello Chemeri, Sabino Giovannoni, and Gioia Germani, "L'intervento di restauro," in *La cappella Brancacci. La scienza per Masaccio, Masolino e Filippino Lippi: Quaderni del restauro* 10 (Milan: Olivetti, 1992). The only comprehensive treatment, though very summary, given the nature of the publication, has been attempted by Hellmut Wohl, "Masaccio," in *The Macmillan Dictionary of Art,* ed. Jane Turner, 34 vols. (New York: Macmillan, 1996), 20: 529–39. A few aspects of the underlying drawing technique by Masaccio are included in Maria Clelia Galassi, *Il disegno svelato. Progetto e immagine nella pittura italiana del primo Rinascimento* (Nuoro: Ilisso, 1998).

 The present study is based entirely on direct investigation of the works of art and has been undertaken by the authors of this chapter within a broader context of research on the techniques of Masaccio and Masolino carried out by the Opificio delle Pietre Dure e Laboratori di Restauro of Florence in collaboration with the National Gallery of London and the Philadelphia Museum of Art. The authors wish to especially thank Giorgio Bonsanti, Carl Brandon Strehlke, and Dillian Gordon.

2. Miklòs Boskovits, "Mariotto di Cristofano: un contributo all'ambiente culturale di Masaccio giovane," *Arte illustra* 13/14 (1969): 4–13.

3. James H. Beck, "Masaccio's Early Career as a Sculptor," *Art Bulletin* 53 (1971): 177–95.

4. With regard to the hypothesis on Mariotto di Cristofano, an examination of documents relating to Masaccio's family history clearly shows that the acquired "kinship" between the two artists only came about at a time when Masaccio was already an autonomous artist and therefore no longer in need of support; furthermore, the relations between the two families were very bad indeed, complicated as they were by never-ending quarrels on matters of inheritance. See Cecilia Frosinini, "Alcune precisazioni su Mariotto di Cristofano," *Rivista d'arte* 39 (1987): 443–55. The wealth of documentation on Bicci di Lorenzo's workshop, which is known by scholars, tends to exclude any likelihood of Masaccio having passed through it.

5. "[Q]uanto più tosto puoi, incomincia a metterti sotto la guida del maestro a imparare; e quanto più tardo puoi dal maestro ti parti"; Cennino Cennini, *Il libro dell'arte,* ed. Franco Brunello (Vicenza: N. Pozza, 1971), ch. 3, 6; English trans. Cennino Cennini, *The Craftsman's Handbook. The Italian "Il Libro dell'arte,"* trans. Daniel V. Thompson, Jr. (New Haven and London: Yale University Press, 1933; rpt. New York: Dover Publications, 1954), 3. Elsewhere, 109–10, he says that at least thirteen years apprenticeship is necessary: "altrimenti . . . nonne sperare mai che vegnino a buona perfezione"; "otherwise . . . you need never hope that they will reach any high degree of perfection," 64–5.

6. *Il notaio nella civiltà fiorentina,* exh. cat. (Florence: Vallecchi, 1984).

7. It has been authoritatively proposed by Ugo Procacci that Masaccio followed his mother to the house of his stepfather, in "Masaccio e la sua famiglia negli antichi documenti," in *La storia del Valdarno,* 4 vols. (Florence: Luciano Landi, 1980–3), 2: 553–9, on the basis of a declaration made by lo Scheggia in the *catasto* entry of 1469 ("rimaritossi mia madre ed ella m'allevò"); see Ugo Procacci, "Documenti e ricerche sopra Masaccio e la sua famiglia: le portate al catasto di Giovanni di ser Giovanni detto lo Scheggia," *Rivista d'arte* 37 (1984): 231–57. The sentence does not, however, cite Masaccio, and moreover, the difference in age between the two brothers might well favor a different interpretation of the data. Masaccio, who was already more than ten years old, could have remained with the paternal family, whereas the younger Giovanni could have followed his mother to a new family unit. This would have been plausible in the strongly patriarchal society of the time, so much so that lo Scheggia may well have found himself in completely different circumstances. The fact remains that among the bequests of Tedesco di maestro Feo administered by the magistracy of the Pupilli, rental payments are recorded for a house owned by "Madame Piera dei Bardi" in the parish of San Niccolò Oltrarno, which would appear to have been the first house inhabited by Masaccio in Florence – a sign that in any case, or at least during her widowhood, Masaccio's mother continued to participate in the life and activity of her son, with whom she and lo Scheggia lived in 1427 following the reunification of the original family.

8. We believe it necessary to point out that Masaccio's first mural, recorded by the documentary sources, was the *Sagra* (Consecration) in Santa Maria del Carmine, executed in *terra verde,* a technique that according to Cennini, ch. 177, 194–5, was very similar to working on a panel.

9. Cennini, ch. 103, 109: "E tieni bene a mente che chi imparasse a lavorare prima in muro e poi in tavola non viene così perfetto maestro nell'arte, come perviene a imparare prima in tavola e poi in muro"; "And bear this well in mind, that anyone who learns to work on the wall first, and then on panel, will not get such perfect mastery by his bargain as one who starts learning on panel first, and then on the wall," trans. Cennini-Thompson, 64.

10. Cennini, ch. 148, 153: "Poi togli un poca di sinopia scura, con un miccino di nero, e profila ogni stremità di naso, d'occhi, di capellature, di mani, di piè, e generalmente d'ogni cosa"; "Then take a little dark sinoper and a trace of black; and outline all the accents of nose, eyes, brows, the hair, hands, feet, and everything in general," trans. Cennini-Thompson, 94. Also Cennini recommends the use of a black outline for the flesh colors on a wall: "Poi abbia un poco di negro in un altro vasellino, e col detto pennello profila il contorno degli occhi"; "Then take a little black in another little dish, and with the same brush mark out the outline of the eyes," trans. Cennini-Thompson, 47.

11. Theophilus, *Diversarium artium schedula,* ed. C. De L'Escalopier (Paris: Firmin Didot fratres, 1843; anastatic rpt. Nogent-le-Roi: n.p. 1977), ch. 13, 20–21: "Omnes vero tractus circa nuda corpora fac cum rubeo." The chapter from which the quotation is taken is dedicated to the way to emphasize various parts of an already painted figure. Similarly, *De arte illuminandi,* in a note probably by the scribe, "et fac profilaturas in locis debitis cum rubeo"; a little further in the text, however, it indicates the new practice of using black outlines: "aut nigrum, quod melius est"; see *De arte illuminandi,* ed. Franco Brunello (Vicenza: N. Pozza, 1975), 132–5 (n. to ch. 28, "Nota modum incar-

nandi facies et alia membra"). Masaccio's possible education in the field of manuscript illumination is also corroborated by the artist's very distinctive way of executing the flesh colors in his earliest work, the *Cascia di Reggello Altarpiece*. He indeed ignores the Giottesque practice, described by Cennini (ch. 67 and 147), on the use of *verdaccio* (green) as the undertone for flesh areas. Instead, he utilizes a grayish base for the figures of the central panel and a reddish one for Saint Juvenal. Again, evidence of this gray ground color, also called "protoplasm," is found in treatises on manuscript illumination.

12. Following the controversy over attribution immediately after the *Cascia di Reggello Altarpiece* was discovered, critics today generally agree on its attribution to Masaccio, with the exception of James H. Stubblebine et al., "Early Masaccio: A Hypothetical Lost Madonna and a Disattribution," *Art Bulletin* 62 (1980): 217–25; and Luciano Bellosi, "Il Maestro del Cassone Adimari e il suo grande fratello," in Luciano Bellosi and Margaret Haines, *Lo Scheggia* (Florence and Siena: Maschietto & Musolino, 1999), 7–33.

13. Dillian Gordon, personal comunication.

14. Perri Lee Roberts, *Masolino da Panicale* (Oxford: Clarendon Press, 1993), doc. II, 167–8.

15. Ugo Procacci, "Di Jacopo di Antonio e delle compagnie di pittori del Corso degli Adimari nel XV secolo," *Rivista d'arte* 35 (1960): 3–70.

16. Jeanne van Waadenoijen, *Starnina e il Gotico Internazionale a Firenze* (Florence: Istituto universitario olandese di storia dell'arte, 1983).

17. Roberts, doc. V, 168. We again find the names of Masolino and Francesco d'Antonio quoted together in proceedings of the Court of Mercatanzia after 1423, and even among the list of debtors and creditors in the *catasto* of 1427. We are, however, dealing with later documentation of earlier activities in common, where what proves to be significant is the dual registration of the debt in the names of Masolino and Francesco d'Antonio, unique to a "partner" relationship (and definitely atypical of a hierarchical work connection where the paid worker, legally and juridically insignificant, never was mentioned).

18. In reality, the three-year reckoning (more exactly counting thirty-six months) did not usually happen in the practice of the time, and a solar year was usually considered sufficient for its computation. See Cecilia Frosinini, "Un contributo alla conoscenza della pittura tardogotica fiorentina: Bonaiuto di Giovanni," *Rivista d'arte* 37 (1984): 107–31; idem, "Un documento per la compagnia di Donatello e Michelozzo (con note su alcune maestranze di scalpellini settignanesi)," *Rivista d'arte* 39 (1987): 436–41.

19. Letizia Montalbano, "Il disegno a punta metallica. Storia di una tecnica ormai dimenticata," *OPD Restauro* 8 (1996): 241–54.

20. In *Sant'Anna Metterza*, the use of the metallic point, in fact, coexists with the use of charcoal, easily detectable even with the naked eye, given the rubbed condition of the pictorial surface.

21. Carl Brandon Strehlke and Mark Tucker, "The *Santa Maria Maggiore Altarpiece*: New Observations," *Arte cristiana* 75 (1987): 105–24; Jill Dunkerton, "Modifications to Traditional Egg Tempera Techniques in Fifteenth-Century Italy," in *Early Italian Paintings. Techniques and Analysis: Symposium, Maastricht, 9–10 October, 1996* (Maastricht: Limburg Conservation Institute, 1997), 29–34.

22. Andrea de Marchi, *Gentile da Fabriano* (Milan: Federico Motta, 1992), 157.

23. "Costui era amato da Filippo di ser Brunellesco, el grande architetto, per ché

lo vedeva d'ingegno perspicace, e insegnolli molte cose dell'arte"; from *Il Libro di Antonio Billi,* ed. Fabio Benedettucci (Anzio [Rome]: De Rubeis, 1991). Brunelleschi's aptitude in teaching his discoveries to others is again evidenced by his biographer, Antonio Manetti, who tells how "insegnava volontieri a chi gli pareva che lo disiderassi e fussi atto a riceverlo" ("he willingly taught those whom he believed were eager and prepared to receive him"). See Antonio Manetti, *Vita di Filippo Brunelleschi,* ed. Carlachiara Perrone (Rome: Salerno Editrice, 1992), 54–5.

24. The observations here have been kindly given in advance of their publication by Fabrizio Bandini and Cristina Danti of the Opificio delle Pietre Dure e Laboratori di Restauro, Florence, who are currently involved in the restoration of the *Trinity.*

25. The use of incised and then glazed silver leaf is, indeed, often found in Gentile da Fabriano's work, as noted in de Marchi, 160, 189 n. 62; the author is not, however, aware of the same technical application by Masolino.

26. "a colorire un vestire pagonazzo over morello"; from Cennini, ch. 76, 89; trans. Cennini-Thompson, 53.

27. "in qual modo si contraffà in muro il velluto, o panno di lana, e così la seta, in muro e in tavola"; from Cennini, ch. 142, 143, 144, 144–8; trans. Cennini-Thompson, 89–91. The substantial novelty about Masolino's technique has so far even left the critics baffled, who, faced with this unknown phenomenon, have provided erroneous interpretations of it, even though the technique was explored significantly by traditional Florentine artists. Paul Joannides, *Masaccio and Masolino. A Complete Catalogue* (London: Phaidon Press, 1993), 64–9, speaks of small black brushstrokes that simulate cloth, introducing the parallel with the Goldman *Annunciation,* Washington, D.C., National Gallery of Art, a painting in which, instead, there is a painterly attempt to render the effect of elaborately worked silver leaf. Roberts, 23 n. 33, even mentions incisions in the preparatory gesso obtained with a mold.

28. For a report on the work, see Antonio Paolucci, *La Pinacoteca di Volterra* (Florence: Cassa di Risparmio, 1989), 92.

29. De Marchi, 189 n. 62. For a new proposal of the identification of the anonymous Maestro di Borgo alla Collina with the Florentine painter Scolaio di Giovanni, with whom relations with Alvaro Pirez are documented, consult Annamaria Bernacchioni in *Mater Christi: altissime testimonianze del culto della Vergine nel territorio aretino,* ed. Anna Maria Maetzke, exh. cat. (Cinisello Balsamo: Silvana Editoriale, 1996), 46–7.

30. We here put forward the hypothesis that the Washington painting may be the "colmo" quoted in the document of August 23, 1426. In this document, Masaccio was brought before the law court of Mercatanzia by a certain furrier, Tommaso di Jacopo, for a debt of 3 florins and 8 lire, "scontato il prezo et la valuta d'una Nostra Donna in uno tabernacolo existente, per lo dicto Tommaso vaiaio avuto dal detto Tommaso dipintore." The Washington painting, in fact, has the correct measurements and structural support to define it as a "colmo," according to the technical nomenclature of the period: a painting, in other words, destined for private devotion, of a tabernacle form with an ogival cusp and single side columns. It must, however, be repeated that the date of the document is to be taken as the latest possible date for the work, since we are dealing with a legal case that could have dragged on for quite some time.

31. For a thorough examination of the problem, see Ugo Procacci, "Importanza

del Vasari come scrittore di tecnica della pittura," in *Il Vasari storiografo e artista: atti del Congresso internazionale nel IV centenario della morte, Arezzo-Firenze, 2–8 settembre 1974* (Florence: Istituto nazionale di studi sul Rinascimento, 1976), 35–64.

32. Jill Dunkerton, "La Musa di Londra: analisi delle tecniche pittoriche delle due stesure," in *Le Muse e il Principe. Arte di corte nel Rinascimento padano*, ed. Alessandra Mottola Molfino, exh. cat. (Modena: F. C. Panini, 1991), 251–62; Roberto Bellucci et al., "La scuola ferrarese: indagini e confronti tecnici sulle Muse dello Studiolo di Belfiore," *OPD Restauro* 4 (1992): 189–215; Roberto Bellucci and Cecilia Frosinini, "Ipotesi sul metodo della restituzione pittorica di Piero della Francesca: il caso dei ritratti di Federico da Montefeltro," in *La pala di San Bernardino di Piero della Francesca. Nuovi studi oltre il restauro: Quaderni di Brera* 9, eds. Emanuela Daffra and Filippo Trevisani (Florence: Centro Di, 1997), 167–87; and idem, "Piero della Francesca's Process: Panel Painting Technique," in *Painting Techniques: History, Materials and Studio Practice: Contributions to the Dublin Congress, 7–11 September 1998*, eds. Ashok Roy and Perry Smith (London: IIC [International Institute for Conservation of Historic and Artistic Works], 1998), 89–93.

33. Strehlke and Tucker, 105–24; Raymond White and Jennifer Pilc, "Analyses of Paint Media," *National Gallery Technical Bulletin* 17 (1996): 91–7.

CHAPTER 6. THE ALTARPIECES OF MASACCIO

1. I should like to thank Christa Gardner von Teuffel, Cecilia Frosinini, Roberto Bellucci, and Mauro Parri for their generous help in discussing the altarpieces painted by Masaccio in Pisa and Rome. This chapter is partly based on the entries in the revision of the catalogue of Italian Renaissance paintings 1400–60 currently being undertaken by the present author in which the altarpieces for Pisa and Rome are discussed in greater detail. The *Madonna of Humility* (Washington, D.C., National Gallery of Art) is not discussed here due to its uncertain authorship.

2. Luciano Berti, "Masaccio 1422," *Commentari* 12 (1961): 84–107. See also Luciano Berti and Rossella Foggi, *Masaccio. Catalogo completo dei dipinti* (Florence: Cantini, 1989), cat. 1, 26–31; Luciano Berti, "Trittico di San Giovenale," in *L'età di Masaccio. Il primo Quattrocento a Firenze*, eds. Luciano Berti and Antonio Paolucci, exh. cat. (Milan: Electa Editrice, 1990), cat. 29, 118–19; and Paul Joannides, *Masaccio and Masolino. A Complete Catalogue* (London: Phaidon Press, 1993), 51–9; cat. 26, 426–9, with full bibliography.

3. Some scholars have doubted the attribution; see most recently Luciano Bellosi, "Il Maestro di Cassone Adimari e il suo grande fratello," in Luciano Bellosi and Margaret Haines, *Lo Scheggia* (Florence and Siena: Maschietto & Musolino, 1999), 31–3.

4. For the earlier use of the single vanishing point by the Master of 1419, see Joannides, 56, pls. 4, 5.

5. Ivo Becattini, "Il territorio di San Giovenale ed il Trittico di Masaccio. Ricerche ed ipotesi," in *"Masaccio 1422/1989." Dal trittico di San Giovenale al restauro della Cappella Brancacci. Atti del Convegno del 22 aprile 1989* (Pieve di San Cascia-Reggello, Figline Valdarno: n.p., 1990), 17–26.

6. Luciano Bellosi, "Il decennio di Masaccio," in Berti and Paolucci, 34–5; Joannides, 51–2.

7. See Annamaria Bernacchioni in *Mater Christi: altissime testimonianze del culto della Vergine nel territorio aretino,* ed. Anna Maria Maetzke, exh. cat. (Cinisello Balsamo: Silvana Editoriale, 1996), cat. 13, 44–5; Luciano Berti, "Madonna col Bambino e Angeli," in Berti and Paolucci, cat. 36, 132; and Anna Maria Maetzke, "Recuperi e restauri dal 1968 al 1974," in *Arte nell'Aretino: recuperi e restauri dal 1968 al 1974,* eds. Lionello G. Boccia et al., exh. cat. (Florence: Edam, 1974), 81–5. Berti, 1961, 86, n. 4, discusses the Child eating grapes and the iconography of the completely nude Child.

8. See James H. Beck, "Masaccio's Early Career as a Sculptor," *Art Bulletin* 53 (1971): 177–95, and Emanuela Andreatta, "Biografie," in Berti and Paolucci, 249, 256.

9. Beck, 179, figs. 7, 8, attributes to Masaccio the terra-cotta relief of the *Coronation of the Virgin* on the facade of Sant'Egidio, Santa Maria Nuova, dating it 1420–4.

10. Joannides, 59.

11. Joannides, 56–7, discusses the reasons for the lapse in quality in the saints on the left. Bellosi, in Bellosi and Haines, 25, has made a connection with the work of lo Scheggia, who is himself ruled out as the author because he was aged only sixteen in 1422.

12. For the altarpiece, see Christa Gardner von Teuffel, "Masaccio and the Pisa Altarpiece: A New Approach," *Jahrbuch der Berliner Museen* 19 (1977): 23–68; Berti and Foggi, cat. 6, 45–74; and Joannides, 153–70; cat. 21, 382–98, with full bibliography.

13. The documents concerning the commission were published by Leopoldo Tanfani Centofanti, *Donatello in Pisa: Documenti* (Pisa: n.p., 1887), and selectively under the heading for "Donatello" by the same author in *Notizie di artisti tratte dai documenti pisani* (Pisa: Enrico Spoerri, 1897), 176–81. The documents, with some additional ones, were selectively published by Gardner von Teuffel, Appendix, 63–8, and more fully by James H. Beck with the collaboration of Gino Corti, *Masaccio. The Documents* (Locust Valley, N.Y.: J. J. Augustin, 1978), Appendix, 31–50, docs. 1–14. There are a few minor and usually insignificant variations in their transcriptions. A selective transcription of the documents is given in Joannides, 382–3.

14. The chapel was furnished with a painted (altarpiece) curtain, a wooden step, painted iron torch-holders, and seats. An altar cover, as well as a wooden altar frontal painted with the half-length figure of Saint Julian by Cola d'Antonio, decorated the altar.

15. Alessandro da Morrona, *Pisa illustrata nelle arti del disegno da Alessandro da Morrona, patrizio pisano,* 2nd ed., 3 vols. (Pisa: Per Francesco Pieraccini, 1787–93), 2: 273–4, says the construction was well advanced in 1568 and finished except for the facade in 1574; the church was consecrated in 1612.

16. For the documents, see Gardner von Teuffel, 57, 60; Beck, 1978, doc. III, 36, and doc. V, 39. Gardner von Teuffel was probably wrong in arguing that the chapel was one still extant to the right of the choir. Marcia B. Hall, "The *Ponte* in S. Maria Novella: The Problem of the Rood Screen in Italy," *Journal of the Warburg and Courtauld Institutes* 37 (1974): 168, argued that the chapel was against a rood screen. See also Beck, 1978, 33.

17. Gardner von Teuffel, 28; Beck, 1978, doc. II (item 8), 36, and doc. V, 39.

18. See, for example, Gardner von Teuffel, 38, 38 n. 49; and Beck, 1978, 34.

19. John T. Spike, *Masaccio* (New York: Abbeville Press, 1996), 200, and Richard Fremantle, *Masaccio. Catalogo Completo* (Florence: Octavo, 1998), 114, are wrong to imply that a contract survives.

20. Giorgio Vasari, *Le vite de' più eccellenti pittori, scultori ed architettori,* ed. Gaetano Milanesi, 9 vols. (Florence: G. C. Sansoni, 1906), 2: 292. This was more detailed than the description given by Vasari in *Le vite* (1550); see Giorgio Vasari, *Le vite dei più eccellenti pittori, scultori e architettori: nelle redazioni dal 1550 e 1568,* eds. Paola Barocchi and Giovanna Gaeta Bertelà, 2 vols. (Florence: SPES, 1971), 1: 285–6. Martin Davies, *The Earlier Italian Schools. National Gallery Catalogues,* 2nd ed. (London: The National Gallery, 1961), 350 n. 5; and Gardner von Teuffel, 24 n. 2, point out that between 1558 and 1568, Vasari himself was working in Pisa and would have had greater opportunity to study the altarpiece.

21. Bernard Berenson, who saw it in the collection of Rev. A. F. Sutton at Brant Broughton, Newark, and immediately recognized it as from the *Pisa Altarpiece,* in "La scoperta di un dipinto di Masaccio," *Rassegna d'arte* 7 (1907): 139, followed this with a fuller discussion in "La Madonna pisana di Masaccio," *Rassegna d'arte* 8 (1908): 81–5. Unfortunately, the condition of this painting is generally poor with ugly discolored retouchings; the wings of the standing angels are false, and the faces of the seated angels have been considerably repainted. The panel, which is in a modern frame, has lost about 22 cm from the bottom, where the feet of the seated angels must have been.

22. The sequence of scenes shown in the reconstruction given here is proposed in the forthcoming revision of the National Gallery catalogue.

23. I am grateful to the Opificio delle Pietre Dure e Laboratori di Restauro, Florence, for taking the X-radiograph of the *Crucifixion,* and to the Director of the Capodimonte Museum in Naples for allowing this to be done. See also Gardner von Teuffel, 43 n. 60, who first suggested that the *Crucifixion* and *Virgin and Child* were on a continuous plank structure.

24. Bruce Cole, *Masaccio and the Art of Early Renaissance Florence* (Bloomington, Ind.: Indiana University Press, 1980), 135, doubts that these three panels were part of the altarpiece and makes the unlikely suggestion that they formed a triptych or small polyptych. This view is described as "iconographically and circumstantially bizarre" by Francis Ames-Lewis in his review in the *Burlington Magazine* 124 (1982): 301, and is disproved by the X-radiographs showing the linking of the *Crucifixion* with the main tier as described earlier. The exact relationship of the panels with *Saint Paul* and *Saint Andrew* to the altarpiece is currently under review. In view of the number of missing panels from the main tier, this may never be resolved.

25. See the documents of 1428 for the upkeep of the altar cited by Gardner von Teuffel, 64.

26. Gardner von Teuffel, 52.

27. Gardner von Teuffel, 52; Beck, 1978, 34.

28. Gardner von Teuffel, 56.

29. The earliest reconstruction was that of Wilhelm Suida, "L'altare di Masaccio già nel Carmine a Pisa," *L'arte* 9 (1906): 125–7, fig. 3, made before the central panel with the Virgin and Child had been identified (see n. 21). See also Kurt Steinbart, *Masaccio* (Vienna: A. Schroll, 1948), 29, who considered the marble structure commissioned from Pippo di Ghante as the frame for the altar-

piece; Mario Salmi, *Masaccio,* 2nd ed. (Milan: U. Hoepli, 1947), pl. 35; and Ugo Procacci, *Tutta la pittura di Masaccio* (Milan: Rizzoli, 1951), 27. The evidence of the X-radiographs (described earlier) proves it is impossible that paired saints were placed between the *Virgin and Child* and *Crucifixion* as shown in the recent reconstruction by Berti and Foggi, 47.

30. John Shearman, "Masaccio's Pisa Altarpiece: An Alternative Reconstruction," *Burlington Magazine* 108 (1966): 449–55. Everett Fahy has suggested that a small panel showing the *Virgin and Child with Saints* with the *Crucifixion* above (Athens, Byzantine Museum; 81 × 43 cm) attributed to Borghese di Piero was influenced by Masaccio's altarpiece, particularly in its design, and that it confirms Shearman's hypothesis; see *Sumptuosa tabula picta. Pittori a Lucca tra gotico e rinascimento,* ed. Maria Teresa Filieri, exh. cat. (Livorno: Sillabe, 1998), 380–1.

31. The most detailed arguments for this are set out by Gardner von Teuffel, passim.

32. Gardner von Teuffel, 55–6.

33. This sort of symbolism is found also in Masaccio's fresco of the *Trinity* in Santa Maria Novella with the tomb and a skeleton at the base of the composition below the crucified Christ. See Charles Dempsey, "Masaccio's *Trinity:* Altarpiece or Tomb?" *Art Bulletin* 54 (1972): 279–81.

34. Gardner von Teuffel, 50 n. 75.

35. See Paolo E. Arias, *Camposanto Monumentale di Pisa. Le Antichità* (Pisa: Pacini, 1977), LV, fig. 112; LXIII, fig. 131; CXI, fig. 233; CXIII, fig. 238; for examples that are particularly close to the throne step at the central juncture of the strigillations. The use of the strigillated motif by Donatello and later Renaissance architects, painters, and sculptors is discussed in Francesco Cagliotti, "Donatello, i Medici e Gentile de' Becchi: un po' d'ordine intorno alla 'Giuditta' (e al 'David') di Via Larga. II," *Prospettiva* 78 (1995): 22–55, esp. 37. Howard Burns, "Quattrocento Architecture and the Antique," in *Classical Influences on European Culture, A.D. 500–1500,* ed. R. R. Bolgar (Cambridge: University Printing House, 1971), 284, and pl. 10c, says that the recessed columns of the throne are an accurate quotation from a sarcophagus in the Camposanto.

36. Eve Borsook, "A Note on Masaccio in Pisa," *Burlington Magazine* 103 (1961): 212–15.

37. Joannides, 395.

38. See Gardner von Teuffel, 50 n. 74.

39. See Artur Rosenauer, *Donatello* (Milan: Electa Editrice, 1993), 98, no. 14.

40. Beck, 1978, doc. II (items 3 and 6), 35. Luciano Berti, "Donatello e Masaccio," *Antichità viva* 5 (1966): 3–12, has suggested that the influence was reciprocal.

41. Burns, 284.

42. Beck, 1978, doc. II (item 7), 35. For Andrea di Giusto, see Richard Fremantle, *Florentine Gothic Painters from Giotto to Masaccio* (London: Secker and Warburg, 1975), 513–22, and Andreatta, in Berti and Paolucci, 249.

43. Becattini, 17–26, has suggested it may have been connected with the presence in Cascia of the Carnesecchi family, who in 1423, commissioned a *Virgin and Child* (Bremen, Kunsthalle) from Masolino and, around the same date, an altarpiece for their family chapel in Santa Maria Maggiore, Florence, showing the *Virgin and Child* (stolen), with *Saint Julian* (Florence, Santo Stefano

al Ponte) and *Saint Catherine* (lost). Two predella scenes showing *Scenes from the Life of Saint Nicholas* survive: one in Florence, the Horne Museum, attributed to Masaccio, and one in Montauban, Musée Ingres, attributed to Masolino. Although Joannides, 351, considers the *Scene from the Life of Saint Nicholas* by Masaccio to come from the *Carnesecchi Altarpiece,* in fact, Saint Julian's costume in the Montauban panel is identical to the saint's costume in the panel of the main tier, a strong argument for their having been part of the same altarpiece. Masaccio was almost certainly not involved in the *Carnesecchi Altarpiece.* For this altarpiece, see Luciano Berti, "San Giuliano," in Berti and Paolucci, cat. 46, 152–3; Joannides, cat. 13, 350–5; Perri Lee Roberts, *Masolino da Panicale* (Oxford: Clarendon Press, 1993), 18–25; cat. II, 176–8; and Roberto Bellucci and Cecilia Frosinini, "La Cappella Carnesecchi in Santa Maria Maggiore a Firenze: un problema di collaborazione tra Paolo Uccello, Masolino e Masaccio," forthcoming.

44. Vasari, 1906, 2: 390. Timothy Verdon briefly considers the possibility that it was painted for a different location, but it seems likely that it was painted for Sant'Ambrogio. See Timothy Verdon, "La Sant'Anna Metterza: riflessioni, domande, ipotesi," in *I pittori della Brancacci agli Uffizi: Gli Uffizi. Studi e ricerche* 5, eds. Luciano Berti and Annamaria Petrioli Tofani (Florence: Centro Di, 1988), 33–58; Berti and Foggi, cat. 2, 32–5; Roberts, 76–83; and cat. VIII, 182–3, with references; and Joannides, cat. 15, 369–72, with full bibliography.

45. Eve Borsook suggests that once the cult of Corpus Domini had been transferred to Santa Maria Novella, the cult of the Immaculate Conception was promoted by the nuns; see "Cult and Imagery at Sant'Ambrogio in Florence," *Mitteilungen des Kunsthistorischen Institutes in Florenz* 25 (1981): 147–202; and Megan Holmes, *Fra Filippo Lippi. The Carmelite Painter* (New Haven and London: Yale University Press, 1999), 215–31.

46. The pose of the Child was shown by Richard Offner to derive from an Etruscan bronze, either the figure in Rome, Museo Gregoriano, Musei Vaticani, or one similar to it; see Richard Offner, supplementary note to "Light on Masaccio's Classicism," in *Studies in the History of Art dedicated to William E. Suida on His Eightieth Birthday* (London: Phaidon Press, 1959), loose sheet.

47. Ornella Casazza, "Al di là dell'immagine," in Berti and Petrioli Tofani, 93–5.

48. Beck, 1978, 50; Roberts, 10.

49. For a history of the church, see *Santa Maria Maggiore a Roma,* ed. Carlo Pietrangeli (Florence: Nardini, 1988), and Sible de Blaauw, *Cultus et Decor. Liturgia e architettura nella Roma tardo antica e medievale,* 2 vols. (Vatican City: Biblioteca Apostolica Vaticana, 1994), 1: 335–447.

50. Vasari, 1906, 2: 293–4, text of 1568; not in text of 1550.

51. The Naples and Philadelphia panels had been associated by Lionello Venturi, "Contributi a Masolino, Lorenzo Salimbeni e Jacopo Bellini," *L'arte* 33 (1930): 165. The full reconstruction was proposed by Kenneth Clark, "An Early Quattrocento Triptych from Santa Maria Maggiore, Rome" *Burlington Magazine* 93 (1951): 339–47, and won wide acceptance with the exception of John Pope-Hennessy, "The Sta Maria Maggiore Altarpiece" (letter), *Burlington Magazine* 94 (1952): 31–2, who made the unlikely suggestion that the altarpiece had been two-tiered with the *Assumption* and the *Miracle of the Snow* as pinnacles. Pope-Hennessy's misconceptions in his rejection of Clark's reconstruction were corrected by Millard Meiss, "London's new Masaccio," *Art News*

50/2 (1952): 24, 50–1. See also Berti and Foggi, cat. 25, 138–41; Joannides, 72–80; cat. 23, 414–22; Roberts, 86–99; cat. X, 189–92.

52. Other fragments that have in the past been associated with the altarpiece have now been shown by technical investigation undertaken by the Opificio delle Pietre Dure e Laboratori di Restauro in Florence not to belong with the altarpiece. They are a pinnacle panel showing the *Crucifixion* (31.5 × 53.1 cm; Joannides, cat. 24, 423–4, rejects this as part of the altarpiece) and a predella panel showing the *Dormition of the Virgin* (19.7 × 48.3 cm), both Rome, Pinacoteca Vaticana (inv. 260 and 245). Also associated with the latter was a now-lost *Marriage of the Virgin* (48.3 × 19.7 cm), destroyed in World War II, that was published by John Pope-Hennessy, "A Predella Panel by Masolino," *Burlington Magazine* 82 (1943): 30–1. It has been argued that the predella fragments in fact come from the *Annunciation* (Washington, D.C., National Gallery of Art) by Paul Joannides, "A Masolino Partially Reconstructed," *Source: Notes in the History of Art* 4 (1985): 1–5; also see Joannides, 1993, 436–9. Roberts, cat. XXVI, 212, associates both panels with the style of Francesco d'Antonio.

53. The reconstruction first proposed by Clark, 1951, pls. 5–10, and endorsed by Millard Meiss, "The Altered Program of the Santa Maria Maggiore Altarpiece," in *Studien zur Toskanischen Kunst. Festschrift für Ludwig Heydenreich*, ed. Wolfgang Lotz (Munich: Prestel-Verlag, 1964), 169–90, figs. 1, 2, has been reinforced by the studies of the iconography by Allan Braham, "The Emperor Sigismund and the *Santa Maria Maggiore Altar-piece*," *Burlington Magazine* 122 (1980): 106–12, and by Perri Lee Roberts, "St. Gregory the Great and the *Santa Maria Maggiore Altar-piece*," *Burlington Magazine* 127 (1985): 295–6. The reconstruction given by the present author in Jill Dunkerton et al., *Giotto to Dürer: Early Renaissance Painting in The National Gallery* (New Haven and London: Yale University Press in association with London: National Gallery Publications Office, 1991), 252, 254, is probably incorrect.

54. See Dillian Gordon, "Thirteenth- and Fourteenth-Century Umbrian Double-Sided Altarpieces: Form and Function," in *Italian Paintings in the Dugento and Trecento* (Washington, D.C.: National Gallery of Art, Center for Advanced Study in the Visual Arts, forthcoming).

55. For Duccio's *Maestà*, see Henk van Os, *Sienese Altarpieces 1215–1460*, 2 vols. (Groningen: Bouma's Boekhuis, 1984), 1: 39–61.

56. For the *Stefaneschi Altarpiece*, see Julian Gardner, "The Stefaneschi Altarpiece: A Reconsideration," *Journal of the Warburg and Courtauld Institutes* 37 (1974): 57–103. Sible de Blaauw, "Das Hochaltarretable in Rom bis zum frühen 16 Jahrhundert: Das Altarbild als Kategorie der liturgischen Anlage," *Mededelingen van het Nederlands Instituut te Rome. Historical Studies* 55 (1996): 91, doubted that the altarpiece stood on the high altar and proposed the canons' choir instead. For the Roman triptychs, see Edward B. Garrison, *Italian Romanesque Panel Painting: An Illustrated Index* (Florence: Leo S. Olschki, 1949) 116, no. 299; also 111, no. 280; and 110, no. 278.

57. Davies, 354–5; 358 n. 20. Braham, 111, suggested the flowers are there to remind one that the miraculous fall of snow occurred in August. Luciano Berti, in Berti and Paolucci, 42, sees the flowers as a response to Pisanello's presence in Rome. However, Pisanello is first documented in Rome in 1431. The date of his arrival to complete the fresco cycle left incomplete at Gentile da Fabriano's death in 1427 is not known.

58. See de Blaauw, 1994, 1: 398–400.

59. See Eugene F. Rice, Jr., *Saint Jerome in the Renaissance* (Baltimore: Johns Hopkins University Press, 1985), 56–64, and Fabrizio Mancinelli, in Pietrangeli, 194.

60. Lajos Vayer, "Analecta Iconographica Masoliniana," *Acta Historiae Artium* 11 (1965): 222; also thought to be Gregory by Joannides, 1993, 414ff. Roberts, 1985, 295–6, further added that in the *Assumption,* the angels are unusual in that they represent the nine hierarchies, as ranked by Gregory the Great, who is appositely placed beside that scene.

61. Roberts, 1993, 86 n. 9. It has also been pointed out that it could have been commissioned by Cardinal Rinaldo Brancacci, who was archpriest of the church from 1411 and was linked with the Florentine Brancacci, providing a possible link with the painters. See Miklòs Boskovits, "Il percorso di Masolino: Precisazioni sulla cronologia e sul catalogo," *Arte cristiana* 75 (1987): 57ff.; and Joannides, 1993, 416. The possibility of Rinaldo Brancacci having commissioned the altarpiece diminishes if one accepts a date after the *Pisa Altarpiece* as well as Masolino's involvement from the beginning, since Brancacci died in June 1427.

62. Julian Gardner, "Pope Nicholas IV and the Decoration of Santa Maria Maggiore," *Zeitschrift für Kunstgeschichte* 36 (1973): 2.

63. Gardner, 1973, 22–3. Gardner, 38, notes the influence of the scene on the fifteenth-century altarpiece.

64. See Braham, 108, 112, who notes other features of the Roman setting, the pyramid of Gaius Cestius and the Porta San Paolo.

65. Roberts, 1993, 88.

66. Boskovits, 57ff.; Mancinelli, in Pietrangeli, 194; Joannides, 1993, 414; Roberts, 1993, 86–7.

67. De Blaauw, 1994, 1: 424; idem, 1996, 91ff.

68. Meiss, 1964, 171. Joannides considered that the *Miracle of the Snow and the Foundation of Santa Maria Maggiore* was on the back because of its importance to the clergy and its relevance to the history of the church; see "The Colonna Triptych by Masolino and Masaccio: Collaboration and Chronology," *Arte cristiana* 76 (1988): 339; and idem, 1993, 414. However, its importance for the history of the church can be equally well used to argue that it faced the front.

69. The *Miracle of the Snow* is on the front of the fifteenth-century ciborium by the sculptor Mino del Reame; in the *Assumption,* he retained the triptych element of the altarpiece in showing standing figures, on a reduced scale, on either side of the main scene. See illustration in Pietrangeli, 196, 202, and 203.

70. Illustrated in Pietrangeli, 132–3.

71. See H[erbert]. Henkels, "Remarks on the Late 13th-Century Apse Decoration in S. Maria Maggiore," *Simiolus* 3 (1971): 141 n. 42, for the full inscription.

72. See Roberts, 1993, 92; illustrated in Pietrangeli, 134–5.

73. For a discussion of the various dates given to the altarpiece until 1961, see Davies, 1961, 359–60 n. 30. Related to the question of the chronology of execution is whether the altarpiece was painted in Florence or Rome. Joannides, 1993, 72–9, 414–22, and Roberts, 1993, 98, consider it to have been painted in Florence in 1423–5; Roberts proposes, 100, that it was only after March 10, 1429, when Masolino sold his shares in the communal fund in Florence that he moved his workshop to Rome.

74. Joannides, 1988, 342, argues the reverse.
75. First published by Meiss, 1964, 169–90; refined and developed by Carl Brandon Strehlke and Mark Tucker, "The *Santa Maria Maggiore Altarpiece*: New Observations," *Arte cristiana* 75 (1987): 105–24.
76. First attributed by Clark, 1951, 339–47. Davies himself had doubts; see 1961, 356, 359 n. 30, with a summary of views up until 1961. For acceptance of the attribution, see further Bernard Berenson, *Italian Pictures of the Renaissance, Florentine School*, 2 vols. (London: Phaidon Press, 1963), 1: 134; Luciano Berti, *Masaccio* (Milan: Istituto editoriale italiano, 1964), 121–3, 157; Berti and Foggi, cat. 25, 138; Keith Christiansen, "Some observations on the Brancacci Chapel frescoes after their cleaning," *Burlington Magazine* 133 (1991): 5; Joannides, 1993, 417; Roberts, 1993, 92–6. Although Decio Gioseffi, "Domenico Veneziano. 'L'esordio masaccesco' e la tavola con i SS Girolamo e Giovanni Battista della National Gallery di Londra," *Emporium* 135 (1962): 51–72, attributed it to Domenico Veneziano, this was refuted by Hellmut Wohl, *The Paintings of Domenico Veneziano* (New York: New York University Press, 1980), 160, who saw the whole as conceived and designed by Masaccio, but not painted by him.
77. Raymond White and Jennifer Pilc, "Analyses of Paint Media," *National Gallery Technical Bulletin* 17 (1996): 91–2, 96.
78. Strehlke and Tucker, 105–24.
79. Strehlke and Tucker, figs. 10, 13.
80. Roberts, 1993, 96, incorrectly states that Strehlke and Tucker demonstrated that Gregory the Great and Matthias had their positions reversed in the changing of identities discussed here.
81. Strehlke and Tucker, 118.
82. Joannides, 1988, 342, 345. This seems rather unlikely in view of their frequent collaboration.
83. Meiss, 1964, 182.
84. Significantly this was published as by Fra Angelico by Giorgio Bonsanti, *Fra Angelico. Catalogo completo* (Florence: Octavo, 1998), cat. 25, 123, and as by Masaccio by Fremantle, 1998, cat. A.13, 122, in the same monographic series.
85. Vasari, 1906, 2: 294.

CHAPTER 7. MASACCIO IN THE BRANCACCI CHAPEL

1. Giorgio Vasari, *Le vite de' più eccellenti pittori, scultori ed architettori*, ed. Gaetano Milanesi, 9 vols. (Florence: G. C. Sansoni, 1906), 2: 287.
2. Vasari 2: 289–90.
3. Vasari 2: 299.
4. See Ugo Procacci, "L'incendio della chiesa del Carmine del 1771," *Rivista d'arte* 14 (1932): 157–9.
5. There is much controversy concerning the date of its installation. Jacques Mesnil, "Per la storia della cappella Brancacci," *Rivista d'arte* 8 (1912): 39, states that it occurred in 1460; Giuseppe Bacchi, "La cappella Brancacci," *Rivista storica carmelitana* 1 (1929): 59, asserts that it occurred in 1422, after the consecration of the Carmine. The first unambiguous reference to its location in the chapel dates to 1454, as suggested by Leonida Pandimiglio, *Felice di Michele vir clarissimus e una consorteria. I Brancacci di Firenze* (Milan: Olivetti, 1987/89), 112.

6. See Ornella Casazza, "The Brancacci Chapel from its Origins to the Present," in Umberto Baldini and Ornella Casazza, *The Brancacci Chapel,* trans. Lysa Hochroth with Marion L. Grayson (New York: Harry N. Abrams, 1990), 307–11; and idem, "Operatività e risultanze del restauro," in *La chiesa di Santa Maria del Carmine a Firenze,* ed. Luciano Berti (Florence: Giunti, 1992), 235–58, for a discussion of the restoration.

7. Published by Ornella Casazza, "Il ciclo delle storie di San Pietro e la 'historia salutis.' Nuova lettura della cappella Brancacci," *Critica d'arte* 51 (1986): 69–70.

8. Procacci, 149–51, 158, however, observes that the fire did not actually enter the Brancacci Chapel itself, although its entrance wall was severely damaged.

9. Roberto Longhi, "Fatti di Masolino e di Masaccio," *Critica d'arte* 25–6 (1940): 145, citing Milanesi in Vasari 2: 306.

10. See n. 6, and Andrew Ladis, *The Brancacci Chapel* (New York: George Braziller, 1993), who provides a comprehensive discussion of the chapel.

11. The removal of the frame surrounding the *Madonna del Popolo* revealed the original decoration of the window embrasure, an acanthus frieze with two tondi, each enclosing a single head. Umberto Baldini, "Nuovi affreschi nella Cappella Brancacci, Masaccio e Masolino," *Critica d'arte* 49 (1984): 65–72, ascribes one head to Masolino and the other to Masaccio, an ascription rejected by Miklòs Boskovits, "Il percorso di Masolino: Precisazioni sulla cronologia e sul catalogo," *Arte cristiana* 75 (1987): 64 n. 41; Eiko Wakayama, "Masolino o non Masolino: problemi di attribuzione," *Arte cristiana* 75 (1987): 726–7; and Luciano Berti and Rossella Foggi, *Masaccio. Catalogo completo dei dipinti* (Florence: Cantini, 1989), 84. See also in the text the discussion of the badly damaged scene beneath the window.

12. Much archival research was published in the 1970s, including Richard Fremantle, "Some Documents Concerning Masaccio and His Mother's Second Family," *Burlington Magazine* 115 (1973): 516–19; idem, "Some New Masolino Documents," *Burlington Magazine* 117 (1975): 658–9; idem, "Riferimenti ai membri della famiglia Brancacci da parte dello stesso notaio Filippo di Cristofano," *Antichità viva* 17 (1978): 50; Ugo Procacci, "Nuove testimonianze su Masaccio," *Commentari* 27 (1976): 223–37; Anthony Molho, "The Brancacci Chapel: Studies in Its Iconography and History," *Journal of the Warburg and Courtauld Institutes* 40 (1977): 50–98; and the collected documents in James H. Beck with the collaboration of Gino Corti, *Masaccio. The Documents* (Locust Valley, N.Y.: J. J. Augustin, 1978). See also Ugo Procacci, "Masaccio e la sua famiglia negli antichi documenti," in *La storia del Valdarno,* 4 vols. (Florence: Luciano Landi, 1980–3), 2: 553–9; and Pandimiglio.

13. See Procacci, 1932, 141–232; Walter and Elisabeth Paatz, *Die Kirchen von Florenz,* 6 vols. (Frankfurt am Main: Klostermann, 1952–5), 3 (1952): 219–36; Angelo Tartuferi, "Le testimonianze superstiti (e le perdite) della decorazione primitiva (secoli XIII–XV)," in Berti, 143–71; and the discussion following.

14. See Giuseppe Richa, *Notizie istoriche delle chiese fiorentine,* 10 vols. (Florence: Pietro Viviani, 1762), 2: 14–25; Prisca Giovannini and Sergio Vitolo, *Il convento del Carmine di Firenze: caratteri e documenti* (Florence: Tipografia Nazionale, 1981), 10–18, 28–30, 32–45; and Alessandro Guidotti, "Fatti, arredi e corredi carmelitani a Firenze," in Berti, 21–7, for the church's early history.

15. In addition to the texts (especially Giovannini and Vitolo, 10–19) cited in n. 14, see Robert Koch, "Elijah the Prophet, Founder of the Carmelite Order,"

Speculum 34 (1959): 547–60, and Megan Holmes, *Fra Filippo Lippi. The Carmelite Painter* (New Haven and London: Yale University Press, 1999), 31–8.

16. Archdale A. King, *Liturgies of the Religious Orders* (London: Longmans, Green and Co., 1955), 236–323.

17. King, 270–80; Holmes, 29–35.

18. Koch, 548.

19. Joanna Cannon, "Pietro Lorenzetti and the History of the Carmelite Order," *Journal of the Warburg and Courtauld Institutes* 50 (1987): 18–28; Creighton E. Gilbert, "Some Special Images for Carmelites, circa 1330–1430," in *Christianity and the Renaissance. Image and Religious Imagination in the Quattrocento*, eds. Timothy Verdon and John Henderson (Syracuse, N.Y.: Syracuse University Press, 1990), 161–207; and Holmes, 29–39.

20. See n. 5; Cannon, 20 n. 16; and Antonio Paolucci, "La Madonna duecentesca del Carmine," in Berti, 277–80.

21. I concur with Cannon, 20, on its placement. For the statutes of this confraternity, see "Libro degli ordinamenti della Compagnia di Santa Maria del Carmine," in *Testi fiorentini del dugento e dei primi del trecento*, ed. Alfredo Schiaffini (Florence: G. C. Sansoni, 1926), 55–72.

22. Richa 2: 37, 40, lists the miracles ascribed and homage paid to her.

23. See n. 5.

24. Giuseppe Bacchi, "La compagnia di Santa Maria delle laudi e di Sant'Agnese nel Carmine di Firenze," *Rivista storica carmelitana* 2 (1930): 137–51, and 3 (1931): 12–39, 97–122; and Cyrilla Barr, "Music and Spectacle in Confraternity Drama of Fifteenth-Century Florence. The Reconstruction of a Theatrical Event," in Verdon and Henderson, 377–404.

25. Holmes, 50–3, translates the eyewitness account and provides insightful commentary.

26. Vasari 1: 626, identifies Brunelleschi as inventor of the mechanism, for which see further Arthur R. Blumenthal, "A Newly Identified Drawing of Brunelleschi's Stage Machinery," *Marsyas* 13 (1966–7): 20–32. On Masolino and the scenery, see Perri Lee Roberts, *Masolino da Panicale* (Oxford: Clarendon Press, 1993), 9, doc. VIII (July 8, 1425), 169.

27. Koch, 47–8, and Barr, 379–80.

28. See n. 13.

29. Quoted from Schiaffini, 55.

30. Procacci, 1932, 147.

31. Vasari 1: 637. Bruce Cole, *Agnolo Gaddi* (Oxford: Clarendon Press, 1977), does not mention the work.

32. Vasari 1: 376. Procacci, 1932, 152–5, 187, 191–2, 212–32, reconstructs the lost cycle, which rather was painted by Spinello Aretino; see Tartuferi, in Berti, 168.

33. Vasari 1: 679–80.

34. See Marvin Eisenberg, *Lorenzo Monaco* (Princeton: Princeton University Press, 1989), 48–9, doc. 4A–G, 210–11, who corrects earlier assumptions that this was an Annunciation; and Tartuferi, in Berti, 144. Federico Zeri, "Investigations into the Early Period of Lorenzo Monaco," *Burlington Magazine* 107 (1965): 4–11, proposed a reconstruction of the polyptych, the central panel of which is in the Toledo Museum of Art.

35. Barbara Drake Boehm, "The Laudario of the Compagnia di Sant'Agnese," in

Painting and Illumination in Early Renaissance Florence: 1300–1450, eds. Laurence B. Kanter et al., exh. cat. (New York: Metropolitan Museum of Art, 1994), cat. 4a-1, 58–80, discusses the codex, the dispersed leaves of which are ascribed to Pacino di Bonaguida and the Master of the Dominican Effigies.

36. The badly damaged monochrome frescoes are illustrated in Berti, 148. Now in the sacristy, the beautiful altarpiece (c. 1360–5) by Andrea di Bonaiuto (Andrea da Firenze) has been associated with the oratory on the basis of a nineteenth-century description; see Tartuferi, in Berti, 170. On the work itself, see Miklòs Boskovits, *Pittura fiorentina alla vigilia del Rinascimento 1370–1400* (Florence: Edam, 1977), 277.

37. The document was published by Werner Cohn, "Il Beato Angelico e Battista Sanguigni," *Rivista d'arte* 30 (1955): 207–16.

38. My forthcoming article will present this proposal fully.

39. See Procacci, 1932, 199–212; Paatz 3: 300–2 n. 353; Divo Savelli, *La Sagra di Masaccio* (Florence: Giampiero Pagnini Editore, 1998); and Holmes, 42–50.

40. See Vasari 2: 295–7, and, on the drawings. Francis Ames-Lewis in this volume, 269 n. 37.

41. See Ugo Procacci, "Relazione di lavori eseguiti nella chiesa del Carmine di Firenze per la ricerca di antichi affreschi," *Bollettino d'arte* 27 (1933–4): 327–34; and the chapter by Ellen Callmann in this volume. Bicci di Lorenzo generally is identified as the author of the sacristy frescoes. However, Tartuferi, in Berti, 145–6, convincingly justifies the ascription to Lippo d'Andrea (1377–c. 1451) and notes his documented association with Masolino in 1424.

42. Tartuferi, in Berti, 171.

43. Molho and Pandimiglio provide the most complete discussion of the family's history.

44. Pandimiglio, 6.

45. Bacchi, 1929, 55–6.

46. Pandimiglio, 10–13, is the source of the biographical information in this discussion, expanding upon Molho, 72–3.

47. Pandimiglio, 13, 24–6.

48. Molho, 80.

49. Pandimiglio, 42.

50. Richard A. Goldthwaite, *The Building of Renaissance Florence. An Economic and Social History* (Baltimore: Johns Hopkins University Press, 1980), 12–13.

51. For an argument to the contrary, see Molho, 70–1.

52. Molho, 86–93, publishes Felice's three testaments.

53. Molho, 74–80, and Pandimiglio, 29–105, present the sources for this discussion.

54. Molho, 75, and Pandimiglio, 37–44, list these and other activities.

55. In his description of Masaccio's lost *Sagra*, Vasari 2: 295, identifies Antonio di Piero Brancacci, portrayed among the dignitaries in the fresco, as the one "who made the chapel." Molho, 79–81, believes that funds for the chapel's decoration were obtained through the testament of Antonio di Piero Brancacci. In his opinion, the absence of a deduction for the chapel in Felice's tax declaration proves that he did not commission it.

56. Molho, 75.

57. Pandimiglio, 46.

58. Molho, 76; Pandimiglio, 50, 47.

59. Molho, 86–8 (for the testament); 86 (for "his tomb and [that of] his predecessors" in the Carmine).

60. Among these critics are Frederick Antal, *Florentine Painting and Its Social Background* (London: K. Paul, 1948; rpt. New York: Harper & Row, n.d. [1975]), 307–8; Millard Meiss, "Masaccio and the Early Renaissance: The Circular Plan," in *Acts of the 20th International Congress of the History of Art*, 2 vols. (Princeton: Princeton University Press, 1963), 1: 123–45; Peter Meller, "La Cappella Brancacci: problemi ritrattistici e iconografici," *Acropoli* 1 (1960–1): 186–227; 273–312; and Molho, 53–70, 77–8. Although I cannot agree with all the proposals presented in these discussions, several contribute significantly to our understanding of the complexities of society and faith in the early Quattrocento. An inspired discussion of the iconography and its sources, from sermons to hymns, is Astrid Debold-von Kritter, *Studien zum Petruszyklus in der Brancaccikapelle,* Ph.D. diss., University of Berlin, 1975; she also disputes the applicability of contemporary concerns and politics to the iconography, 152–3.

61. See Debold-von Kritter, 77–83, 118–45; Marilyn Aronberg Lavin, *The Place of Narrative. Mural Decoration in Italian Churches, 431–1600* (Chicago: University of Chicago Press, 1990), 133, 138; and Keith Christiansen, "Some observations on the Brancacci Chapel frescoes after their cleaning," *Burlington Magazine* 133 (1991): 9–10.

62. Molho, 66–9. I dispute the thesis of Meller – namely, that the cycle refers to Florence's struggle with Milan – as well as his identification of numerous portraits in the chapel, including one allegedly of Giangaleazzo Visconti, to support it.

63. Antal, 308.

64. For example, Frederick Hartt, *History of Italian Renaissance Art,* 3rd ed. (Englewood Cliffs, N.J.: Prentice-Hall, and New York: Harry N. Abrams, 1987), 187.

65. The statement of Antal, 307, that the subject is infrequently represented has been repeated throughout the literature.

66. Debold-von Kritter, passim.

67. For the lost portico frescoes, see Jens T. Wollesen, *Die Fresken von San Piero a Grado bei Pisa* (Bad Oeynhausen: Bad-Druckerei Adalbert Theine, 1977).

68. Idem, *Pictures and Reality. Monumental Frescoes and Mosaics in Rome around 1300* (New York: Peter Lang, 1998), 51–75, discusses the derivative frescoes in Pisa and Assisi.

69. Lavin, 137–8, identifies the feasts as the source for the chapel's iconography and narrative sequence, which she believes is arranged in what she has defined as a "Festival Mode." Christiansen, 9, further proposes the correspondence of the cycle's triadic division to the three Petrine feasts described by Voragine.

70. The significance of *The Golden Legend* as the source of the chapel's iconography was identified by Debold-von Kritter; Law Bradley Watkins, "The Brancacci Chapel Frescoes: Meaning and Use," 2 vols., Ph.D. diss., University of Michigan, Ann Arbor, Mich., 1976, 1: 70ff.; 2: 303–23; and Lavin, 137–8.

71. *The Golden Legend of Jacobus de Voragine,* trans. and adapt. Granger Ryan and Helmut Ripperger (New York: Arno Press, 1969), v–xvi. On its sources and

influence, see Sherry L. Reames, *The "Legenda Aurea": A Reexamination of Its Paradoxical History* (Madison, Wis.: University of Wisconsin Press, 1985).

72. K. W. Humphreys, *The Library of the Carmelites of Florence at the End of the Fourteenth Century* (Amsterdam: Erasmus antiquariaat en Boekhandel, 1964), discusses the church's library, which served as the *studium* for all Tuscan Carmelite foundations. Several copies of *The Golden Legend* are recorded in the monastery's inventories; see Humphreys, L71, L82, 407, 443, 520, 524, 589.

73. Watkins 1: 304–6; Lavin, 137–8.

74. Voragine, 403.

75. Voragine, 331. A major scene that is not depicted in the chapel is Christ consigning the keys to Saint Peter. John Pope-Hennessy, *Donatello's Relief of the Ascension with Christ Giving the Keys to St. Peter* (London: His Majesty's Stationery Office, 1949), 12, proposed that Donatello's relief in London, Victoria and Albert Museum, might have been made for the chapel, serving as the predella to an altar or tabernacle. Many critics, among them Meller, 217, and Christiansen, 10 n. 33, have accepted his hypothesis. However, given Felice Brancacci's strained financial situation, it seems unlikely that he could have paid for a work by Donatello.

76. See Debold-von Kritter, 129–45; and Baldini and Casazza, 319–21; the latter believe that the iconography demonstrates the "mystery of salvation" compelled by the disobedience of Adam and Eve and redeemed through Christ and the Church, of which Peter was first vicar.

77. Voragine, 337.

78. Voragine, 331.

79. Lavin, passim, presents the most comprehensive discussion of Italian narrative cycles. For the Quattrocento, see also Eve Borsook, *The Mural Painters of Tuscany from Cimabue to Andrea del Sarto,* 2nd ed. (Oxford: Clarendon Press, 1980), 57–126; and Steffi Roettgen, *Italian Frescoes. The Early Renaissance 1400–1470,* trans. Russell Stockman (New York: Abbeville Press, 1996), who analyzes the chapel, 92–7.

80. See *Maestri e botteghe. Pittura a Firenze alla fine del Quattrocento,* eds. Mina Gregori, Antonio Paolucci, and Cristina Acidini Luchinat, exh. cat. (Milan: Silvana Editoriale, 1992); Anabel Thomas, *The Painter's Practice in Renaissance Tuscany* (Cambridge: Cambridge University Press, 1995); Francis Ames-Lewis, *The Intellectual Life of the Early Renaissance Artist* (New Haven and London: Yale University Press, 2000); and the chapter by Perri Lee Roberts in this volume.

81. On the latter, see Ronald W. Lightbown, *Donatello and Michelozzo: An Artistic Partnership and Its Patrons in the Early Renaissance,* 2 vols. (London: Harvey Miller, 1980).

82. Vasari 2: 287–301 (Masaccio); 2: 263–7 (Masolino); and 3: 461–77 (Filippino Lippi).

83. However, see Baldini and Casazza, 322–3, and the contrary opinion of Christiansen, 11–13.

84. Critical opinion through 1993 is summarized by Paul Joannides, *Masaccio and Masolino. A Complete Catalogue* (London: Phaidon Press, 1993), 320–2, 343, 348–9, who discusses the chapel at length, 106–12, 313–49.

85. Umberto Baldini, "The Restoration: History, Research, and Methodology," in Baldini and Casazza, 285–96.

86. The *giornate* first were identified by the conservator Leonetto Tintori, published by Luciano Berti, *Masaccio* (University Park, Pa.: Pennsylvania State University Press, 1967), 103, 155, figs. 61–2, and further explicated by Law Bradley Watkins, "Technical Observations on the Frescoes of the Brancacci Chapel," *Mitteilungen des Kunsthistorischen Institutes in Florenz* 17 (1973): 65–74. See also the diagrams in Baldini and Casazza, 348–64.
87. See the chapter by Roberto Bellucci and Cecilia Frosinini in this volume.
88. Roberts, 30–49; doc. VII, 169.
89. Roberts, doc. VIII, 169.
90. Vasari 2: 264 (Masolino); 2: 294–5 (Masaccio).
91. Roberts, 85–6. For the contract stipulating three years of employment in Hungary, see Roberts, doc. X, 170.
92. Watkins, 1973, 65–74; and Christiansen, 15 n. 46.
93. See the diagrams in Ornella Casazza, "La grande gabbia architettonica di Masaccio," *Critica d'arte* 53 (1988): 82, 83; and Werner Jacobsen, "Die Konstruktion der Perspektive bei Masaccio und Masolino in der Brancacci-kapelle," *Marburger Jahrbuch für Kunstwissenschaft* 21 (1986): 78, fig. 5; 84, fig. 8; and his discussion, 73–92.
94. On the influence of classical sculpture on Masaccio, see Richard Fremantle, "Masaccio e l'antico," *Critica d'arte* 34 (1969): 39–56.
95. On the rendering of architecture in the chapel, see Casazza, 1988, 78–97.
96. Baldini, 1984, 70–2, has identified it as a frescoed altarpiece depicting the crucifixion of Saint Peter; Casazza, 1988, 84 n. 11 concurs. See, however, Paul Joannides, "Masaccio's Brancacci Chapel: Restoration and Revelation," *Apollo* 133 (1991): 26–32, and idem, 1993: 319–20, who believes that it may represent the conversion of Saint Paul; as well as Christiansen, 8. Both correctly observe the absence of the *metae* (pyramids in the Circus Maximus) that are consistent elements in the iconography, which as a rule shows the crucifixion against the city walls: Indeed, Masaccio included them in the Berlin predella panel depicting the martyrdoms of Saints Peter and John the Baptist, a component to the *Pisa Altarpiece*. The landscape setting is appropriate to the conversion of Saint Paul, as Joannides observed, or to his martyrdom by decapitation. Saint Paul does, in fact, appear prominently in the bottom row and is often paired with Peter; these most Roman of saints were martyred on the same day and year. Indeed, in the Carmine itself, as is known from the account of Vasari (see n. 90), Masolino and Masaccio painted Peter and Paul, respectively, in the Carmine's left transept.

 Obviously, identifying the scene as the saint's crucifixion has implications for Filippino Lippi's representation of the same subject. If Peter's crucifixion had been represented, one wonders what was originally planned for the wall frescoed by Filippino Lippi with *Saints Peter and Paul Debating with Simon Magus before Nero and the Crucifixion of Saint Peter*. The fall of the heretic Simon Magus, which followed his disputation with Peter, is a likely possibility, as several scholars have recognized.
97. First articulated by Heinrich Brockhaus, "Die Brancacci-Kapelle in Florenz," *Mitteilungen des Kunsthistorischen Institutes in Florenz* 3 (1919–22): 169–78, this proposal seems to have been accepted as fact by numerous authors, and given great emphasis by Meller.
98. My gratitude to Dale Kent for confirming this.

99. On the *Pisa Altarpiece,* see the chapter by Dillian Gordon in this volume.
100. See Lavin, 133, 136, who remarks, 330 n. 39, that in the Duomo of Monreale, the mosaic cycle of Peter's life also is located to the right of the high altar.

CHAPTER 8. MASACCIO'S *TRINITY*

1. Eve Borsook, *The Mural Painters of Tuscany from Cimabue to Andrea del Sarto,* 2nd ed. (Oxford: Clarendon Press, 1980), 60.
2. The literature on Masaccio's *Trinity* is extensive. In addition to sources specifically cited in these notes, interested readers are invited to consult the bibliography provided in the following: Borsook, 60–3; Luciano Berti, *Masaccio* (Milan: Istituto editoriale italiano, 1964); Joseph Polzer, "The Anatomy of Masaccio's Holy Trinity," *Jahrbuch der Berliner Museen* 13 (1971): 18–59; E[dgar]. Hertlein, *Masaccios Trinität. Kunst, Geschichte und Politik der Frührenaissance in Florenz* (Florence: Leo S. Olschki, 1979); and two essays in the *Marburger Jahrbuch für Kunstwissenschaft* 21 (1986): Alexander Perrig, "Masaccios 'Trinità' und der Sinn der Zentralperspektive," 11–44; and Wolfgang Kemp, "Masaccios 'Trinität' im Kontext," 45–72. See also Alfred Hackel, *Die Trinität in der deutschen Kunst* (Berlin: Reuther and Reichard, 1931).
3. Ursula Schlegel, "Observations on Masaccio's Trinity Fresco in Santa Maria Novella," *Art Bulletin* 45 (1963): 19–34.
4. Otto von Simson, "Über die Bedeutung von Masaccios Trinitätfresko in Santa Maria Novella," *Jahrbuch der Berliner Museen* 8 (1966): 119–59.
5. Rona Goffen, "Masaccio's *Trinity* and the Letter to the Hebrews," *Memorie domenicane* n.s. 11 (1980): 489–504.
6. Charles Dempsey, "Masaccio's *Trinity:* Altarpiece or Tomb?" *Art Bulletin* 54 (1972): 279–81.
7. The source, a sixteenth-century Dominican chronicler named Modesto Biliotti, is cited in Stefano Orlandi, O.P., *Necrologia di Santa Maria Novella,* 2 vols. (Florence: Leo S. Olschki, 1955), 2: 193–4. See also Schlegel, 19, 24; Borsook, 58; John Coolidge, "Further Observations on Masaccio's *Trinity,*" *Art Bulletin* 48 (1966): 382–4.
8. See the "Sepoltuario Fiorentino di Stefano Rosselli," a manuscript of 1657 preserved in the Archivio di Stato, Florence, part II, 708, cited in von Simson, 123 n. 10. See also Borsook, 58, and Ugo Procacci, "Nuove testimonianze su Masaccio," *Commentari* 27 (1976): 233–4, who notes that the date of Domenico's death, January 19, while still considered as falling within the year 1426 according to old Florentine reckoning (which began the year on March 25), for today's way of computing time would actually have occurred in 1427.
9. Procacci, 233.
10. The expression is derived from Saint Thomas Aquinas and fully states what art in Dominican churches is meant to do. See Saint Thomas Aquinas, *Summa Theologiae,* ed. Jacques Paul Migne, 4 vols. (Paris: J. P. Migne, 1841), 3: 1373: "Sicut enim majus est illuminare quam lucere solum, ita majus est contemplata aliis tradere quam solum contemplari." Basic to my reading of the function of the fresco is an understanding of the relationship between the religious community and its site, and between the site and the city, eloquently evoked in Eugenio Marino, O.P., "Santa Maria Novella e il suo spazio culturale," *Memorie domenicane* n.s. 14 (1983): 1–20.

11. Michael Mallory, "An Early Quattrocento Trinity," *Art Bulletin* 48 (1966): 85–9.

12. Gaudenz Freuler, *Bartolo di Fredi Cini* (Disentis: Desertina Verlag, 1994), 357–62.

13. Borsook, 59, notes that "all the figures, even the skeleton, are life size," and explains this unusual feature as meant "to enhance the realism of the subject."

14. Polzer, 49.

15. See Rudolph Schnackenburg, *Il Vangelo di Giovanni*, 3 vols. (Brescia: Paideia, 1981), 3: 453; Henry Langkammer, "Christ's 'Last Will and Testament' (John 19:26–27) in the Interpretation of the Fathers of the Church and the Scholastics," *Anton* 43 (1968): 99–109; Henri Barré, "Marie et l'Eglise. Du Vénérable Bède à Saint-Albert le Grand," *Études mariales* 9 (1952): 59–143; Ignace de La Potterie, "La maternità spirituale di Maria e la fondazione della Chiesa," in his *Gesù verità: studi di cristologia giovannea* (Turin: Marietti, 1973), 158–64; Theodore Koehler, "Les principales interprétations traditionelles de Jn. 19, 25–27, pendant les douze premiers siècles," *Études mariales* 16 (1960): 119–55; Aloys Müller, *Ecclesia – Maria. Die Einheit Marias und der Kirche* (Fribourg: Paulusverlag, 1951), 116–18; Cipriano Vagaggini, *Maria nelle opere di Origene, Orientalia christiana analecta* (Rome: Pont. Institutum Orientalium Studiorum, 1942), 118; Bernardo Toscani, "Due capitoli sulla Trinità di Antonio Barbadoro (1439)," *Rinascimento. Rivista dell'Istituto Nazionale di Studi sul rinascimento,* ser. 2, 25 (1985): 83–100.

16. Millard Meiss, "An Early Altarpiece for the Cathedral of Florence," *Metropolitan Museum of Art Bulletin* 20 (1954): 302–17; Hertlein, 40; Timothy Verdon, "The Iconography of the 'Intercession of Christ and the Virgin' in the Florence Cathedral," in *The Fabric of Images. European Painting on Fabric Supports in the Fourteenth and Fifteenth Centuries,* ed. Caroline Villers (London: Archetype, 2000), 43–54.

17. The scale of the figures is "life-size" in fifteenth-century terms: that is, the people are smaller than modern people would be.

18. Saint Augustine, *De Trinitate* 8, 7, 10, in *Obras de San Augustin. Tratado sobre la santisima Trinidad,* ed. Luis Arias (Madrid: Biblioteca de Autores Cristianos, 1956), 524–5: "Quapropter non est praecipue videndum in hac quaestione, quae de Trinitate nobis est, et de cognoscendo Deo, nisi quid sit vera dilectio, imo vero quid sit dilectio."

19. Augustine, 9, 1–12, in Arias, 570–1: "Et est quaedam imago Trinitatis, ipsa mens, et notitia eius, quod est proles eius ac de se ipsa verbum eius, et amor tertius, et haec tria unum atque una substantia."

20. Peter Lombard, *De misterio Trinitatis* 1, 3, 20, in *Patrologiae cursus completus, series latina* (hereafter "PL"), ed. Jacques Paul Migne (Paris: J. P. Migne, 1865–84), 47: 23–4: "Nec est minor prole parente, dum tantam se novit mens, quanta est; nec minor est amor parente et prole, id est, mente et notitia. . . ."

21. Augustine, 12, 6–8, in Arias, 600–7.

22. Richard of Saint Victor, *De Trinitate,* 3, 11; 3, 14. See Richard de Saint-Victor, *La Trinité,* ed. Gaston Salet (Paris: Éditions du Cerf, 1959), 190–5; 199–201. The phrase quoted here is found in 3, 11: "Est itaque indicium magnae infirmitatis, non posse pati consortium amoris. Posse vero pati, signum magnae perfectionis."

23. Saint Thomas Aquinas, *Summa Theologiae,* 2nd ed. (Milan: Edizioni Paoline,

1988), 150–3 (= Pars prima, quaestio 28, articles 1 and 3 and 4): "Nihil univoce de Deo dici possit, et de creaturis" (art. 4).

24. Augustine, 12, 6, 8, in Arias, 660–1: "Omitto enim quale sit, Spiritum sanctum matrem Filii Dei putare et coniugem Patris: fortassis quippe respondeatur haec in carnalilbus habere offensionem, dum corporei conceptus partusque cogitantur."

25. Aquinas, I. q. 28. art. 2 and q. 29. art 4: "Relatio autem in divinis non est sicut accidens inhaerens subjecto, sed est ipsa divina essentia."

26. "Sic enim Pater et Filius in creaturis magis sibi attinent quam duo fratres." See Emilio Panella, O.P., "I quodlibet di Remigio de' Girolami," *Memorie domenicane* n.s. 14 (1983): 77.

27. Schnackenburg 3: 453, reviews the development of this interpretation in Saint Anselm, Rupert of Deutz, Albertus Magnus, and Gerloh of Reichensberg.

28. "Omnium nostrum salutem beata virgo peperit, plane omnium nostrum mater est. Igitur quod de hoc discipulo dictum est ab Eo, recte et de alio quolibet discipulo . . .": *Commentarium in Evangelium Johannis,* PL 169: 790. See P[ère]. M[arie].-J[oseph]. Lagrange, O.P., *Evangile selon Saint Jean,* 5th ed. (Paris, Gabalda, 1936), 493.

29. Daniel R. Lesnick, "Civic Preaching in Early Renaissance," in *Christianity and the Renaissance. Image and Religious Imagination in the Quattrocento,* eds. Timothy Verdon and John Henderson (Syracuse, N.Y.: Syracuse University Press, 1990), 218.

30. I have several times sketched an ecclesiological reading of the Spanish Chapel. See Timothy Verdon, "Christianity, the Renaissance and the Study of History: Environments of Experience and Imagination," in Verdon and Henderson, 1–37; idem, "L'uso iconografico della Bibbia," in *La Bibbia nell'epoca moderna e contemporanea,* ed. Rinaldo Fabris (Bologna: Edizioni Dehoniane, 1992), 83–9; and idem, "Pagans in the Church: The *School of Athens* in Religious Context," in *Raphael's School of Athens,* ed. Marcia B. Hall (Cambridge: Cambridge University Press, 1997), 114–30. Julian Gardner, "Andrea di Bonaiuto and the Chapterhouse Frescoes in Santa Maia Novella," *Art History* 2 (1979): 107–37, does not develop this theme.

31. Charles Seymour, Jr., *Sculpture in Italy: 1400–1500* (Baltimore: Penguin Books, 1966), 119; John Pope-Hennessy, *Italian Renaissance Sculpture,* 2nd ed. (London: Phaidon Press, 1971), 30. Ralph Lieberman, "Brunelleschi and Masaccio in Santa Maria Novella," *Memorie domenicane* n.s. 12 (1981): 127–39, develops a series of fascinating hypotheses from the now generally accepted attribution to the same Andrea Cavalcanti of the Cardini Chapel in San Francisco, Pescia, where the architectural/pictorial/sculptural elements reproduce in three dimensions the general layout of Masaccio's *Trinity.* Lieberman draws the conclusion that Brunelleschi may have been the overall designer of Masaccio's composition. In the same line of reasoning, one may wonder if the pulpit later situated next to the fresco was not part of an original "Brunelleschian project." The seventeenth-century source Antonio Billi would seem to link the works, describing the fresco as "dietro al pergamo (behind the pulpit)"; see Schlegel, 19.

32. Cited by Innocenzo Colosio, O.P., "Il Beato Giovanni Dominici come uomo, come scrittore e come maestro di vita spirituale, specialmente religiosa," *Memorie domenicane* n.s. 1 (1970): 39.

33. Frontispiece of *La Sainte Abbaye*, London, British Library, MS Add. 39843, f. iv. See Lucy Freeman Sandler, "Jean Pucelle and the Lost Miniature of the Belleville Breviary," *Art Bulletin* 66 (1984): 73–96, fig. 21.

34. Pisa, Museo Nazionale di San Matteo.

35. John Henderson, "Society and Religion in Renaissance Florence," *The Historical Journal* 29 (1986): 213–25. See also Roberto Lunardi, *Arte e storia in Santa Maria Novella* (Florence: Nuova Salani, 1983), which lists ten confraternities as having oratories around the two eastern cemetery areas. For one such group, see Kathleen Giles Arthur, "Cult Objects and Artistic Patronage of the Fourteenth-Century Flagellant Confraternity of Gesù Pellegrino," in Verdon and Henderson, 336–60, and Sharon T. Strocchia, *Death and Ritual in Renaissance Florence* (Baltimore: Johns Hopkins University Press, 1992), who however eschews discussion of the religious dimension of death.

36. See Giovanni Boccaccio, *Decamerone,* ed. Vittore Branca (Florence: Accademia della Crusca, 1976), 16–17, where, in the "First Day," after vividly recalling the plague that had halved the population of Florence, Boccaccio opens his account "in the venerable church of Santa Maria Novella," with the friars singing morning Office. Similarly, in the ninth Novella of the "Eighth Day," Buffalmacco and a friend play a macabre prank on a physician from Bologna, using the *avelli* (arched tombs) of the basilica as setting. See also Anton Francesco Grazzini ('il Lasca'), *Scritti scelti,* ed. Raffaele Fornaciari (Florence: G. C. Sansoni, 1957), 97–8 (Novella 9), who, more than a century after Boccaccio, still evokes funerary associations for the *avelli* of Santa Maria Novella. See more generally Orlandi; Vincenzo Fineschi, *Memorie sopra il cimitero antico della chiesa di Santa Maria Novella* (Florence: Stamperia di Francesco Moucke, 1787); and J. Wood Brown, *The Dominican Church of Santa Maria Novella* (Edinburgh: Schulze, 1902), 94–102.

37. Wood Brown, 97.

38. Roberto Lunardi noted the relationship between the east door and the fresco, interpreting it in terms of an ideal viewing point for the perspective construction. See the article by Rodolfo Gattai, "Ma un giorno Giorgio Vasari murò quella gran porta," *La Nazione* (July 27, 1985): 3.

39. Extracts from the records of the Opera di Santa Maria Novella, noting the demolitions and renovations planned by Vasari, are preserved in the *Cronaca* of Vincenzio Borghigiani, 3, 391–2 (Archivio di Santa Maria Novella, Florence), and published in Wood Brown, 167–8. These include a notation regarding "la Cappella della Trinità posta a ponente nell'arcata di contro la porta del fianco suddetta stata rimurata." See also Marcia B. Hall, *Renovation and Counter-Reformation. Vasari and Duke Cosimo in Sta Maria Novella and Sta Croce 1565–1577* (Oxford: Clarendon Press, 1979), xxvi, 200.

40. Fineschi, 59.

41. Alessandro Parronchi, *Studi su la 'Dolce prospettiva'* (Milan: Martelli, 1964), 289, 491.

42. Lieberman, 130–4.

43. Von Simson, fig. 17, and Ludwig Heydenreich, "Ein In-Memoriam-Bild des Jacopo del Sellaio," *Die Kunst und das schöne Heim* 50 (1954): 253.

44. Wood Brown, 117 (citing Stefano Rosselli's description of 1650); 19: "so strong was the united force of habit and convenience that, for long afterwards [after the building of the nave and new facade with its square], the congregation

came to the church not by way of the new Piazza and the South door, as at present, but by the upper cemetery and an entrance in the east side of the nave which was only closed by Vasari in 1565."

45. Marcia B. Hall, "The *Ponte* in S. Maria Novella: The Problem of the Rood Screen in Italy," *Journal of the Warburg and Courtauld Institutes* 37 (1974): 157–73; see also Hall, 1979, 200.

46. A painting in the Accademia, Venice, illustrates the "crossroads" use of a church in the fifteenth century. By Vittore Carpaccio, it represents the apparition of the crosses of Mount Ararat in the church of Sant'Antonio di Castello. See Manlio Cancogni and Guido Perocco, *L'opera completa del Carpaccio* (Milan: Rizzoli, 1967), 110, fig. 62.

47. Wood Brown, 2–30.

48. Giovanni Villani, *Cronica*, ed. Francesco Gherardi Dragomanni, 4 vols. (Florence: Sansone Coen, 1845), 1: 386 (= Book 8, Chapter 49).

49. Lesnick, 210–13.

50. Lesnick, 214–21; Salvatore Camporeale, O.P., "Giovanni Caroli dal 'Liber dierum' alle Vite fratrum," *Memorie domenicane* n.s. 16 (1985): 199–233; and idem, "Humanism and the Religious Crisis of the Late Quattrocento: Giovanni Caroli, O.P. and the *Liber dierum lucensium*," in Verdon and Henderson, 445–66. See also Marino, 3–8.

51. Lesnick, 213–14.

52. Paradiso XV, 74: "la prima equalità"; and Paradiso X, 3: "lo primo ed ineffabile valore."

CHAPTER 9. MASACCIO AND PERSPECTIVE IN ITALY IN THE FIFTEENTH CENTURY

1. See Antonio di Tuccio Manetti, *Life of Brunelleschi*, intro. and annot. Howard Saalman, trans. Catherine Enggass (University Park, Pa.: Pennsylvania State University Press, 1970); and Martin Kemp, "Science, Non-Science and Nonsense: The Interpretation of Brunelleschi's Perspective," *Art History* 1 (1978): 134–61.

2. Rudolf Wittkower, "Brunelleschi and 'Proportion in Perspective,'" *Journal of the Warburg and Courtauld Institutes* 16 (1953): 275–91.

3. See Martin Kemp, *The Science of Art: Optical Themes in Western Art from Brunelleschi to Seurat* (New Haven and London: Yale University Press, 1990); and J. V. Field, *The Invention of Infinity: Mathematics and Art in the Renaissance* (Oxford: Oxford University Press, 1997; rpt. 1999).

4. The idea of coordinates was, of course, thoroughly familiar in the astronomy of the time, in which the positions of stars were generally given in terms of their angular distances along and perpendicular to the ecliptic.

5. It may be necessary to make an exception for Piero della Francesca; see J. V. Field, "When Is a Proof not a Proof? Some Reflections on Piero della Francesca and Guidobaldo del Monte," in *La prospettiva: fondamenti teorici ed esperienze figurative dall'antichità al mondo moderno: Atti del convegno internazionale di studi: Istituto svizzero di Roma: Roma 11–14 settembre 1995*, ed. Rocco Sinisgalli (Florence: Edizioni Cadmo, 1998), 120–32, figs. 373–5.

6. On the name "centric point," see n. 10.

7. My ideas on the subject were greeted with little enthusiasm by my collabora-

tors, but are printed as an appendix to J. V. Field, Roberto Lunardi, and Thomas B. Settle, "The Perspective Scheme of Masaccio's *Trinity* Fresco," *Nuncius* 4.2 (1988): 31–118.

8. A suggestion for a construction method that may have been used in this picture is given in Field, 1997, 39.

9. Working methods are known not only from Cennino Cennini's treatise – Cennino Cennini, *The Craftsman's Handbook. The Italian "Il Libro dell'arte,"* trans. Daniel V. Thompson, Jr. (New Haven and London: Yale University Press, 1933; rpt. New York: Dover Publications, 1954) – but also from the traces of them found in surviving works of art. In particular, straight lines were regularly made by rubbing a length of string with a wet preparation of red clay (called sinopia), holding the ends in appropriate positions, and then plucking the string so that it struck against the wall, leaving a red line. Sometimes, when working on damp plaster, a similar method was used without putting clay on the string; this made an indentation in the soft plaster, a so-called snapped line.

10. Alberti's common sense name of "centric point" for this point of convergence will be used throughout this chapter. In the sixteenth and seventeenth centuries, it acquired a number of other names, some of them decidedly confusing. One of the worst, for anyone studying the fifteenth century, is the one that has now stuck, namely "vanishing point," for which we are indebted to Brook Taylor, *Linear Perspective* (London: n.p., 1715). Taylor does not explain this name, but it seems to derive from thinking about the point in the real scene to which the point in the picture plane corresponds. This type of consideration is entirely foreign to fifteenth-century modes of thought about perspective.

11. Curiously, the team who found the two points do not say this. See Ornella Casazza, "Il ciclo delle storie di San Pietro e la 'historia salutis.' Nuova lettura della cappella Brancacci," *Critica d'arte* 51 (1986): 69–84.

12. In analyzing pictures, one must constantly be aware that one is making assumptions about certain features of what is shown in them.

13. On later names for this point of convergence, see n. 10.

14. Giorgio Vasari, *Le vite dei più eccellenti pittori, scultori e architettori: nella redazioni dal 1550 e 1568*, eds. Paola Barocchi and Giovanna Gaeta Bertelà, 2 vols. (Florence: SPES, 1971), Life of Masaccio (1568), 2: 127.

15. For details, see Field et al.

16. Painters seem to have recognized this effect, since many pictures have been constructed with surprisingly short viewing distances.

17. About 11 ¾ *braccia*.

18. G. J. Kern, "Das Dreifaltigkeitsfresko von S. Maria Novella, ein perspektivisch-architekturgeschichtliche Studie," *Jahrbuch der königlichen preussischen Kunstsammlungen* 24 (1910): 36–58; Joseph Polzer, "The Anatomy of Masaccio's Holy Trinity," *Jahrbach der Berliner Museen* 13 (1971): 18–59; and Field et al.

19. Horst W. Janson, "Ground Plan and Elevation in Masaccio's *Trinity* Fresco," in *Essays Presented to Rudolf Witthower on His 65th Birthday*, eds. David Fraser, Howard Hibbard, and Milton J. Lewine (London: Phaidon Press, 1967), 83–8.

20. Alerted by their predecessors' failures, Field et al., 40–4, measured the squares associated with the back columns.

21. Only Field et al. measured the ribs.

22. Rectangular coffers are not known in fifteenth-century buildings, and, when they appear in later ones, there usually seems to be a deliberate attempt to mislead the eye into reading them as square.

23. Field et al., 54–7.

24. There have been several attempts to evade this mathematical logic by feeding the measurements published in Field et al. to a commercially available Computer-Aided Design program, which presumably then silently made its own choices, unguided by any understanding of the history of art. Prominent among these silly alleged reconstructions is one by a professor of psychology, who continues to be unwilling to recognize the futility of arguing against mathematical proof. See Marc De Mey, "Late Medieval Optics and Early Renaissance Painting," in Sinisgalli, 75–84, figs. 356–62.

25. See Field et al., 49–51.

26. See Field et al., 44–8.

27. See Field et al., 59–61, 108–14.

28. Vasari, Life of Brunelleschi, 4: 143.

29. Vasari, Life of Masaccio, 3: 125.

30. The *Trinity* has been restored, but there is no difficulty in distinguishing Masaccio's original intonaco: He seemed to have preferred to work on plaster that was not flat. Indeed, this preference is so marked that I am inclined to regard it as diagnostic – which ascribes the face of Christ in the *Tribute Money* to Masolino.

31. Robert Munman, "Optical Corrections in the Sculpture of Donatello," *Transactions of the American Philosophical Society* 75 (1985): xiv, 96.

32. For a discussion of some of Donatello's reliefs, see John White, "Developments in Renaissance Perspective – II," *Journal of the Warburg and Courtauld Institutes* 14 (1951): 42–69, pls. 5–11.

33. There is an interesting discussion of the wide range of Donatello's art in Artur Rosenauer, *Donatello* (Milan: Electa Editrice, 1993).

34. In a later generation, Michelangelo's rather dismissive attitude to mathematics may perhaps have had a similar root.

35. Like most of Donatello's works, the Lille relief cannot be dated securely. The bronze *Feast of Herod* relief in the Siena Baptistery, which dates from early in Donatello's career, shows less floor than the marble one does.

36. Since in other works, such as the reliefs in the Old Sacristy of San Lorenzo, Florence, Donatello displays bravura showmanship, using a modeling technique as bold as Masaccio's brushwork, one must suppose that making the picture in the Lille relief correct, but nearly invisible, was an intentional ploy.

37. There is a startling exception in a predella panel to the Louvre *Coronation of the Virgin* by Fra Angelico (c. 1395/1400–55) showing *Saints Peter and Paul Appearing to Saint Dominic*. Here the images of the receding orthogonals of the colonnade appear to converge on the left edge of the picture. This curious scheme is explained by the fact that the panel to the left in the predella shares this centric point. Angelico is attempting to unify the perspective schemes for the two predella scenes.

38. In his life of Uccello, Vasari says that when his wife came to call him to bed, Uccello murmured what a sweet thing perspective was.

39. In badly damaged works, such as the scenes in the fresco cycle of the Story of Noah (Florence, Santa Maria Novella, Chiostro Verde), the perspective schemes are more legible than the subjects of the pictures.

40. See Martin Kemp and Alain Massing, with Nicola Christie and Karin Groen, "Paolo Uccello's 'Hunt in the Forest,'" *Burlington Magazine* 133 (1991): 164–78.

41. In fact, adapted versions of Euclid's *Elements* continued to form the basis of education in geometry until the beginning of the twentieth century.

42. See *John Pecham and the Science of Optics: Perspectiva communis,* ed. and trans. David C. Lindberg (Madison, Wis.: University of Wisconsin Press, 1970).

43. Ernst H. Gombrich, "From the Revival of Letters to the Reform of the Arts: Niccolò Niccoli and Filippo Brunelleschi," in his *Studies in the Art of the Renaissance: The Heritage of Apelles* (London: Phaidon Press, 1976), 93–110.

44. The name *costruzione legittima* is introduced in Pietro Accolti, *Lo inganno de gl'occhi prospettiva pratica* (Florence: Appresso Pietro Cecconcelli, 1625). Accolti had apparently misunderstood the significance of a proof in Giovanni Battista Benedetti, *De rationibus operationum perspectivae,* in his *Diversarum speculationum mathematicarum, & physicarum liber quarum seriem . . .* (Turin: n.p., 1585). On this latter work, see J. V. Field, "Giovanni Battista Benedetti on the Mathematics of Linear Perspective," *Journal of the Warburg and Courtauld Institutes* 48 (1985): 71–99; and idem, 1997.

45. All known manuscripts have the Latin title, but the work was originally written in the vernacular.

46. See J. V. Field, "Piero della Francesca and the 'Distance Point Method' of Perspective Construction," *Nuncius* 10.2 (1995): 509–30.

47. See idem, "Piero della Francesca's Mathematics," in *The Cambridge Companion to Piero della Francesca,* ed. Jeryldene Wood (Cambridge: Cambridge University Press, in press).

48. The mistaken claim that Piero's proof is invalid, put forward in James Elkins, "Piero della Francesca and the Renaissance Proof of Linear Perspective," *Art Bulletin* 69 (1987): 220–30, is based on an inadequate grasp of fifteenth-century mathematics in general and of Piero's terminology in particular. Its getting into print is a reflection of an inadequate refereeing system. For the relevant mathematics, see J. V. Field, "Piero della Francesca as practical mathematician: The painter as teacher," in *Piero della Francesca tra arte e scienza: atti del convegno internazionale di studi, Arezzo, 8–11 ottobre 1992, Sansepolcro, 12 ottobre 1992,* eds. Marisa Dalai Emiliani and Valter Curzi (Venice: Marsilio, 1996), 331–54; and more briefly in Field, 1997.

49. All known manuscripts, both of the vernacular original and of the Latin translation, have the Latin title *De prospectiva pingendi.*

50. For a detailed study of the work, see Marilyn Aronberg Lavin, *The Flagellation of Christ* (New York: Viking Press, 1972; rpt. with additional bibliography, Chicago: University of Chicago Press, 1990).

51. Hence the repeated appearances of Piero della Francesca's *Flagellation* in writings on perspective. It is rather hard to understand why so many art historians have clung to the prejudice that most fifteenth-century works used perspective in a manner that was mathematically correct.

CHAPTER 10. MASACCIO'S LEGACY

1. Giorgio Vasari, *The Lives of the Artists,* trans. George Bull (Harmondsworth: Penguin Books, 1965), 124.

2. Vasari, 132.

3. The date of Masaccio's departure from Florence is not known, but he may

have traveled to Rome with Masolino in May 1428; see Paul Joannides, *Masaccio and Masolino. A Complete Catalogue* (London: Phaidon Press, 1993), 33.

4. For Gentile da Fabriano's work in Florence, see Keith Christiansen, *Gentile da Fabriano* (Ithaca, N.Y.: Cornell University Press, 1982), 18–49.

5. Joannides, 153–72.

6. For Fazio's writings on artists, see Michael Baxandall, *Giotto and the Orators: Humanist Observers of Painting in Italy and the Discovery of Pictorial Composition* (Oxford: Clarendon Press, 1971), 103–9.

7. See discussion in text, following.

8. Leon Battista Alberti, *On Painting and On Sculpture,* ed. and trans. Cecil Grayson (London: Phaidon Press, 1972), 33.

9. Baxandall, 126 n. 11.

10. John Pope-Hennessy, *Paolo Uccello* (London: Phaidon Press, 1969), 157–9, pls. 107–12. It should, however, be said that this is a highly problematical work around which there is little scholarly consensus regarding attribution and date. The identifications of the five portraits given in the later inscriptions agree with those given by Vasari in his discussion of the panel in the 1550 version of the life of Masaccio (to whom he then attributed the panel; in 1568 he gave it instead to Uccello). Other identifications, including that of Masaccio for the leftmost figure of the group, have been proposed, but without conclusive evidence.

11. Filarete (Antonio Averlino), *Filarete's Treatise on Architecture,* trans. John R. Spencer, 2 vols. (New Haven and London: Yale University Press, 1965), 1: 120.

12. Fazio's choice of Jan van Eyck, Rogier van der Weyden, Gentile da Fabriano, and Pisanello evidently reflected the aesthetic preferences of the princely court of Alfonso of Aragon in Naples.

13. Giovanni Rucellai, *Giovanni Rucellai ed il suo Zibaldone,* ed. Alessandro Perosa, 2 vols. (London: The Warburg Institute, 1960), 1: 23–4; Creighton E. Gilbert, *Italian Art 1400–1500. Sources and Documents* (Englewood Cliffs, N.J.: Prentice-Hall, 1980), 112.

14. Benedetto Dei, *Memorie istoriche* (unpublished MS of 1470), excerpted in Gilbert, 181–4.

15. Gilbert, 94–100, esp. 99.

16. Alamanno Rinuccini, dedicatory letter to Federigo da Montefeltro in his translation of Philostratus's *Life of Apollonius of Tyana*; see Ernst H. Gombrich, "The Renaissance Conception of Artistic Progress and Its Consequences," in his *Norm and Form* (London: Phaidon Press, 1966), 1–10, esp. 1–2; Latin original at 139–40; Gilbert, 185–6.

17. Ottaviano Morisani, "Art Historians and Art Critics – III: Cristoforo Landino," *Burlington Magazine* 95 (1953): 267–70; and Michael Baxandall, *Painting and Experience in Fifteenth Century Italy. A Primer in the Social History of Pictorial Style* (Oxford: Oxford University Press, 1972), 118–28; this translation from Gilbert, 191–2. Surprisingly, Ugolino Verino, whose account of Florentine art and artists in his *De Illustratione Urbis Florentiae* (Paris, 1790 ed.), 129–37, is similar to (though briefer than) Landino's, fails to mention Masaccio.

18. Leonardo da Vinci, *Leonardo on Painting,* ed. Martin Kemp, trans. Martin Kemp and Margaret Walker (New Haven and London: Yale University Press, 1989), 193.

19. Peter Murray, "Art Historians and Art Critics – IV: *XIV Uomini Singhularii in Firenze*," *Burlington Magazine* 99 (1957): 330–6; Gilbert, 195–7.

20. Francesco Albertini, *Memoriale di molte statue et picture sono nella inclyta cipta di Florentia . . .* , Florentia MDX (unpaginated); cited in Peter Murray, *An Index of Attributions Made in Tuscan Sources before Vasari* (Florence: Leo S. Olschki, 1959), 10–11.

21. The Anonimo Magliabecchiano (the Anonimo Gaddiano) is a series of lives of Italian artists written in the early sixteenth century; cited in Murray, 1959, 110–11. For the "Libro di Antonio Billi," see Carl von Fabriczy, "Il Libro di Antonio Billi e le sue copie nella Biblioteca Nazionale di Firenze," *Archivio storico italiano,* ser. 5, 7 (1891): 299–368 (on Masaccio at 325–6); and Murray, 1959, 110–11.

22. Benvenuto Cellini, *I Trattati dell'oreficeria e della scultura di Benvenuto Cellini,* ed. Carlo Milanesi (Florence: Felice Le Monnier, 1857), 364–6: "Avvenga che la sua lucerna viene ad essere la Scultura, e da quella tutti gli eccellentissimi pittori, ogni cosa che loro hanno volsuto [sic: voluto] fare di pittura, in prima l'hanno fatto in piccole sculture, e da quelle ritratte. E con quella mirabile lucerna, come dice il nostro maravigliosissimo Michelagnolo, so sono fatti lume, so come si vede in nel Carmine, in Firenze, per Masaccio pittore, et in Milano et in Firenze alcune belle cose per Lionardo da Vinci pittore; et in Roma per mano del nostro Michelagnolo, scultore, pittore et architettore. Questi dipingendo hanno adoperata la lucerna detta: e dopo loro la Pittura piange essersi spenta, e così cieca trampolando vive. . . ."

23. Vasari, 91.

24. Vasari, 92.

25. Vasari, 93.

26. Vasari, 128.

27. Vasari, 125.

28. Vasari, 130–1. In the life of Fra Filippo Lippi, Vasari reiterates, "Fra Filippo . . . used to go every day in his spare time and practice in company with many other young artists who were always drawing there [i.e., in the Brancacci Chapel]"; Vasari, 214.

29. Giorgio Vasari, *The Lives of the Painters, Sculptors and Architects,* ed. William Gaunt, 4 vols. (London: Dent, 1963), 3: 126–7; Patricia L. Rubin, *Giorgio Vasari: Art and History* (New Haven and London: Yale University Press, 1995), 74–5.

30. *Il disegno fiorentino del tempo di Lorenzo il Magnifico,* ed. Anna Maria Petrioli Tofani, exh. cat., Florence, Uffizi (Florence: Silvana Editoriale, 1992), cat. 1.8, 34–5; see also Alessandro Angelini, *Disegni italiani del tempo di Donatello,* exh. cat., Florence, Uffizi (Florence: Leo S. Olschki, 1986), cat. 25, 40–1. Also for Joannides, 330, it is a copy after Masaccio.

31. George R. Goldner, "A Drawing by Masaccio. A Study for the Brancacci Chapel," *Apollo* 140 (1994); 22–3.

32. Vasari-Bull, 127.

33. Vasari-Bull, 130; as noted earlier, "the figure of a naked man shivering with cold" is also highlighted by Vasari in the Preface to Part Two of his *Lives,* 91.

34. Florence, Uffizi 30F; see Angelini, 15 cat. 1, fig. 1 (as "sequace di Donatello"); Joannides, 450–1 (as "Paolo Uccello or Masaccio (?)"). Joannides argues for its greater closeness to Masaccio than to Donatello, but given the dearth of reliably comparative material, I'm not sure one can be as confident as this.

35. Florence, Uffizi 44F; see recently Lucy Whitaker, "Maso Finiguerra and Early

Florentine Printmaking," in *Drawing 1400–1600. Invention and Innovation,* ed. Stuart Currie (Aldershot: Ashgate Publishing Limited, 1998), 45–71, esp. 50–1.

36. Munich, Graphische Sammlung inv. 2191r; Charles de Tolnay, *Corpus dei disegni di Michelangelo,* 4 vols. (Novara: Istituto Geografico de Agostini, 1975), 1: cat. 4r, 25.

37. Paris, Musée du Louvre inv. 706r, and Vienna, Albertina Sc.R.150 inv. 116, respectively; de Tolnay 1: cat. 3r, 23; and cat. 5r, 25. The Vienna drawing is almost universally considered to be a copy after figures in Masaccio's *Sagra,* but for an alternative view, see the complex and intriguing argument of Creighton E. Gilbert, "The Drawings Now Associated with Masaccio's Sagra," *Storia dell'Arte* 3 (1969): 260–78; on the *Sagra,* see Joannides, cat. L3, 443–6.

38. Martin Kemp, *Behind the Picture. Art and Evidence in the Italian Renaissance* (New Haven and London: Yale University Press, 1997), 153.

39. *The Drawings of Filippino Lippi and His Circle,* eds. George R. Goldner and Carmen C. Bambach, exh. cat. (New York: Metropolitan Museum of Art, 1997), pl. 10 (Chatsworth 886B); and see also cat. 19, 134–5, for the stimulus of the Brancacci Chapel frescoes on the development of Filippino as a portraitist.

40. Goldner and Bambach, cat. 16, 126–7.

41. Hamburg, Kunsthalle 21273; see Hellmut Wohl, "The Eye of Vasari," *Mitteilungen des Kunsthistorischen Institutes in Florenz* 30 (1986): 537–66; 542, fig. 3; 550; and 556, app. 10.

42. Baxandall, 1972, 118, 128–39; Gilbert, 1980, 191.

43. For the Sassetti Chapel frescoes, see Eve Borsook and Johannes Offerhaus, *Francesco Sassetti and Ghirlandaio at Santa Trinita, Florence. History and Legend in a Renaissance Chapel* (Doornspijk: Davaco Publishers, 1981), and now Enrica Cassarino, *La Cappella Sassetti nella chiesa di Santa Trinita* (Lucca: Maria Pacini Fazzi editore, 1996); for good recent reproductions of all of Ghirlandaio's work, see Ronald G. Kecks, *Ghirlandaio* (Florence: Cantini, 1995), and now Jean K. Cadogan, *Domenico Ghirlandaio. Artist and Artisan* (New Haven and London: Yale University Press, 2000).

44. Vasari-Bull, 290.

Selected Bibliography

Diane Cole Ahl, "Fra Angelico: A New Chronology for the 1420s," *Zeitschrift für Kunstgeschichte* 43 (1980): 360–81.

Leon Battista Alberti, *On Painting and On Sculpture,* ed. and trans. Cecil Grayson (London: Phaidon Press, 1972).

Francis Ames-Lewis, *The Intellectual Life of the Early Renaissance Artist* (New Haven and London: Yale University Press, 2000).

Giuseppe Bacchi, "La cappella Brancacci," *Rivista storica carmelitana* 1 (1929): 55–68.

Umberto Baldini, "Nuovi affreschi nella Cappella Brancacci, Masaccio e Masolino," *Critica d'arte* 49 (1984): 65–72.

"Del 'Tributo' e altro di Masaccio," *Critica d'arte* 54 (1989): 29–38.

"The Restoration: History, Research, and Methodology," in Umberto Baldini and Ornella Casazza, *The Brancacci Chapel,* trans. Lysa Hochroth with Marion L. Grayson (New York: Harry N. Abrams, 1990), 285–96.

Umberto Baldini and Ornella Casazza, *La Cappella Brancacci* (Milan: Electa Editrice, 1990); English trans., *The Brancacci Chapel,* trans. Lysa Hochroth with Marion L. Grayson (New York: Harry N. Abrams, 1990).

Ivo Becattini, "Il territorio di San Giovenale ed il Trittico di Masaccio. Ricerche ed ipotesi," in *"Masaccio 1422/1989." Dal trittico di San Giovenale al restauro della Cappella Brancacci. Atti del Convegno del 22 aprile 1989* (Pieve di San Cascia-Reggello, Figline Valdarno: n.p., 1990), 17–26.

James H. Beck with the collaboration of Gino Corti, *Masaccio. The Documents* (Locust Valley, N.Y.: J. J. Augustin, 1978).

Luciano Bellosi and Margaret Haines, *Lo Scheggia* (Florence and Siena: Maschietto & Musolino, 1999).

Bernard Berenson, "La Madonna pisana di Masaccio," *Rassegna d'arte* 8 (1908): 81–5.

Luciano Berti, "Masaccio 1422," *Commentari* 12 (1961): 84–107.

Masaccio (Milan: Istituto editoriale italiano, 1964; English trans. University Park, Pa.: Pennsylvania State University Press, 1967).

Luciano Berti and Rossella Foggi, *Masaccio. Catalogo completo dei dipinti* (Florence: Cantini, 1989).

Eve Borsook, *The Mural Painters of Tuscany from Cimabue to Andrea del Sarto,* 2nd ed. (Oxford: Clarendon Press, 1980).

Miklòs Boskovits, "Il percorso di Masolino: Precisazioni sulla cronologia e sul catalogo," *Arte cristiana* 75 (1987): 47–66.

Allan Braham, "The Emperor Sigismund and the *Santa Maria Maggiore Altarpiece*," *Burlington Magazine* 122 (1980): 106–12.

Heinrich Brockhaus, "Die Brancacci-Kapelle in Florenz," *Mitteilungen des Kunsthistorischen Institutes in Florenz* 3 (1919–22): 160–82.

Ornella Casazza, "Il ciclo delle storie di San Pietro e la 'historia salutis.' Nuova lettura della cappella Brancacci," *Critica d'arte* 51 (1986): 69–84.

"Al di là dell'immagine," in *I pittori della Brancacci agli Uffizi: Gli Uffizi. Studi e ricerche* 5, eds. Luciano Berti and Annamaria Petrioli Tofani (Florence: Centro Di, 1988), 93–101.

"La grande gabbia architettonica di Masaccio," *Critica d'arte* 53 (1988): 78–97.

"The Brancacci Chapel from Its Origins to the Present," in Umberto Baldini and Ornella Casazza, *The Brancacci Chapel*, trans. Lysa Hochroth with Marion L. Grayson (New York: Harry N. Abrams, 1990), 307–11.

"Masaccio's Fresco Technique and Problems of Conservation," in *Masaccio's Trinity*, ed. Rona Goffen (Cambridge: Cambridge University Press, 1998), 69–85.

La chiesa di Santa Maria del Carmine a Firenze, ed. Luciano Berti (Florence: Giunti, 1992).

Keith Christiansen, "Some observations on the Brancacci Chapel frescoes after their cleaning," *Burlington Magazine* 133 (1991): 5–20.

Kenneth Clark, "An Early Quattrocento Triptych from Santa Maria Maggiore, Rome," *Burlington Magazine* 93 (1951): 339–47.

John Coolidge, "Further Observations on Masaccio's *Trinity*," *Art Bulletin* 48 (1966): 382–4.

Martin Davies, *The Earlier Italian Schools. National Gallery Catalogues*, 2nd ed. (London: The National Gallery, 1961).

Charles Dempsey, "Masaccio's *Trinity*: Altarpiece or Tomb?" *Art Bulletin* 54 (1972): 279–81.

Il disegno fiorentino del tempo di Lorenzo il Magnifico, ed. Annamaria Petrioli Tofani, exh. cat., Florence, Uffizi (Florence: Silvana Editoriale, 1992).

L'età di Masaccio. Il primo Quattrocento a Firenze, eds. Luciano Berti and Antonio Paolucci, exh. cat. (Milan: Electa Editrice, 1990).

J. V. Field, *The Invention of Infinity: Mathematics and Art in the Renaissance* (Oxford: Oxford University Press, 1997; rpt. 1999).

J. V. Field, Roberto Lunardi, and Thomas B. Settle, "The Perspective Scheme of Masaccio's *Trinity* Fresco," *Nuncius* 4 (1988): 31–118.

Richard Fremantle, "Masaccio e l'antico," *Critica d'arte* 34 (1969): 39–56.

"Some Documents Concerning Masaccio and His Mother's Second Family," *Burlington Magazine* 115 (1973): 516–19.

Masaccio. Catalogo Completo (Florence: Octavo, 1998).

Christa Gardner von Teuffel, "Masaccio and the Pisa Altarpiece: A New Approach," *Jahrbuch der Berliner Museen* 19 (1977): 23–68.

Creighton E. Gilbert, "The Drawings Now Associated with Masaccio's Sagra," *Storia dell'Arte* 3 (1969): 260–78.

Prisca Giovannini and Sergio Vitolo, *Il convento del Carmine di Firenze: caratteri e documenti* (Florence: Tipografia Nazionale, 1981).

Rona Goffen, "Masaccio's *Trinity* and the Letter to the Hebrews," *Memorie domenicane* n.s. 11 (1980): 489–504.

E[dgar]. Hertlein, *Masaccios Trinität. Kunst, Geschichte und Politik der Frührenaissance in Florenz* (Florence: Leo S. Olschki, 1979).

Megan Holmes, *Fra Filippo Lippi. The Carmelite Painter* (New Haven and London: Yale University Press, 1999).

I pittori della Brancacci agli Uffizi. Gli Uffizi, Studi e ricerche 5, eds. Luciano Berti and Annamaria Petrioli Tofani (Florence: Centro Di, 1988).

Paul Joannides, "The Colonna Triptych by Masaccio and Masolino: Chronology and Collaboration," *Arte cristiana* 76 (1988): 339–46.

Masaccio and Masolino. A Complete Catalogue (London: Phaidon Press, 1993).

Martin Kemp, *The Science of Art: Optical Themes in Western Art from Brunelleschi to Seurat* (New Haven and London: Yale University Press, 1990).

Wolfgang Kemp, "Masaccios 'Trinität' im Kontext," *Marburger Jahrbuch für Kunstwissenschaft* 21 (1986): 45–72.

Andrew Ladis, *The Brancacci Chapel* (New York: George Braziller, 1993).

Marilyn Aronberg Lavin, *The Place of Narrative. Mural Decoration in Italian Churches, 431–1600* (Chicago: University of Chicago Press, 1990).

Il Libro di Antonio Billi, ed. Fabio Benedettucci (Anzio [Rome]: De Rubeis, 1991).

Ralph Lieberman, "Brunelleschi and Masaccio in Santa Maria Novella," *Memorie domenicane* n.s. 12 (1981): 127–39.

Henrik Lindberg, *To the Problem of Masaccio and Masolino,* 2 vols. (Stockholm: P. A. Norstedt & söner, 1931).

Roberto Longhi, "Fatti di Masolino e di Masaccio," *Critica d'arte* 25–6 (1940): 145–91; rpt. in his *'Fatti di Masolino e di Masaccio' e altri studi sul Quattrocento 1910–1967* (Florence: G. C. Sansoni, 1975).

"Masaccio 1422/1989." Dal trittico di San Giovenale al restauro della Cappella Brancacci. Atti del Convegno del 22 aprile 1989 (Pieve di San Cascia-Reggello, Figline Valdarno: n.p., 1990).

Masaccio's Trinity, ed. Rona Goffen (Cambridge: Cambridge University Press, 1998).

Millard Meiss, "Masaccio and the Early Renaissance: The Circular Plan," in *Acts of the 20th International Congress of the History of Art,* 2 vols. (Princeton: Princeton University Press, 1963), 1: 123–45.

Peter Meller, "La Cappella Brancacci: problemi ritrattistici e iconografici," *Acropoli* 1 (1960–1): 186–227; 273–312.

Jacques Mesnil, "La data della morte di Masaccio," *Rivista d'arte* 8 (1912): 33–4.

Anthony Molho, "The Brancacci Chapel: Studies in Its Iconography and History," *Journal of the Warburg and Courtauld Institutes* 40 (1977): 50–98.

Leonida Pandimiglio, *Felice di Michele vir clarissimus e una consorteria. I Brancacci di Firenze* (Milan: Olivetti, 1987/89).

Alexander Perrig, "Masaccios 'Trinità' und der Sinn der Zentralperspektive," *Marburger Jahrbuch für Kunstwissenschaft* 21 (1986): 11–44.

Mary Pittaluga, *Masaccio* (Florence: Felice Le Monnier, 1935).

Joseph Polzer, "The Anatomy of Masaccio's Holy Trinity," *Jahrbuch der Berliner Museen* 13 (1971): 18–59.

Ugo Procacci, "L'incendio della chiesa del Carmine del 1771," *Rivista d'arte* 14 (1932): 141–232.

"Relazione di lavori eseguiti nella chiesa del Carmine di Firenze per la ricerca di antichi affreschi," *Bollettino d'arte* 27 (1933–4): 327–34.

Tutta la pittura di Masaccio (Milan: Rizzoli, 1951).

Masaccio (Florence: Leo S. Olschki, 1980).

Perri Lee Roberts, "St. Gregory the Great and the *Santa Maria Maggiore* Altarpiece," *Burlington Magazine* 127 (1985): 295–6.

Masolino da Panicale (Oxford: Clarendon Press, 1993).

Steffi Roettgen, *Italian Frescoes. The Early Renaissance, 1400–1470,* trans. Russell Stockman (New York: Abbeville Press, 1996).

Mario Salmi, *Masaccio,* 2nd ed. (Milan: U. Hoepli, 1947).

Divo Savelli, *La Sagra di Masaccio* (Florence: Giampiero Pagnini Editore, 1998).

Ursula Schlegel, "Observations on Masaccio's Trinity Fresco in Santa Maria Novella," *Art Bulletin* 45 (1963): 19–34.

John Shearman, "Masaccio's Pisa Altarpiece: An Alternative Reconstruction," *Burlington Magazine* 108 (1966): 449–55.

Curtis Howard Shell, "Giovanni dal Ponte and the Problem of Other Lesser Contemporaries of Masaccio," Ph.D. diss., Harvard University, Cambridge, Mass., 1958.

Otto von Simson, "Uber die Bedeutung von Masaccios Trinitätfresko in Santa Maria Novella," *Jahrbuch der Berliner Museen* 8 (1966): 119–59.

John T. Spike, *Masaccio* (New York: Abbeville Press, 1996).

Carl Brandon Strehlke and Mark Tucker, "The *Santa Maria Maggiore Altarpiece:* New Observations," *Arte cristiana* 75 (1987): 105–24.

James H. Stubblebine et al., "Early Masaccio: A Hypothetical Lost Madonna and a Disattribution," *Art Bulletin* 62 (1980): 217–25.

Angelo Tartuferi, "Le testimonianze superstiti (e le perdite) della decorazione primitiva (secoli XIII–XV)," in *La chiesa di Santa Maria del Carmine a Firenze,* ed. Luciano Berti (Florence: Giunti, 1992), 143–71.

Giorgio Vasari, *Le vite de' più eccellenti pittori, scultori ed architettori,* ed. Gaetano Milanesi, 9 vols. (Florence: G. C. Sansoni, 1906).

Timothy Verdon, "La Sant'Anna Metterza: riflessioni, domande, ipotesi," in *I pittori della Brancacci agli Uffizi: Gli Uffizi. Studi e ricerche* 5, eds. Luciano Berti and Annamaria Petrioli Tofani (Florence: Centro Di, 1988), 33–58.

Law Bradley Watkins, "Technical Observations on the Frescoes of the Brancacci Chapel," *Mitteilungen des Kunsthistorischen Institutes in Florenz* 17 (1973): 65–74.

"The Brancacci Chapel Frescoes: Meaning and Use," 2 vols., Ph.D. diss., University of Michigan, Ann Arbor, Mich., 1976.

Hellmut Wohl, "Masaccio," in *The Macmillan Dictionary of Art,* ed. Jane Turner, 34 vols. (New York: Macmillan, 1996), 20: 529–39.

Index

Plates are indicated in **boldface** type.